Cover picture:
Parliament, 2008, acrylic on canvas, 270x150cm,
private collection, *West*

FROM STYLE WRITING TO ART

a Street Art anthology

By Magda Danysz
In collaboration with Mary-Noëlle Dana

DRAGO

"There's no one history of graffiti. It depends on what borough you lived in, what year you were born in, and what lines you rode... The best you will ever get is a personal history of graffiti." **HAZE**

"All you really see is the art of your own generation." **Leo Castelli**

For Antoine

006 ABOUT THE AUTHORS

007 ACKNOWLEDGEMENTS

009 FOREWORD

011 INTRODUCTION

011 Movement: The Graffiti Internationale

021 Getting up

023 Advertising and the Fame Game

025 Tag and Street Art: from Vandalism to Art

035 PART 1

035 Style Writing History

037 The old-school Pioneers

039 The Birth of an esthetic Language

046 Graffiti and Hip Hop

047 Using an Alias

048 Building a Language of its own

049 Turning an illegal Activity into a respectable Practice

055 FUTURA (2000)

066 QUIK

074 BLADE

080 LEE Quinones

083 PHASE 2

088 RAMMΣLLZΣΣ

094 SEEN

104 CRASH

112 DAZE

118 DONDI

128 ZEPHYR

132 NOC 167

136 DOZE GREEN

138 LADY PINK

156 PART 2

156 The Rise of a worldwide Art Form

157 The Show Frenzy

160 The War on Graffiti

162 The Race for Survival

169 Charles "Chaz" Bojorquez

170 Cholo Style Graffiti Art

186 A-ONE

192 MODE 2

196 MARE 139

200 WEST

210 COPE 2

212 Keith Haring

215 Jean-Michel Basquiat

218 SHARP

222 DELTA

224 DAIM

228 LOOMIT

230 JONONE

242 ASH

248 JAY

256 SKKI

262 MISS VAN

282 PART 3

282 The Renewal

282 An explosive Evolution

284 Ramifications and Origins

286 Murals

289 Street Art Stencil

292 Street Art Wheatpaste and Print

293 Street Sticker Art

295 Mosaic Tiling

296 Woodblocking

297 Street Installations

297 Video Projection/LED Art

298 Worlwide Repression

302 Getting Inside

304 BLEK LE RAT

310 MISS.TIC

314 BANKSY

317 Barry McGee (TWIST)

324 OS GÊMEOS

327 Shepard Fairey (OBEY)

334 SWOON

337 D*FACE

342 FAILE

348 SPACE INVADER

354 ZEVS

358 KAWS

360 BUFF MONSTER

364 BLU

367 M CITY

370 VHILS

374 NUNCA

378 JR

386 GLOSSARY

396 INDEX

ABOUT THE AUTHORS

Magda Danysz is a Paris and Shanghai-based art dealer. She was 17 when she opened her first art space. She presented a first show in 1991, quickly followed by a first collective graffiti art show in 1992, with artists such as JonOne, Sharp, Psy, Ash, Jay, or Skki. Since 1999, she's made it a point to continually present emerging artists, including Street artists, among whom D*face, Miss Van, Shepard Fairey, West and the likes. She has so far presented about 50 shows related to Street Art in her gallery and in the main art fairs around the world. Since 2001, Magda Danysz has been teaching cultural policies at the Sciences Politiques Institute (Paris), and sits on the board of multimedia cultural art center Le Cube, in Issy-les-Moulineaux. She is the co-founder of ShowOff, the Paris contemporary art fair, which was launched in 2006. In 2007, she was made "Chevalier des Arts et des Lettres" by the French Culture Ministry. In 2009 she inaugurated a new gallery space in Shanghai, China.

Mary-Noelle Dana is a French-American writer and translator, based here and there and everywhere. She has a soft spot for the arts in general, and a thing for contemporary art, screenplays and lyrics in particular.

ACKNOWLEDGEMENTS

Thanks to: Antoine Barrère for his unconditional support and for believing in me for so many years. Mary-Noelle Dana for jumping in such an adventure with both feet; Grazyna, Jan, Hanna for respecting my choices from the beginning; Marie, Jacques and Céline for their support; Stéphane Bisseuil for sharing this passion since the New York years; Hubert Barrère, Stéphanie Benzaquine, Valérie Benzaquine, Cédric Dassas, Virgile Hermann, Raphaëlle and Pierre Vergnes, my truest friends, for whom the first pages were written before I even knew it could be a book.

And to all the artists, for their inspiration through the years. Without them, as my mother always told me, we would be nothing: the 9ème concept (our best years), A-One (respect), Alexone, Anne (G.), Ash (shared a lot for a long time), Barry McGee, Blade, Blek Le Rat, Blu, Buff Monster, Cope 2, Steph Carricondo, Crash (France is fun and crazy), Daim, Dave Kinsey (peace from L.A.), David Ellis (keep the music going), Daze, Delta, D*face, Dondi (respect again), Doze Green, Faile, Futura (for inspiration), Maya Hayuk, Ikon, Jay (time goes by fast), Jerk, Jonone (you wanted more, you got it), Lee, Lokiss, M City, Mambo, Mare 139, Miss Tic, Miss Van (for her determination through the years), Mode 2, Nasty (first steps), Mark Newton, Ned, Nunca (for his belief in France), Os Gêmeos, José Parla (love the debate), Phase 2, Lady Pink (a real lady), Popay, Quik (a guardian angel), Rammellzee, Seen (for his work), Sharp, Shepard Fairey (and Amanda and their great and sweet family too), Skki (for all these years), Space Invader (for his independence), Swoon, Veenom, Vhils, West (for sharing), Zephyr, Zevs and all the artists out there.

To my staff and the extended gallery family: Sophie, Stéphane and Louisa Duhamel, Boris Cohen, Pauline Foessel, Fanny Giniès, Silvia Guerra, Charles Halperin, Aylin Kowalewsky, Astrid de Maismont, Julie Leveau, Jerôme Pauchant, Axel Teinturier, Clémence Wolff.

To all those who, in one way or another, helped me complete this project; on my own it would have taken another 10 years at least: Jamie Camplin, Henry Chalfant (for his kindness and above all his eye), Thierry Froger, Patrick Lerouge, Henk Pijnenburg, Nicola Scavalli, Paulo and Dominittla Von Vacano.

For backing me up, whatever the whim or concept: Landry Ajavon, Roxana Azimi, Florent and Nils Aziosmanoff, Colette Barbier, Pascal Béjean, Luc Bellier, Delphine Benchetrit, Natacha Bensimon, Florence Berès, Maximin Berko, Patrick, Viviane and Irina Berko, Laurent Boudier, Bruno and Helen Bouygues, Yves Bouvier, Aldo Cardoso, Philippe Cohen, Axelle Corty, Jean-François Debailleux, Alexndre Dubourg, Valérie Duponchelle, Sylvie Dupuis, Nathalie and Max Fischer, Romain Flageul; Michèle and Jean-Jacques for their open-mindedness as they, later on, caught up the train; Freddy Jay, Fabien Gago, Martin Guesnet, Jacques Halperin, Didier, Sophie and Fiona Imbert, Aurélien Janillon, Jacques and Katia Judeaux, Patricia Keever, Patricia Kishishian and Jean-Claude, Eléonore Lambertie, Nicolas Laugero, Alexandre Lazarev, Nicolas and Delphine Ledoux, Pierre Levy, Maï Lucas, Stéphane Magnan, Nicolas de Montmarin, Arnaud Odier, Christine Ollier, Arnaud Olliveux, Jean-Michel Paillès, Philippe Peuch-Lestrade, Bounmy Phonesavanh, Eric de Remeaux, Eric Rodrigue, Jean-Marc Salomon and Daniella, Vanna Teng.

FOREWORD

It's time to stand for what is true, or maybe it's just time for me to speak up for truth. A truth that struck the teenager I was in the 80s in such a massive way, I have made my whole life revolve around it. The book you're holding, since truth must be told, is about how I consider everything around Style Writing, Graffiti and Street Art, to be the most interesting artistic movement at the turn of this century.

Let me repeat myself, if only for the skeptic eye, for the blind and lost, or for the late-comers who just missed the boat: I believe this type of urban art to be the most important artistic movement at the turn of our century.

There is major talent in the history of Graffiti. And this talent is, in the end, the only answer to the infamous "But… is it really art?" question. Out of this both compact and diffuse form of expression, real art practices have emerged, absolutely unquestionable in terms of quality and longevity. This book is about why this is Art.

I think of Graffiti/Street Art/Style Writing (check the box once you've found the term that suits you) as a cousin to the cubist revolution fifty years ago. As far as I can see, Style Writing has shaken the art establishment as hard as cubism hit painting back in the days, branching out into a whole new modern era, leading a whole new Art History chapter.

A chapter of Art History is in the making. And I'm often asked which ten artists, I would choose, if I had to. I remember following the artistic path of numerous artists who started with Style Writing and evolved to Graffiti or, later, to Street Art. I couldn't help wonder, then, who amongst them would turn out to be the next Picasso. Now, after four decades, what has become a real Art movement has its history, its stars and probably its ten most important representatives. Yet it does not exclude all the creative energies, the passion and the talent of many others. Once thing I'm sure of: amongst them, are geniuses.

There have been numerous books on this Movement, some great, some lacking. In this anthology, I intend to analyze who, in my opinion, are its greatest artists. From the prolific years that the Movement has gone through, who will be remembered as the great fine artists I believe them to be?

And now, we can acknowledge that contemporary art history benefits from live-experience testimonials in writing. That's probably the most fascinating aspect of Art, after the act of creating itself.

I'm a passionate person. When I was sixteen, Daniel Templon, the art dealer, warned me I'd never write a single page in art history. I promised myself I would. I have the feeling I am bringing this chapter to light today. Eventually, the art dealer was right, because this chapter was written a long time before I myself started typing. The artists took care of it: they wrote it loud, clear, right in front of our eyes, in big and bold, outside and inside. On the walls.

INTRODUCTION

Movement: The Graffiti Internationale

How is Street Art an enduring, global, unique, strong Movement?

Enduring: Artist from this movement who started as writers, Graffiti artists or Street artists, have been around for the past four decades, if not more. Forty years of unbroken history line illustrate the movement, In which all the events are linked, techniques are passed on and everyone involves is out to improve their style and become the best.

Global: The practice linked to Writing, Graffiti and Street Art can be found all around the world, from New York to Seoul via Moscow or Cape Town or São Paolo, and many other cities. It has been said to originate mainly from New York, yet in less than a few years from its origins It was everywhere. In the same way, all new forms of street art were almost instantly picked on at the other end of the globe. From the United States to Europe, from Australia to Africa, from China to anywhere in the world, there is not one place free of graffiti and street art.

Technique: Style Writing, Graffiti and, later, Street Art are defined by techniques of their own, hardly mastered in such a way by any other art movement. Whether through the use of aerosol paint, or stencil for instance, artists from the movement can be considered as masters of the genre. Any other artist will tell you how aerosol is technically hard to handle and master, or how stencil can be technically challenging in terms of precision.

Unique: By their unprecedented history and the way they have emerged spontaneously in the streets, Style Writing, Graffiti and Street Art are unique in Art history. Never has such a movement so rapidly and largely spread its influences, away from the usual Art schools. In Style Writing, Graffiti and Street Art, subway station benches replaced school benches.

Strong: In Style Writing, Graffiti and Street Art, the codes are very precise, shaping a language that has been built over the years and transmitted from one artist to another. Documenting, transmitting, sharing, learning and debating are key components to the Movement. In order to improve, one has to see what others do. For all of them, way before the Internet age, sharing images of the works has also been a priority. Transmission and codes being the basis of this movement, just try and imagine how strong of a community all these artists might be. They all know each other's work and respect it for its artistic input.

Personally, and because instinct is what originally drove me as a wee 17-year old art dealer, I have been living this part of history, a revolution even, from the Inside. It's been more than twenty-five years since Street Art caught my attention, and I am convinced it is a major artistic movement, if not the most important at the turn of our century. And forgive me for repeating myself, but I believe this in a complete and indisputable way, supported in that sense by my daily life as an art dealer, by all the exhibits shown in my gallery, of course, but also outside these walls, on the walls of other galleries, museums, and of course the streets of every city around the world.

Like any movement, Street Art is in motion, and the simple act of giving it a name, of reducing it to one word or expression, is problematic. Style Writing, Graffiti, Subway Art, Stencil Art, Street Art… How is anyone supposed to define the most important artistic movement of our brand new century? As some of its artists point out, the market has now labeled and acknowledged it as Street Art, for the better or the worst.

Out of respect for the Movement's pioneers, many use the term "graffiti", which has actually replaced the original "spraycan art" expressions. As artists grew, they started using different techniques and evolving in their art practice, making the term "graffiti" unsuitable to the complexity of the movement. Because it was born in the streets, logic has reduced its terminology. We know it today as Urban Art, or Street Art. But doesn't that define it in terms of street production only? Doesn't it make the artist a prisoner in his or her own environment? Using the term Street Art, today, implies inner limitations. Out of respect for all the talents in the Movement, we need to encompass Street Art's spectrum in its full width; we need to reaffirm the street's indisputable influence,

how its vibrations have challenged all these artists in the last forty or fifty years, influencing their artwork outside and inside, inspiring their process. And while the street is, and must be, the beginning, it's not always the end.

The most important artistic movement at the turn of this century... Twenty-five years into it, surely it is time today, at last, to pass this movement under closer scrutiny, from an artistic and critical point of view, rather than the usual social one or rather than just, even if that's priceless, documenting it.

What makes it so strong? Street Art's practice was born from a new "ultimate city" environment, with its own techniques (spray, collages, stencils, etc.), with its particular effects and high-impact messages, from individual simple signatures to activism. And more than anything, Street Art is an indisputable common culture, overcoming all frontiers.

The "Graffiti Internationale" exists. Imagine an artist from, say, Barcelona, getting off the plane in Los Angeles, driving from the airport to downtown L.A. Now imagine their surprise as the walls all unravel before their eyes, covered in graffiti left there by well-known artists. They've never met them in the flesh, they know of them through their work, and yet, they're able recognize the artists behind the graffiti instantly, anywhere. Writers and Street Artists confront and respect one another, close at hand or from a great distance. Never before has a movement generated so many international connections and photographic documentation for everyone to share.

This book is a manifest, through which I hope to set the foundations for an art analysis of the Style Writing, Graffiti and Street Art movement, in its ever-changing flow.

Forty years have passed since its early development, as we know it, and yet no book has explored it artistic potency. In what way is it seismic, revolutionary, a page in Art history?

Defining Style Writing, Graffiti and Street Art

The semantics in any art movement lead to endless debates. And even as we write, many still spend their nights discussing the word, label, that shall be used and remain in Art history to depict the Style Writing, Graffiti and Street Art Movement. Or rather they debate on why one word is never good enough to explain it all. In this introduction, and throughout this book, many words will be used to grasp a very large and rich reality. No word is perfect and only time will five us the exact title of this chapter in Art history.

Here are a few of the terms that have been in use over the years:

Style Writing

In the beginning, there were tags. Soon enough, some taggers started putting some style into their letters, and among those some showed an undeniable, yet often unconscious, artistic talent. Those putting this type of effort in their lettering became known as style writers.

As legendary PHASE 2 states himself: *"These are the facts... First of all it's not even called graffiti, it's writing. Graffiti is some social term that was developed (for the culture) somewhere in the 70s. (…) Undoubtedly, from the very beginning and quite officially, writers referred to themselves as "writers" and what they did as "writing," for the simple fact that this is what they did. In their own unique way, they continually reinterpreted the English language to their liking as they saw fit. (...) It was afterwards that newspaper articles surfaced referring to their writing as "graffiti," that the terminology latched itself onto the culture as the appropriation for it, as well as stigmatizing it into an abominable controversy.*

This has always been a case of the powers that be, more concerned with denouncing and attempting to obliterate something before they even attempt to understand or relate to it in any way shape or form. Their initial recourse was to take a negative approach towards it (...) and refuse to recognize the magnitude of what's taken place and what has been created by the existence of writing and this subculture.

This wasn't like an invention or something that you painstakingly take an initiative to label or assimilate. In any event it happened naturally and instinctively. (...) What we need to respect and wholly understand is that this is our creation, our child, our responsibility, and not someone else's.

Writing. Technically it begins with the signature and proceeds with the masterpiece. Both have their stages of metamorphosis. Then there is the throw up. The signature and masterpiece would be considered writing's main or major components. The masterpiece is the dominant of the two forms. Far from science or theory, they are its makeup and primary elements.

Writing is centered on names, words and letters. Combined with the objective of their execution, this creates the product and the overall makeup of the writer.

Writers agree without a doubt, that there is an attitude and commitment within the soul that accompanies being a true writer (as well as being true to the culture), that one's volume of work, brandishing a can of paint, or going through the motions, can in no way replace.

One's use of spray paint is not an automatic right of passage into the ranks of writing. In the aerosol domain a writer would be one whose main function is painting signatures or rendering pieces of any style, simple or complex.

Aside from those ever so important redeeming qualities, an individual's concentration in those aforementioned areas would still account for their being known or labeled as a writer".

Subway Art

The phenomenon started in its very particular and unique way, in the subway. It comes as no surprise that some named it after the place it was born from. Yet the very same artists switched to walls, when repression was getting too strong, and even to interior locations, such as artist studios when they felt the urge to express themselves on canvas, for instance. The subway served many, yet not every artist. While it came as the means and the end to some, others found inspiration elsewhere. The *Subway Art* book by Henry Chalfant and Martha Cooper, published in 1984, remains in the collective mind as a testimony to what this movement has to offer.

Aerosol Art/Spray Can Art

An easy distinction between the Movement and any other art form is its use of aerosol paint, hence the labeling according to the tool and technique. But soon enough, artists expanded their horizons and the term turned obsolete as they experimented, invented new concepts and techniques or even used traditional brushes to get the desired pictorial effects. About aerosol, PHASE 2 states: *"Let us again clarify the total spectrum of our subject matter, "Writing," (signatures, pieces — complex, intricate and other style lettering and throw ups). Apparently aerosol writing is a derivative of the alphabet; but the instance of its evolution and transformation weighed in its entirety, exceeds the limited curriculum of the alphabet. Undoubtedly the user of the aerosol can is an integral part of the culture that must also be recognized. Outside of writing the culture has extended itself and now consists of other forms connected to, as*

well as removed from its original format (writing) and this too must be recognized. The appropriate terminology that describes this atmosphere in relation to all of the aspects within it is "AEROSOL CULTURE": i.e.:

"I am a bomber, strictly throw ups... quantity"...

"I do a lot of animation... B'Boy style characters"...

"Hard-core... totally into crazy letters"...

"I hit all over... with signatures"...

"You name it, abstract, surreal, fantasy scenes"... etc.

Based on one's perception of what art is, all of the ingredients within Aerosol culture can be classified as 'Art' or 'Aerosol Art'. This terminology technically defines that which could be considered as having aesthetic attributes."

The book called "Spraycan Art" by Henry Chalfant and James Prigoff, published in 1987, also fueled the expression for quite some time.

Graffiti

Graffiti was the first attempt to label the movement in its entirety, aiming to embrace it beyond just a technique or a location. It is an accepted term for all artists who started creating murals or subway art based on letters, whether using aerosol or not. But because some artists eventually steered away from the traditional letters and walls, the label became somewhat reductive.

Let's scratch that itch and explore a bit of semantics to see what the word refers to: "Graffiti comes from the Greek "graphein", meaning "to write" in its most common use. It can also mean "to draw". The suffix "graphein" has been modified in today's modern English, and now often completes words, i.e. typography, geography, photography, etc.

While the Greek infinitive γράφειν – "graphein" - is mostly translated as "to write", let's remember that the term carried a visual reference within, closer to ideograms, for example, than to words per se. These were non-textual elements, much like our contemporary culture images. A "sgraffito" is therefore the action of putting an idea into an image. In ancient times, many writings, such as hieroglyphs, had a double dimension, similar to what oriental writing bears today: from a primary "graphein" are born both an image, and a text.

In short, "graphein" in its infinitive form also means "to scratch, to carve; to draw, to sketch; to write; to write down a law, to propose a law as an indict, to prosecute". Hence, the original "graphein" should be translated as "to write" in its most complex wholeness: I write, thus I say, I draw.

The more recent "graffiti" (sing. graffito), or "sgraffito" in its singular form, is also an Italian word, meaning a drawing or scribbling on a flat surface, and it originally referred to those marks found in ancient Roman architecture.

So "sgraffito" is the past participle of "sgraffire", which means to do "sgraffito" work, which became a well-known art technique during the Renaissance.

> graffito [graf'fito]: Italian language." Tecnica di incisione su muro, consistente nel mettere allo scoperto, lungo la linea di incisione eseguita sull'intonaco esterno bianco, il sottostante intonaco smuro": wall incision technique, consisting of different layers of paint or colors, in which incisions are made, in order to reveal parts of the work beneath.
>
> graffiàre [graf'fjare]: Italian language." Lacerare la pelle con le unghie o altro, producendo solchi più o meno profondamente": to scratch the skin using a nail or something else, leaving a more or less deep mark.
>
> graffiatùra [graffja'tura]: Italian language." Segno lasciato sulla pelle da un graffio; leggera ferita": sign left on the skin from a scratch; light wound.
>
> (s)graffiare: Italian language. To scratch, to draw on plaster with a pointed tool.

"Sgraffito" was, and still is, an ornamental technique for pottery and ceramic. It's also part of wall decors of which scratching the top color layer reveals hidden color beneath." Sgraffito" has been used in Bavaria, Germany, since the 13th century and was common in 16th century Italy. Combined with ornamental decoration, these techniques formed an alternative to the prevailing painting of walls.

Princeton's definition of "Graffito": "A rude decoration"?

In a somewhat more contemporary definition, Princeton's official dictionary tells us, with no doubt possible, that a "graffito" is "a rude decoration inscribed on rocks or walls"[1].

But, if only because this book longs for objectivity, let us share another one of Princeton's definitions: "Graffiti is the name for images or lettering scratched, scrawled, painted or marked in any manner on property. Graffiti is sometimes regarded as a form

1 Source: WordNeta lexical database for the English language Cognitive Science Laboratory at Princeton University.

of art and other times regarded as unsightly damage or unwanted."[1] With such a definition, you can't help but wonder, and I've been asked that question time and time again: what, if anything, does graffiti have to do with art?

Let's keep in mind, if you will, that these inscriptions gained their status of artistic expression, in our most ancient times, during Prehistory[2]. Latin, as well as the word's Italian origins, both beg us to mention that the city of Pompeii[3] was also very rich in graffiti, left by gladiators for instance. And during WWII, graffiti and self-expression seemed to reach a new stage. And what of 1968, with it share of protests in various countries, also an important stone mark in the recognition of graffiti as a form of expression? Yet the phenomenon became even more famous towards the end of the 20th century, as an undeniable form of art. Beyond the simple marks that were left to signify someone's passage somewhere, beyond the declarations of love left in the open, carved in picture-perfect trees, other styles emerged: stenciled or drawn texts on city street walls. A new page of art history was being written.

Urban Art

Used for a while to embrace the variety of techniques and forms rising from Graffiti, "Urban Art" was a term meant to be large enough to describe all of the art originating in and from the streets, from stencil to stickers via writing. Yet not everyone uses this term, probably because it seems too large and because it embraces ways of working that are independent of the movement we are analyzing here. Mexican murals or architecture could be for instance considered as urban art yet they are only cousins of the Street Art movement.

Street Art

Street Art and Urban Art are the most commonly used labels for the contemporary movement originated from writing, also often called Graffiti. Yet the term "Street Art" tends to actually incorporate more forms, techniques and forms of expression than the original words used to.

Vague enough to be understood by the outsiders, Street Art is a term that gives credit to the artistic flow that emerged from the streets. Some artists agree now that this term is the one used by the outside and the art worlds, as a means to acknowledge and learn

1 Source: London: Macmillan Publishers - Grove's Dictionaries Inc. © copyright 1996 Susan A. Phillips.
2 Discovered in 1940, the caves of Lascaux (located in south-western France) are famous for their paintings, commonly referred as graffiti, and an estimated 16,000 years old.
3 A Roman city near modern Naples. Pompeii was destroyed during a long catastrophic eruption of the volcano Mount Vesuvius in AD 79.

about the movement. Yet, for the artists at least, it's often seen as too wide to encompass the reality of what the Movement is. For a whole generation, growing up in the city meant owning the place. Yet it owns you as much as you own it.

The term "Street Art" covers, today, numerous forms of art carried out in the street or in public spaces, and includes various methods such as graffiti, stencils, stickers, posters, lighting installations, mosaics, etc.
Forms and techniques have grown beyond writing and spray paint. And the environment is the key factor to everything we've just mentioned: it's all about the street.
The street as a **territory:** a territory where you live, advertise, express yourself.
The street as a **challenge:** a challenge that generates inspiration, adrenaline and fame.
The street as a **medium:** the street and its details become an infinite canvas.
The street as a **spectator:** from your own crowd to the anonymous spectator, everyone can see you.
The street as a **constant evolution:** a never-ending flow where art evolves, disappears and reappears.

Graffiti and Street Art are a specific reality, in time and in space. As far as I'm concerned, I admit that I avoid referring to Graffiti or to Street Art. I simply refer to ART, and so do many of the artists.

"Our works have always hung alongside Warhol; Basquiat; Holzer; Kruger; DiRosa; Combas etc. around the world, in the USA, and throughout Europe especially in Germany and Holland. Now with this media trendy-frenzy our work is lumped with all the newbies, and just wrongly labeled as the same thing for the sake of auctioneers and such ilk." **QUIK**

And as French stencil artist MISS.TIC sums it up in a very poetic and subtle way.

"j'enfile	*"I slip on* [litteraly to do a lot]
l'art mur	*wall art* [phonetic for "armor" in French]
pour bombarder	*to bomb*
des mots coeurs" **MISS.TIC**	*heart words"* [phonetic for "those who mock" in French]
	"I slip on
	the armor
	to bomb
	those who mock"

How do you get started?

As the key website *Art Crimes* states: *"The first thing you need to do is choose a tag, or a name which you will be known by in the graffiti community. DO NOT TAKE THIS LIGHTLY; if you choose something stupid it will come back to haunt you." Stupid" things include choosing initials, nicknames, names already in use, famous people, corny or trite words, and words that are just plain dumb. A tag is usually 3 to 7 characters but can be shorter or longer if really deemed necessary. Those with a tag greater than 4 letters will often find it necessary to develop a "shortened" version of the tag for time and space-sensitive places."*

The book *Subway Art* book adds that *"style is a very concrete idea among writers. It is form, the shapes of the letters, and how they connect. There are various categories of style, ranging from the old, simple Bubble Letters… to highly evolved and complex Wild Style, an energetic interlocking construction of letters with arrows and other forms that signify movement and direction."* As you choose a tag you then have to develop a style that sticks out. Yet style does not come easy. One has to relentlessly train and be committed to the pursuit of something special, different from the others and perfectly achieved.

"Each tag without style can be thought of as a writer without true devotion and commitment for the art. It represents a writer who wants the fame, glory, and recognition without sacrificing the many hours necessary to obtain the skills required for style. Becoming adept in translating emotions into rapid and smooth lines is a never-ending process that in essence is the key to all graffiti" adds *Art Crimes.*

And as *Subway Art* explains, *"Graffiti is a public performance"* seen by everybody, all day long, in the street. Every passer-by will judge the piece. Hence the writing on the wall has to be perfect. If not, another writer can come and catch up on the good ideas to improve and master them. How do you improve your style? Before even going outside one has to learn from the elder. Learning is done in private, as any training should be, by drawing in your sketchbook, redoing your piece again and again on paper. *Art Crimes'* advice is to *"start learning in private with someone you admire. Try going down to derelict train lots with someone who has been writing for a few years, and hit the place up. Have the writer point out what he or she does or does not like about your style, and have the writer suggest ways to improve it. (…) Remember, everyone in the graffiti community was a toy (inexperienced writer) once, and anyone who says they weren't lies through their teeth. The writing community, like most communities, is one that places elders (those with many years of experience) first."*

Style is acquired through constant training. At first, letters do not come out as hoped. You have to start with simple letters, train until the outline is mastered. Patience is key. The train and the wall are not going anywhere. It is no use wasting paint and energy doing pieces outside right away. Only when the letters are smooth and the outlines not shaky can you play with fill-ins and cap sizes. Per *Art Crimes*, *"If you can, try to acquire some caps (nozzles) which either spray a really fat line (reducing the amount of paint that can drip) or release the paint at a slower rate."*

When spray paint is mastered and the basics acquired, you can start. As the hand is now more certain, lines are frank and executed in a decided stable way, you can experiment more complex shapes, forms and ornaments. Experimentation is key, yet to much style can kill the style. One thing writers are aware off is the need for transmission: in the streets a writer learns from a writer. Yet, *Art Crimes* warns *"It is important to keep in mind that while learning others' style is a great learning tool, stealing their letter style (biting), is perhaps one of the worst offenses a writer can be charged with."* and concludes *"above all, don't be afraid to be criticized. So, for all you real writers out there who will be around to pass the torch on to the next generation, keep practicing, and don't get caught."*

Getting up

It's all about the Street

The Street Art phenomenon expansion can be linked to the city's recent mutations, be it on architectural, or organizational levels. But because the new model has not replaced its predecessor per se, they now coexist: peripheries become interconnected, crossed in their center by complex transit systems, subways, buses, roads, etc. Such architectural illustrations exist all around the world in the 70s, with the intensive construction of massive social housing ensembles. Sure, these new territories represent, initially, new housing possibilities. But soon, they're seen for what they are: marginalized places with environments that worsen by the day.

This networked territory brings people together, goods, services and information in a giant exchange system. Public transportation and the amazing amount of information exchanged on these territories have totally changed the city role and its organization. The omnipresence of advertisement, billboards, street signs, flyers, clothing, etc. leads to a tacit, yet perpetual communication between individuals. Style Writing, Graffiti

and Street Art are the embodiment of a new urban organization that revolves around a generalized sign exchange system. Writing, from its beginning is a way of exchanging information from one part of the city to another.

Come to think of it, the street is defined and ruled as a common physical public space, as opposed to a private space in which one is free to behave as wished. Since the street is a collective space, anyone should act within mutual respect. But because there are rules concocted to protect said spaces, Style Writing, Graffiti and Street Art violate a principle. When a street activist applies a tag or paints a fresco, it is perceived as an aggression by some, a simple degradation of common property. That said, many perceive advertising as a similar type of violation, and anti-advertising groups are considered illegitimate activists. Sure, when you come right down to it, Style Writing, Graffiti and Street Art could be perceived as inappropriate privatization of public space. Behind any graffiti lies an individual reaffirming their personality with one of the most personal signs ever: a signature.

True to a society of exponential exchanges, Style Writing, Graffiti and Street Art travel indeed beyond time and space. Not only do they take over public spaces, they also invade it. From the suburbs and less favored part of the cities, to downtown and historical centers, to monuments, Style Writing, Graffiti and Street Art are everywhere. Limited only by the sizes of walls, Style Writing, Graffiti and Street Art's propagation seems unstoppable. The "no limit" motto[1] is often used, and Street artists see a challenge in places with little or no access but with great public visibility (subway stations, trains, high-top buildings, bridges are key locations). In the network city model, the street artist knows how to use the public transportation grid better than anyone. Is there any greater, faster way to be seen? To write your name on a train guarantees you a wider audience than you could dream of. People all over the city, whatever their backgrounds, origins and neighborhoods, will see you. People will know about you. As a Street artist, your audience is potentially infinite.

Yet, the general public's support for Style Writing, Graffiti and Street Art is clearly secondary in the artist's mind. First and foremost, it clearly is about the number of people who will be able to lay eyes on it, or about finding that perfect location for a piece, within its environment. It has to be seen and it should resonate with its surroundings. If Style Writing, Graffiti and Street Art seem to be mainly done historically on subways and then on walls, they are also found on billboards, subways, bus stations, doors, store curtains, post boxes, etc. whether private or public, neat or already damaged. It is

1 French Graffiti artist PSYKOZE signed his walls "PSYKOZE NO LIMIT" for some time.

a gratuitous act seen by some as a generous way of enhancing spaces we don't even look at anymore. Artists such as JR even use hills and roofs in African villages, facades of Brazilian favelas.

Some Street artists perceive this environment as a spacious and virginal piece, an inspiring blank canvas. Others are quite simply stimulated by the potential risks taken when they indulge in their illegal practice in public spaces. SPACE INVADER for example has even turned his art in to a life-size game. He invades cities with is characters in mosaic tiles, counting points as a video game would.

The street is both a familiar and yet totally open space, filled with unspoiled discoveries. Style Writing, Graffiti and Street Art break down distances and turn the city into a possible continuous territory up for conquest. What's interesting in this conquest is the game itself, as well as whatever illegal aspects it offers. Infringing a sacred principle (respect of the public common space) makes Street artists a target for law enforcement. Being a target raises adrenaline levels in any regular individual, motivating them to pursue their territorial conquest beyond space and law. Street artists frequently mention adrenaline rush or its equivalent as their first motive. Scores of them admit that without it, they probably would have not started, or pursued an action that, eventually, became a form of art.

Advertising and the Fame Game

In most of today's societies, you will be the target of thousands of successful advertisements on any given day. In most of today's societies, you will seek your 15 minutes of fame. We grow up and in between daily massive propaganda. The desire to make your mark on this world leads to great innovations in many fields, and particularly in Art. Style Writing, Graffiti and Street Art have, like many innovations, been fed and nurtured with those visual codes, appearing as the direct result of post-war advertising.

As children and later as teenagers, citizens (i.e. the people living in cities) from all over the world have been exposed to marketing and advertising. It's not hard to imagine how a young mind can try to emulate what it sees on television or billboards, particularly in New York from the 50s to the 80s where popular culture and advertising are at their best. Since before the epitome of Pop Art, New York has been considered the most media-saturated city in the world. Style Writing, Graffiti and Street Art and advertising operate at a Phenomenological level or dimension, with only one thing in mind: to awaken the viewer's curiosity. As Shepard Fairey aka OBEY underlines in

his Manifesto, *"Phenomenology attempts to enable people to see clearly something that is right before their eyes but obscured; things that are so taken for granted that they are muted by abstract observation. The FIRST AIM OF PHENOMENOLOGY is to reawaken a sense of wonder about one's environment. The OBEY sticker attempts to stimulate curiosity and bring people to question both the sticker and their relationship with their surroundings. Because people are not used to see-ing advertisements or propaganda for which the product or motive is not obvious, frequent and novel encounters with the sticker provoke thought and possible frustration, nevertheless revitalizing the viewer's perception and attention to detail."*

And since the beginning of the Movement in the late 60s, people from all over New York can see what someone has done in Queens, including people who probably are not interested in this form of art or have never stepped in Queens. The fact that graffiti was practiced on the subway system of New York shouldn't come as a surprise, indicating that mobility is an element that graffiti writers gravitated towards early in the game.

Your tag, your alter ego, the name by which most people will know you, your very own brand, rather than your birth-given name, takes a life of its own. It becomes something separate, something that, as it grows in the public eye, also gets observed, scrutinized and admired. The 'fame game' brings popularity, a sense of self-esteem, friends and recognition from people you don't even know. As a graffiti writer, you're driven by the desire to be known and to be respected. In Style Writing someone like SEEN, since the 70s, picked his tag according to his motive: to be seen. Later, in the 90s, someone like OBEY (aka Shepard Fairey) did pursue a specific goal ("visual disobedience" as he calls it himself), and raise awareness with the choice of his street name.

While most admit that these motivations were of the unconscious sort during their early years, the desire to be subversive, to cause an impact, to represent graphically what everyone thinks but doesn't say out loud, is at the origin of this movement, with the street being the broadest and most powerful platform to gain visibility.

Advertising has played a decisive factor in the formation of Style Writing, Graffiti and Street Art in two major ways. Ideologically, it manifests itself in the quest for fame. Competition among a wide variety of writers and artists contending for respect is harsh. Another influence is the visual factor. The letter-based palette of words and tags, with the subsequent advent of postering and stickering, represents the 'brand' that is repeated on and on. These are precisely the premises upon which advertising works; products need fame in order to stand out, something we see in the omnipresence

of ads. There's humor to be found in the fact that, today, the tendency has reversed to what we now know of advertising: brands get their inspiration, in large amounts, from the street.

Essentially, one could argue that Style Writing, Graffiti, Street Art and advertising evolve in the same ball game, the only difference being the league they are in. Commercial consumer advertising is propelled by immediate financial profit and mediated by boardrooms and stockholders. It aims at exposing that product in an appealing way, and at doing it in order for the widest possible number of people to become aware of that product. Graffiti is a tool used by individuals with their own agenda, one however that doesn't include profit as its foremost target. The main agenda of a Graffiti artist is exposure by means of guerrilla tactics.

Today, there is a tendency to differentiate classic hip-hop type ("modern") graffiti, where people have tags and want to get their tags in as many places as possible, from the later Street Art, where people may have tags, but deploy techniques such as stencils to pass a message somewhat more profound than a simple tag. The process of reawakening one's awe in their environment has been with us for a long time, but in the context of Street Art, it's been a practice used slowly but steadily over the years.

Tag and Street Art: from Vandalism to Art

Tagging, the most primitive form of graffiti, consists of a writer's signature, usually done in permanent marker or spray paint. Artistically, tagging is the root of graffiti, and a skill a writer must become proficient at before becoming an accomplished graffiti artist.

Street art ranges from simple monochrome "tags" (the artist's "name tag" often represented in an exaggerated cursive style) to elaborate, multi-colored works called "pieces" (derived from the word "masterpiece") which are considered in some circles to be of museum quality. As graffiti has begun to find its way from its original urban locations to the walls of galleries and museums, the question of vandalism and graffiti as an art form has provoked endless controversy, raising such questions as whether vandalism can be considered art or whether graffiti can be considered graffiti when done legally.

When talking about Street Art, doesn't the mere use of the word "art" imply a creative part in the process, which has become a discipline?

Street Art has been polished over time. Simple tags and graffiti have imposed themselves with the use and the juxtaposition of various techniques and are more committed than ever.

Creativity expresses itself in a more obvious way through graffiti, largely exceeding tags in terms of the required and necessary competences and artistic qualities. However, let's keep in mind that tags are hardly dissociated from Graffiti and Street Art. That creativity part of the movement expresses itself through the perfect complexity and curves of the signature.

At the beginning of the Movement in the 60s and the 70s most writers came straight from the ghetto, and dragged the image of unschooled, unruly youngsters, with too much energy, no training, no talent and not much of a future. It's an interesting cliché. Studying the Hip Hop movement a little more closely than a few prejudiced sociologists did then, you can't help but acknowledge the huge amount of work that graffiti, dance, music or painting, all part of Hip Hop culture, required. And still do. All those disciplines demand improved technical abilities, constant training, an alert mind, and creative imagination. To say the least.

Writers and Graffiti artists make their own (yes, disputable by some) contribution to the city they are a part of. Self-affirmation, in a society that tends to erase individuality, shows a strong sense of preservation. It's a peaceful uprising against authority figures that would rather keep everyone anonymous and under control, despite difficult social contexts and basic rights.

Street artists do not simply satisfy themselves with the delivery of their work in the eye of the public, the way a painter, presenting his latest masterpiece, expects amateurs and patrons to acknowledge its value. Out on the street, they impose, or generously offer their art, without necessarily expecting public judgment or recognition. It is an unforeseen and unforeseeable form of art, since it doesn't emerge from the usual art places. Yet the constant pursuit of improvement in such shapes and messages as they are presented, as well as the respect of visual codes established over the years, whether they be followed or distanced in a creative leap, give Style Writing, Graffiti and Street Art their undisputable legitimacy.

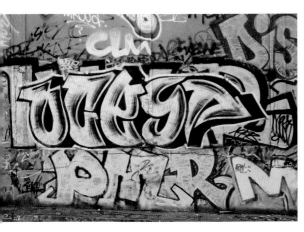

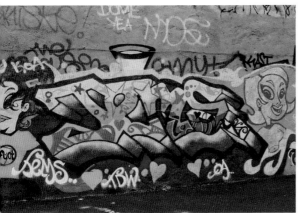

Photos of graffiti in NYC, courtesy sb@ny

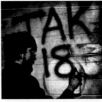

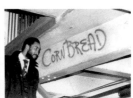

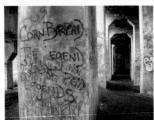

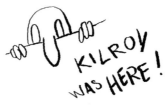

From left to right and top to bottom:

Tag, *STAY HIGH 149*

Tag, *JULIO 204*

Train, PHASE 2

Tag, *CORNBREAD*

Tag, *TAKI 183*

Tag, *CORNBREAD*

PHASE 2 in action

STAY HIGH 149 and a two-colored *Saint* character

Train, *PHASE 2*

Tag, *KILROY*

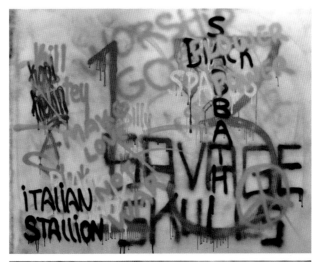

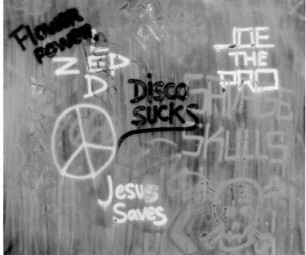

Paint on canvas, 2009, *SEEN.* Testimony by legendary artist
SEEN of what walls looked like, back in the 70s. SEEN devel-
opped on purpose a series of large format paintings showing
the first tags and the calligraphic styles that emerged in the
beginning.

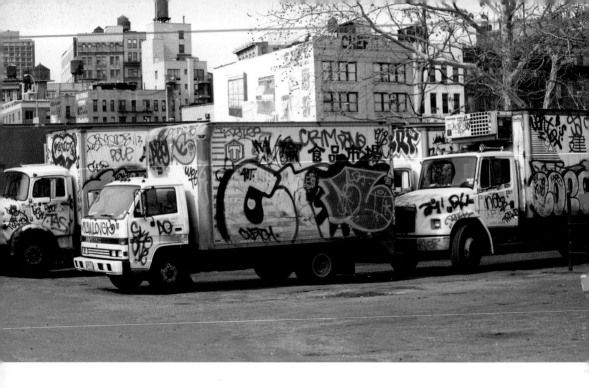

These pages and next page:
Photos of graffiti in NYC, courtesy sb@ny

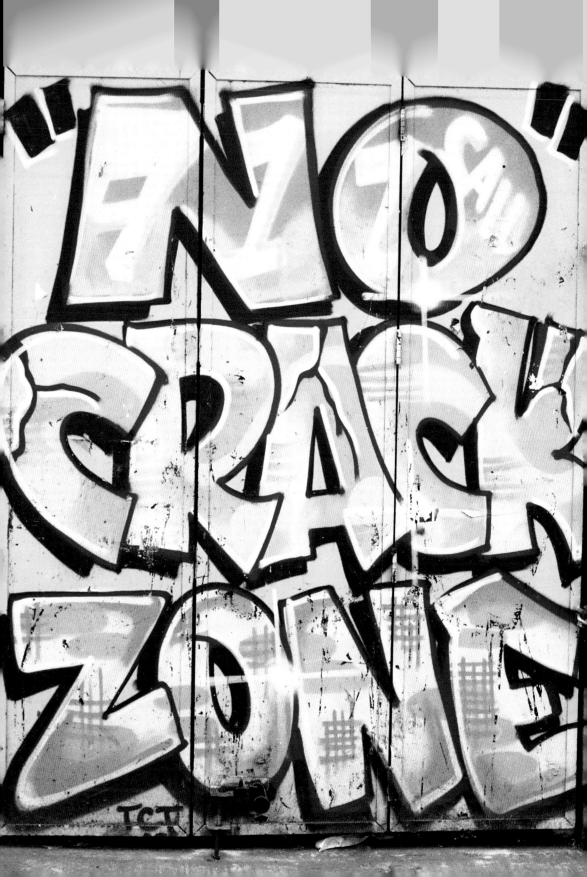

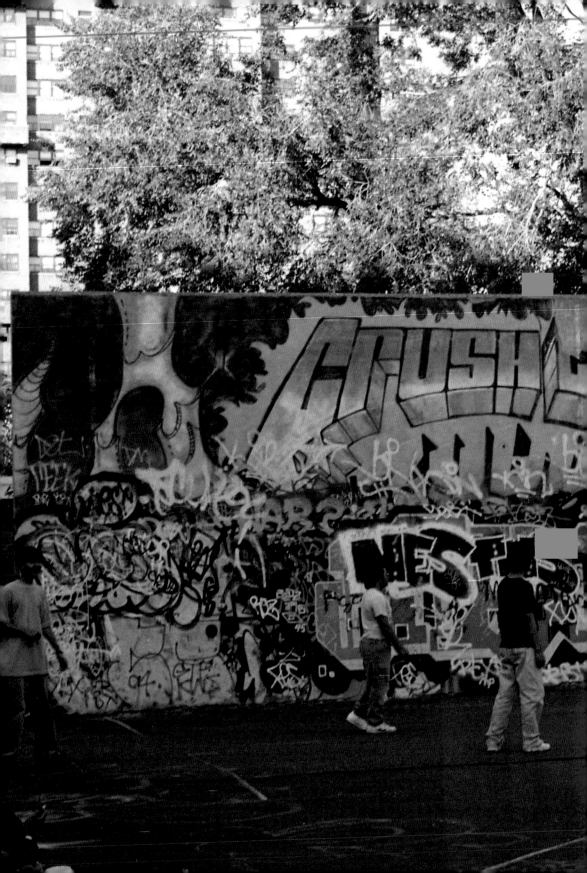

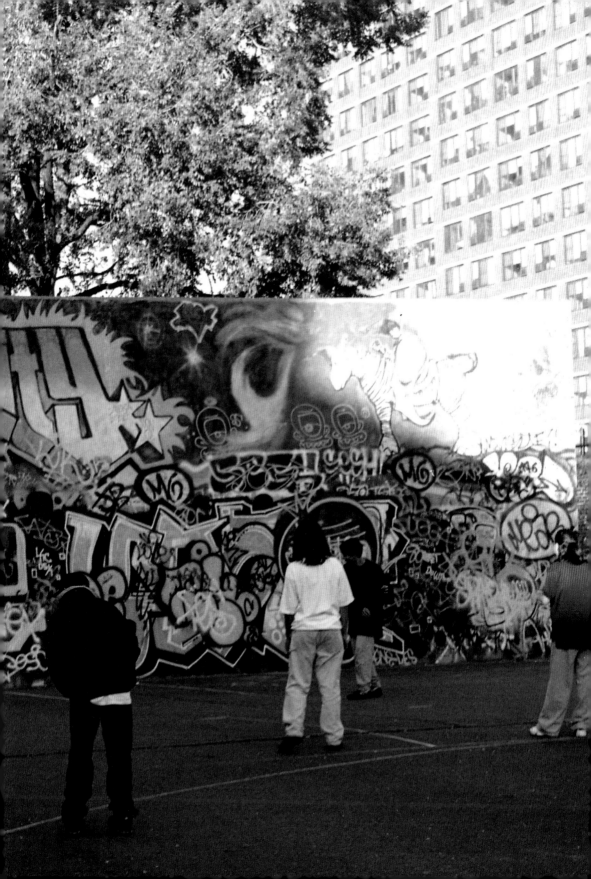

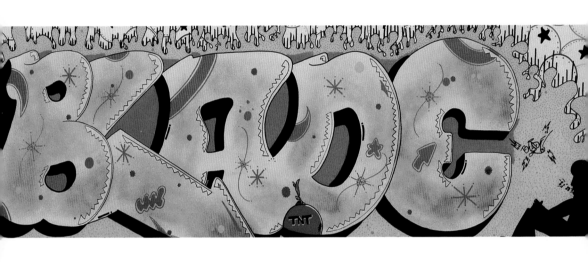

Spray paint and marker on canvas, 60x206cm, 1886, Kenk
Pijnenburg collection, *BLADE*

PART 1

Style Writing History

The Premises

1942

As a major art form born in the 20th century somewhere, we do know one thing: modern graffiti began around 1942 during WWII, when both a name and its graffiti version were first linked to each other. That name is KILROY. A worker in a bomb manufacture in Detroit, Michigan, Kilroy got the habit of writing "Kilroy was here" on each item that came through his factory line for inspection. The bombs were then sent to Europe, where Kilroy became famous. Soldiers started writing "Kilroy was here" on any wall that still stood after a bombing. And later, Kilroy actually became a symbol during peace protests.

1960

We acknowledge that graffiti, defined as public and unsolicited markings, has been around forever. Art in the form of graffiti, on the other hand, originated in the 50s and the 60s when CORNBREAD (aka Darryl A. McCray) from Philadelphia took the scene over, with his buddies KOOL EARL and TOP CAT. The three of them contributed to make Graffiti what it is today and helped define the role of the modern day Graffiti writer. One major part of that role was achieving fame.

For CORNBREAD, it all began as a way to get attention from that one special girl he wanted to impress. His first few tags soon turned into a full time mission, "getting up" (painting his tag) in so many places that he gave himself a crown. The press chronicled CORNBREAD's exploits with pride and each party soon fed off the other, to the point where some journalists started exchanging, in their columns, their ideas of potential challenges for CORNBREAD, hoping to strike his imagination. One of them, for ex-

ample, wrote about how amazing it might be to tag the Jackson Five's jet as it landed in Philly. CORNBREAD was too happy to oblige, and the press covered it extensively. By the late 60s, a sub-culture had ignited in Philadelphia, with its own distinct style: long letters with platforms at the bottom. For some strange reasons, when it came to New York years later, it became the "Broadway Elegant" style. That said, the one thing missing from the Philadelphia movement was the subway.

McCray accomplished fame by spraying his tag - CORNBREAD, with a swoosh at the end and a crown over the B - along every bus and trolley in the city. In one of his most memorable attempts, he managed to spray it on the flank of an elephant at the zoo.

The Philadelphia 60s saw some other writers emerge. The PHILLY'S WICKED, a crew of very active taggers who quickly gave their name to a style in itself, characterized by long letters of energetic style, looking to give a feeling of raw speed, hurried aggressiveness. The WICKED's deformed lettering are impossible to decipher for the non-initiated. The main WICKED writers were: KAD, RAZZ, ESPO, CURVE, RAKAN and BOZA.

The late 60s saw an explosion of names on buildings and walls throughout the city, as gang graffiti weaved its way through political slogans that reflected the social change of a nation. The peace sign was certainly ubiquitous among college campuses. Black militancy was seen with spray painted messages of "FREE HUEY" and "OFF THA' PIG". In most "barrios" (neighborhoods), Puerto Rican flags were painted everywhere with an added "VIVA PUERTO RICO LIBRE" mention. In the late 1960s, JULIO 204 began writing his tag all around **New York City** in what would become the New York style.

As for CORNBREAD, he stopped writing in 1972. In the documentary *"Cry of the City: The Legend of CORNBREAD"* by Sean McKnight, CORNBREAD appears as the self-proclaimed king of graffiti. After all those years McCray now remembers his then quest for fame as his potential *"ticket out of the ghetto life"*. As the filmmaker himself testifies: *"In his days, McCray was notorious. His fame is not exaggerated. And not just in Philadelphia. (…) CORNBREAD is "the first 'bomber,' the earliest example of a person going out on the streets with no other purpose than to write his name on everything."*

The old-school Pioneers

In your opinion, who were some of New York's graffiti pioneers?"
FUTURA: *"Easy... STAY HIGH 149... PHASE 2... TOPCAT 126... FLINT 707... TRACY 168..."*

(1967 - 1970)

In the late 60s, graffiti arrived in New York City. No one really knows if it happened in a deliberate effort or as a spontaneous occurrence, but it seems it all started in Manhattan's Washington Heights section.

Originating from the Upper West side of Manhattan, most of the early writers used to add to their name a number reflecting the street they actually lived on, as in TAKI 183 or TRACY 168. Graffiti writers from the other boroughs also appeared quickly, such as LEE 163 from the Bronx, and FRIENDLY FREDDIE from Brooklyn.

(1971)

By the late 1960s and early 1970s, "writing" began to distinguish itself from other forms of graffiti found everywhere. By 1971, "tagging", or "hitting" as it was better known, began to find its way, as a start, inside the trains. JULIO 204 was the first one to add his street number at the end of his tag. As a gang member, JULIO 204 tagged on the streets where he lived but never outside of his neighborhood. The first writer to be recognized outside his own neighborhood was TAKI 183, who started in 1969. TAKI was a young Greek boy by the name of Demetrios. He used the alternative for his first name, Demetraki, as a base for his tag. Like JULIO 204, TAKI 183 also attached his street number to his tag, but he started hitting everything in the city, from trains to hallways, from hallways to mail boxes. He lived in Washington Heights, on 183rd street, and worked as a messenger. Traveling all day, he was able to hit all of the city easily, with partners in crime sometimes, or on his own. And if TAKI 183 was by no means the first writer or even the first king, he was, however, the first to be recognized by the news Media in New York. He's also considered to be the pioneer in motion tags. Everywhere he went, he methodically left a trace of his passage, and clearly piqued people's imagination. On July 21st, 1971, the *New York Times* interviewed him. The article *Taki 183 Spawns Pen Pals* was the reflection of how big public curiosity had grown. A newly formed subculture had emerged.

TAKI 183's newspaper fame resulted in a competition between the taggers, and his tag quickly inspired hundreds of young people across the five boroughs.

> TAKI was last known to be the owner of a foreign car repair shop. In an interview with the *New York Daily News* of April 9, 1989, he talked about his retirement as a graffiti writer: *"As soon as I got into something more productive in my life, I stopped. Eventually I got into business, got married, bought a house, had a kid. Didn't buy a station wagon, but I grew up, you could say that."*

The early writers usually liked to work with a marker and to hit places as they exited the train. The first stylistic evolution was noted with LEE 163. He was the first to join his letters together and to turn his tag into something closer to a logo.

As BUG 170, COOL CLIFF 120, JOE 136, LEE 163, PHASE 2, SCOOTER, STAY HIGH 149, and TRACY 168 each came up with their own stylized tag, everyone of them started looking for more rapid attention. Trains would be bombed overnight. The first to get the official "king title", for having bombed the most important number of cars on the 1 line, was JOE 136.

In this whirlwind competition, LEE 163 can be credited for yet another progress. LEE 163 started hitting the front of every car in a train after observing the cars' rotations and how any car could, eventually, become the lead car. With his cousin PHASE 2, they became the first kings of the Bronx.

Meanwhile, in Brooklyn, FRIENDLY FREDDIE, for instance, was another famous writer. A group, the Ex Vandals also emerged and is, even today, considered as the first kings of Brooklyn. The members of the group would hit the words with their name, easily increasing the number of tags to be seen. DINO NOD, LAZAR, and WICKED GARY became famous for gridding their city map and tagging all the neighborhoods, looking for the most out of reach spots for their tags.

In this interborough competition, the subway played an essential role, traveling from their initial location, covered in tags by other artists, for the viewing pleasure and interest of local writers. People in all the five boroughs of Manhattan were able to witness each other's efforts. The whole MTA[1] system became the catalyst to a fierce competition and unified the boroughs as one scene. Within the first years of the 70s, a scene was born at the speed of light. And the "style war" began.

1 MTA: Metro Transit Authority (see Glossary).

Tags undergo, around the end of the 60s, a major symbolical change. STAY HIGH 149, as an example, keeps adding to the words and numbers of his tag: first with a joint on the horizontal bar of his H, and then, next to his name, with the distinctive silhouette of the title-character from *The Saint* TV series.

STAY HIGH 149, aka the 'Voice of the Ghetto', was 18 in 1969, and is considered one of the pioneers. He is an absolute legend, and contributed significantly and from his very beginnings, to the expansion of Graffiti. Based in the Bronx, STAY HIGH 149 was one of the first to instill, within the spirit of competition, the need for original expression. He influenced in that way a considerable number of writers who followed his footsteps, adding a halo here, a star there. To this day still, a large number of Street art celebrities give STAY HIGH 149 credit for having an impact on their work as writers.

At the height of his glory, in 1974, STAY HIGH 149 decides to retire from the street and the graffiti art scene, achieving instant aerosol art icon status. 26 years later, in 2000, he reappeared for a show presented by The State of the Art gallery in Brooklyn.

The Birth of an esthetic Language

(1972)

By the early 70s, a style war rages between most graffiti artists/activists seeking fame, drawing their inspiration from the general emulated spirit. This gives birth to Graffiti's original formal theory. The first female tags also appear around that same period. Until then, graffiti has been a notably male-driven world, if only because of the dangers encountered when painting or writing in a high-risk environment. Among their places of choice, artists develop a strong affinity for subway train yards where the trains where parked at night. Painting trains inside the yards itself is far less dangerous than on the tracks, and allows for maximum productivity with minimum time spent in each location.

What started as somewhat of an isolated phenomenon becomes of tremendous proportions, with kids realizing the kind of notoriety they can obtain in a matter of weeks. Sprouting from everywhere, teenagers spread across New York's many neighborhoods, playing by this new set of rules with only one thing in mind: "getting up", as in getting your name known, achieving street fame, being seen in as many places as possible. At this point in the game, it's not so much about quality as it is about spreading your name. Tags appear massively across the city, on its walls, in and on the subway trains.

Many writers from those days remember their lack of artistic conscience. Getting up and tagging had nothing to do with art, but rose in an irrepressible flow, in pure inspiration.

Since the game involves a huge amount of players, distinctive signs start being used. While their original decorative purpose allows for easier recognition among the many signatures, those signs quickly start bearing specific meanings. With stars, crowns and other features added next to or above the tags, the signatures become more and more elaborate and ornamental, in addition to symbolizing the coronations and achievements of the newly and often self-titled "kings of the line". BABY FACE 86, for example, added a crown above his tag early in the game. CAT 2233 was the first to add the letters "ISM" at the end of his. And SUPERKOOL 223 is known to be the first to tag comic book clouds. Slowly and surely, terms and codes come together.

> The concept for spray paint actually comes from France. The first air-pressurized drinks appear in 1790. In 1837, Perpigna invents the soda siphon valve, and steel metal cans are to be found as early as 1862, even though they don't find immediate commercial use per se, due to their weight. In 1899, Helbling and Pertsch register the aerosol patent with methyl and ethyl chloride as propellants. In 1927, Norwegian Erik Rotheim launches the first can and valve aerosol as we know it, which will lead to various uses, from liquid gas to pesticides, and paint. Edward Seymour invented the first aluminum paint spray can in 1949.

Thanks to spray can paint, graffiti becomes very popular and spreads rapidly. Walls are covered in tags and painting. Too many layers make it difficult to add on your own. Doors, advertising boards, and anything medium bearing some sort of flatness are assaulted by every graffiti artist. The quest for relative longevity to any given piece increases as writers compete by, too often and systematically, covering everything up with their own creations.

Urban scenery, as it was then understood, undergoes a massive metamorphosis. City walls are changed, breathing to a new rhythm, filled with new colors.

In the early 1970s, suddenly the more daring artists start painting more than simple pseudonyms, bombing purposely their pieces in the most forbidden and the most controlled locations. Thoughtlessly, a movement is born, without a doubt. Individual ex-

pression, by that time, has clearly become the central motor to Graffiti, as pages of its History turn. Quality adds up to quantity, opening the door to graffiti's first stylistic innovations.

BARBARA 62 and EVA 62 start spreading their "signature pieces", a somewhat improved type of pieces in which the writers outline their creations. This style becomes known as the "Broadway Elegant" style and technique and is launched by Philadelphia's TOPCAT126. Many artists, including PHASE 2, consider by then that a good piece must start with its outline. SUPER KOOL 223 starts executing pieces across trains in full height. The term "top-to-bottom" is born. And even if those pieces are still close, in their form, to the movement's original tags, the added designs and the use of color are proof, if need be, of indisputable artistic progression.

By then, "block letters", "leaning letters" and "blockbusters" come to life. PHASE 2, for example, develops his own style of lettering: originally known as "softie letters", they later evolved under the name Bubble Letters. PHASE 2 also gets credit for being the first to add arrows, bringing new esthetic rhythm to his pieces. More and more writers embellish their tags with curves, twists and other variations, defining the basis for what eventually will become the Mechanical or Wild Style.

RIFF, among others, greatly contributed to developing many different and innovative styles, while FLINT 707 and PISTOL came up with 3D lettering, a classic for generations to come.

By then, subway stations and platforms have also become, ironically, a place to meet for Graffiti artists. Sitting on their "writers' benches", they watch the trains go by, their sketchbooks in hand, and share together new ideas and upcoming projects, all the while enjoying the passing view of their competitors' pieces, observing, taking notes, and scheduling their next bombing - when they're not pulling spray cans out of their bags and getting to work on the spot. A clear, if somewhat informal teacher-apprentice system is now in place, connecting the newcomers to more confirmed artists. They get to learn from the greatest, in exchange for the assistance they provide in the execution of those large-size pieces that need to be completed in record timing before escaping police squads or gang attacks (even though graffiti is, more often than not, non-gang related). Writing "crews" were originally created for the simple purpose of executing collaborative pieces.

In 1972, new symbols known as "designs", appear, adding to the circles, stars and crowns already of common use. HONDO1 paints candy canes, as an example. Right around then, SUPER KOOL 223 is the first to introduce traditionally industrial "fat caps" in his tag, in a successful attempt to distinguish his lettering from the rest. Soon enough, size becomes an additional distinctive element, essential in such a competitive environment. A number of writers start bombing tags in oversized versions and using color to fill their fat cap letters. What results is of incredible visual impact.

The first "masterpieces" are, depending on versions, attributed to SUPER KOOL 223 (Bronx) or WAP (Brooklyn).

Around 1972, certain pieces start gaining somewhat of an official artistic credit. Hugo Martinez, a sociologist from NYU, also happens to be the founder of United Graffiti Artists, a graffiti collective entity through which he intended, from the very start, to sell Street Art. Thanks to the Razor Gallery, which hosted the group shows he put together, Hugo Martinez is able to present his selection of Style Writing and Graffiti.

COCO 144 is UGA's president, while Martinez makes sure the media coverage is what it should be for what he considers to be to the elite of Graffiti. UGA includes PHASE 2, STAYHIGH 149, STITCH 1, SNAKE 1, RIFF 170, JEC STAR, SJK 171, C.A.T. 87, MICO, PISTOL, FLINT 707, BAMA, STITCH and more.

That same year, The *New York Magazine* inaugurates its Best Subway Graffiti Contest, along with its Tag Awards. Within and outside that context, *New York Magazine* editor Richard Goldstein did a lot to give Graffiti and its artists the public recognition it deserved. Not only did he write extensively about the movement in his various articles, but he mentioned, time and time again, PHASE 2, NOVA, SNAKE 1 and the "All City King" STAY HIGH 149, bringing their names out in the open.

(1973)

Richard Goldstein's groundbreaking article (one of many), "*This Thing Has Gotten Completely Out of Control*", came out in March 1973 in the "*Graffiti Hit Parade*" issue of *New York Magazine*. In it, he lists the most important Graffiti artists of the time, stands firmly against anti-graffiti positions, including those of NY mayor John Lindsey or of MTA, which was in full active lobbying mode, pushing for laws against the movement. Against the general consensus typifying graffiti artists as vandals, Richard Goldstein portrayed "*these kids (who) all turn out to be ordinary fourteen-to-fifteen year olds*". Goldstein was the first of his kind to discuss graffiti as an art form, and to compare it to sport (two activities that require creative innovation and a strong competitive spirit). Be-

cause of his critic against the easy and generalized discourse on NY's urban crisis, Goldstein became one of the most important commentators on Hip Hop culture as a social movement.

(1974)

The 70s are now on a roll, and so are Style Writing and Graffiti... In 1973, STAY HIGH 149 executes a top-to-bottom on The Inter-borough Rapid Transit Subway (the IRT), which represents a giant version of his tag. Norman Mailer will make it legendary in 1974, in his book *"The Faith of Graffiti"*. In 1974, crews gain their own letters of nobility, inviting the best writers to join forces. As the leader of the CRAZY FIVE, whole car king BLADE is reigning over lines 2 and 4.

(1975)

You're standing there in the station, everything gray and gloomy, and all of a sudden one of those graffiti trains slides in and brightens the place like a big bouquet from Latin America."
Claes Oldenburg, sculptor

In 1975, PHASE 2 is proclaimed king of style and starts talking about retirement, while the rare all city king title goes to a mere three writers: TRACY 168, CLIFF 159, and IN (KILL 3). By then, the title is subject to many conditions, including boasting both street and train pieces, whole car and window down pieces on entire lines. In that context, whole cars are nothing but a standard graffiti feat. The throw-up, Bubble Letters' derived form, has become the basic shape, with its rapidly executed outline, of which the surface is then spray-filled.

Throw-up kings go for short tags, that allow for quick execution in the mad NY city race, with the most famous ones such as TEE, IZ, DY 167, PI, IN, LE, TO, OI, FI aka VINNY, TI 149, CY, PEO. In a parallel scene to the writer's race for fame, artists to the likes of TRACY 168, CLIFF 159, BLADEONE choose focus on developing more graphic works that include scenes and comics characters.

These years are considered epitomic in the race for innovation. By then, all the codes have been defined, and the movement is ready to welcome a new generation of youngsters, eager to learn from the masters.

In 1975, and during the years that follow, UGA becomes the "institution" in charge of promoting different legal events, with the support of the City of New York. The Razor Gallery still hosts a number of shows, but by then, most of the artists represented have

studied art and have accessed a legal and a professional status. Still, this establishment process is marginal and does by no means include the tag phenomenon that defies authorities daily.

> Tags, throw-ups and pieces characterize the levels of execution of works. The first level is defined, in its basic and familiar form, as the tag. It represents its creator's stage or street name, executed in a stylized way. Further up the road, the throw-up imposes its large size but is still a rapidly elaborated two-color shape, in the name of its author. Finally, comes the Piece (short for Masterpiece, and sometimes also called a Burner). A Piece requires more technique, and is considered the only actual demonstration of its author's talent.

(1976)

With writers such as CLIFF 159, BLADE, TRACY 168, KINDU and others, whole trains spreads also start integrating comic book characters. CAINE 1 celebrates July 4, 1776 American Declaration of Independence's bicentennial by painting both sides of a ten-car train, setting tracks for the FABULOUS FIVE, ROGER, CHINO 174, DIME 139, TAGE, FLAME 1 who do just that in turn, giving New York's its new colors to keep, for a while at least.

But the fact is that, while pieces have become more and more complex, finding locations and work conditions that allow for ambitious creation (in terms of available time and safety) has become just as increasingly difficult. While some artists turn to legal walls, finding solace in the long hours they can spend on one piece, most writers find the process less challenging, and know that those pieces will not impact the scene and their peers in the same way.

(1978-1980)

In the early 80s, LEE and the FABULOUS FIVE's reputations grow steadily, and not just because they're walking in their predecessors' footsteps, respecting the code set by the Old School. During this Style War, MTA allegedly spent close to 150 million dollars, between 1970 and 1980, in order to clean up graffiti and to implement high-security systems (feel like taking on 15-feet barbwire fences, anyone?). In 1978, the movement takes a major blow when MTA introduces a new high-pressure train-cleaning device, called Buff. Within a few weeks, hundreds of BLADE's trains are wiped clean. Interestingly enough, coffins (those older cars from the 50s that are still in service then), don't do too well with the high-pressure cleaning Graffiti washed-up traces cling to the metal, making them look dirtier than ever. It should be noted that MTA's war on graffiti is mainly what incited many in the movement to focus on walls,

and to drop the trains altogether. Lee QUINONES, aka LEE, spent most of his nights in 1978 around the Brooklyn Bridge, turning it into an open air gallery. Some consider that the scene somewhat split around that time.

In terms of style, this key-period sees the birth of graffiti's basic principles. A very precise code is established, from a formal, technical standpoint, that also includes a code of conduct. From that period and on, pretty much everyone follows the code to the dot, even those who eventually leave the graffiti scene and explore other forms of artistic urban expressions.

The story continues.

Graffiti and Hip Hop

Graffiti has found great inspiration in comics, movies, video and television, as well as photography, or album covers even. But beyond any influence, its relationship to Hip Hop is quintessential.

Hip Hop[1] is a cultural movement, both artistic and protest-based, born in the early 70s, in the Bronx, New York, at the heart of the ghettos, before spreading at the speed of light around the country, first, and everywhere else, in the early 1980s. Hip Hop's international expansion is mainly due to the founder of the Zulu Nation, Afrika Bambaataa, and his European tour.

Though Graffiti started before Hip Hop, it is considered one of its four constitutive elements, along with emceeing, djaying, and b-boying. Emceeing represents speech, DJing, music, B-boying performing arts, in this case dance, and Graffiti visual arts. As an ideal concept, all four elements of Hip Hop come together on stage or during an event, which was the case in the movement's early period. Those are the four means of creative expression that sweep from The Bronx and Brooklyn to the rest of the world.

1 There is plenty to be said about the Hip Hop movement. So much, in fact, that entire books have been written on the subject, one of which we strongly recommend to you, reader, should you be interested in exploring its history and complexity. *Can't Stop Won't Stop: A History of the Hip-Hop Generation* by Jeff Chang, D.J. Kool Herc.

Using an Alias

The use of an alias is a process known as "artistic self-designation". Tags, allowing for a name to be "made" before even proving technical and artistic qualities, bear true originality in that regard. Most writers start with a tag to make a name for themselves, a name they've chosen and uually stick to. Whereas artists from other disciplines thrive to acquire technical proficiency and public recognition for their art, writers have other priorities. The artwork is therefore reduced to what makes it most singular: the signature, a representation which then reproduced endlessly, so as to be seen by the highest number of people who become, in turn, the audience.

The choice and the construction of this name follow a specific logic. The name can bear a territorial claim, i.e. the case of TAKI 183, 183 standing for his street (183th street in New York City). It can be a nickname or a title that give the writer a sense of power and entitlement, like SEEN of FUTURA. Names often have, explicitly or not, a sense of irony and insolence. An alias can also use a word out of its initial context or meaning, or be chosen based on its letters, simply for phonetic or esthetic reasons, some letters being more inspiring or more challenging to play with, as in SKKI, TWIST or WEST. Some play with words as MISS.TIC whose name as a double meaning: the feminine proposition and the phonetic for "mystic". Whatever the case may be, each name has its true story, unlike birth names. And unlike birth names, no two people may bear the same street name. The rule can eventually (though it rarely is) be bent if a distinctive sign is added (usually, a number, like royalty as in JONONE). This singular logic has to do with a name's strong distinctive value: claiming their name is a writer's only actual right. Women in the movement have also made their feminity part of the distinction as for LADY PINK or MISS VAN for instance.

Last but not least, this signature symbolically reflects a writer's identity. Choosing a new name pretty much allows for a new projected persona, and writers virtually start fresh, shedding their civil status and their former identity as for BLADE and QUIK. The actual stake is to keep that name alive daily, in a permanent and recognized way. In the end, it's about giving a borrowed name some true artistic recognition. And to do that, there's a more or less intensive learning curve, a process leading technical and esthetic qualities that will give birth, or not, to a writer's achievement.

Building a Language of its own

Rap musicians are like graffiti writers: both use, and play with, words, which they embellish, rime together, build upon, transform. Both invent, unwind and reshape words themselves, or their meaning. Graffiti, like rap, like poetry, aims to give words a sort of materiality, whether it be in terms of sound, in the case of rap and poetry, or in terms of the physical formality of scripture, in the case of graffiti. This type of writing, both esthetic and playful, bears some resemblance with calligraphy. And the language used by writers is, more often than not, rich and complex (see our glossary). This language has evolved greatly, integrating general terms used in a writer's everyday life, as well as esthetic and artistic terms that allow for critical evaluation. From flops to wildstyle, quickly each style has its very specific name.

There are two main registers. One comes from the Hip Hop world, the other designates emotions raised by the street. Graffiti's Hip Hop origins are easily established through the frequent use of terms originating directly from the scene: bubble style, bad boys, fat or skinny cap, top-to-bottom... This subset of terms is mostly used when referring to styles, schools, supplies and types of pieces, and designates all that has been invented by the American graffiti pioneers. Another subset is used to describe the variety of emotions born from the illegal and aggressive aspects of graffiti, in its practice: to burn, to kill entire trains, etc. Note that profusion is the key word here, rather than production itself, etc.

Turning an illegal Activity into a respectable Practice

Paradoxically, while graffiti has it at its heart to implement a certain form of ethics, it has been interpreted as a distress signal born in a degrading environment and in a society based on exclusion. The delinquent and risk-taking aspects are part of the game: considered by some to be the essence of graffiti, without which painting and writing are of no interest whatsoever. Other writers in touch with their artistic persona do everything to gain the public and critic's recognition and insure the means to continue their art, sometimes even making a living out of it. Therefore, the discourse around graffiti closely involves both urban behavior ethics and specific graffiti aesthetics, in order for the actors of the movement to insure its survival.

And of course, for some writers, there's the hardcore approach, because they can't risk coming off as sell-outs within the movement, with no practice other than in the street. And talented as they might be on public walls, they don't make the move to a studio or, of course, to a gallery.

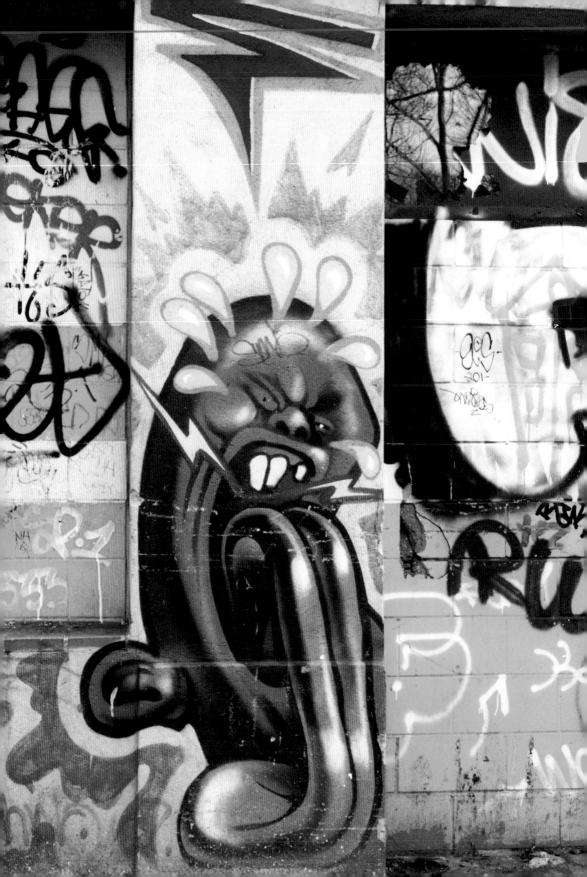

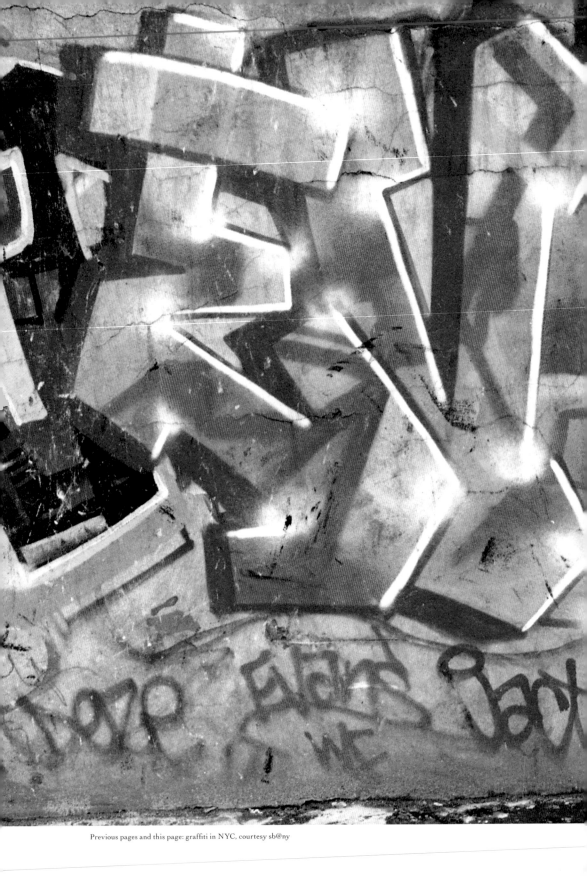

Previous pages and this page: graffiti in NYC, courtesy sb@ny

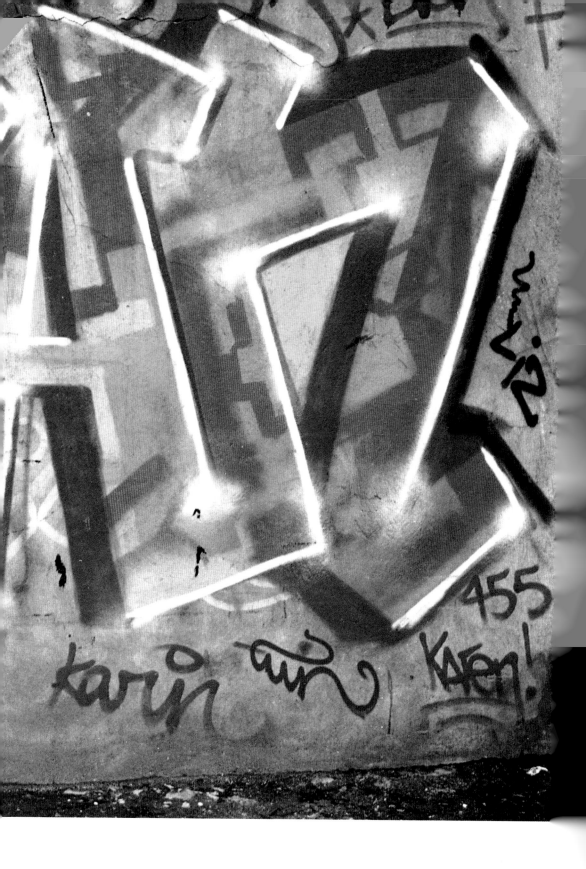

Painting on canvas done on stage during the Clash concert in
1983, P. Lerouge collection, *FUTURA 2000*

FUTURA (2000)

Date of Birth: 1955

Place of Birth: New York City

Starting Point: 1970

Influence(s): ALI, STAY HIGH 149

Style: Abstract, futurist, multi-layered genius

Distinctive Feature(s): Energetic strokes that manage to stay light and refined

The Beginnings

In 1955, at New York's Bellevue Hospital, one of the greatest street artists was born. FUTURA 2000 starts painting New York subway trains in the early 70s, with other young writers of his time, such as ALI. As he recalls *"I was 15 and I knew better"* and meets members of the United Graffiti Artists. From the start, he acknowledges influences from writers in Manhattan (SNAKE, CAT 87, STITCH I, COCO-144, etc.). The Bronx (EL MARKO 174), in Brooklyn (PHASE 2, FLINT 707 and STAY HIGH 149 who inspires his passion for writing as an art form). FUTURA then joins crews such as SA, 3YB, CIA, Interpol, KGB and mainly covers the No.1 Broadway Local line, with its abandoned stations and easy access. It isn't long before he decides to do most of his pieces on his own: *"I did most of my 'getting up' alone. I was always worried about (them) doing something stupid. For dangerous missions, I rolled solo".* Even so, he ran the usual races through the tunnels, fleeing the police, ending up in hiding in a train's under-carriage once. Among the writers of that generation, FUTURA is one of the first to exclusively focus on abstract pieces, at a time when most writers are obsessed with lettering. And as an abstract street art pioneer, his very particular aerosol strokes stand out immediately. His brush-like strokes are clearly different from others'. Yet after too many years of mission, he takes a break from graffiti and enrolls for four years in the Marines.

The "Aha!" Moment

"For me the transition was rapid, one minute we were bombing trains and living the culture, and the next minute BOOM." In 1979, FUTURA receives a letter from ALI, asking him to come back to New York and be a part of the movement's new development. The two of them start a new crew, under the name "Soul Artists of Zoo York". FUTURA resumes his New York subway writer's life. In 1980, he works with ZEPHYR at the Esses Studio, collector Sam Esses' project that offers graffiti artists the possibility of trying themselves out on canvas, and into the art world.

Into the Art World

His first group show takes place in 1981 at the SA Alternative Space, in New York. He's on stage with The Clash, painting live. He also appears on the band's Combat Rock album, as the spoken word voice in *Overpowered by Funk*. The Clash return the favor and appear on his own song, *The Escapades of FUTURA 2000*. In 1982 he collaborates with director Emile Antonio by creating a mural in lieu of the opening credits for the movie *In the King of Prussia*. Meanwhile, the solo and group shows keep adding up, amongst which PS1's. After his 1982 Fun Gallery show in New York, and a French small exhibit in Strasbourg, he moves up the gallery scale in 1983, with shows at Baronian-Lambert in Gent (Belgium), Yvon Lambert in Paris, and Tony Shafrazi in New York. During the next few years, his work takes him around the world's museums and galleries: Michael Kohn in Los Angeles, the Galerie du Jour in Paris, Bologna's Modern Art museum in Italy, the Groninger Museum, the Boymans Museum in Rotterdam, Netherlands, the Tate Gallery in London, Hong Kong, Hanover, Munich, Tokyo, and more.

In the 90s, he invests his time and resources in street wear companies, experimenting on merchandise products such as toys, sneakers, and what himself calls *"a diverse range of creative media"* before founding his own company, FUTURA LABORATORIES, based in Fukuoka, Japan. This doesn't steer him away from the world, and he continues collaborating with the Galerie du Jour in Paris, for example, with shows in 1991 and 1992, as well as participating in group projects with his friends MODE 2, AONE, SHARP, ECHO, JONONE, CRASH and others. In addition to his numerous gallery shows, he's part of the Street Art exhibit at the Palais de Chaillot in Paris and shown at the Groningen Museum. A decade of solo shows leads him to the Martin Lawrence Gallery in New York in 1993, and at the Aeronef in Lille (France) in 1996 en passant par la Zero One Gallery de Los Angeles par exemple.

These are years of multiple exhibitions and of intense production, during which his canvas works becomes particularly powerful. As 2000 dawns, and with it the rise of the Internet, FUTURA surprises

everyone with his decision to slow down his artistic production, in order to focus on his company and express himself via the web. He's fascinated by the idea of sharing images and thoughts, and his connections throughout the world inspire him to develop his astounding website, in what he calls his *"personal propaganda procedure"*. *"Over the past five years I have presented my images/language/design/signature to the global community via the world wide web (…) and there I am, in Bosnia, Brazil, Berlin and Bangkok."*

He also keeps up with his musical collaborative projects, and even lends his voice to MiLight's record. In DJ Mehdi's 2002 video for *Breakaway*, FUTURA a room with tags, using markers and spray cans. He also appears in the 2005 movie *Just For Kicks* on Hip Hop culture and in the video called *Waiting on the World to Change* by John Mayer featuring DAZE et the Tats Cru. More recently, he can be seen playing his own role in Mark Ecko's video game *Getting Up: Contents Under Pressure*. In 2009, the Fondation Cartier in paris includes his early works in the *Born in the streets show*.

Style

FUTURA is one of the leaders of Graffi ti's new orientation in the 80s (at Fashion Moda, the Mudd Club, or PS1). Only a handful of style writers are able to hold on to their status in the art world, and FUTURA is part of that rare breed. Paint-

ing has always been for him both a way to connect to the world, and escape it. Speed and movement are by nature part of Graffiti, but FUTURA's challenge is about managing the energy projected onto his works. In his artistic work, his approach is unique. He uses a futurist style to create an abstract universe in which he mixes drippings and clean-cut lines. The contrast between the color ranges, the ethereal elements and his strokes cutting across the canvas, creates a code that is both hard to decipher and elating. Aerosol painting allows him to create gradient range effects and subtle color mixes. On his sprayed backgrounds, he then applies, in a yet ever so subtle game of caps, various curves, shapes or signs that materialize, like codes waiting to be cracked. The paint used sometimes for specific details (such as spray drops) bears a shine that adds volume to the pieces.

When speaking about his work, FUTURA refers to energies going into different directions. One can't help but feel that energy, as it vibrates, spins, explodes. He admits to working in a rather obsessive mode. But so does his environment, with its various objects, a smile encountered, feelings and perceptions… His creative impulse is spontaneous: *"You can't sleep on an idea"*. He supports *"the Marco Polo in us all"*, and like an explorer would, draws maps of an imaginary world. The multi-sided genius now finds expression through many mediums, from painting to music to photography, with an energy that constantly seems to renew itself.

Previous page:
Painting on canvas, private collection, *FUTURA 2000*

This page:
Missile Command, painting on canvas, 214x92cm, 2007,
P. Lerouge collection, *FUTURA 2000*

Painting on Fashion Moda Gallery's fridge door, P. Lerouge collection, *FUTURA 2000*

Painting on canvas, P. Lerouge collection, *FUTURA 2000*

QUIK

Date of Birth: 1958

Place of Birth: Hollis
(Queens, New York)

Starting Point: 1970

Influence(s): Roy Lichtenstein,
Jasper Johns

Style: Lettering and abstraction,
brightness and darkness

Distinctive Feature(s): Double
language, colorful and tortured;
filled with social protest

The Beginnings

Lin Felton, aka QUIK, was born in 1958 and raised in Queens. His family provides him with a strict religious upbringing. *"God gave me a strange talent"*, QUIK quickly does his best to impress his teachers, who acknowledge both his talent and his efforts with good grades. As a child, he collects comic books, which inspire his drawings, though he is not encouraged by the adults around him to follow that path. *"I always knew I would paint"*. Stubborn, he keeps at it, much like he keeps doing graffiti when asked to stay away from the streets. QUIK demonstrates a strong, contradicting mind from the start and throughout art school. *"If I don't like the cigarette billboard, I graff it."* As far as graffiti itself, he's quick to join the original stars, such as SEEN, next to whom he executes a number of pieces.

The "Aha!" Moment

As a teenager exposed early to racial discrimination, and while he isn't artistically conscious of his actions, yet, he does integrate strong messages in his murals, clearly looking to push some buttons. By the time he's twenty, QUIK has a habit of representing rabbis, Hitler, or Asian characters, on his trains, as a way to protest and manifest his rebellion, as well as his refusal to be part of a minority. His tone soon stands out from those of other writers, and is probably the reason his work is shown in the first graffiti shows in the early 80s.

With the support of his friend FUTURA, who truth be said, doesn't really give him a choice, he shows his work in the various exhibits of downtown New York's blooming scene, along with BLADE, SEEN, and CRASH. They're part of *Beyond Words* at the Mudd Club, in 1981 and fixtures of the New York scene that also includes Jenny Holzer, Keith Haring, Jean-Michel Basquiat, etc.

QUIK considers his show at the Yaki Kornblit Gallery in 1983 to be his actual first solo exhibit. It also happened to be a great commercial success, allowing for Museum exhibits around the world, which give the young artist a new vision of his artistic creation: *"so from that moment I would be the best QUIK I could be"*.

Into the Art World

After the Mudd Club and the Fun Gallery group shows in the early 80s, exhibits add up, both in the US and in Europe. PS1, the Boymans van Beuningen Museum, the Groninger Museum, the Stedelijk Museum or even the Helmond Museum, in the Netherlands. Over the course of twenty years, QUIK's works are shown in over 150 exhibits, and integrated in prestigious collections, among which those of the Museum of the City of New York, the Studio Museum of Harlem in New York City, the Becht Collection in Amsterdam, the Martin Visser Collection in the Netherlands, the Herning Kunstmuseum in Denmark, the Gro-

ninger Museum in the Netherlands, the Helmond Museum in the Netherlands, the Henk Pijnenburg Collection, the Rudolph Scharpf Collection, the Martin Wong Collection, the Yaki Korenblit Collection, the Martin Sanders Collection, the Wildenberg Collection, or the Dieter Weber Collection. To name a few.

Style

QUIK's style is strongly autobiographic, mixing in his works both his personal questions and more global inquiries, such as the place of black minorities in American society. QUIK questions the American Dream beyond its simple expression, yelling and mixing his confusion about the world and its social issues, in a very subtle way, to his more personal and intimate quests. *"I can't sing, I can't play an instrument so I paint the blues"*.

This justifies the difficulties found when trying to define QUIK's work, which cannot be qualified as simple graffiti or writing. Even in his most colorful works, that appear to be just lettering, he includes his questioning messages.

Yet, it would be a mistake to qualify QUIK's practice as political art. It has more to do with personal anxiety. The Black Man is a recurring icon in his work. In other pieces, his male status in the face of women overtakes the visual field. His insecurities are fully expressed, in what could be seen as a probably cathartic process.

QUIK connects his work in a constant dialogue with his peers. In his pieces that underscore the difficulties met by minorities, he also integrates the American flag, both as a way to support his social interrogations and in homage to Jasper Johns' flag. In the way he draws black contours around his female characters, he also refers to the way Roy Lichtenstein represents women.

Though QUIK's work seems pop-like, it also integrates his utmost personal demons, including his sexual fantasies around dominatrix figures, which fill his work. He likes to think that his most intimate and sexual pieces are in his collectors' bedrooms.

Women play an essential part in QUIK's works, whether as sexual targets, as objects of desire, or as ladies. With his rich graffiti heritage and his former taste for comics and cartoons QUIK knows how to mix his dark and abstract style with colorful and alive figures, from Felix The Cat to beautiful women borrowed directly from pop culture. His titles, such as *Dark meets colors, sorrow looks at nice figures* or, for example, *I wish I was blond haired and blue eyed* (1989), are evocative. His color range is therefore extremely rich, with an ability to move from hot pink to darker browns. Joyful representations alternate with more personal and obscure messages that, together, turn his body of work in a contrasted ensemble.

In 1990, the emaciated Negro figure appears in his work. His years spent in Pennsylvania in those years add to QUIK's dismay when faced with the still very active existence of the Ku Klux Klan ideals among the population. In 1993, he even goes as far as representing a Black man trying to hang himself, to no avail, in the cynical piece *Killing Yourself to Live*. QUIK adds to that dark demonstration a colorful and wild background that underlines the opposition between the joy found in the pursuit of the American Dream, and the sadness when confronted to failure. Quik's social commentary in his work can be compared to that of Lee Quinones or Jean-Michel Basquiat, who both expressed their very strong feelings in the face of discrimination issues in the American society.

While QUIK does remain rather faithful to Graffiti's codes in terms of lettering, peppering his works with cartoon-like short texts, his lettering is often broken-up and dynamic, adding to the amazing richness of his pieces.

QUIK's work is deceiving. It is way more complex than what it seems. The initial perception is that of an obsessive, recurring yet simple pop imagery, with its bright colorful and cartoon-like faces, bulging eyes and expressive mouths. A close look reveals characters ridden by critical jubilation or suffering, and the

artist's grimacing vision of the world. Today, he still pursues his provocative quest, though in a gesture closer to the

American Abstract Expressionists, mixing his classic lettering with liberated paint drips, which, as he is quick to admit himself, exert a stronger attraction than simple lettering. In the artist's own words: *"It's action painting, it's aggressive, energy and sweat"*.

Up and right:
Painting on flag, 2009, courtesy Magda Danysz gallery, **Quik**

Bottom:
Painting on a door, P. Lerouge collection, **Quik**

069

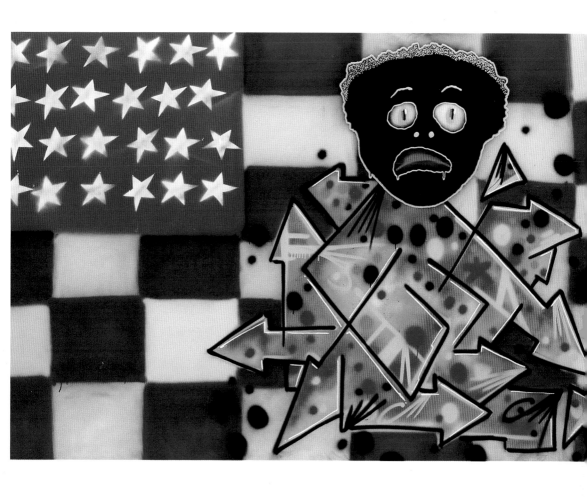

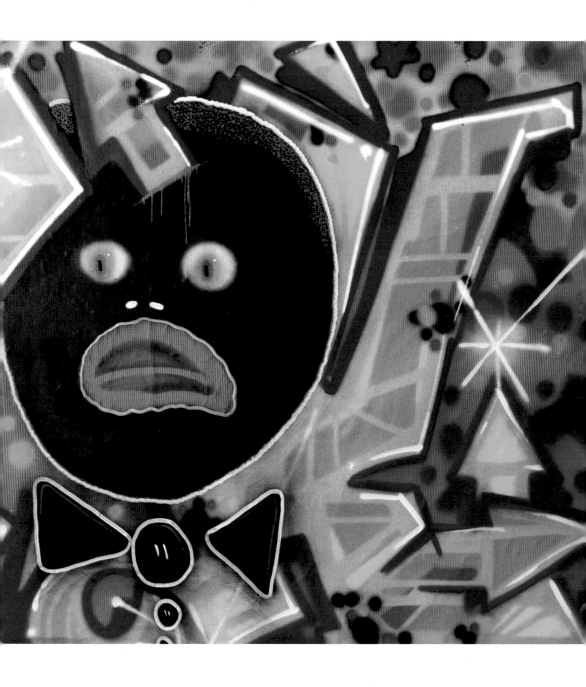

Untitled, painting on canvas, P. Lerouge collection, **Quik**

BLADE

Date of Birth: 1958

Place of Birth: The Bronx

Starting Point: 1973

Influence(s): Phase 2,
Super Kool 223

Style: Whole cars, geometrical,
futuristic, driven by perspective

Distinctive Feature(s): Visionary
artist

The Beginnings

Steven Ogburn, aka BLADE, was born in 1958 in the Bronx. He was only 15, in 1973, when he founded The Crazy Five crew. Within the graffiti community, he was know as the whole car king to have reigned the longest over lines 2 et 5, which he substantially covered from 1975 to 1980. He reached every single train.

BLADE was one of the first to cover train cars from top to bottom, a practice known as blockbusters. While he wasn't the first, he completed so many that he, most certainly, started the trend. BLADE was also known for his guts. He'd paint trains in broad daylight and brag about it via "NEVER BUSTED!!!!!!" tags.

His style was recognizable among all, if only because it showed, from the start, a great inspiration in terms of lettering. BLADE's greatest competitor was LEE, who admittedly learned a lot from observing his rival's work.

BLADE is a graffiti legend. Some even say he's painted over 5,000 train cars. In 1978, when the Transit Authority Council launched a massive clean-up campaign, BLADE lost hundreds of his Whole Cars, instantly.

The "Aha!" Moment

BLADE playfully combiness lettering and imagery with perspective and geometrical shapes that surround them. While his work could be considered as NOT graffiti per se, which several writ-

ers vehemently pointed out at the time, BLADE's originality brought him many fans. In February 1981, Diego Cortez invited him to participate in the PS1 *New York/New Wave* exhibit. By 1983, when the Dutch art dealer Yaki Kornblit noticed him and asked him for canvas paintings he could exhibit, BLADE was already and very officially considered "King of Graffiti".

This is most likely what led Sydney Janis to show BLADE's work, that same year, in New York. And consequently, why the Boymans-van Beuningen Museum in Rotterdam included BLADE in its year-end show "Graffiti", with SEEN, ZEPHYR et NOC 167.

Into the Art World

With more than 100 exhibits throughout the world, BLADE's career is exemplary. After the Boyemans Museum in Germany, his work was shown at the Bronx Museum, the Brooklyn Musem, the Groninger Museum and the Gemeentemuseum in the Netherlands, the Musée National des Monuments Français in France, the Museum der Stadt Ratingen, Mynheim Museum and the Museum Dortmond in Germany, the Rotterdam Museum, the Leopold-Hoesch museum, and the Whitney Museum, to only name a few. In 2004, Martha Cooper & Henry Chalfant published his first monography, enlightening the public to his dense and extraordinary career.

Style

BLADE wasn't the first street artist. But he was the most enduring one in terms of serving the cause of traditional graffiti, all the while being considered an outsider to the actual graffiti medium. His canvas pieces show his love for lettering, and his loyalty to the perspectives that made him famous. The infinite variations around the letters of his name are proof, if need be, of BLADE's innovative talent.

Each of his paintings explores perspective, giving to BLADE's letters an added quality: they are more than what they initially seem to be. They become constructions of sorts. In some of BLADE's works, letters even seem to be made, not of paint, but of steel, for instance.

BLADE also adds multiple effects to his letters, shiny reflections, twinkling stars, etc. Even these smallest details show how the artist works: precisely and meticulously.

In addition to his work on perspective and details, BLADE puts impressive effort into his backgrounds. If you look closely, you'll see that the backgrounds are anything but plainly applied paint. You'll even find hidden stars and other small elements. Simplicity might seem to be his signature, yet BLADE's work is a very subtle combination of old school letters in a futuristic world of his own.

21st century art today, canvas, 125x200cm, 1989,
P. Lerouge collection, **BLADE**

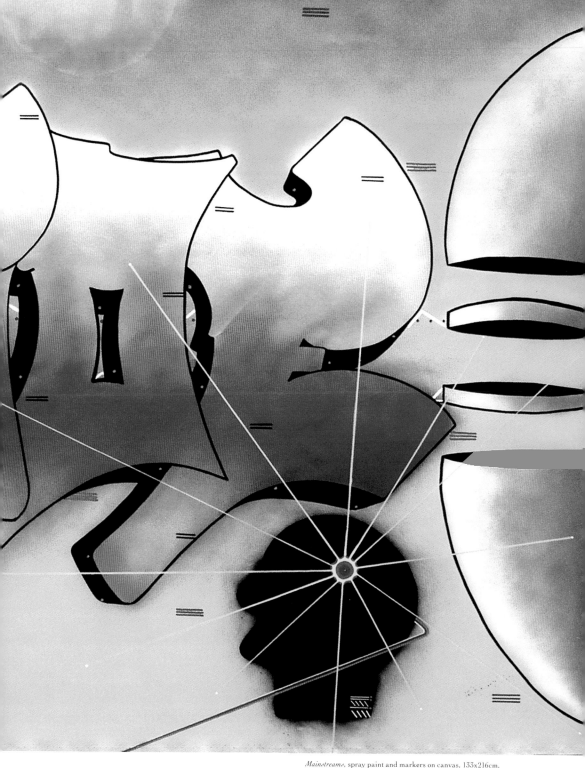

Mainstreams, spray paint and markers on canvas, 133x216cm,
1990, Henk Pijnenburg collection, **BLADE**

The Beginnings

Lee George Quinones, aka LEE, grew up in New York's Lower East Side Nuyorican community. From the age of 5, LEE shows strong predispositions for drawing. He's into the colorful characters of the neighborhood's imagery, and loves Japanese post-war monster movies, such as Godzilla, Speed Racer et Kimba the White Lion. He discovers movies and television with his mother, and becomes a great fan of film and TV music composer Lalo Schiffrin (Bullitt, Inspector Harry, Operation Dragon, Mission impossible, Mannix, Starsky et Hutch…). The Vietnam War's constant flow of images also leaves its mark in LEE's mind.

In the early 70s, his graffiti artist name is known as LEE 163, and he's famous for being the first to link the letters of his tag together. 1974 sees his first train pieces, and by the end of 1975, he's created the very first 40-foot long train piece. During those initial graffiti years in New York, LEE also gets noticed as the first to hit the front of train cars which eventually are placed at the head of trains. He and his cousin PHASE 2 quickly become the first "Kings" of the Bronx. That same year, he joins the mythical Fabulous Five crew, an elite quintet that achieved glory by painting from top to bottom the only 10-car train in circulation. By 1976, LEE is a legend, and focuses on Line 5's, covering 115 of MTA's trains over the next ten years.

LEE Quinones

Date of Birth: 1960

Place of Birth: Ponce (Puerto Rico)

Starting Point: 1971

Influence(s): CLIFF 159 of the 3-Yard Boys, BLADEONE of the Crazy 5

Style: Large scenes, earthly colors

Distinctive Feature(s): Expressionism

The "Aha!" Moment

During Spring 1978, LEE completes the first 30 foot-long wall piece[1], right in front of Corlears Junior High School, where he goes. He calls his painting *Howard the Duck*. Known today as the "All-Time Great Whole Car King," LEE was also one of the first to take over large walls in order to create monumental pieces. In 1978, he also takes over the walls around the Brooklyn Bridge, turning them into open air galleries which bring him even more recognition. *"My sense of art was to create art without a reference point to art history, because this was art history in the making."*

Following those heroic deeds, the art world notices him. He's offered his first personal show at Claudio Bruni's Galleria La Medusa in Rome, in late 1979. A year later, he makes his New York art debuts in the New York scene with the show *The Third Phase* at the White Columns Gallery. He also participates in a key-exhibit in Times Square, presented in a former massage parlor. The exhibit brings together the works of the main post-modernists of the time, and includes Lee, Jenny Holzer, Keith Haring, Kiki Smith, Jane Dickson, and Jean-Michel Basquiat. Lee Quiñones is considered to be one of the major artists of the great and recently born movement called street art." *There are people who see the graffiti experience as a vocation of adolescence, the rites of passage without a sense of direction,"* shares

1 About 10 meters long.

LEE." *I'm not surviving by offending it or defending it, but I saw it early on as a catalyst to develop as a painter and explore the other horizons outside of a forty foot subway car."*

Into the Art World

In 1981, LEE's works are shown in PS1's *New York/New Wave* exhibit. He then plays in the legendary movie *Wild Style*, directed by Charlie Ahearn, inspired by LEE's life. It comes out in 1983. His following shows are at the Fun Gallery, at BARBARA 62 Gladstone, Sidney Janis, Riverside Studios and Zwirner Gallery. His works are part of the prestigious Dokumenta 7 in 1982 in Kassel in Germany. He works on the movies *Smithereens* by Susan Seidelman (1982) and *Desperately Seeking Susan* (1985). In that same period, the ties between the worlds of graffiti and music strengthen. LEE, FAB FIVE FREDDY and Jean-Michel Basquiat paint backgrounds for Blondie's video Rapture. In the 90s, LEE is hard at work, between exhibits and special commissioned works, which he honors with the same taste for challenge. In 1999, he starts working on a new mural, on a 5-story building, which he names *Securing The Requiem* as a reflexion on the physical and spiritual experience of Vietnam War. In 2002, he plays a cameo in Adam Bhala Lough's *Bomb the System* (2002). His support towards needy communities is still strong, and in 2005, he even rides his bike from New York to Miami to collect funds for the victims of Hurricane Kat-

rina. LEE is considered today to be one of the artists to have developed graffiti by constantly bringing higher esthetic and technical ambitions to the movement. After taking the greatest risks to paint the city's subway trains, he started working on canvas and successfully showing his works: some of his paintings are now part of the Whitney Museum's permanent collection, the Museum of New York City, the Groninger Museum in Groningen, Netherlands, the Museum Boijmans Van Beuningen in Rotterdam, Netherlands. He's had shows at the New Museum Of Contemporary Art in New York City and at the Staatliche Museum in Germany.

Style

LEE is inspired by everyday life and by his surrounding popular culture. He often makes direct references to music, as the subject of his work, or in a more subtle way, through the rhythm of his painting and the tones and harmonies he puts in a piece. LEE always uses the basic graffiti tool: the spraycan. He's an expert at controlling all of its potential effects, from color decomposition to written layers.

His color palette is usually nature's heritage, from earthy ocres to sky blues, far more neutral than your basic New Yorker graffiti artist.

LEE's painting is at the cross of Hip Hop culture and punk rock, and is often filled with messages and allegories that bring rhythm to his large b-boy, pretty girl or word compositions. All his characters bear more than a cartoony heritage. They stare at you intensely and LEE points to their souls. With time, in his paintings, human figures get more important, reminding even his Puerto Rican background and getting closer to the tradition of South American muralists.

Thanks to the Graffiti codes and techniques that LEE uses, there's a certain 70s nostalgia to be found in his artwork. Overlaying numerous symbols and characters, he manages to translate the extraordinary richness of his urban environment, including its colors. Often called the Pollock of graffiti, LEE is more than anything an expressionist master, with the ability to project his own subjectivity while inspiring an emotional reaction in his viewer.

Murals, *Lee Quinones*

PHASE 2

Date of Birth: 1958

Place of Birth: The Bronx

Starting Point: 1971

Influence(s): CAY 161, TURUK, RICAN 619, TAN, COCO 144, JUNIOR 161, JOE 136, JEC STAR, BABY FACE 86.

Style: Lettering innovation

Distinctive Feature(s): Inventor of many ornaments and Graffiti styles

The Beginnings

Lonny Wood, aka PHASE 2, was born in the Bronx in 1958, and became one of the Graffiti pioneers as a highschool freshman in DeWitt Clinton High School. As early as 1971, he'd throw his name, PHASE 2, as a reference to a party he wanted to name that way, which he still remembers: *"The previous year we'd given this party. We were getting ready to give another one and I said, 'We'll call this one Phase Two.' I don't know why, but I was stuck on the name. It had meaning for me. I started writing Phase 2".* Many graffiti artists from those early 70s get together at a doughnut shop called the Coffee Shop, across the street from DeWitt Clinton High, before heading to the 149th street subway stop to watch the tagged trains go by, discussing and comparing what they saw with their own creations. PHASE 2 gained rapid recognition for his contribution to the original graffiti scene, if only by inventing the Bubble Letters in 1972. He started writing before the concept of pieces per se even came up. Very early on, whether it be with his buddy RIFF 170 or later, with his cousin LEE 163, PHASE 2 emphasized the importance of personal style and innovation.

The "phasemagorical phantastic" (Bubble Letters with stars), the "bubble cloud", the "bubble drip" are all creations of his. He's also recognized as the pioneer in the use of arrows in his graffitis. Journalist Jeff Chang, a Hip Hop expert, mentions how PHASE 2's works *"have been widely*

recognized as defining the early genre." During this period, he sprawled his paintings across thousands of trains, always winning his races against the police. He even sent a poem to the police officer who mistakenly thought he'd arrested him: *"If you only knew/the real Phase 2/the super sleuth/ who's still on the loose/ you caught Cool T/ but you didn't catch me/I got away while eating/ my vanilla ice cream."*

The "Aha!" Moment

Noticed by all, PHASE 2 is mentioned as one of the main graffiti figures in an article published by Newsweek alongside SNAKE 1, NOVA, STICH et FLINT. In 1974, he joins United Graffiti Artists, Hugo Martinez' first gallery founded around the graffiti artist collective, and presenting the very first graffiti art shows. Richard Goldstein's article, titled *This Thing Has Gotten Completely Out of Control* and published in March 1973 in the *Graffiti Hit Parade* issue of the *New York Magazine* also mentions PHASE 2.

Into the Art World

PHASE 2 got an early gallery start in the exploding New York 80s scene. As an early activist, he founded in these years the first graffiti writers fanzine, the *International Graffiti Times*. In 1982, PHASE 2 became a regular at Kool Lady Blue's legendary Hip Hop shows at the Roxy Club in Chelsea. Bringing together The

Bronx' top of the crop in terms of DJs, MCs, breakers and graffiti artists, the shows were instrumental in bringing this new culture to the downtown crowd. PHASE2 would often paint on stage during the shows, and handled the flyers' art design. He also joined the first international New York City Rap Tour, heading to France and England. The tour included Rock Steady Crew, the Dark and Lovely Double Dutch Girls, Grandmixer DXT, Afrika Bambaataa, Fab Five Freddy, the Infinity Rappers, FUTURA, DONDI, RAMMELLZEE, TAKE 1, Fristy Freeze, Ken Swift, Crazy Legs, Little Norman. The event is a cornerstone in the history of Hip Hop, as the first to combine the four pillars of its culture PHASE 2's success also comes from his connection to music and to the Hip Hop scene, even more so than other graffiti artists: he's a DJ.

In addition to fathering several styles, he's considered to be one of the main founders of the conjunction between rap music, break dance, dee-jaying and graffiti, which implies he's one of the inventors of Hip Hop. Very active in the NY music scene, Phase 2 released two rap singles in 1982. *Beach Boy* is born from his collaboration with Barry Michael Cooper, who eventually became famous as the co-writer of *New Jack City*. The Clash, Bill Laswell and Grandmixer DST are the producers behind his second single, *The Roxy*. The self-titled reference to the famous club obviously became a hit there, and elsewhere too. And PHASE 2 is still remembered as a b-boy (ie. break-

dancer). Whille PHASE 2 is not a part of the cult Hip Hop movie, *Wild Style*, director Charlie Ahearn clearly and admittedly got his inspiration from him to create Phade's character, played by graffiti artist FAB 5 FREDDY. In 1984, though, PHASE 2 will be involved in the movie *Beat Street*, as a major consultant.

PHASE 2 is still committed to the Hip Hop scene in its diversity, and still paints murals from NY to Minneapolis. He's shown old and recent works during exhibitions at the Rock and Roll Hall of Fame and at the Art Museum in Cleveland, as well as the Brooklyn Museum of Art (2000). He's been a guest at conferences such as the *First Annual Creativity Now Conference* (2003), and was featured in major Graffiti events, like *Board the Train* (2005) or the *Aerosol Art Series* (2007) with his live mural paintings.

Style

PHASE 2 is a legend because of what he brought to the movement, in terms of Styles, from the very beginnings. Beyond their formal aspects, his additions to Writing show an extraordinary inventivity, which the world still salutes. He's the first one, early in the movement, to have grasped how writing a name could become obsolete. In his own words, *"Super Kool 223 writing his name on a train changed everything -- bombing and signatures became obsolete, and people understood that."* The common factor to fuel his process is how rich his style is. Whatever particular technique, whatever letter-type he uses, he takes it as far as it can be taken, including by blurring his background lettering. What PHASE 2 is experiencing in New York's 80s can be perceived in the rebellious feel of his paintings.

Left to right:
Eye Storm, spray paint on canvas, 133x426cm, 1983,
Henk Pijnenburg collection, *Phase 2*

Majestic P, spray paint on canvas, 175x255cm,
Henk Pijnenburg collection, *Phase 2*

Drawing, courtesy Alan Ket, **Phase2**

The Beginnings

RAMMΣLLZΣΣ

Date of Birth: 1960

Place of Birth: Queens

Starting Point: 1974

Influence(s): SLAVE, IZ THE WIZ, SNACK, GEAR, JESTER, SNAK, MOVIN, OU

Style: Abstract, gothic futurism

Distinctive Feature(s): Built on a very strong and complex code

RAMMELLZEE (or RAMMΣLLZΣΣ) was born in 1960 in Far Rockaway Queens (New York). He starts painting subway trains around his neighborhood in 1974 with his friend SONIC 202. The New York subway phenomenon, as an open and available sky gallery, bears an early and very strong impression on him. Finding his inspiration among the other graffiti writers he sees at work, he is particularly interested in those who have already developed a personal style with ornaments that can be easily recognized, such as JESTER, who draws a harpoon over the letters of his name. In his early stages, he uses several of the aliases he's chosen himself: HYTESTYR, EG (EVOLUTION GRILLER THE MASTER KILLER), SHARISSK BOO, RAZZ. RAMMELLZEE, on the other hand, is the name given to him by Jammel-Z (of the Five Percent Nation). During those times, he shares his time between a number of crews, such as The Master Blasters or The Master Bombers led by IZ THE WIZ, moving on to join ROTO and SNAK's No Competitional Bombers or No Comp Boys, before becoming a member of SONIC's crew: Boys Are Down, and TOP. JESTER introduces him to The Crew and to The Killer Crew, as well as the Majestic Kings. In 1979, he starts his own crew, the Tags Master Killers. He's also the man behind

the NGG (Notorious Graffiti Gangsters and LAW (Legions Assassins Wizards). Lastly, he joins DONDI and CIA.

RAMMELLZEE's motivations are fueled by his extremely strong sense of graffiti culture. In 1980, and under FAB FREDDY FIVE's impulse, he actually sends for Jean-Michel Basquiat, in order to interrogate him on his motives for allowing himself to be a "puppet king" in the hands of the art world. That same art world, in those days, that has not yet taken an interest in "burners", the hardcore graffiti artists who massively attack trains. RAMMELLZEE is all about the urban guerilla, and earns other writers' admiration, among whom DONDI. He even puts comes up with penetration tactics to infiltrate the subway system more efficiently, i.e. cover as many trains as possible.

The "Aha!" Moment

His passion for lettering is, uniquely enough, stronger than the race for fame. He spends part of his time in libraries, doing research on ancient illuminations and other sources of inspiration, and particularly the works of monks between the 10th and 15th centuries. In his mind, these elements are the true sources and principles of his work and commitment. When he invents the "Letter Racers", it is only because he considers the alphabet to be an unfinished business, with a lot of work left to achieve.

In 1980, yet even though he's very involved in train painting with DONDI, he soon decides to give up illegal painting and focus on canvas. And in the early 80s, RAMMELLZEE enters the downtown art gallery scene. Soon enough, he actually becomes famous beyond those borders, thanks to Charlie Ahearn's cult movie, *Wild Style* and Jim Jarmusch's *Stranger Than Paradise*.

His style then evolves at the speed of light, beyond graffiti's past standard techniques, codes and traditions. Experimentation leads his work, and while others are still toying with 3D lettering, he goes further and starts actually building the letters and most important his canvas.

Into the Art World

RAMMELLZEE's career is built around regular exhibits. In 1983, he has shows at the Fun Gallery and the Bonlow Gallery in New York, before participating in the Graffiti show at the Boymans-van Beuningen Museum in Rotterdam, which then travels to the Groningen Museum. His work is consistently presented by Yaki Kornblit, in Amsterdam, as well as by the Sylvia Menzel gallery in Berlin and, later, by the Thomas Gallery in Munich. In 1984, he's part of New York Graffiti, at the Modern Art museum of Bologna, in Italy and at the Louisiana Museum in Copenhaguen. In 1985, he travels to Brasil to present his work at the Sãn Pao-

lo Biennal before showing more pieces at the Sidney Janis Gallery, in New York for the *Post Graffiti* exhibit.

The 90s were slower for everyone, including RAMMELLZEE but he still split his time between New York and the Netherlands, and between galleries and art centers or museums.

In typical Graffiti tradition, RAMMELLZEE nurtures close bonds with music. He's a member of the Death Comet Crew, with Stuart Argabright and Michael Diekmann. They record a few tracks, put out an LP record, and perform live. 2004 sees the release of his solo album, *The BiConicals of the RammEllZee*, and in 2006, he's part of PS1's *Music is a Better Noise* exhibit.

Nowadays, RAMMELLZEE defines himself as a pluridisciplinary artists: a graffiti writer, a performer, a hip-hop musician and a sculptor. With a fondness for performance, he continues to experiment and explore new horizons, all the while remaining true to his b-boy culture.

Style

RAMMELLZEE's style is among the most developed and advanced in street art, and based on in-depth research. His alias is conceived like a math equation ("RAM" plus "'M' for 'Magnitude', 'Sigma' (\sum) the first summation operator, first 'L' - 'longitude', second 'L' - 'latitude',

'Z' - 'z-bar', Σ, Σ- 'summation'.") And he's one of the few writers to have extensively written about his style, giving it the name of "Gothic Futurism". Born out of the ancient illuminating techniques, he pushes forward the more or less intelligible and therefore sometimes secret links that can be found between letters and the symbols that surround them. He sees his own approach as the logical extension of what he built in his career's early stages, through the almost systematic invasion of a train's surface. It's therefore easier to understand the power and the energy that cover up letter segments that have almost disappeared under the layers of paint and symbols. While RAMMELLZEE's art is futurist, and focused on substance, it still finds it energy in graffiti, renewing itself and growing constantly. Paint and symbols are intertwined in his work making them pieces with dual energy: the strenght of the drips and the texture plus the mysteries of the signs, from solar to numeric.

This page:
Ikonoklast Panzerism - letter S, spray paint and marker on board,
50x60cm, Henk Pijnenburg collection, *RAMMΣLLZΣΣ*

Next page
Untitled, fresco on wood, 85x110, 1984, private collection
RAMMΣLLZΣΣ

SEEN

Date of Birth: 1961

Place of Birth: The Bronx

Starting Point: 1973

Style: Prolific artist sporting numerous styles from the bright old-school lettering to abstract experimentations

Distinctive Feature(s): Multitalented, powerful

The Beginnings

Richard Mirando, aka SEEN, started spray painting at age 9, in his uncle body shop. The garage is right behind the Line 6 train depot, and that's where he paints his first train car, at age 11. The following year, in 1973, he signs his first piece with the name SEEN. As a member of the UA (United Artists) crew, he is the legendary king of line 6. He paints intensively, creating dozens of walls during the 70s and 80s, while achieving fame with his train pieces. This is a highly competitive period in the graffiti train scene, with each writer engaged in outperforming the other in terms of quantity. SEEN executes top-to-bottoms with such dexterity and rapidity that he becomes officially known as "The Godfather of Graffiti", a unique title. The title is still his today, due to the impressive quantity of pieces he's created and to his continuous resourcefulness in terms of style.

The "Aha!" Moment

Precocity is SEEN's leitmotiv. He paints his first canvas at the end of the 70s. In the early 80s, he meets Henry Chalfant who invites him over to Europe to paint and show his work. He initially declines the offer, before accepting it. *"I painted my first canvas in 1979. At the time, I wasn't thinking about art, museum exhibits or anything like that. It was the last thing on my mind. So when in 1981, or 1982, Henry Chalfant said:*

"Let's go to Europe paint on canvas", I had no interest. He said he wanted to take several of us to Europe. Still refused. I told him I'd miss the trains". Eventually, SEEN heads over to Europe.

Into the Art World

In the early 80s, SEEN shows his canvas pieces in the incredibly alive New York scene. They also travel abroad. He gets offered the Yaki Kornblit Gallery in Amsterdam, the Stellweg-Seguy gallery in New York, Suntory in Tokyo, as well as the *New York/New Wave* show at PS1 in1981 and the Louisiana Museum in Copenhagen in 1984, next to artists like Keith Haring, Andy Warhol, Jean-Michel Basquiat, DONDI, QUIK, BLADE and LEE. That same year, SEEN and BLADE travel to Los Angeles, and decide the "Hollywood" sign needs a makeover. And while they're at it, they cover the city buses with "SEEN and BLADE From DA BRONX" inscriptions, along with a little cloud.

Despite his great exposure in Europe, and his constant travel, SEEN continues to cover the NY subway lines until 1989, even after most artists have dropped out of the race, due to MAT's major repression.

SEEN's determination to keep up the work, going back and back again to complete a train in spite of constant police pursuits, has become his trademark.

Since, SEEN has had regular solo shows throughout the world, in Vancouver, San Francisco, Londres, Tokyo, Paris and New York and has been key to the Fondation Cartier show in 2009 in Paris: *Born in the Streets.*

Style

Often referred to as *"the man who invented modern graffiti"*, SEEN is precocious and wildly creative. And while his name is easily recognizable in his works, his style is ever-changing.

Having sworn allegiance to the graffiti movement (*"GRAFFITI is my life, always has been and always will be!"*), his ongoing artistic work continues to honor the different aspects of graffiti. Highly colorful, or at the very least diversified in terms of chromatic palettes, his works are the reflection of the 80s trains, if somewhat more self-conscious, and therefore more elaborate. His multi-layered backgrounds are extremely complex, combined to spray-canned softies that are as good as his best trains. His spraying strokes are technically perfect, and SEEN is able to express himself with ease.

In many works of his, subway maps are set up as a remembrance of his prime inspiration source. In other pieces, he integrates street sign elements from his environment, as a private joke. Whatever SEEN paints, he always takes a subtle stand for his commitment to graffiti culture.

More recently, SEEN has shown the world his multifaceted talent. Apart from his perfectly outlined bright letters on canvas, SEEN has developed more personal and inventive series. In many of them he experiments the abstract power of painting, layering spray paint and acrylic in amazing combinations.
Other series feature, as an homage to his early days, blurred tags and decayed graffitis.

Last but not least, SEEN also works on darker subjects inspired from the tattoo culture, where he is active too. Executed with various techniques, theses pieces are for instance featuring skulls whose eyes look straight into your soul.

Common to all his work is the powerful expression. Let them be colorful, blurred with grey or just black and white, all his paintings exude with an amazing energy shiffting from traditional, almost by the book, graffiti to a very subtle world. With time SEEN has also mastered the work on textures making blurred backgroungs cohabitate with decay-like parts.

Falling Into Oblivion, painting on canvas, 1990, courtesy of the artist, *Seen*

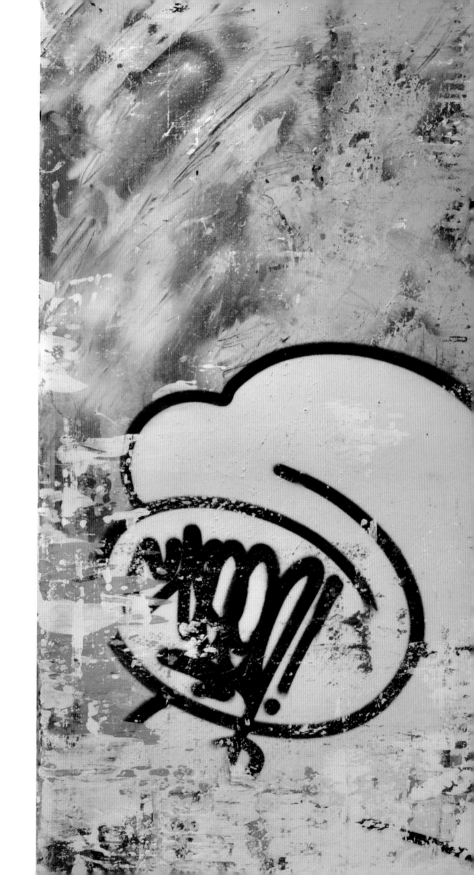

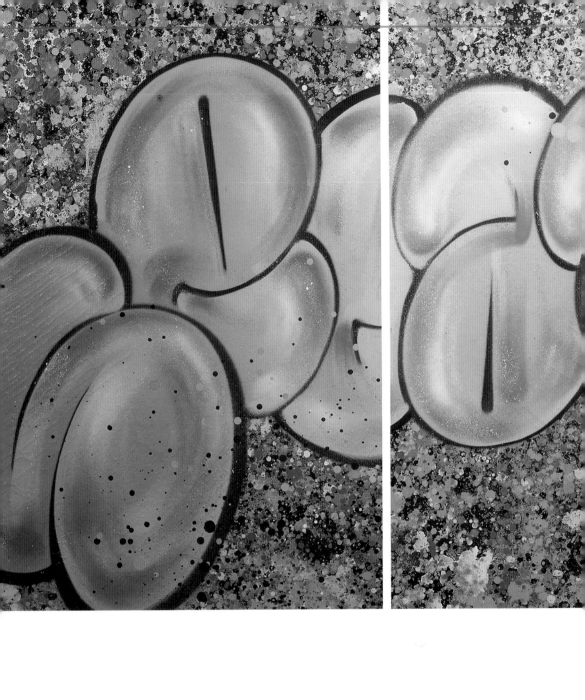

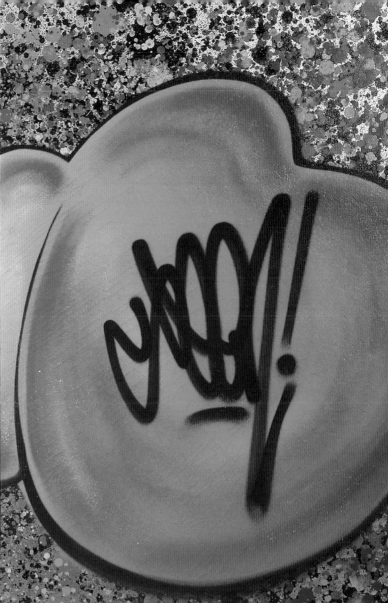

Painting, private collection, *Seen*

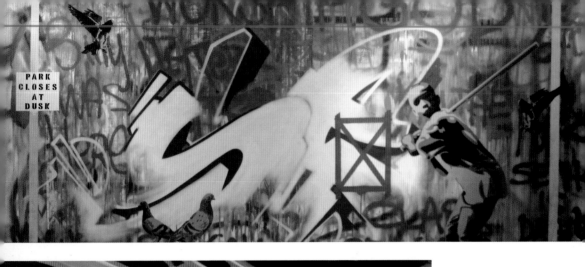

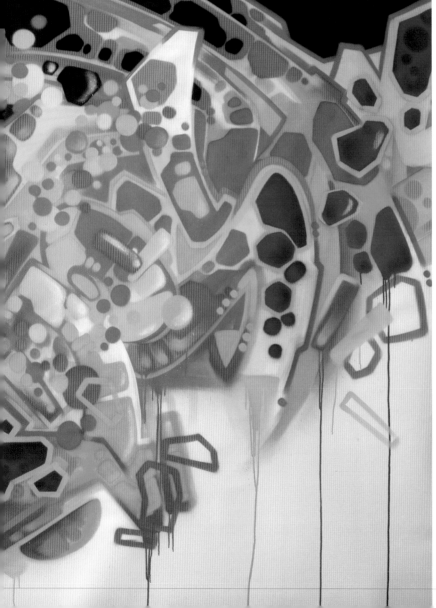

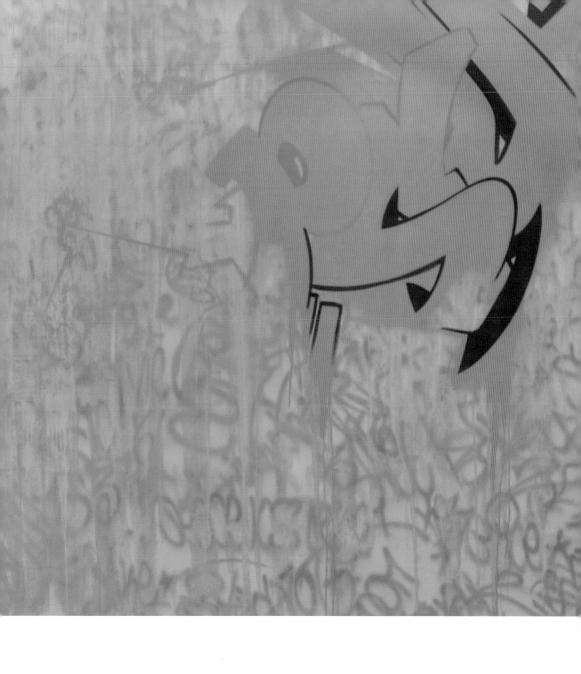

Top:
Painting on canvas, courtesy of the artist, *Seen*

Left:
Painting on canvas, courtesy of the artist, *Seen*

Right:
Painting on canvas, courtesy of the artist, *Seen*

This page:
Painting on canvas, 2009, courtesy of the artist,
Seen

Next page:
Painting on canvas, courtesy of the artist,
Seen

CRASH

Date of Birth: 1961

Place of Birth: The Bronx, NY

Starting Point: 1974

Influence(s): Gerhard Richter, Jasper Jones, James Rosenquist, Wesselman, Roy Lichtenstein, FUTURA.

Style: Pop Art inspired Graffiti

Distinctive Feature(s): Face elements and close-ups mixed with letters

The Beginnings

John Matos, aka CRASH, was born in the Bronx, on October 11, 1961. In 1971, he discovers graffiti while taking the subway to go see his mom who's working on 42nd street. True passion strikes upon him: *"From early morning, till late at night, all I could do is think about trains. Trains, the way they move, the sounds they made, the smell they had... and the paintings on them"*. In 1974, at the age of 13, he starts writing, alongside DAZE and KEL 139. His murals get immediate attention, but he's got it in his head that entering graffiti requires a long preparation and apprenticeship. He waits until 1976 before painting his first train. In 1980, he's commissioned to paint the Bronx Graffiti Roller Disco, and asks his friends Mitch 77, Noc 167 and Med to help him.

The "Aha!" Moment

As early as 1979, CRASH gets interested in canvas painting, experimenting at home on spray-paint pieces. In 1980, CRASH and his friend DAZE dicover Fashion Moda, Stefan Eins' hip exhibition space and New York's "place to be". CRASH is asked to curate and puts on Fashion Moda's first graffiti show, in October. *Graffiti Art Success* brings together the works of CRASH, DISCO 107.5, FAB FIVE FREDDIE, FUTURA, JOHN FEKNER, KEL 139TH, LADY PINK, LEE, MITCH 77, NAC 143,

NOC 167, STAN 153, ZEPHYR. The show's success gives the artists another exhibition opportunity: a month later, the New Museum gives them another show: *Events, Fashion Moda exhibition at the New Museum.*

Into the Art World

CRASH's career is launched rapidly thanks to Fashion Moda. In 1981, one show follows the other *Beyond Words* at the Mudd Club; *New York/New Wave* at PS1), and in November of that same year, entrepreneurs Joyce Towbin and Mel Neulander approach him. They're launching their multiple-floor gallery in the Village, called *Graffiti Aboveground*. The Gallery will work with CRASH, DAZE, NOC167, CAINE 1, TRACY 168, CEY and LADY PINK, but only lasts a couple of years, closing its doors in 1983.

CRASH's works can also be seen at Real Art Ways, an alternative art space created in 1975 promoting innovative practices.

In 1982 CRASH quits the street graffiti altogether, and dedicates himself to his work on canvas. In 1983, introduced by Dolores Neumann, CRASH meets Sidney Janis and gets his first solo show at Sydney Janis' New York gallery. CRASH produces 25 large canvas paintings for this exhibit. Among the pieces, he presents a painting entitled "A-U-T-O-matic", which reflected at the time his obsession with hard work, as an answer to those who considered spray painting to be a quick and easy process: *"This work is a way of saying, 'It's not automatic, it's a real process,' I look at the piece now, and I'm like, 'Wow, I was really angry.'"* CRASH stays with Sidney Janis Gallery for almost ten years.

Following the show, he's invited to participate in the Boymans-Van Beuningen-Museum's Graffiti exhibit, which then travels to the Groninger Museum. This will seal the expansion of CRASH's career to the international level. The Yaki Kornblit Gallery in Amsterdam starts inviting him every year.

To this day, CRASH has been a part of 75 exhibits, among which the Brooklyn Museum's 2006 *Graffiti*. His artwork can be found in numerous private and public collections all over the world, such as the Brooklyn Museum of Art; Dakis Joannou, Athens; Cornell Museum, Florida; Frederick R. Weismann Foundation, Los Angeles; Galleria d'Arte Moderna, Bologna, Italy; Groniger Museum, Groningen, The Netherlands; Henk Pijnenburg, Deurne, The Netherlands; Museum Boymans-van Beuninger, Rotterdam, The Netherlands; Museum of Modern Art, New York City; Rubell Collection, Miami, Florida; the Stedelijk Museum, Amsterdam, The Netherlands and the New Orleans Museum of Art, to name a few.

Style

CRASH's style evokes comics, with wild
colors used in advertising, standing as a
pure product of the contemporary world.
His paintings also bear some common ele-
ments with Wesselman and Lichtenstein,
both true children of Pop Art. However,
his tight frames, bringing a certain ab-
stract quality to his subjects as well as his
compositions, which accumulate various
elements on a single canvas, give his work
a strong specificity.

A number of symbols are recurrent in his
pieces. Eyes, for example, are *"a window to
someone's soul"*. Clocks remind us that life
should be lived with passion because time
flies by. A master in spray-paint, CRASH
reaches extreme color effects that give his
work a stunning intensity.

Apart from the patchwork of close-ups,
one of CRASH's characteristics is the
brightness of the colors he uses. Even
though it is common in the streets, he is
also a master at colors on canvas which is
rare. He knows how to keep red, orange
and green at the same time on a canvas.
CRASH is also very talented at spirals,
whirlwinds and shinny effects. His paint-
ing are made of clean cut lines and effects
added to a bright palette of colors.

This page:
After Broadway Boogie Woogie, spray paint on canvas, 180x180cm,
2009, courtesy of the artist, **CRASH**

Next pages:
Drawing on paper, 1990, private collection, courtesy of the
artist, **CRASH**

Arcadia Revisited, spray paint on canvas, 1988, courtesy of the
artist, **CRASH**

Previous page, from top to bottom:
Candida, spray paint on canvas, 173x179cm, 1987,
Henk Pijnenburg collection, **CRASH**

Zoe's afterparty, spray paint on canvas, 120x75cm,2007,
courtesy of the artist, **CRASH**

Spray paint on canvas, courtesy of the artist, **CRASH**

This page:
Te Amo, spray paint on canvas, 1990,
courtesy of the artist, **CRASH**

DAZE

Date of Birth: 1962

Place of Birth: The Bronx
(now Brooklyn-based)

Starting Point: 1976

Influence(s): Death Squad,
TRACY 168 and BLADE,
PHASE 2 and RIFF 170,
CHAIN 3 and NOC 167

Style: More creative aspects of
graffiti, lettering with illustration
"I wanted to be a guy that was known for
style"

Distinctive Feature(s): Visionary,
early fame

The Beginnings

Chris Ellis, DAZE, starts painting in 1976. He's 14. Born and raised in Brooklyn, DAZE is actually closer to the Bronx scene, because of his cousin NAK, who lives two blocks away from CRASH. He chose the name DAZE because, at the time, nobody else had a "Z" or an "E" in their name, both letters being hard to style. That same year, he attends the High School of Art and Design where he meets a lot of new people. He spends most of his time with the writers from 149th Street. In his own words: *"Before that I had always seen pieces on trains. Just like everybody else how people did it and where did it come from, but it wasn't until I got into Art and Design that I really came into contact with people that were actually painting."*

In the very beginning, around 1976 and 1977, he is inspired by the likes of BLADE, TRACY, LEE and FABULOUS FIVE, THE DEATH SQUAD, TMT, NOC 167. The ones that fascinate him the most are those whose style is well asserted. Meeting writers such as DON ONE and CHINO MALO is instrumental in encouraging him to stear away from the classes and books and to express himself in the street: *"All this book shit is for toys. You gotta get your name out there. Around that time I met 2MAD. He was a guy that got good really fast and he was also the kind of guy that was about action. He didn't just talk about what he was gonna do, he did it."*

The observation of people like PHASE2 and RIFF 170, the true innovators in regards to style, and this as early as the beginning of the 70s, inspires DAZE. Like CHAIN 3 and NOC 167, DAZE is aiming high, looking to be a specific type of writer: the kind that innovates.

Unlike many writers, DAZE never satisfied himself in belonging to one unique crew. He painted with CRASH, T KID, REPEL, MITCH 77, ZEPHYR, COPE 2, DEZ, SKEME, DONDI, REPEL et CAZ 2, prevailing in all of the New York subway system.

The "Aha!" Moment

Because of his original style and of his will to affirm himself as an artist, galleries take a swift interest in DAZE. It all starts when collector Sam Esses sets up the Studio, tired of seeing MTA erasing all the graffiti. Sam Esses puts money in a project that would allow many writers to work in a studio, to move on to canvas, and to start considering themselves as main stream artists. This initiative did a whole lot to reinforce solidarity between the writers. BLADE remembers *"That was the first place that I actually sat down and did a spray painting on canvas and concentrated on it. To me it was just sort of an experiment."*

This stepstone offers DAZE new prospects. He starts taking his time and concentrates more on his work, whether it be on trains or canvas. As a result, his art becomes more sophisticated, more detailed.

In the trail of Esses' project, FUTURA, ZEPHYR and ALI start the collective Soul Artists. DAZE spends much time with them. The media in particular are interested and the *Daily News*, The *Village Voice* publish several articles.

In 1980, CRASH curates the exhibit *Events: Graffiti Art Success* at Fashion Moda. The show then travels to the Downtown New Museum. These exhibits bring DAZE under the spotlights of the art scene, in a major way. He then has a show at Joyce Tobin et Mel Neulander's Graffiti Above Ground Gallery on West 14th Street, before opening the Fun Gallery the 51X Gallery.

Into the Art World

Dolores Neumann becomes DAZE's official art dealer. Her in-laws, all famous collectors, and other US and Europe based collectors buy most of his work. In 1983, Dolores Neumann organized an exhibit entitled "Post Graffiti" at Sydney Janis's gallery. It shows together the works of 18 Graffiti artists, from DONDI White, LEE, ZEPHYR, LADY PINK, DAZE, FUTURA 2000, to CRASH, RAMMELLZEE. Dolores then manages to have DAZE be represented by Sidney Janis' Gallery, and his connections lands him recognition on a more international scene. Art Basel welcomes him in 1984, the ARCO in Madrid shows his work in 1985, and museums open their doors.

DAZE is one of the most public graffiti artists, with more than 200 group shows. Numerous public and private collections rapidly get a hold of his works, which have been shown in many museums around the world, such as The Brooklyn Museum of Art, Brooklyn; The Dannheisser Foundation, New York; Groniger Museum, The Netherlands; Klingspor Museum, Affenbach, Germany; The Museum of the City of New York; The Museum of Modern Art, New York; The Patterson Museum, New Jersey; The Frederick R. Weisman Foundation, Los Angeles, California; etc.

His connection to the club scene is also tight and he collaborates with many DJ. *"A lot happened in a really short space of time"* as he admits. At that time Sidney Janis himself collects DAZE. Thus, in 1999 its heirs Carroll et Conrad Janis donate close to 50 DAZE pieces to Brooklyn Museum. In 2006, a selection of street art is put together during the Graffiti exhibit. Artists are Michael Tracy (TRACY 168), Melvin Samuels, Jr. (NOC 167), Sandra Fabara (LADY PINK) Chris Ellis (DAZE), and John Matos (CRASH).

Throughout his career, DAZE also was a prolific mural painter. In the 80s, he executes a number of murals across the United States, Europe (in Bâle, Florence, Lyon...). Twenty years later, he continues his mural work and creates new ones almost ever year, in Brazil, sometimes collaborating with OS GÊMEOS.

Style

DAZE defends his artistic practice and refuses to be labeled as just a graffiti artist. However his painting bears strong graffiti codes, both in the characters and the portraits. He often uses spray paint, and plays with bright color nuances and shiny effects.

The characters he paints are ambiguous, yet reassuring, amusing yet melancholic, almost disturbing. These cartoon-like figures give off certain lightness, but if you look more closely, they also carry a relative seriousness.

In time, he starts giving his canvas works more subtle and personal titles: *Blue Dream; Comfort Level; The Family Tree; This Ass Saved My Life; The pursuit of happiness.*

Sharing his studio with CRASH for years also pushes DAZE into more of a style of his own. While his friend CRASH masters bright colors, DAZE focuses on the contrasts created between brightness and darkness.

Next page:
From the Depth of the concrete Jungle, marker on paper, 27,5x35cm,
Henk Pijnenburg collection, **DAZE**

Dreams
&
Tomorrow...

DONDI

Date of Birth: 1961 (deceased 1998)

Place of Birth: Brooklyn

Starting Point: 1975

Influence(s): STAYHIGH 149, MICKEY, HURST, SLAVE, NOC 167

Style: Abstraction. Evanescent characters with small letters; green, blue, brown palette on white backgrounds

Distinctive Feature(s): Bomb effect expertise; stylized characters that go beyond the simple comic books figures

The Beginnings

Donald Joseph White, better known as DONDI White or, more simply, DONDI, was born April 7, 1961 in Manhattan, and raised in the East New York section of Brooklyn. His tag is actually the nickname his parents gave him as a child. He is the youngest of five children, with Italian and African-American parents. He attends a catholic school, which will impact his painting later, and shows precocious dispositions for creativity. DONDI's parents nurture their children with a strong sense of family values, respect and good manners.

His family moves six blocks away when he's nine and DONDI's brother recalls seeing him tag for the first time in that new neighbourhood. The boy also keeps himself busy with solitary passions such as his pigeons that keep him on his parents' house roof and out of the streets. But the Whites are worried by the rise of gang and drug activity, and decide to move again, in 1976, to a new house located near the three major New York train yards. This new location marks the acceleration of DONDI's graffiti activity. He starts under the names of NACO and DONDI, refining his style from simple tags to much more elaborate wall pieces.

In 1977, he joins The Odd Partners (TOP), before starting, in 1978, the Crazy Inside Artists (CIA). He's painting trains, and quickly becomes one of the

city's most famous writers. Among his aliases, he uses BUS 129, MR. WHITE, PRE, POSE, ROLL, 2 MANY and ASIA. His best known work as a graffiti writer is "Children of the Grave Parts 1, 2 and 3", that comprises three whole cars in the years 1978-1980. He's also of the first to break graffiti's reigning law of anonymity, painting a giant DONDI across his own rooftop.

His graduation in 1980 is a simple formality, and he takes a mindless government office job. The family house basement is then turned in an artistic testing ground where he's able, from that moment, to focus on the very detailed preparation of his graffiti pieces. DONDI clearly integrated the art process in his activity from the very beginning.

The "Aha!" Moment

In 1980, painting trains turns into a difficult endeavor, if only because of their systematic clean up, but also because their access has become more dangerous than ever. DONDI keeps working on canvas and seeing his friend Martha Cooper, who has been documenting his work methodically, taking photos of all his murals, including *Children of the Grave Part 3*, which will later be published in the legendary *Subway Art*.

During the Summer of 1980, and encouraged by his friend KEL 139, DONDI is a part of collector Sam Esses' Studio project. Heartbroken by MTA's stubbornness to erase all graffiti from its network of trains, Esses has financed a project to allow a number of writers to work in a studio, to transition to canvas and to gain artist status. For DONDI, the experiment is a success, inspiring a new artistic orientation to his career. Between 1980 and 1981, he paints some of his most beautiful work on trains, in addition to producing a great number of canvas pieces. Thanks to his collaboration with The Soul Artists, he takes his first steps in the art scene, with a few collective exhibits in the East Village and at the Fun Gallery, which will present his solo show in 1982. That same year, he's in the movie *Wild Style*, and is hired as a consultant for the television film *Dreams Don't Die* before participating in the European *New York City Rap Tour*.

During those years, he spends time in the downtown club scene, hanging out at The Roxy, Negril, and Danceteria, the first clubs to introduce Hip Hop to the downtowners, and even designs Malcolm McClaren's Hip Hop record sleeve.

Into the Art World

While New York's MTA is busy treating graffiti writers like criminals, California and the rest of the world can't get enough of them. In 1982, the University of California in Santa Cruz invites DONDI along with FUTURA et ZEPHYR, presenting 25 pieces all born at the Esses

Studio. Three months later, he goes to Hong Kong to paint a 10,000 square feet wall in a nightclub before traveling to Europe for the first time. The New York City Rap Tour includes breakdancers, rappers and graffiti writers performing together. The two-week tour features Afrika Bambaataa, RAMMELLZEE, the Rock Steady Crew, Grandmixer D.ST, the Double Dutch Girls, PHASE 2, FAB 5 FREDDY, FUTURA and WHITE.

As of 1983, DONDI's work is shown regularly in Europe. Yaki Kornblit, the collector and art-dealer, offers him his first European solo show, which turns into a major commercial success. DONDI is part of the Boymans-Van Beuningen Museum "Graffiti" exhibit in Rotterdam, before it travels to three other museums. By then, DONDI is 22 years old, and has seven solo shows behind him. His work enters several permanent museum collections. DONDI recollects: *"Moving into the gallery, I had a whole other audience I had to communicate with which was good, because it made my work evolve."*

In 1984, exhausted by too much travel, Dondi White slows down a little and goes into semi-retirement, working more quietly. He experiments with collages, mixing crayon and Indian ink. What results from that period is a series of technically elaborate works, each requiring several months of labor.

In 1986, commissioned by the Art Train project, he recreates his mythical Children of the Grave mural. All in all, twelve graffiti artists are invited to paint an Amtrak train. In 1991 he is one of the numerous artist exibiting in the historical graffiti show at the Palais de Chaillot in Paris and is granted the cover of the catalogue.

In 1992, DONDI decides he needs what he defines as a more settled life, takes on a part-time job in a clothing store, and spends time with his girlfriend. Meanwhile, the Groninger Museum (Netherlands) puts together a retrospective of his work and the Rempire gallery in Soho continues to represent him, through its exhibit entitled *The Legacy*.

In 1995, he's part of Fifteen Years Aboveground, a show curated by CRASH. But in 1998, after years of illness, he dies from AIDS. In 2003, the DONDI White Foundation is created, as a way to support a number of actions against AIDS.

Style

Throughout his paintings, DONDI proved his ability to create innovative color ranges and color masses. His process became, with time, increasingly complex. For each given piece, DONDI fills numerous sketchbooks with preparatory studies, which demonstrate acute experimentations around lettering. His letters are often defined as "acrobatic", or "aerodynamic" even.

DONDI could spend months on a piece. His symbolic characters, usually reduced to broken silhouette parts, bear a strong connection with STAY HIGH 149's influential icons and strokes. He often choose one chromatic range over the others, declining different elements on the canvas in order to juxtapose, blend, until they became abstract. His style is also remarkable for the scarceness of its contours, unlike classical graffiti. DONDI leaves aside the classical black outline so common in style writing and graffiti and lets his figures loose. Abstraction, expertise in bomb effects and stylized, rather than comic based characters, are DONDI's distinct marks of fabric.

In regards to his work, DONDI often referred to classical painting and to Leonardo da Vinci more specifically. But more generally, the battle against obscurantism is at the heart of his works. He also includes elements from his childhood, such as his tricycle, or religious references encountered though through school, such as Anno Domini, in reference to Anno Domini Nostri Jesu Christi, about the birth year of Jesus Christ.

DONDI also mixed techniques, from enamel paint to crayon, via Indian ink, even sometimes integrating subway blueprints inside his pieces, turning each of his works into an intricate detailed spectacle.

Next double page:
Painting on canvas, P. Lerouge collection, *DONDI White*

Frozen Fire....

Previous double page:
Frozen Fire, spray paint on canvas, 137x180cm, 1983, Henk
Pijnenburg collection, **DONDI White**

This page:
Pre Altered States, spray paint on canvas, 180x185cm, 1984,
Henk Pijnenburg collection, **DONDI White**

The Beginnings

Andrew Witten, aka ZEPHYR, chose his tag name based on that of a skateboard. He starts tagging in 1975, but doesn't sign ZEPHYR in the New York subway before 1977. Though considered a latecomer in comparison with graffiti's founding fathers, he remains an important actor of the scene, and a proud defender of its codes. In 1980, he meets DONDI and they become friends. And like many other graffiti artists, he gets to travel and paint a few European trains, among which German trains, in Dusseldorf, as early as 1982.

ZEPHYR

Date of Birth: 1961

Place of Birth: New York City

Starting Point: 1975

Style: Gothic-like effects; chrome reflections

Distinctive Feature(s): Integration of tattoo symbolism

The "Aha!" Moment

In February 1980, Johnathan Dobkin publishes *Talking With Zephyr*, an article in the *Brooklyn Paper*, which draws some public attention. Soon enough, everyone is talking about ZEPHYR, from *Art Forum* to the *Village Voice*. He appears in a number of movies on graffiti, such as *Wild Style*, *Style Wars* and *Kings of Broadway*, and is cited as a key-figure in graffiti in nearly sixty articles during the 80s, including eighteen in 1984 alone.

Into the Art World

Style

In the early stages of his canvas work, ZEPHYR paints the same way he used to paint walls or trains. But the possibilities quickly dawn on him: *"Canvas allowed for stranger things"*.

ZEPHYR starts presenting his canvas works at the beginning of the 80s, in the East Village and at Fashion Moda. He is of course part of PS1's *New York/New Wave* show, and is one of the artists featured at the Fun Gallery, amongst legends such as Keith Haring, Jean-Michel Basquiat and Kenny Scharf. During five years, he collaborates with a gallery in the Netherlands, and slowly begins showing his canvas pieces all over Europe. At the end of 1983, he is part of the Museum Boymans-van Beuningen Graffiti exhibit in Rotterdam, which then travels to the Groninger Museum (the same museum that, later, integrates his work in its permanent collection).

In 1995, recognizing his contribution to the 80s graffiti scene, as well as his activism, the *New York Times* designates ZEPHYR *"The elder-statesman of graffiti"*. In 2001, he writes *Style Master General*, the biography of his friend and graffiti legend DONDI, who died from AIDS in 1998. Today, true to himself, he continues to spread the Graffiti doctrine around the world.

ZEPHYR's style is characterized by his strong graffiti culture and influence. His work show utmost respect for the codes and traditions, even if he also does integrates new references, found in the tattoo culture, for example: snakes, gothic letters…

His pieces could be considered a constant homage to his subjects' visual potency, with snakes coming out of the canvas, motorcycles riding off the frame, in addition to chrome effects on his lettering.

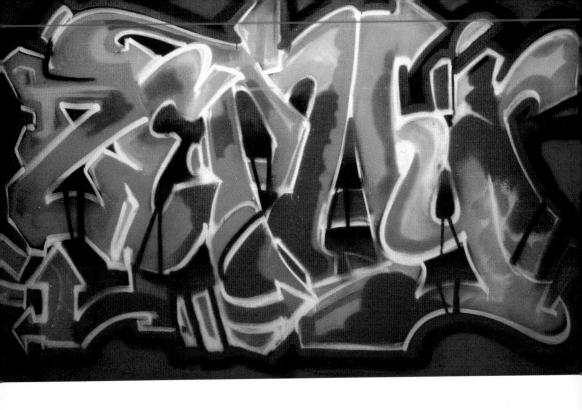

Left page:
Diabolical Dice Up, spray paint on canvas, 150x235cm, 1983,
Henk Pijnenburg collection, **Zephyr**

Right page:
Venom, spray paint and marker on metal, 240x240cm, 1981,
Henk Pijnenburg collection, **Zephyr**

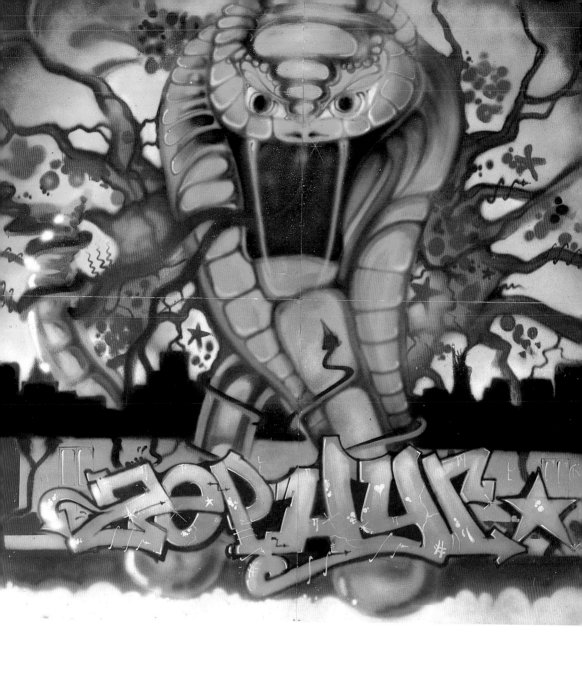

NOC 167

Date of Birth: 1961

Place of Birth: Bronx

Starting Point: 1972

Influence(s): Death Squad, OTB

Style: Wild Style, 3D, futuriste

Distinctive Feature(s): Intricated

The Beginnings

Melvin Samuel Jr aka NOC 167 was born in the Bronx. By the time he turns 11, he loves comic books, and keeps busy painting in the street, following the trail of his older brother. He then attends John F. Kennedy High School on 225th Street, in the North Bronx, before joining the infamous Death Squad and, later, becoming its leader. He also is a member of OTB (Out To Bomb), specialized in trains.

In the street, NOC 167 quickly stands out as one of the inventors of the Wild Style, consisting of 3D letters that almost seem to be moving, steering away from the Bubble Letters, typical of the 70s. His influence on all the future generations of writers is unparalleled. NOC 167 will eventually choose his own street title, Prince of Graffiti, as a response to the important number of Kings already in place.

At the beginning of the 80s, he even attends the Parsons School of Visual Arts, within an art class program reserved to the most talented students. There, he learns the fundamentals in animation. But soon enough, realizing none of his teachers will recognize graffiti as an art form, he gives up the program in order to go back to the street, and learn.

The "Aha!" Moment

In June of 1980, he is part of the Times Square Show, in a space that used to be a massage parlor, with more than 100 artists, writers, feminist activists, Xerox artists, performance artists, etc. Among them are Kenny Scharf, Kiki Smith and Keith Haring. All mention NOC 167 as one of their major influences.

With his writer friends, he then participates in most of the early exhibits, including, of course, those of the Fashion Moda gallery.

Considered a style boss, NOC 167 achieves major recognition in 1982, when he creates the opening credits for the cult movie *Wild Style*.

Into the Art World

The 80s are clearly a time of success for NOC 167. His work is shown worldwide, in Italy, in France and in the Netherlands at the Boymans-van Beuningen Museum of Rotterdam in 1983, and again in 1984, at the Groninger Museum for the exhibition "Graffiti". Sidney Janis also shows his pieces, along with works by DAZE, before presenting him during the Art Basel Fair, in Switzerland.

But his success is short-lived. Partly due to the City of New York's very strong repression against Graffiti artists, NOC 167 quits slowly, but surely, painting trains. In 1984, he completes his last subway car.

Deeply affected by psychological problems, and after several stays in psychiatric hospitals, he becomes homeless in 1986, sharing his time between the streets and city shelters before getting heavily into drugs. In October 1990, *Style Wars*, his most famous subway car (generally considered the most beautiful train ever painted), is reproduced and shown next to works by Picasso and Warhol during the *High and Low: Modern Art and Popular Culture* exhibit at the MoMa and, later, at the Art Institute of Chicago and at the MOCA, in 1991. Despite all that, NOC 167 falls into oblivion.

Fate works mysterious ways, though, and more than ten years later, NOC 167 reaches the end of the tunnel. By then, most writers are convinced of his death, and murals are even painted "in memoriam" of his talent. But in 1994, while conducting an art workshop in a homeless shelter, artist Andrew Castrucci recognizes him, and immediately contacts DAZE and LEE. After the initial shock, they set up a reunion.

Melvin Samuel is as creative as ever, hungry for new artistic experiences. Little by little, he starts showing his work again, during outdoors projects or in the con-

text of major exhibitions, such as summer 1998's *Urban Encounters* at the New Museum. In 1999 he participates in the *Graffiti* exhibition at the Brooklyn Museum. The exhibition presents twenty large canvas paintings from the Sidney Janis collection given to the Museum after his death. Among the artists featured are TRACY 168, CRASH, LADY PINK, DAZE, NOC 167.

pretty good speed-motion-movie idea of his works, movies being another one of NOC 167's major, and recognized, influences. NOC 167's "almost in motion" 3D style will be named Wild Style, making him the inventor of a key element within the history of Graffiti.

Style

In his early graffiti period, NOC 167 is still heavily influenced by comics and by video games (at the peak of the Pac Man cycle). He paints on numerous walls and trains, but his work is also all over the Bronx Graffiti Roller Disco. Even before the beginning of the Hip Hop movement, he recognizes disco culture's influence on his work by including mechanical beats combined with afrocentric and psychedelic designs.

His palette consists mainly of primary colors inspired by comics and by the Times Square neons which he's particularly fond of. His strokes are all about rhythm and ruptures, reflecting the music of his time, filled with experiments and beats.

The use of arrows, exploding letters, razor-sharp angles, twisted perspectives, strongly characterize NOC 167's style. Add to that massive amounts of clouds taking off on the horizon, and you get a

Sketch, courtesy Alan Ket,
NOC 167

The Beginnings

Jeffrey "Doze" Green was born in the Manhattan Upper West Side's ghetto, in 1964. As far back as he can remember, drawing has been part of his life. *"I have always drawn painted or created some shit, ever since I was a wee lil ghetto bastard. My mother and Granny would set me up with newspaper, crayons, poster paint, shoe polish and I'd chill all day while they did their chores or whatever. They always promoted free expression, imaginary and not so imaginary friends to play with. I was always in some kind of museum eating lunch or just glaring at the endless boring cavernous rooms of 19th century contemporary shit. It taught me a lot"*. Needless to say that it didn't take long for him to express himself on street walls. In 1974, he starts tagging the city. By 1976, he's painting his first trains. And in 1977, he joins the break-dancing pioneers' Rock Steady Crew, with whom he starts performing in art gallery exhibits, in Soho and the Lower East Side, while attending the High School of Art and Design (also known to have nurtured other Graffiti artists like LADY PINK, DAZE, SEEN, MARE 139, etc.)

DOZE GREEN

Date of Birth: 1964

Place of Birth: Washington Heights, New York

Starting Point: 1974

Influence(s): Dondi White, PHASE2, LEE, RAMMELLZEE, H.P. Lovecraft

Style: Symbolism mixed with Pop references

Distinctive Feature(s): Performance; geometrical shapes and coded language

The "Aha!" Moment

In 1982, DOZE GREEN's career takes off. *"It all started in the early 80s with the Fun gallery, 51x gallery and P.S.1 shows. I had been discovered as a Graffiti artist through the many performances that we did in Soho and the Lower East Side gallery scene. Patti Astor gave me my first show. It snowballed until the mid eighties."* He's also still dancing, and therefore gains major recognition both as a writer, and as a dancer: *"After appearances in major movies such as 'Flashdance', 'Style Wars', and 'Wildstyle', the Rock Steady Crew was launched into action and the limelight."*

Into the Art World

Graffiti repression puts a grinding halt to his self-expression. *"The dark years ensued after that. I basically went to the lab on a 10 year hermetically sealed reality search, studying magic mush filled with encounters of the fifth kind. It was around 1996 that I decided to showcase my newly discovered terrain. It'd been a groovy sit-in freak-out to say the least."* Back in the spotlight, he's part of a large number of exhibits, with works mixing Wildstyle and his metaphysical interests, and putting some of his energy into live painting, which he considers his *"biggest and most fun challenge: there's a communion between the audience, the DJ and myself. The DJ is feeding off the music, and if the crowd is hype, he goes that extra mile. The same applies to me."*

Style

DOZE GREEN's quest is comparable to those of an artist like RAMMELZEE, blending Graffiti roots with other art theories. His pieces find grounds to grow upon based on important research and studies. *"H.P. Lovecraft was an inspiration, as one of the people with theories about time and space. In his work, he's looking "to touch on darkness and shadows and refracted light and spirits more than usual."*

Characters in his paintings come as fragmented ornaments. The artist sees them as metaphors to his own life experiences, *"windows to the soul."*

DOZE GREEN uses a number of symbols in his art, studying ancient symbols and pop symbols and merging them together to create his own version of a language. *"I started working with the pentacle of my crew, the five star, which represented so many things. It has the five original members, then there's a sub-star that shoots down, for the new generation, which was us. I used the original TC5 from the early 70s. A six-pointed star represented male power. The eight-pointed star stood for the goddess Isis. At this point I'm always developing new symbols, but I'm merging them. Obviously, in sacred geometry, shapes are very important because they translate to numbers, which translate to parts of the body. I integrate a certain belief system based on alchemy and the occult."*

LADY PINK

Date of Birth: 1964

Place of Birth: Equador based in Queens

Starting Point: 1979

Influence(s): TPA, TC5

Style: Colorful and feminine murals

Distinctive Feature(s): The most important female Graffiti artist

The Beginnings

Sandra Fabara (aka LADY PINK) was born in Ambato, Ecuador, in 1964, before being raised in Queens. Her career starts as early as 1979, while attending Manhattan's High School of Art and Design on Second Avenue, between 56th and 57th Streets (the school which has seen, among its students, creators like fashion designers Calvin Klein and Marc Jacobs, fashion photographer Steven Meisel as well as Graffiti artist Chris "Daze" Ellis. She starts writing when her boyfriend is deported to Porto Rico. Young Sandra exorcises her pain by tagging his name throughout the city. But Sandra, who paints wearing her teenage heels, has a strong personality and soon enough realizes that *"it didn't make me stand out. The idea in Graffiti is to get fame. The more you do, the more you get noticed, and if it isn't exactly by skills, it's by doing some crazy, outrageous thing or just being like the only girl out of 10,000 guys"*.

She adopts LADY PINK as her alias, in homage to her taste for Victorian romances. She joins crews like TPA and the TC5, at a time when very few women are making graffiti. And while her chosen name is a way to assert her femininity, she's quickly recognized for her skills. Still, Graffiti is mainly a male world, and getting respect is another story.

The "Aha!" Moment

In October, 1980, LADY PINK is part of Fashion Moda's first Graffiti exhibition. *Graffiti Art Success for America* is a group show curated by CRASH. It features CRASH's own work, as well as DISCO 107.5, FAB FIVE FREDDIE, FUTURA, JOHN FEKNER, KEL 139TH, LADY PINK, LEE, MITCH 77, NAC 143, NOC 167, STAN 153 and ZEPHYR.

She still has two years of school ahead of her, but in 1982 she lands one of the main parts in the cult movie *Wild Style,* along with Graffiti artist LEE. The film is inspired by her personal life, adapting for the screen her intense relationship with LEE. She convinces him, with some difficulty, to participate in the project.

The movie presents them as the king and queen of Graffiti, telling the story of a Graffiti writer named Zoro (played by LEE), and of his road to fame, alongside his love story with his queen LADY PINK. Zoro leaves the Bronx subway halls for Manhattan's art galleries and spotlights. *Wild Style* is half-film, half-documentary, with non-professional actors known in the Hip Hop movement as writers or DJs... In 1982, Rap music has not come forward yet, and the movie explores a culture that, while in the making, has clearly emerged, introducing it to the whole world. In addition to shedding some light on the Hip Hop movement, the movie also depicts its relation to art. Zoro is conflicted when Pink joins a group that tries to make a living from Graffiti, while he's agreed to sell his work in a gallery. The debate between vandalism and art is unleashed.

Following her role in the movie, LADY PINK, still in her teens, gains major recognition. Her work is shown is numerous art places, and the trendy New York scene loves her.

Into the Art World

LADY PINK is attracted from the start to the street excitement and the illegal aspect of the Movement. But soon enough, she blooms under the spotlights, as she still remembers vividly. *"At sixteen, I started exhibiting in galleries and running in the crowd of older, more respected Graffiti writers like DONDI. With Keith Haring, Basquiat, Andy Warhol - in those kinds of circles."*

In 1984, she's featured in Martha Cooper and Henry Chalfant's mythical book, *Subway Art.* She also collaborates with Jenny Holzer. Yet, in 1985, she stops painting in the New York subway to focus on murals she gets paid for, as well as on her canvas works. This is also the year of her first solo show, at the Moore College of Art. From there, exhibitions add up. Her work is shown at the Contemporary Arts Museum in Houston, at the New Museum of Contemporary Art, at the Kunsthalle Darmstadt in Germa-

ny, at the Hillwood Art Museum, at the Brooklyn Museum of Art, at the Phoenix Art Museum, etc.

Today, LADY PINK continues to show her work, and manages her mural painting company with her husband and Graffiti artist Smith, in addition to spending an important part of her time with underprivileged communities. The Whitney Museum, the Metropolitan Museum in New York, the Brooklyn Museum and the Groningen Museum in the Netherlands have acquired her artwork for their collections.

Style

LADY PINK is first and foremost a mural adept. What sets her apart from other Graffiti artists is, among others elements, the use of feminine, if not downright feminist topics, as well as political issues. Her work is a medium for what she stands for.

The colors she uses on walls are often pink-based, or at the very least very colorful. Her letterings are usually abstract, integrating mixed and complex shapes. On canvas, her visual language, as well as the colors she tends to use, become darker.

LADY PINK often refers to the feminine figure in her works: *"When I first started, and through the 70s, women were still trying to prove that they could do everything guys could do. The feminist movement was growing very strong and as a teenager I think it affected me, even though I didn't realize it, really. Unconsciously, I was a young feminist. The more guys said "you can't do that", the more I had to prove them wrong."*

In her recent works, LADY PINK finds personal influences in architecture (her father was an architect), painting characters made of bricks, in reference to the original walls. Her stunning construction can be seen as buildings from an imaginary city, in which she includes a lot of details and references to her own life and to the street culture, from tagged trains to famous places.

Queen Matilda, 2008, 160x110cm, acrylic on canvas, artist's collection, **LADY PINK**

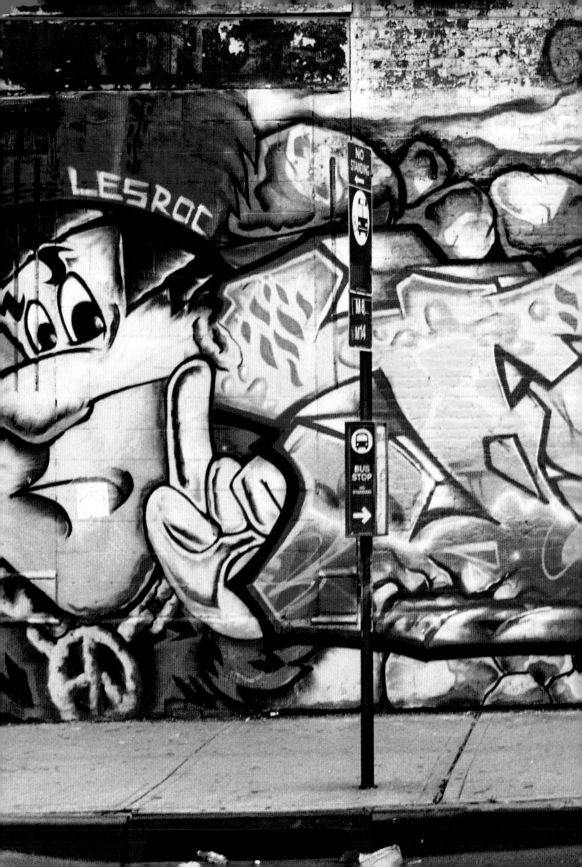

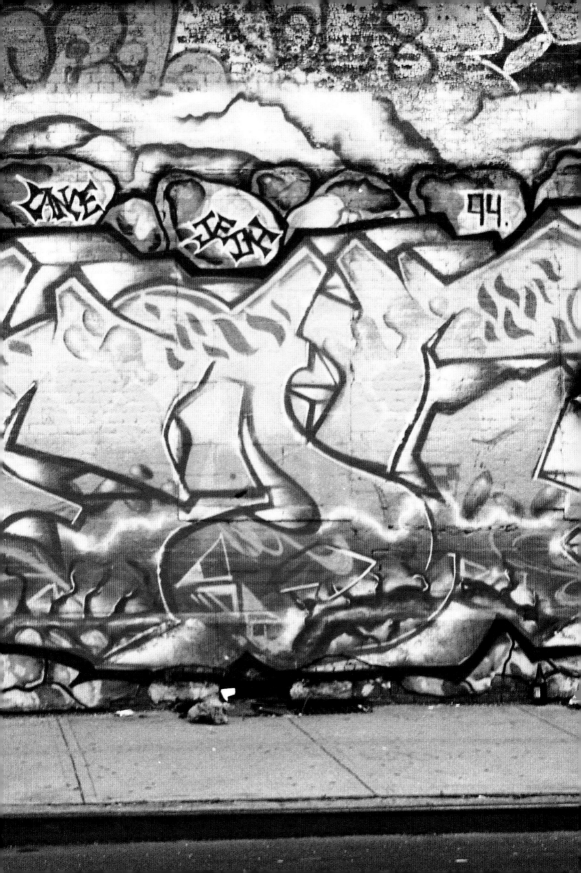

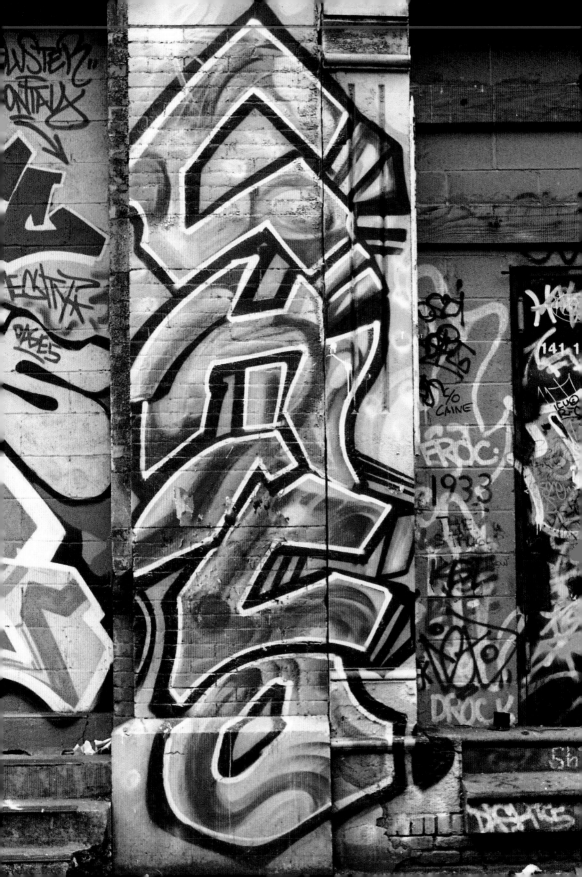

Previous double page:
Graffiti in New York City, courtesy sb@ny

Left page:
Graffiti in New York City, courtesy sb@ny

Right page:
B-Boy by Jay, courtesy of the artist

Next double page:
Graffiti in New York City, courtesy sb@ny

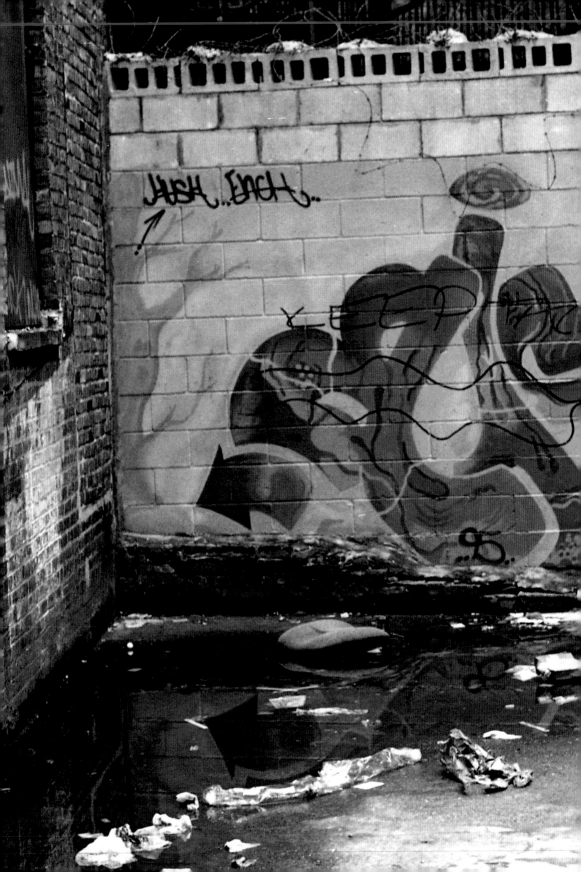

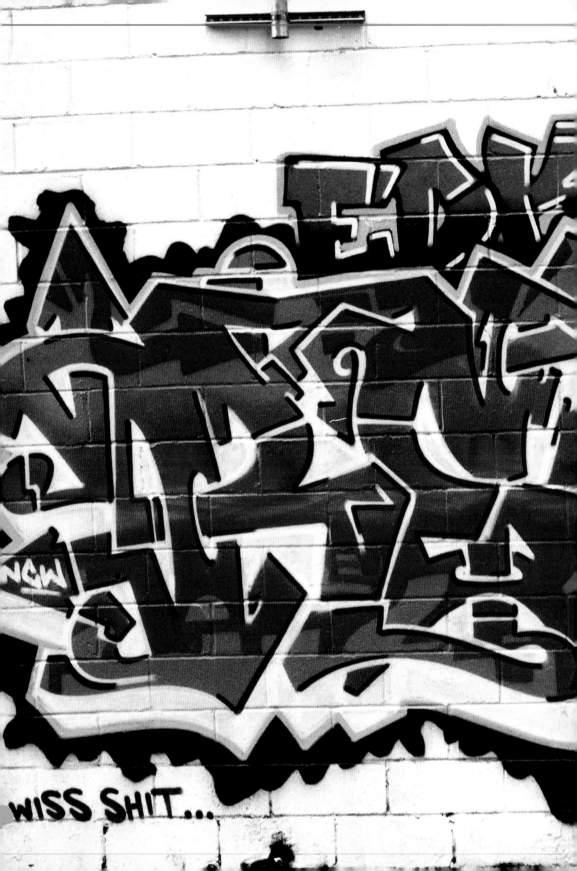

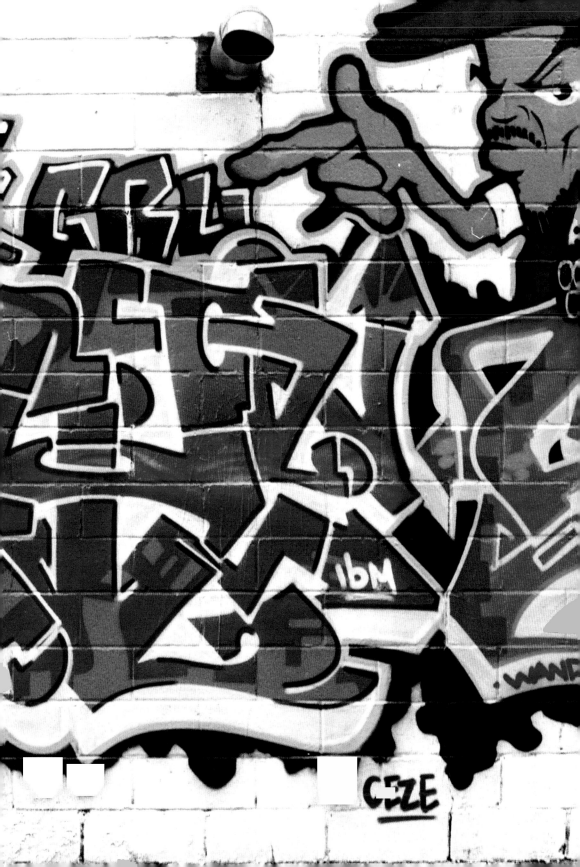

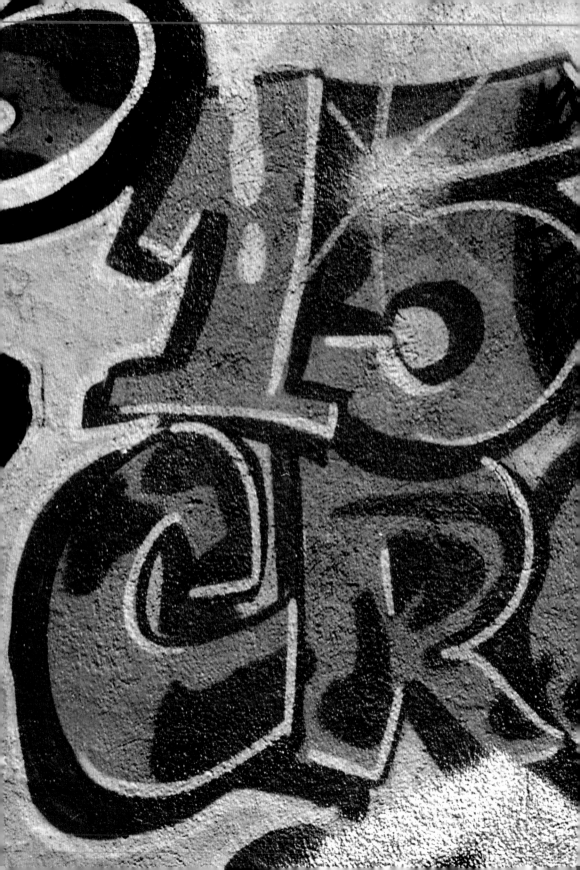

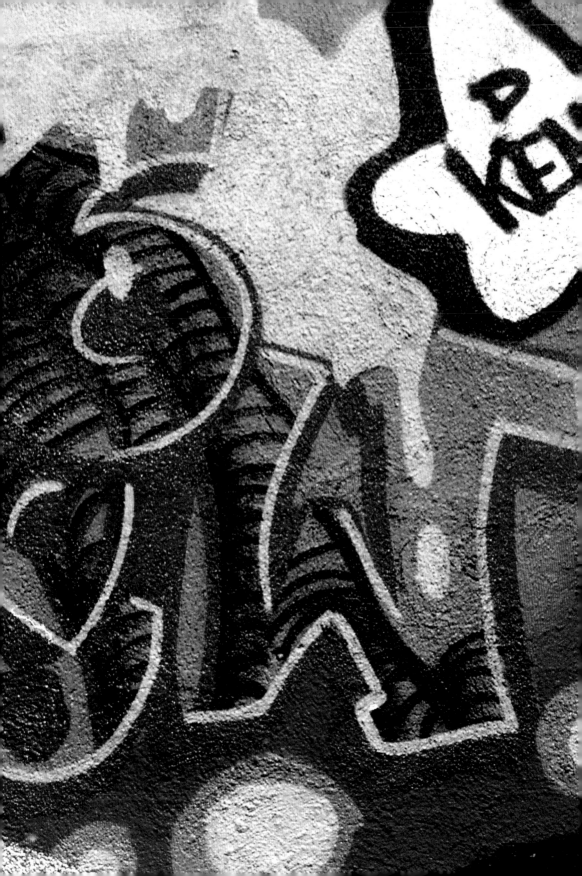

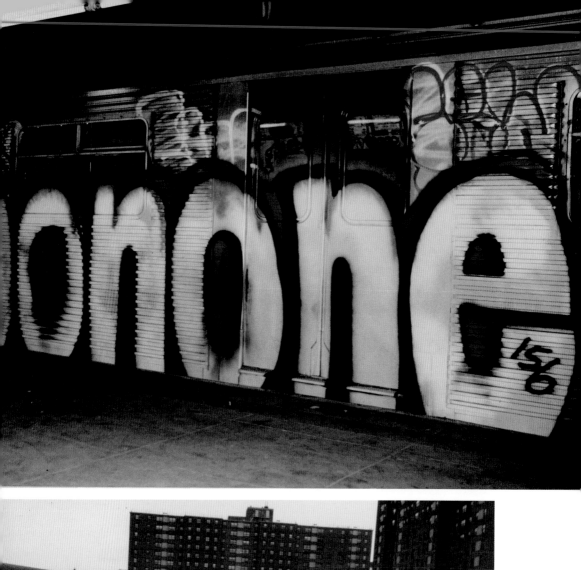

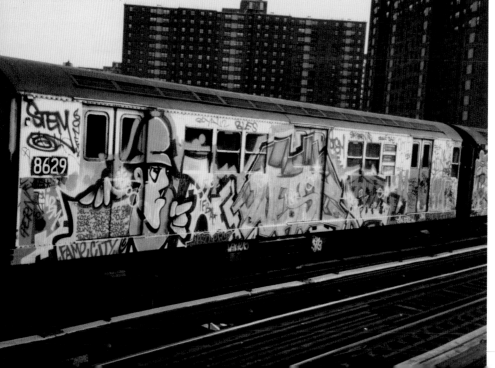

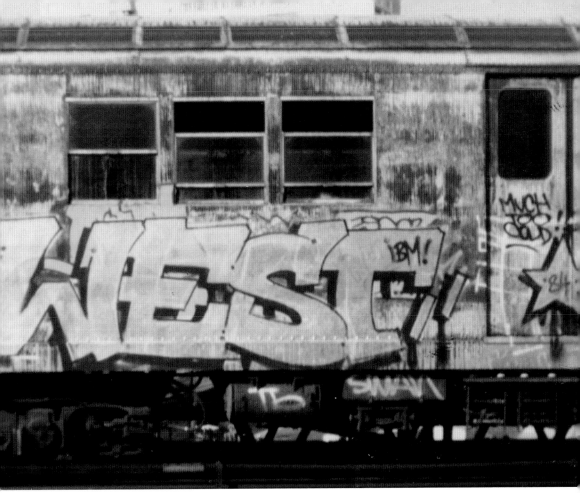

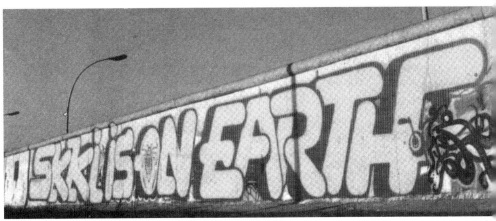

From left to righ, top to bottom:
Train, courtesy of the artist, *JonOne*
Train, courtesy of the artist, *West*
Train, 1984, courtesy of the artist, *West*
Mural in Berlin, 1988, courtesy of the artist, *Skki*

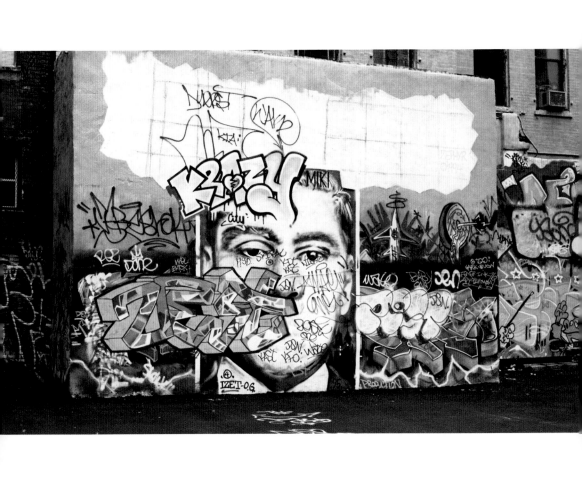

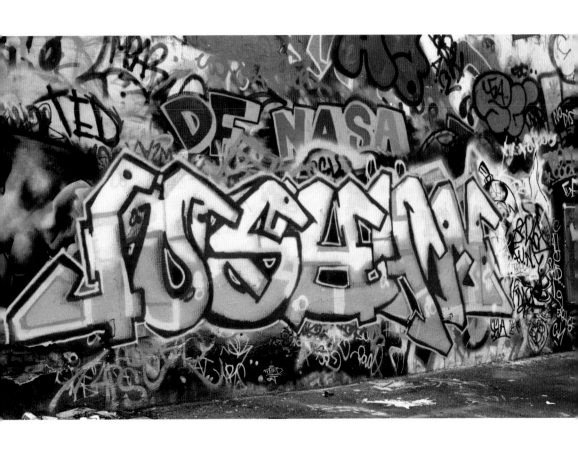

Walls in New York City, courtesy sb@ny

PART 2

The Rise of a worldwide Art Form

> *"Graffiti were the most beautiful things I ever saw. The kids who were doing it were very young and from the streets, but they had this incredible mastery of drawing which totally blew me away. I mean, just the technique of drawing with spray paint is amazing, because it's incredibly difficult to do. And the fluidity of line, and the scale, and always the hard-edged black line that tied the drawings together! It was the line I had been obsessed with since childhood!"*
> **Keith Haring**

In the late 70s explosion, New Yorkers witness the explosion of Graffiti are set. The foundations are set. The first Graffiti artists have left their marks and their style legacy. And so, as early as 1979, a new generation is born, bearing just as much passion, vigor and stubborn energy as its predecessor. However, it is the beginning of a new era. New styles are about to appear.

Crews such as TDS, TMT, UA, MAFIA, TS5, CIA, RTW, TMB, TFP, TC5 and TF5 are going wild. A new style war is raging, with what will be the last fierce competition before the MTA clamps down by systematically erasing all painted trains. On the Broadway subway line, juniors like KOOL 131, PADRE, NOC 167 find their place among writers with confirmed styles, like PHASE 2. Others distinguish themselves: KEL 139, COMET, REVOLT, ZEPHYR, CRASH, DAZE, LEE, DONDI, BLADE, COMET; SEEN, MAD, PJ and DUST. The latter rule over line 6, for example, with their complex and esthetic creations on whole cars.

> *"Going to the yards was like visiting silent whales. This was the feeling we got at night. It became our ritual. Just looking at that thing, a black silhouette just sitting there with blinking red lights sticking out. It's alive. In actuality we brought life to these steel boxes that carried the sheep to work everyday."* **LEE**

The Show Frenzy

"It's tricky to call graffiti 'art' because it was born to operate outside the system." **FUTURA 2000**

(1980)

In the very early 80s, everything changes. Time starts shrinking dangerously. With MTA's aggressive cleaning squads, pieces get little circulation time, forcing writers to leave the subway platforms and to start seeking horizons that might show more respect for their creativity. What they're looking for is a way to leave an actual imprint on their time, and in order to achieve that, they need for their work to stay up somewhat longer. And since galleries have started acknowledging street artists, street artists start paying some attention to galleries. In 1979, LEE QUINONES and FAB 5 FREDDIE are shown at Claudio Bruni's, in Rome. For people outside of New York, this is their first encounter with Graffiti. And in 1980, places with an open mind, such as the Esses Studio, Stephan Eins' Fashion Moda gallery and Patti Astor's Fun Gallery, open their doors to Style Writing and Graffiti. Those same initial galleries will, later, play a major part in these artists' career developments abroad.

The Esses Studio: Collector Sam Esses was broken-hearted when MTA initiated, in 1978, its systematic destruction of all train graffiti. He decided to finance an artist studio project that would allow many writers to work in peace, hence making it possible to switch from the street to the canvas, hence owning up to their visual artist status. This initiative contributed greatly to reinforce solidarity between writers. BLADE still recalls: *"That was the first place that I actually sat down and did a spray painting on canvas and concentrated on it. To me it was just sort of an experiment."*

Fashion Moda: Stephan Eins opened his art space in 1979 in South Bronx. Fashion Moda's initial goal was to grow as *"a collection of science, invention, technology, art and fantasy"*, rather than a simple exhibition gallery. In time, Fashion Moda became known as one of the places that remained the closest to the Downtown Art world scene. A great variety of talents, such as Jenny Holzer, Kiki Smith or Louise Lawler, walked through Fashion Moda, but the ones we mostly remember today are the famous graffiti artists who took their first steps there: John Fekner, Jean-Michel Basquiat, and Keith Haring. CRASH and DAZE were the first to discover the hip location. Stefan Eins pursued Fashion Moda's work, with the community especially, until 1985.

Fun Gallery: Movie star Patti Astor, a night queen in her own right during the 80s, founded the Fun Gallery in 1981 with Bill Stelling. Located in Manhattan's East Village, the gallery bridged the gap between New York's contemporary Art preppy areas and graffiti from the Bronx and Brooklyn. Through the years, Fun Gallery hosted artwork by FAB 5 FREDDY, FUTURA 2000, DONDI White, KENNY SCHARF, SHARP, A-ONE, LEE QUINONES, LADY PINK, ZEPHYR, RAMMELLZEE, REVOLT, and many others. The shows had a great impact on the international scene and gave Graffiti its legitimacy in the eyes of the Art world. For many of the artists shown there, it was a first time opportunity to present a solo show. Fun Gallery also benefited from the relaxed atmosphere it offered, and the fact it never put the artists in a place where their street credibility might have been compromised. In 1983, Jeffrey Deitch, then an art advisor for Citibank, declared in *People Magazine* that Fun Gallery was *"one of the hottest galleries in the city"*. In 1985, the gallery closed.

One of the very first all Graffiti show, entitled *Graffiti Art Success for America*, is hosted by Fashion Moda in late 1980. CRASH, as its curator, invites eleven of his friends to come paint. MITCH, KEL, 139TH, DISCO 107.5, FUTURA, ALI, ZEPHYR and LADY PINK create pieces during that event, whether directly spray-canned on walls or on canvas, presented as blown-up tags, stencils or even more narrative scenes. On opening day, invited by Stephan Eins, all the neighborhood's graffiti artists get together to paint the wall of Fashion Moda's back room. This contributes to the show's massive success.

(1981)

In January 1981, the renowned *Artforum* magazine writes about Fashion Moda, describing its genesis and expansion in English, Chinese, Spanish and Russian. One month later, an article in the *Arts and Leisure* section of the *Sunday New York Times*, entitled *The New Collectives-Reaching for a Wider Audience* also mentions Fashion Moda. The art space quickly enough becomes the East Village's main scene, and is linked to the New Wave Punk Art trend.

In February 1981, art critic and curator Diego Cortez brings his new project to PS1. The show, entitled *New York/New Wave*, includes the paintings of a young unknown artist by the name of Jean-Michel Basquiat. The publication of a very complete catalog draws the art critic world's attention. The exhibit gives birth to somewhat of a polemic. *Village Voice* art critic Peter Schjeldahl finds it sad that in lieu of *"something fervid, volcanic"*, he only finds in the show *"participatory narcissism"*. Detractors condemn what they see as recuperation by the fashion industry. Despite all this and more, the Movement's

vital forces are stronger than ever. While downtowners wave the air around Graffiti, Eins pursues his work on a local level, in the Bronx, defending the right for communities to access culture. Thanks to long-term projects he has implemented in the heart of the South Bronx community artists visit schools and generate awareness for art among the students.

In April 1981, FAB 5 FREDDY is so excited by his participation in Fashion Moda's exhibit that he organizes his own show, at the Mudd Club. *Beyond Words* also introduces the work of an American musician pioneer, inventor of Hip Hop and Zulu culture Afrika Bambaataa.

(—1982)

In June 1982, Fashion Moda makes such an incredible name for itself that artists in connection with the space are invited to the Dokumenta 7 in Kassel, Germany, curated by Rudi Fuchs and considered one of the world's most prestigious contemporary art events in the world. For the occasion, Fashion Moda is faithfully rebuilt, store-like, and visitors can find prints and t-shirts by artists like Holzer, Haring, Fekner, Wells, Rupp, Kenny Sharf, Mike Glier, Tom Otterness, Kiki Smith, Louise Lawler. In addition, anyone can walk in and enjoy the video lounge showing various video works (also on sale) by Charlie Ahearn, Jane Dickson, Dieter Froese, Joseph Nechvatal and Glenn O'Brien. Art critic Benjamin Buchloh refers to this project as "one of the few courageous curatorial choices".

> Between 1980 and 1989, BLADE, DAZE, CRASH and FUTURA are featured in nearly 170 expositions across the world. In addition to Fun Gallery, New York galleries such as the Sidney Janis Gallery and the Tony Shafrazi Gallery regularly curate Graffiti shows. Bronx' Fashion Moda relentlessly shows numerous graffiti artists among other talents of its time, such as Jenny Holzer or, worth mentioning, Sophie Calle. Calle's first solo show in 1980 is the very same show for which she will receive, in 2007, the Prize for the Venice Biennale.

The *Beyond Words* show leads the way for the *New York City Rap Tour* in 1983, which will even reach London and Paris, and bring together on stage both FAB 5 FREDDY et FUTURA 2000. Hollywood's antennas are shaking to the phenomenon's beats, and PHASE 2 is hired as a consultant on the movie *Beat Street*, which is released in 1984.

(1983)

In December 1983, the Sidney Janis Gallery holds its *Post-Graffiti* exhibit. The show includes artists like Keith Haring, Jean-Michel Basquiat, CRASH, and LADY PINK and presents a good number of first-timers on 57th Street. Critics soar, among which Grace Glueck in the *New York Times*: *"Now, graffiti is not a subject to be taken lightly in New York. Most citizens - including this one - find this teenage phenomenon a scourge and an eyesore, whether it's sprayed on canvas, on public walls or on the steel sides of subway cars... Apart from its illegality, the very idea of enshrining graffiti - an art of the streets impulsive and spontaneous by nature - in the traditional, time-honored medium of canvas, is ridiculous."* As narrow as it may be, her point of view at the time opens the debate on the legitimacy of graffiti's passage from street to gallery. This is very likely, for some, the announcement of graffiti's death, which the show's title does suggest. Time will show them wrong. Yet, the real threat comes from somewhere else…

The War on Graffiti

As of the early 1980s, the Graffiti movement is indeed threatened. Its home, i.e. the street itself, sees the rise of crack, a raging epidemic in terms of usage, traffic, guns and, consequently, major insecurity issues. Another factor is the reinforcement of laws that target, directly, graffiti. One law, voted, actually forbids the sale of spray cans to underage customers. And as the legislation against Graffiti artists hardens, tensions arise. The war on Graffiti, already pretty much declared by Mayor John Lindsay in 1972, intensifies.

Philadelphia is not just graffiti's original crib, it's also the home of Philadelphia's Anti-Graffiti Network (PAGN), with a simple goal: graffiti's eradication under the assumption of its gang connection. It implements heavy measures, such as fines against offenders. Paradoxically, PAGN is also responsible for the Mural Arts Program, which has commissioned numerous works.

Meanwhile, in New York, mayor Ed Koch (in office from 1979 to 1989), preaches a "zero tolerance" line of conduct, vigorously following the "broken window theory" according to which a degraded environment, visual in this case, is a factor for added deterioration. Within such a principle, graffiti even becomes a cause for the state of certain neighborhoods. Anti-graffiti budgets increase, with the consequential appearance of "buffing" techniques, the systematic use of chemical cleaners on trains. Works that used to have a life span of several months, now disappear after a few days.

Hard-core writers respond to this massive cleaning with new techniques, in order to survive in the subway. They use "burners", homemade markers that combine different permanent inks. Long gone are the days of style war and esthetic research. By then, the one and only priority is to leave a trace.

(–1984)

In the history of Graffiti, these years are essentially those of MTA's repression, with its millions of dollars spent to that effect. From 1984 to 1989, thousands of MTA employees clean the 6 245 cars and 465 subway stations for a 52 millions dollars yearly budget. Anti-graffiti ad campaigns are launched. Security is reinforced around train depots, which are circled with barbwire and turned into inaccessible fortresses. Many writers become discouraged. In 1989, MTA officially announces its "victory" on graffiti.

Of course, certain writers don't give up. Despite having to change their habits, they accept the challenge. And if the territory issue has always been an underlying factor in graffiti, it has slowly turned into a violence issue. Writers now have to defend their location, using force if need be, in order to hold on to what has become so hard to get. Being physically fit, and belonging to a street gang, slowly but surely have become longevity factors.

The Race for Survival

(1985 - 1989)

Rather than face the increasing difficulties and the heating debates around their work's legitimacy in New York, a great number of Graffiti artists decide to flee the negative ambiance and seek brighter opportunities in cities where their work is still respected, if not downright admired. With shows across the USA, in Los Angeles, at the University Museum of Iowa City, in Washington DC, Chicago, as well as in major European cities, Graffiti spreads around the world, sharing one common spirit: freedom of expression. And around the world, the movement grows as steadily and massively as it had in New York's streets, ten years earlier.

Around the World

If New York is seen as Graffiti's home sweet home, it's because of its historical weight within the movement. The city of New York remains, today, the core center of Street Art and Graffiti on an international level. Yes, the greatest writers and historic figures of the movement still live there and yes, some of them keep its codes and flame alive. Yet, while New York remains the mainstream Art world's hub, it has somewhat failed, from an Art world's point of view, to maintain the type of vibrant and innovative excitement that could be found during the 80s. And in the last decade, other hot cities have emerged, nurturing the movement with new energies, such as San Francisco and, most notably, the City of Angels.

Los Angeles (USA)

Graffiti in Los Angeles has gone through two basic phases. The first one can be set between 1983 and 1988, before a strong expansion phase that takes place from 1989 to 1994. Graffiti shows up early in L.A., which should come as no surprise for those who are familiar with the city, known since the 30s for its murals, with its own style of "cholo markings" or "placas", born from the Mexican culture of that time. Mexican muralism and Chicano graffiti are undoubtedly the roots of the city's specificity. The public wall tradition stays strong during the 70s (before graffiti is introduced on the West Coast) during the protests that characterize this period in time. The National Chicano Moratorium, for example, hosts a massive protest by 30000 Chicanos against Vietnam War on August 29, 1970. All in all, between 1972 and 1978, eighty -two walls are painted in Los Angeles within the protest context.

Nevertheless, many writers can testify that, in 1983, Los Angeles graffiti, which isn't even called like that yet, bears a wildly different reality than that of mural painting. All the city knows of, in regards to Graffiti, is gang-related. In his book, *The history of Los Angeles graffiti*, REKAL remembers how it all started. So does TELER: *"Before '85, I only saw gang writing, but in '85, I started to notice something else which turned out to be hip-hop graffiti. And that's when we realized, you don't have to be putting up a neighbourhood, you can put yourself up! The new graffiti was about promoting yourself, while the gang graffiti was about promoting your neighbourhood. And you wanted to be up, famous and have people noticing you. A lot of guys would tag and not even put their crew, because you knew what crew they were from anyway and that was part of the special knowledge you had. It was something to see L.A. Bomb Squad up in '84; and it was like whoa! Who are these guys getting together and actually doing it? They were doing big productions at Radiotron[1], and I thought, this is cool, and I want to be a part of this! And I wanted to form or be part of a crew, although it was still mainly about putting yourself up."*

Hence, in the early 80s, New York's influences take baby steps in a city where Hip Hop rules, and where latino Graffiti culture is big (see Charles "Chaz" Bojorquez testimony, at the end of this chapter). When New Yorkers like ZODIAC and SOON decide to create artworks for the breakdancers, their work is purely and simply received as an epiphany. Knowledge quickly gets around, and the New York Graffiti codes are transmitted, and blended in the local culture. The first crews are founded, with the West Coast Artists Crew, the CBS "Corporate Blood Shed", "City Bomb Squad" "Can't Be Stopped" or LABS. Little by little, Los Angeles writes its own history.

Among those discouraged by the MTA's repression, some New York Graffiti legends arrive in L.A., hoping to find fresh walls. And in 1984, SEEN organizes an attack on the Hollywood sign, which he still vividly recalls: *"In 1984 BLADE 1 and I went to Hollywood, California on a mission to leave our mark. We bombed from Venice Beach to the Sunset Strip. We even decided to throw Hollywood a bonus and tag the Hollywood Star Tour Buses run by the famous Manns Chinese Theater. (…) We hit every side on every bus. We would fight for fronts of each bus, but that was only natural being writers and wanting the better spots. (…) All I could think about was the "HOLLYWOOD" sign. To me, that was Hollywood's prize possession and we didn't hit it! I knew then I had unfinished business in California and I would be back. A few months later I returned to Hollywood alone to put the icing on the cake. My sole mission this time around was to paint the Hollywood sign. I planned to proceed with my mission on my first night there, not to waste anytime. There were some small trees and some six-foot weeds that would be in my way, so I got the tools that I would need to pull the job off, a saw, weed-whacker and most importantly the paint. The colors I decided to use were red, black, and silver. I chose Silver as my fill-in color because*

1 Radiotron: Kids used to hang out in this club, listening to Rap music or praticing break dance. Writers met there, making friends or starting crews.

I wasn't sure how much time I had to paint and silver would cover quickly. (...) I was half way done when suddenly from behind the sign came a searchlight and the sounds of a helicopter. Again, huge spotlights flashed across the sign but now an unfinished SEEN piece as well. I ran down the hill again ripping the film out of my camera just in case I got busted, and jumped into the bushes. I must have hid there for, at least, two hours. Sitting there looking up at the lights reminded me of Yankee Stadium during a night game - it was bright!

After what seemed an eternity, the lights went down and the helicopter left. I was even more determined to pull this off! I was here for one reason and I wasn't leaving until it was done. After a few more hours and with the sun beginning to creep up, I was done! Exhausted, I went back to my hotel room for some sleep. After I woke up, I had to make one last trip up there for my flicks. It was easier now that all I had to carry was my camera and my piece was up there. I got up there, admired the view and kissed HOLLYWOOD good-bye."

Other locations are taken over. RELAX remembers the Belmont tunnel as *"the first true longest living yard in LA"*, where the first battles take place, with graffiti that is, still, very bubble-ish. Writers like SLICK or HEX get a lot of attention during legendary battles at the Levitz walls in Glendale in 1989, or at Belmont in 1990. CHAKA is another mythical figure in those days, and considered the Los Angeles Graffiti King, due to the incredible amount of tags he puts up, and his uncanny locations, from walls, freeways to water towers and even signs above the freeways. Among all of Los Angeles' yards, Belmont, Motor, and the Venice Pavilion have stood out the most, in a trainless environment, as the locations of choice for talents to face one another. This is where writers want to get up, and be seen.

The Movement appears to remain somewhat underground in L.A., until an article comes out in the *Los Angeles Times*. *Graffiti Work of N.Y. Moves West*. Published on November 10, 1984, and written by Robert L. Pincus, it makes a point of stressing the rising importance of the Movement. Some local collectors have already gotten started, like Elli Broad or Frederick R. Weismann, and galleries are doing their first Graffiti shows. The Michael Kohn Gallery and the Flow Ace Gallery invite FUTURA in 1985; the Tamara Bane Gallery welcomes DAZE in 1988 and CRASH in 1989.

At the beginning of the 90s, YEM becomes the first artist to make "corporates", which basically refer to colorful billboard pieces that sometimes even integrate parts of the billboard's original visual. Repressionis almost instantaneous and walls are already being "buffed out". In 1992, the city complains of an additional $3,7 M cost in cleaning, and the Fast Transit District gives a $13 M figure. The sale of spraycans to minors is forbidden, and penalties against writers are voted in 1993.

Graffiti conveys important messages, even in LA. What you say and how you say it matter. Joey THE SHADOW MAN is a good example, getting up all over Los Angeles in the 80s and 90s, and adding to his signature slogans that reflect his commitments: "To feed the hungry... Oh how we mourn for strength"... "Lost Angeles"... "The city that sleeps all day" "Impeach Mother Teresa... jk". Hitting thousands of walls, he spreads his heart-felt messages across the city.

With the 90s, repression grows steadily, but new initiatives, like legal walls, appear in various cities. The general public is, by then, changing its perception of Graffiti, recognizing it as, possibily, an Art form. Little by little, new generations of writers gain access to local art schools, and new Street Art variables appear, from wheatpasting to mosaics. Stars are born, like Shepard Fairey, known at the time as OBEY. In the city of pop imagery and Disney culture, old cholo traditions flirt with graffiti, giving local Street Art specific aspects that often anchor one common theme: the shallowness of a city based on appearances.

Los Angeles, because of its structure, becomes an action field, attracting other prominent artists from the US and abroad. Among them, SPACE INVADER, for example, invades the city in 2002, putting up hundreds of mosaics in the most unexpected of places while BUFF MONSTER's wheatpastings bring together the L.A. culture and mixed influences linked to Japanese esthetics.

By the time we reach the early 80s, Graffiti is being labeled as Urban Art. And its illegal and clandestine aspects are inspiring a great number of artists. A light and humor-tinted approach appears in paintings, along with very new and interesting techniques, like stencils. Filled with color and borderline excitement, Graffiti is hip!

The rise of Hip Hop culture all over Europe brings a renewed and welcome recognition to the Movement. Promoted by the media, a number of Zulu Nation personalities become, like Afrika Bambaataa, major stars. Aspiring Spanish b-boys also dream of belonging to the Zulu Nation. In England, the Nation's symbol is painted everywhere. DOZE, as a member of the Rock Steady Crew, is touring all over Europe, spreading the myth. Movies like *Beat Street* add to the legend, (though it's got more to do with the big Hollywood system than the street's actual reality). Yet, it inspires new generations, and trains in Vienna, Düsseldorf, Munich, Copenhagen, Paris or London are soon covered in graffiti. With specific stories and particular contexts, each of these cities becomes a fertile land for the movement.

In Germany

Allow us to draft a quick note about the context… In the 60s, a lot is happening in Germany. The Wall separating East from West Germany is built in 1961. In 1976, the East German border troops put up a new version of the Berlin Wall: the 12-foot high concrete 'Border Wall 75', painted in white. While no one is granted access to the Eastern side of the wall, many artists (from Berlin and from pretty much every part of the world) start painting on its Western façade, as early as 1980. The Wall becomes a giant canvas, available to all. When, in October 1986, Keith Haring discovers the Wall, as many others before, he gets to work. And because the West zone is occupied by US troops, the roots of Graffiti culture spread. A few years later, the Wall is demolished and both parts of Germany reunited. Part of the Graffiti culture history disappears.

In France

Meanwhile, in France, as early as 1960, graffiti is considered an art form, which is rather surprising for the time. Even with detractors and some very strong critics, Urban Art is born and integrated as a movement, allowing a great many artists around that period to practice their craft. Towards the end of the 60s, conventional graffiti finds a newly found and strong intellectual value, inspired by politics in most cases. Often filled with humor or poetry, catchy and friendly slogans appear, with underlying double-entendre. With the exception of certain artists, graffiti is usually painted using roll-ons, stencils or paintbrushes.

And just around that same time, New York style graffiti appears in Paris. Linked to Hip Hop culture, they're often painted by collectives based on the same models found in the US. But the implementation of theMovement in France bears particular aspects. And if its connection to New York is indeed strong, the French phenomenon has its own, incomparable specificities. During its early period, Graffiti grows around artists longing to be recognized by the art scene, benefiting from the legitimacy that American graffiti has gained at the beginning of the 80s. Street painters Mesnager or Zlotykamien, for example, are in their twenties, and well-ignored by the market and the media. They're the first to target the French subway systems and its poster ads. In 1981, the Centre Pompidou holds its *Graffiti and Society* exhibit, rehabilitating graffiti, and inscribing it a historical perspective. The stencil technique, which has been around since the 60s, also grows from the impact of this newly found recognition. Until then, street "graphists" are able to pursue their illegal activities with the police's relative benevolence. But soon enough, a parallel movement appears: a new generation, essentially teenager-based, starts taking over the streets with spraycans, claiming its connection

to the U.S. Hip Hop culture (and in some cases, to the Zulu Nation). The tag phenomenon begins, stigmatizing graffiti, which becomes seen less as artwork, and more as urban markings, a sure sign of social issues arising, from the media's point of view.

In 1986, writers from the Stalingrad lot (Paris) suddenly get real media attention, thrusting the Movement into the spotlight. They're all about tags, steering away from the "graphists" like later, other mural artists such as BANDO, MODE 2, BOXER among the most recognized. The first quickly find an institutional and artistic path, while the latter share the same Hip Hop culture. When a whole subway train is "massacred" for the first time, in 1987, politics and public opinions both see red. The RATP (Paris subway transit authorities), the SNCF (railroad transit authorities) and the Paris City Council hire special cleaning and monitoring brigades. All three institutions publish alarming (though unconfirmed) figures pertaining to the cost of these operations. Penalties worsen, whether via ticketing or public service work, and communication campaigns are implemented. The debate on tags versus art is now very loud opposing conceptions. Some artists censor themselves, focusing on mural art rather than tags, whether it be in public or in private. While the line between writers and Graffiti artists remains thin, because of their common references, the conflict opens the door to heated semantic discussions. What is graffiti? Some writers are all about tags and vandalism, others speak of art, and some are even hired by the RATP for their ad campaigns, like FUTURA 2000, subverting the subway's most famous ad ('ticket chic, ticket choc'). Tag writers are more and more blind-sided by the French section of the Zulu Nation, because of the bad reputation they're bringing to the Movement.

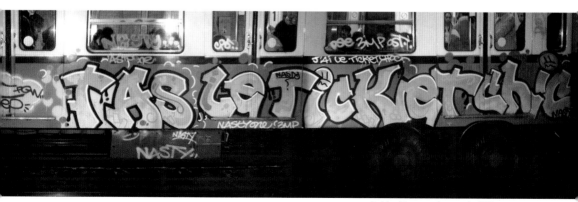

Le ticket chic, spray paint on train, 1990,
courtesy of the artist, **NASTY**

In the Netherlands

Interestingly enough, American Graffiti artists have found particular recognition in the Netherlands. In 1983, Yaki Kornblit, the art dealer, returns from New York with one obsession: bring to Amsterdam the incredibly vibrant scene he's just witnessed in the City. To begin, Kornblit brings together several famed writers. DONDI, CRASH, RAMMELLZEE, ZEPHYR, FUTURA 2000, QUIK, LADY PINK, SEEN, BLADE and BIL BLAST are reunited for an ambitious exhibit at the Museum Boymans van Beuningen, entitled *New York Graffiti*. It's a huge success. The Galerie Yaki Kornblit then acts as one of Europe's pioneers in the scene, presenting in Amsterdam solo shows by great American names. During that period, some of American Graffiti's most historical pieces integrate several of Holland's private collections. In 1984, the Boymans van Beuningen exhibit travels to the Groninger Museum, in Groningen.

Netherlands collector Henk Pijnenburg started following graffiti from the early 80s and has greatly contributed to get Street Art into the main stream. He shares his conception of Graffiti, or Street Art: "I think it is the most culturally significant art movement of the second half of the 20th century, since Cubism and Surrealism. This art is very powerful, engaged and direct. After all these years I am still moved by its strength, and passion". In 1982, Pijnenburg is checking out Riekje Swart's Amsterdam gallery and hears about the nearby Yaki Cornblitt Gallery, where he discovers works by DONDI White. The collector immediately buys two available pieces and begins a journey into Street Art. He becomes an active witness of Graffiti's European success in the mid-80s, and he's also one of the few people out there who stuck behind artists after 1987, when the movement goes through a somewhat tepid period. In an effort to promote the culture he loves and the artists he supports, Henk Pijnenburg has also gotten involved in publishing.

Charles "Chaz" Bojorquez

"My personal involvement with graffiti started in the late 1960's, but art has been a part of my entire life. I had spent a summer at art school in Guadalajara, Mexico and had started to attend art classes at Chouinard Art Institute (now Cal Arts) the year before I graduated from High School. I had always seen and understood graffiti, even in grammar school in the 1950's, but it wasn't until I was out of High School in 1967 that I became truly aware what graffiti was all about and also the current international art movements. Minimalism, Pop and early Conceptual assemblage was in. I hated it! I felt that the gallery art market was thin and shallow. Too much head and not enough heart. I turned away from the painting/gallery/money scene for fifteen years. I needed to find my own voice in art that described my existence, my surroundings, and what was important to my generation, not mentally formulated solutions. I wanted "in-your-face" Art.

By the end of 1969, I had created a symbol that represented me and my streets. It was the Skull. Written Cholo letters turned into an image. Senor Suerte (Mr. Luck), with a Super Fly big hat, and fur collared long coat, a skull with fingers crossed and a Dr. Sardonicus smile. To the Latino people, a skull's representation is not about death, but about rebirth. A tradition from our Aztec heritage, these images are still manifested in our Latino festivals today. My Skull is the gangster image of protection from death. Here in our local neighborhood, the old homeboy street gang, The Avenues, has claimed the Skull as their own. Many have the Skull tattooed on their body, from the top of their skull to the sides of their neck, arms, chest and full backs (check out the movie, American Me). The Skull has become a lowrider gang icon. You have to earn it to have it tattooed. I was not a gang member. But in my neighborhood of northeast L.A. you live with the gang style next door your entire life. I took up stenciling my Skull/tag, and writing roll call names in the streets all through the 1970s, until I stopped in 1986.

In 1975, in collaboration with a photographer, Gusmano Cesaretti, I wrote a book called 'Street Writers' (Acrobat Books). In this small photo book of L.A. graffiti I described the streets and the attitude of graffiti writing. There were many stories coming out of New York about TAKI, DONDI, FUTURA, LEE, LADY PINK, SEEN and more. We heard about the Fun Gallery and finally the blocking of the train yards with dogs and razor wire. But New York was so far away.

There is no influence here until the beginning of the 1980s. In my mind, the early New York style was about 'getting up' writing individual names, it was about 'identity'. While here in L.A., it was about defining 'territory'. My own work was about finding the soul of graffiti. I started to shift from the streets to my first graffiti canvas painting in 1978. I needed to have longer conversations with the image. The streets were not giving me enough time to draw what I wanted to say. I needed months on one painting."

Cholo Style Graffiti Art

"The graffiti that I started with in 1969 is our own, west coast 'Cholo' style graffiti, and it's still the same style of graffiti that I paint today. I say paint, because I almost always use a brush. The brush was the weapon of choice before spray cans were introduced in the early 1950's in Los Angeles.

Our history and age of 'Cholo' Latino begins in the mid-1930s. Beatrice Griffith refers vaguely to graffiti in 'American Me' (published in 1948). The most important and influential time comes from the early 1940s. Here in Los Angeles, the Latino Zootsuiters were defining their Americanism. The Zooters were formed by forces like non-acceptance by the Anglo-Americans, mass deportations of Mexican-American citizens back to Mexico, and in Los Angeles, the beatings by U.S. servicemen during World War II. New York Harlem black Zooters, and of course, Jazz and Swing music also had a big influence. Los Angeles Zootsuiters felt and wanted to be different. With their hair done in big pompadours, and 'draped' in tailor-made suits they were swinging to their own styles. They spoke 'Calo', their own language, a cool jive of half English, half-Spanish rhythms. The term applied to the slang the gypsies and bullfighters of Mexico and Spain used at that time. Here the 'Old School Cholo' L.A. graffiti style still has its most direct influence. Out of this experience came lowrider cars and culture, clothes, music, tag-names, and again, its own language.

Los Angeles graffiti has its own visual presentation. It is a public announcement. L.A. gang graffiti writings are called 'Placas' (plaques, symbols of territorial street boundaries), and are pledges of allegiance to your neighborhood. Its letter face has always been called 'Old English' and is always printed in upper case capital letters. This squarish, prestigious typeface was meant to present to the public a formal document, encouraging gang strength, and creating an aura of exclusivity. The Placa is written in a contemporary high advertising format, with a headline, body copy, and a logo. These three major building blocks of corporate public advertising can also describe the type layout from ancient Sumerian clay tablets to the Constitution of the United States. The headline states thang or street name, the body copy is your rollcall list of everyone's gang name, and the logo refers to the person who wrote it by adding his tag at the end. Placas are written with care to make them straight and clean. They are flushed left and right or words are stacked and centered. Rarely are they ever done in lower case free-script, or other than in black letters, one of the many differences from N.Y. style. This tradition of type, names and language rarely deviates drastically and is handed down from generation to generation.

The Los Angeles walls are an unofficial history of the Mexican-American presence in the streets of East L.A. This traditional form of Los Angeles graffiti is a graffiti seeking RESPECT (something all graffiti has in common). They are markings by generations of rebellious youth announcing their pride and strength to all outsiders. I feel that by writing your name makes you exist, how you

write makes you strong, and by writing on the wall, it makes you immortal. It is graffiti by the neighborhood, for the neighborhood. That's another difference between Cholo and Hip Hop. In Cholo, usually one writer writes for the whole gang, and only writes within his own territory. In Hip Hop graffiti styles, there is an individual focus, where 'getting up' all-city or all-state with your tag is more important. Generally speaking, the typeface of Hip Hop tags changes to a more personalized upper and lower case free-script." **Charles "Chaz" Bojorquez**

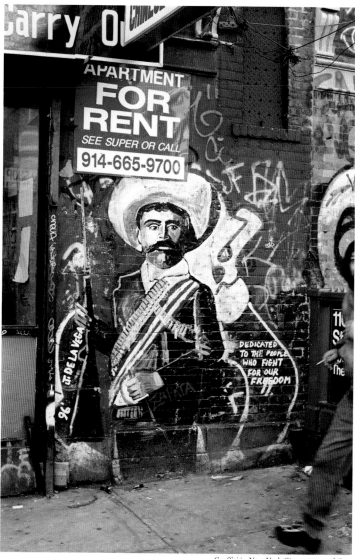

Graffiti in New York City. courtesy sb@ny

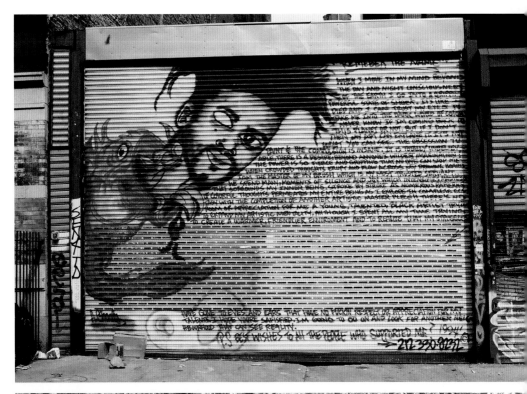

All pages:
Graffiti in New York City, courtesy sb@ny

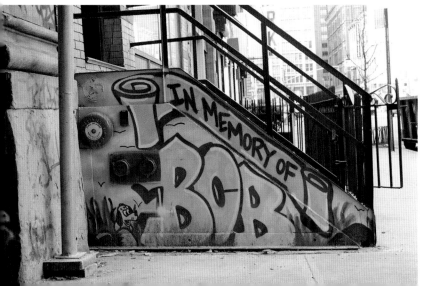

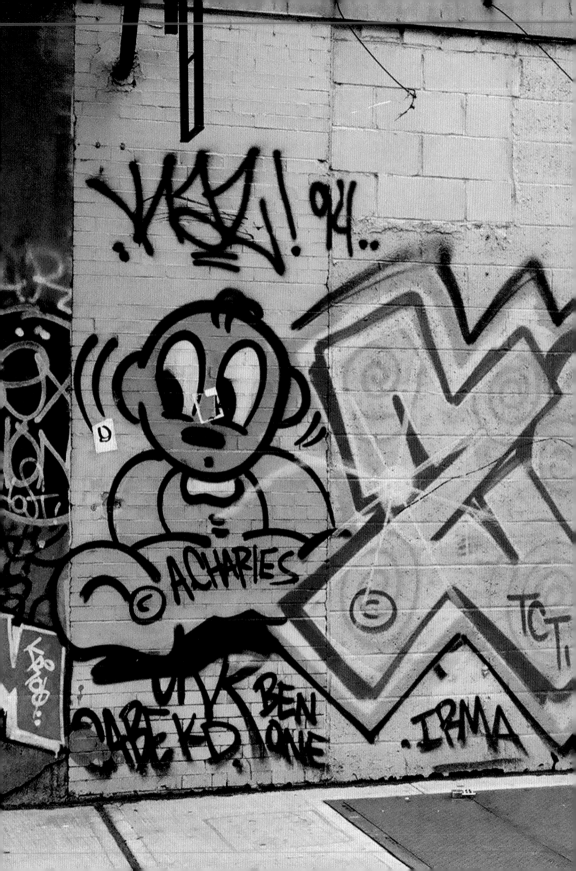

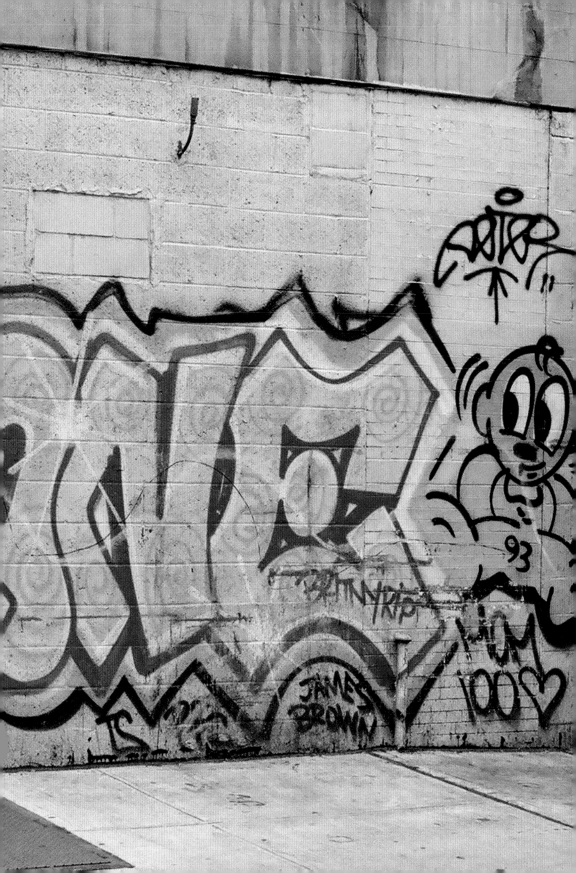

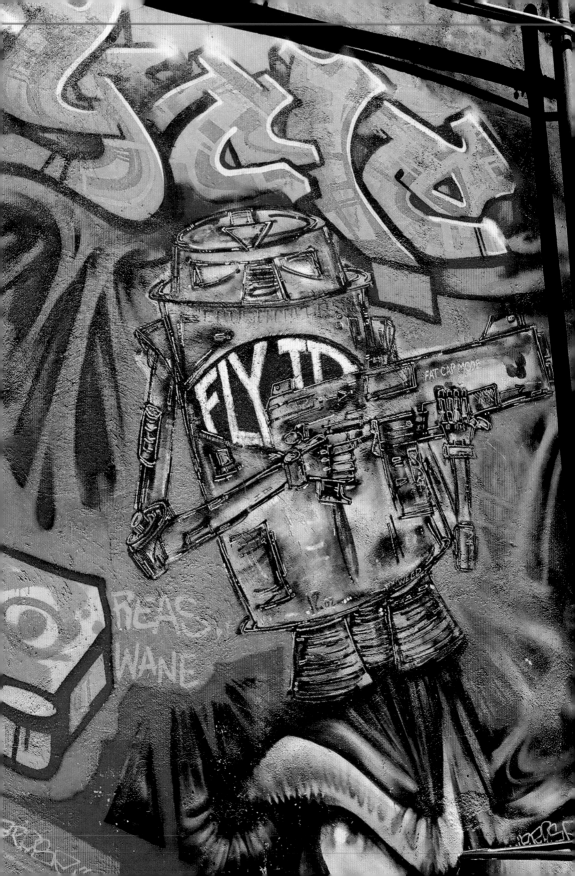

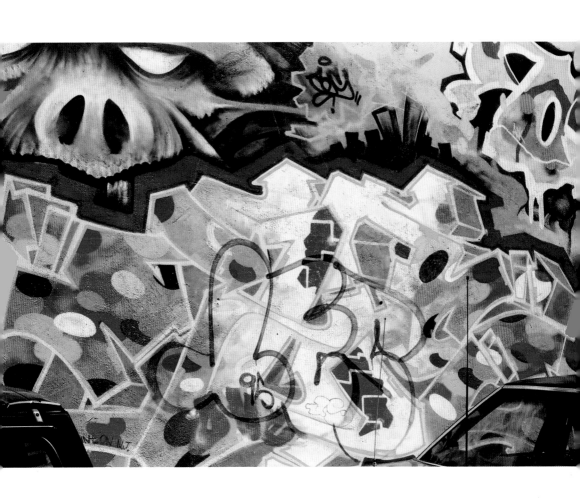

The Beginnings

Anthony Clark, aka A-ONE was born in Manhattan in 1964. By the age of six, his artistic talent is obvious to everyone, including his parents who discover it sprawled over every single one of his schoolbooks. Still, the street is where he gets his education, like many self-taught artists. Later, he studies architecture for which he develops a strong interest.

A-ONE is part of the TMK crew (the Tag Master Killers), that includes other writers like TOXIC, DELTA, KOOR, and its founder RAMMELLZEE.

What's interesting is that, at the beginning and for a long time, A-ONE doesn't paint trains, despite criticisms, and sticks to canvas. When he finally gives trains and top-to-bottoms a try, they clearly stand out from other traditional creations at the time. He reproduces his wild, detailed, energy-packed style, and insists that photographer Henry Chalfant document every piece.

A-ONE

Date of Birth: 1964

Place of Birth: Manhattan New York

Starting Point: 1975

Style: Aerosol Expressionist

Distinctive Feature(s): Rastafarian elements

The "Aha!" Moment

It all begins in 1982, when he's invited, with TRASH, DAZE and FREEDOM, among others, to participate in the South *Bronx Show*, organized by the infamous Fashion Moda Gallery. A few months later, Fashion Moda invites him, as well as TOXIC and KOOR, to paint *Camouflage Panzerism*, a piece that is, for the most part, painted directly on the walls, on a

black backdrop that includes a sign by John Fekner. In those days, A-ONE lives right around Fashion Moda, and usually meets his friends there, using the space to paint. He completes several great works before, and after 1982.

Into the Art World

As of 1982, he's got at least one solo show a year, in addition to various group exhibits. And there's the Venice Biennal in 1984, which leads him to settle in Verona, Italy for a few years, and later in Paris, France. A-ONE finds Europe to be more of an open land for his art. In 1995, the Stones are getting ready to tour France. They choose him, along with ELIO, FUTURA, JONONE, JAYONE, MODE 2, and SHARP, to interpret their songs into pieces for a traveling art show. October 2001 marks his last appearance (at the Galerie du Jour), alongside with ANDRÉ, FAFI, OS GÊMEOS, JAYONE and FUTURA 2000. A-ONE dies on November 11, of a brain aneurism, putting an end to a stellar career.

Style

A-ONE is a has shown consistent innovative respect for Graffiti and its tradition. He is a self-defined Aerosol Expressionist, more than a Graffiti Artist: *"I look at myself as an artist or better, an Aerosol Expressionist, not as a Graffiti Artist. Everyone can call it Graffiti, I don't mind, I know what*

I'm doing." His work reflects the quest for a symbiosis between American culture and that of his origins. Fighting the great Babylon, he preaches unity, reminisces his African roots and depicts urban mythology, peppering his works with musical resonance and a Rastafarian-like mystical and spiritual mystique. A-ONE cultivates a sort of unequivocal trans-culture, similar to Jean-Michel Basquiat's, his friend and advisor.

Like his little rasta-hat, his work is filled with energy, life and humor. In his work A-ONE oftenly include characters that are painted with a dark brown or black outline. Yet, his lines seem a little old school, not shaky but almost, bringing out the fragility of every human being A-ONE portrays so well. His colors blend in a particular way, making the overall textures of his paintings special: somewhat blurred. A-ONE's effects are not a mere blend, they are superpositionned in an almost aerial, fragile way.

Next double pages:
Ouverture Explosion, spray paint on canvas, 130x210cm, Henk Pijnenburg collection

Communication Breakdown, spray paint on canvas, 173x315cm, 1990, Henk Pijnenburg collection

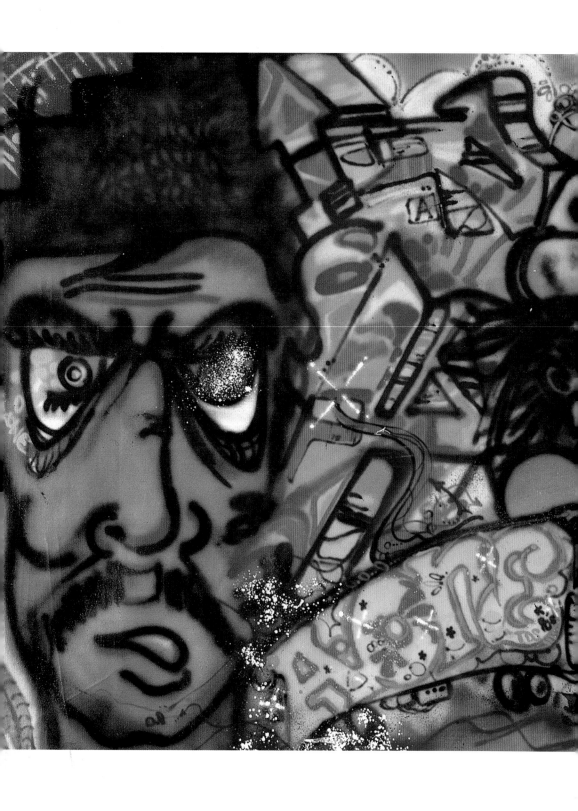

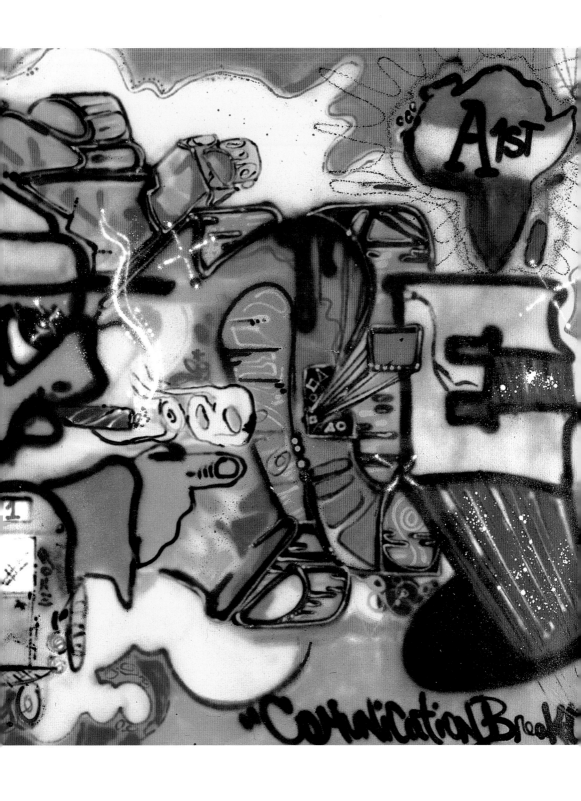

MODE 2

Date of Birth: 1967

Place of Birth: Mauritius

Starting Point: 1984

Influence(s): DONDI, DAZE, NOC 167, LEE

Style: Allegory of characters

Distinctive Feature(s): Detailed characters, filled with life and dynamic.

The Beginnings

MODE 2 was born in Mauritius in 1967 and followed his family to London in 1976, where he spent the greatest part of his school years. As far as he can remember, MODE 2 liked to draw, and spent most of his time as a young boy reading comics and sci-fi books, and playing *Donjons and Dragons*. His first Graffiti encounter is on television when he sees *Welcome Back Kotter* and *Buffalo Gals*, in which DONDI paints one of his pieces. Like a lot of kids his age, DONDI becomes his role model.

In 1984, freshly graduated, MODE 2 starts spending a lot of time in Covent Garden, at the center of London, which in those days has become Hip Hop's general quarters per se. His drawing skills naturally lead him towards Graffiti within the Movement. Soon enough, he gets commissioned to do murals in various locations. In addition to painting, his fascination for Hip Hop as a whole motivates him to document as much of it as possible, and he starts taking photos.

He becomes a member of The Chrome Angelz crew, with whom he does several commissioned murals as wells. MODE 2 is one of UK's first style writers.

The "Aha!" Moment

In 1987, MODE 2 appears on the cover of Henry Chalfant's book, *Spraycan Art*. It's the first actual book to document Graffiti on an international level, as opposed to focusing on just the New York scene. That same year, a small French IT animation company hires him, motivating a move to Paris. And though he doesn't work there long, he decides to stay in Paris, where he feels the Hip Hop scene to be more open, even defining it as a "cultural explosion". The booming comic book scene is also an attractive factor for MODE 2, and in the end, it's the diversity of it all that incites him to settle in France. After meeting French rap band NTM at a party, he starts working with them, and quickly becomes a dynamic actor of the French Hip Hop scene.

Into the Art World

In 1989, MODE 2 is given a state commission in the context of the French Revolution bicentennial and gets involved with suburban teenagers through the creation of graffiti workshops. He also becomes photographer Jean-Baptiste Mondino's assistant, in 1990. All these commitments do not keep him from traveling at an intense rhythm, and he participates in various worldwide Hip-hop events. He does a mural for Costa Gavras in 1991, celebrating Amnesty International's 25th anniversary. He's a speaker at a number of conferences around Hip-hop culture, among which San Diego in 1996 and in 1997, and for Cleveland State University's Seminar, in September 1999, entitled *Hip Hop: A Cultural Expression*. And of course, he keeps collaborating on a number of projects and painting dozens of murals. One of his collaborations, with DELTA and FUTURA, leads to a DVD and an exhibition. He also draws on a model, photographed by Harri Peccinotti, in an attempt to push traditional graffiti boundaries

Style

MODE 2's style has little to do with his early lettering, even though it was clearly unique in its genre at the time, so much so that it got him the cover of Henry Chalfant's book. Throughout his evolution, he's focused his attention on the many characters that have always been a feature in his murals. And while any writer today is happy to recognize MODE 2's influence and importance within the Movement, his style is even more more personal today. He's left spray paint behind, working with brushes, and tends to prefer natural colors, in a palette of deep browns and bright reds. He's also very influenced by contemporary comics esthetics. His recent body of work definitely reveals, if need be, his taste for feminine shapes, but it also stands out in the new ways he seems to approach his fill-ins and detailed backgrounds

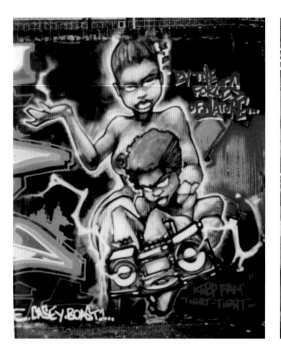 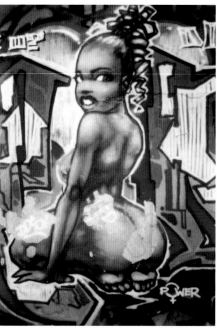

MARE 139

Date of Birth: 1965

Place of Birth: Harlem

Starting Point: 1975

Influence(s): Juan Gonzalez, Picasso, Frank Stella

Style: 3D

Distinctive Feature(s): Sculpture, and metal work

The Beginnings

Carlos Rodriguez, of Puerto Rican descent, was born in 1965, in New York Spanish Harlem, but was raised in South Bronx. His brother KEL is to thank for his introduction to Graffiti in 1975, and he starts hitting the lines by 1977. Very early on, he's particularly impressed by LEE QUINONES' work: *"I was so impressed by it that I knew I had to learn. I started looking at more trains and noticed that that there was a big difference between the more accomplished Wild Style writers and the novice toys like myself and the bombers who tagged or hit up quick simple style throw-ups on as many trains as possible."* He learns painting outside of his school hours, as an apprentice to his elders. His main influences, aside from his brother, are LEE, NOC 167, PART 1, DONDI and CRASH, to name a few.

Between 1981 and 1984, he attends the High School of Art and Design before integrating Parson's School of Design two-year cycle, and concludes his studies with an additional year at Apex Technical School.

The "Aha!" Moment

Photographer Henry Chalfant, a vibrant witness of those times, remembers: *Rodriguez, the untutored teenage Graffiti artist, attended the large retrospective Picasso show at MOMA. This and other eye-opening experi-*

ences encouraged) the young man to consider Art as a career choice for his life." MARE's early career is the result of a conscious artistic turn, rather than the consequence of the usual 'multiple strikes of fate' that somewhat characterizes many Graffiti writers' careers. The transition takes place in 1985, when he decides to focus on shape, steering away from traditional lettering to study and explore actual 3D in depth." After the trains I wasn't bringing anything original. One day I saw this sign in front of a restaurant in polished steel and I said "that's it, that's the future of graffiti, it's making it into sculpture!" I began to think about how letters bend and fold, and how script just curls and rolls into space. That year I went to England to do a lecture at the Norwich School of Art and these ideas were still fresh in my mind. As I was explaining the whole idea of "signature," "calligraphy," "style", and the whole evolution of Graffiti (from simple tags to Wild Style), I started to talk about how letters could be three dimensional and have movement; I found myself being very physical with my hands, I was articulating the whole thing by throwing my hands in the air like arrows, and that's something I saw with the breakdancers, the boogie boys do. That was like physical graffiti, and at this moment it started to make a lot of sense, it all came together."

Much like NOC 167, who liked to give his letters a certain relief by twisting them and bending them in every direction, MARE takes advantage of the possibilities that multilayering offers. Faithful to Wild Style, MARE is on the road to groundbreaking innovation.

Into the Art World

As a sculptor, MARE 139 participates in numerous solo and collective shows across the United States and all over Europe. He has completed several artist residencies, at Brighton University, for example, concluded by sculpture installations. His talents as a sculptor also earned him a number of commissions, including the design of the BET/Black Entertainment Awards. Committed to the Graffiti movement, he's received a Webby Award for his creation of the Style Wars website, and he continues to give lectures throughout the world.

Style

MARE's work stands out in the Graffiti world with his use of unorthodox mediums such as metal. His greatest achievement probably lies in the way he's been able to switch from subway Wild Style to sculpture, all the while maintaining graffiti's founding energy intact. Respecting his early year imagery, he uses its typical letters and classic ornaments, like the arrow or the star, as starting points to a sculpture. Once executed, his works bear a strong reminiscence to the Russian constructivists.

In Henry Chalfant's own words, "MARE 139 *saw the possibilities in taking a sculptural approach to the letter forms, moving from the illusion of depth in painting to concrete forms*

in sculpture." He adds: *"Curious and inspired to look further, Rodriguez came upon the works of Frank Stella and he was struck by the way these sculptures resonated kinetically and rhythmically with his own sensibilities honed by painting art on a moving object. Rodriguez, still working predominantly in relief, was able to jettison much of the graffiti imagery from his palette, and to work in a non-objective mode, deepening the relief, incorporating textural variety and line with sheet metal, grids, wire and steel rod."*

Still pursuing his work on abstract painting, in which he uses enamel on metal, MARE has successfully steered away from the somewhat classic graffiti shapes, taking more steps towards his metal experimentation. In his drawing, MARE's research has brought him closer to a Picasso, or to David Smith's studies on space.

"The works that I create now are a reflection of a culture that thrived on originality and competition. There is a dynamic relative to the elements of Hip Hop culture in my work, there is the obvious Wild Style graffiti language, the movements and rhythms of the breakdancers - the way they occupy and assault open space and there is the rhythm of music in the form of complex lyrical shapes."

Top:
Majestic Killer, courtesy of the artist, **Mare 1**39

Bottom:
Monumental installation, project for the Fondation Cartier,
2009, courtesy of the artist, **Mare 1**39

The Beginnings

Isaac Rubinstein, aka WEST is the grandson of Russian-Jewish immigrants, and was born in Manhattan, New York in 1969. As a young boy, he was shy and discreet, and he admittedly was motivated by the desire to express himself and exist in the eye of the world. In the early stages of his street activity, SKEME, DEZ (TNT), ZEPHYR and REVOLT (RTW), who are all over the IRT lines, are his true source of inspiration. KEO (X-Men of Brooklyn) introduces him to the basic principles of the Graffiti code, as well as its history and culture. He learns by observing. When KEO suggests he find a street name, the boy presents him a list of five names, among which KEO selects one, WEST, that he has kept ever since. He starts tagging on the Broadway1, in 1983, around the 225th street subway stop.

When he meets FLITE (TDS), he's still in high school. FLITE teaches him the bases of the alphabet, for example, and takes him in the 145th tunnels, the same tunnels that will later become Fame City members' preferred locations. During that time period, WEST draws major influence and inspiration from the TNT and FBA crews, in terms of style.

During the 80s, he makes a name for himself, thanks to his clean and simple style letters, but also as one of the lasts to resist the anti-graffiti subway police

Date of Birth: 1969

Place of Birth: NYC

Starting Point: 1984

Influence(s): Pollock

Crew(s): X-Men from Brooklyn, TC5, FBA, IBM, Fame City

Style: Style Abstract deconstructivism

Distinctive Feature(s): Energy in lettering

force. Besides the line 1, he bombs the D line in the Bronx, the 175th Street A line and the number 3, on 148th street.

In 1984, West joins the very exclusive and recognized Fame City International crew, which he will even preside later. Fame City was created in 1982 by THUD (PHIL 167), JEL (WASPY), RAZZY RAZ, AXE, SLIN 2, C.W. (CRAZY WHITEBOY) and BRONX STYLE BOB. It was joined, around 1986, by writers such as SEEN and JONONE.

The "Aha!" Moment

In January of 1985, modern art dealer Rick Librizzi organizes an exhibit entitled *Graffiti and East Village Artists* at the Librizzi Gallery, in New York, with writers like WEST and JONONE. In 1987, Henry Chalfant and James Prigoff include his work in their mythical book, "Spraycan Art". That same year, WEST gives up subway painting, facing too great a repression. He's part of a number of group shows, at the Stony Brook University Gallery in Long Island, at the Light Gallery and at the Free Space, in New York.

In the 90s, WEST and his Fame City crew pursue their activities through mural projects which have been documented and can be found in books such as *R.I.P. Memorial Wall Art* by Martha Cooper and Joseph Sciorra (1994), *The Art of Getting Over* by Stephen Powers (1999) and *New York Graffiti 1970-1995* by Markus Weise (1999).

Into the Art World

As of 2001, WEST takes further steps in the development of his own style. Putting emphasis on a rather more abstract style, he nonetheless maintains a strong lettering base. His work is presented in New York, that year, at the Bob Gallery. He also gets commissioned to paint a mural for the Tenement Museum, and another one, produced live, in Tokyo.

The Fame City tour takes place in 2002, and WEST's work is presented in New York, Hong Kong and Tokyo. The following year, he's among *The Magnificent 7* at the McCaig Welles Gallery in Brooklyn and does a mural with the Pierogi Gallery.

In 2004, he presents the results of his style experimentations, during a solo show entitled *Anti Graff* hosted by the McCaig-Welles Gallery, and a number of other exhibits follow, from the Bronx Museum of the Arts to the Parco Museum of Tokyo, via Paris, at the Magda Danysz Gallery.

His work is regularly mentioned in books on Graffiti, like *Broken Windows* by James and Karla Murray (2002), *Aerosol Kingdom* by Ivor Miller (2002), or *Bombshell* (2006), to name a few.

Style

In terms of style, WEST takes a break in 2001, to escape what he feels are narrow constraints within Graffiti's strict rules and codes that leave little room for improvisation. He studies the history of abstract expressionism, focusing on Franz Kline, Jackson Pollock, Robert Motherwell, and Clifford Still. This brings new paths to his work, a door towards autonomy, which traditional Graffiti lacks. His approach to painting changes, setting him free from standard tools and colors, as he lets go of outlines and preparatory sketches. He starts deconstructing letters, first giving them transparency, then stacking them on top of another. In this process, new powerful shapes appear. As an abstract expressionism descendant, WEST mentally reconstructs the traditional shapes in lettering before painting them in an abstract way. Every letter is represented by no more than one piece extracted from its initial shape. Lines overlap and give an abstract reading grid, where movement and shape become more important than the subject itself.

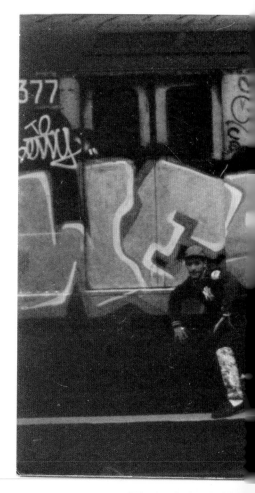

Trains in New York City, 1984, courtesy of the artist, *West*

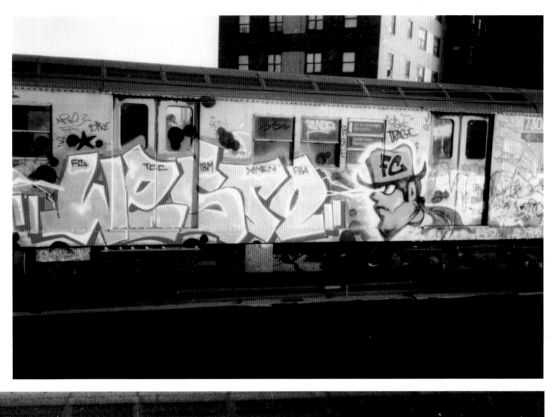
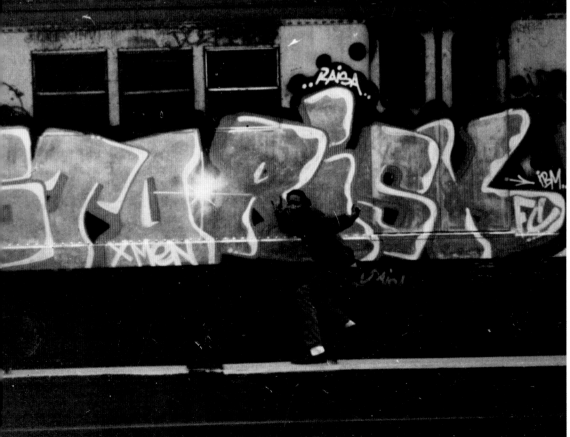

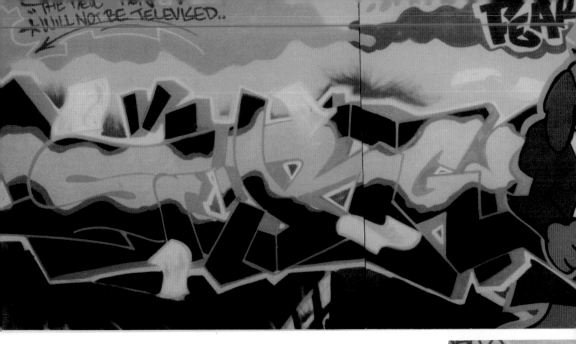

Top:
Hong-Kong, Phœcry Wall, courtesy of the artist, *West*

Bottom:
Wall in the Bronx, 1995, courtesy of the artist, *West*

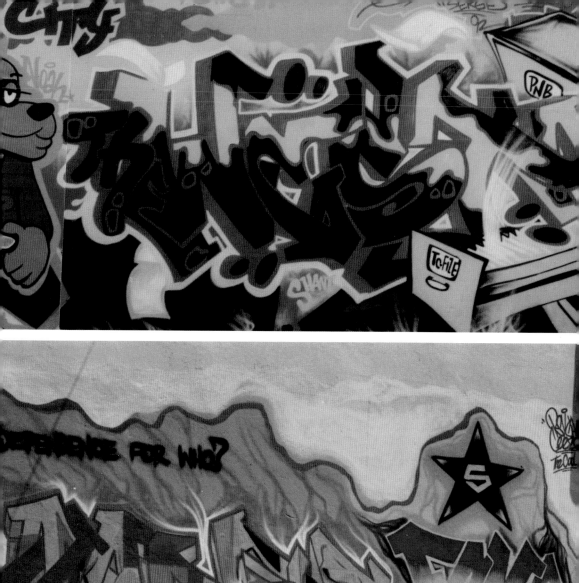

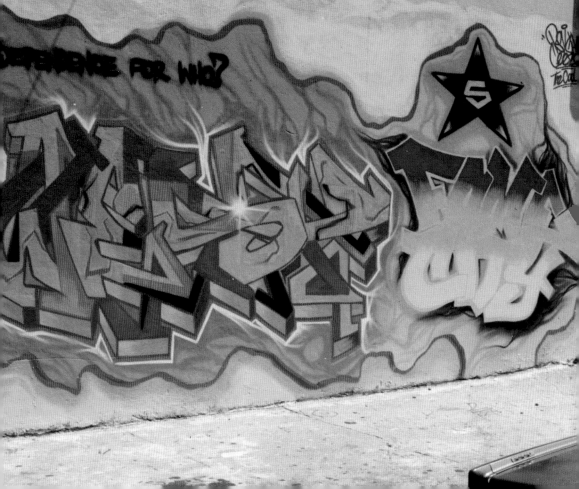

From the top to the bottom:
Style Master General, painting on canvas, 103x230cm, 2008,
private collection, **West**

The Dance, painting on canvas, 220x230cm, 2008, private
collection, **West**

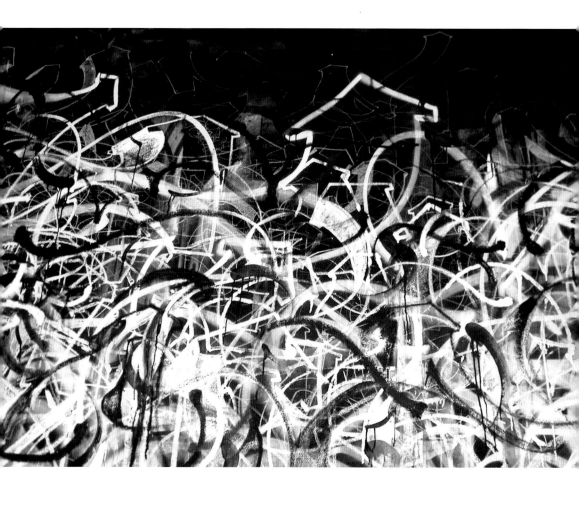

Blue, painting on canvas, 230x145 cm, 2008, courtesy galerie
Magda Danysz, *West*

Untitled, painting on canvas, 270x161cm, 2008, courtesy
galerie Magda Danysz, *West*

The Beginnings

Fernando Carlo aka COPE 2 was born in the South Bronx, which he considers Hip Hop's birthplace. In 1978, he starts writing, inspired by his cousin Chris (who's tagging under the alias CHICO). Secretly borrowing his cousin's markers, he spends his time tagging the name NANO all over his grandmother's roof. But in 1979, his cousin takes him to the subway. They start tagging the inside of trains massively together, on their line 4. He becomes a great fan of FRITOS' giant pieces, and discovers MARK 198, DR. PEPPER, KILLER56, COMET, BLADE, POPEYE, TRACY168, DELI167, LEE, SEEN, PJAY,P-NUT2, MEDISCO92 as well as his idol MITCH77, who inspires him to pursue his efforts and to improve his practice.

On Dekalb Avenue, where he lives, every kid is a tagger. COPE 2 hangs out at the Bench on 149th Grand Concourse and at the Line 4 train depot, where he meets a number of other taggers, among which TRAP and RIP7. His name, COPE 2, is chosen around that time: his best friend suggests "cope", close to his own "KOPE" alias, with the number 2 relating to BAN2, who happens to be, at the time, "the King of the insides".

COPE 2

Date of Birth: 1968

Place of Birth: South Bronx

Starting Point: 1978

Influence(s): FRITOS, MARK 198, DR.PEPPER, KILLER 56, COMET, BLADE, POPEYE, TRACY 168,DELI 167, LEE, SEEN, PJAY, P_NUT 2, MEDISCO 92 ET MITCH 77

Crew(s): Kids Destroy, MPC

Style: Traditional of graffiti

Distinctive Feature(s): Absolut purist

The "Aha!" Moment

In 1982, he creates his own crew: KD (Kids Destroy) and invades other lines. From that year on, COPE 2 emphasizes his status as a prolific writer. Tackling more and more trains, he joins the MP, and dedicates his whole life to Graffiti. "That's when things got crazy for me", he reveals. A tireless actor in the style and location war, "killing it with throw-ups", he teams up with QUIK, who shows him where to tag around the highways. In 1984, the *Daily News* illustrates an article on the city's brand new measures against graffiti with one of COPE 2's throw ups. 1981-1985 are his golden years.

Into the Art World

In 1988, rumor has it that graffiti is dead: hundreds of writers purely and simply give up. COPE 2 is one of the few to keep going. He's still all over the subway, along with CAP, PJAY, SEEN, JOZ, BOM5, EASY, DELTA2, TRAP, JA, JSON, POVE, DERO, GHOST, IVORY, FLITE, etc. Age has also brought on new responsibilities towards his family, and COPE 2 starts painting on legal walls. He remains nonetheless one of the New York City Vandal Squad's favorite targets, and is regularly arrested.

COPE 2's influence on Graffiti and writers is, by then, acknowledged around the world, but the mid-90s bring him, finally, actual artistic legitimacy. A documentary on his work and activities is released in 1999, which shows that it is indeed still possible to paint in New York's streets. And in 2002, Adam Bhala Lough's movie *Bomb The System* covers 20 years of graffiti culture, including COPE 2's work. In 2003, deux Graffiti fans, Myre et Orus, manage to regroup an incredible quantity of photos into one book. *COPE 2: True Legend*, acknowledging his importance within the movement. COPE 2 then collaborates with a number of brands, like Converse or Adidas, to come up with merchandising products, and video games, following Marc Ecko's example. In 2005, *Times Magazine* commissions him for a mural in Soho, that includes tags, and a text: *"Post-Modernism? Neo-Expressionism? Just Vandalism? Time. Know Why"*. He also shows his work in a few Graffiti group exhibits, (like McCaig Welles in Brooklyn in 2009).

Style

COPE 2's style follows Graffiti tradition at its best. He has proclaimed himself *"the most purest and realest writer in history"*. He has dedicated his entire career to tag in its many variations, and summarizes perfectly the importance of his practice in these three lines:

"Post Modernism ?
Neo Expressionnism ?
Just Vandalism?"

Keith Haring

Date of Birth: 1958

Place of Birth: Reading, Pennsylvania

Starting Point: 1978

Influence(s): Dubuffet, Paul Klee, Picasso, Pollock, Matisse, NOC 167

Style: Figurative; universal symbols; Pop Art, Urban poetry

Distinctive feature(s): Naïve drawings; simple stroke; infinite repetition

The Beginnings

Keith Haring was born on May 4th 1958, in Reading, Pennsylvania and was raised in a city close to Kutztown. From a very early age, he develops a strong taste for drawing, and his father teaches him basic cartooning skills.

In 1976, he graduates high school and enters Pittsburgh's Ivy School of Professional Art, specialized in applied graphic arts. Though he quickly realizes he lacks the proper motivations for a graphic designer's career, he stays on for two-and-a-half years before giving up, while pursuing at the same time his personal career. In 1978, the Pittsburgh Arts and Crafts Center offers him a show. And that same year he decides to move to New York.

Haring is quite simply fascinated by the graffiti he discovers in the street: *"Graffiti were the most magnificent thing I had ever seen"*. He begins to draw, in white chalk, on the black advertising panels around New York's subway, and etching the East Village's pavement.

He's accepted as the School of Visual Arts, which is where he integrates the works of his admired elders, Dubuffet, Paul Klee, Picasso, Pollock or Matisse, whose works, admittedly, influence and inspire his whole career. However, his encounter with Alechinsky's work is what truly triggers his artistic convictions, and acts as the real detonator of his artistic certainties. He begins experimenting

with performance, video, installations and collage, in addition to his constant drawing work.

He soon befriends artists Kenny Scharf and Jean-Michel Basquiat, as well as musicians, performers and other writers. At the heart of New York's whirling scene in the 80s, Haring is an active component of the city's artistic life, through his exhibitions, performances (at Club 57 for example) and during alternative meetins. By that time, he is already manifesting a certain anxiety, and declares: *"I really believe that my time will come, that I'll be famous. It will happen when I'm not around to enjoy it anymore."*

The "Aha!" Moment

His first personal exhibit takes place in 1982, at Tony Shafrazi's New York gallery. It's a massive public success. He's also offered a show, that same year, at the Rotterdam Arts Council (Netherlands). The following year, he's part of a collective show with the other rising Graffiti artists at New York's Fun Gallery. These shows lead him straight to worldwide exposure. From Tokyo, Japan, to Milan in Italy, Haring is everywhere. And in 1982, he's invited to the Paris Biennale. His international fame, from that point on, never ceases to increase.

Between 1980 and 1985, Haring is offered 22 personal exhibitions, from Leo Castelli himself, to the University Mu-

seum of Iowa City. At the same time, he continues producing hundreds of drawings in the streets, leaving up to forty "subway drawings "a day. New York commuters become quickly familiar with his daily working silhouette. For Haring, the subway becomes a laboratory, in which he experiments with his stroke. Wood and metal fences, garbage trucks, walls, unusual objects, Grace Jones's body in 1984, everything becomes a potential support to his urban poetry.

Into the Art World

Haring participates in numerous and grand exhibitions. In 1986 he's invited by the Whitney Museum of American Art and by the Stedelijk Museum, in Amsterdam (Netherlands). He also receives a number of prestigious commissions. To fulfill his desire to meet as wide a public as possible, he makes his art accessible to the largest number, and opens his Pop Shop. Based on Warhol's Factory model, Haring launches a first shop in April of 1986, in Soho. Offering merchandised versions of his work in the form of diverse objects, from posters to T-shirt, the artist pushes the envelop of commercial process in art.

During the 80s, Haring participates in more than a hundred shows. In the year 1986 alone, the press dedicates him over forty articles. With more than fifty state commissions worldwide, often within the framework of projects implying sick or

discriminated children, His art becomes internationally recognized. Haring is a star.

Diagnosed with AIDS in 1988, Haring creates the Keith Haring Foundation, in charge of helping children and supporting AIDS organizations. On February 16 of 1990, he dies from AIDS complications. He's 31 years old.

Since his death, Keith Haring has been the object of numerous retrospectives worldwide.

Style

Keith Haring's work has a direct connection to Graffiti and is close to the free figurative movement. His art, a figurative and talkative language in its own, that covers universal issues, remains as one of late twentieth century's most important bodies of work.

His urban poetry uses the codes of Graffiti: shapes in rapidly executed strokes. Like the writers, trained to tag trains, Haring expresses himself with a simple but confident gesture. The Haring touch is all about infinite repetition of synthetic shapes underlined in black, with lively, enlightening colors, on various supports.

Haring develops a esthetic of signs, comprised of simple and denoted symbols, defined by his early 1980s drawings: the flying saucer represents important power, Mickey Mouse stands for popular culture, his sticks for instruments of power, a red cross symbolizes death, a green one, life, etc. The Radiant Baby, his signature turned into a logo, is above all an essential reference to life force, an energy tainted with joy and childish wholesomeness.

Keith Haring has left a work in which innocence hides real inspiration. The artist, refusing to grow up, seems to be looking at the world with a child's eyes, to better speak about the adult world. He's done several thousands of these drawings, in lively flowing lines. His work is a permanent narrative filled with babies on all fours, dolphins, television sets, yapping dogs, snakes, angels, dancers, androgynous silhouettes, flying saucers, pyramids or walking alarm clocks, but also includes sexuality and death impulse references. By expressing universal concepts in a very simple and direct way, such as life, death, love, sex and war, Haring has become universally known.

Jean-Michel Basquiat

Date of Birth: 1960

Place of Birth: Brooklyn

Starting Point: 1977

Style: Symbolism; nervous, violent and dark

Distinctive Feature(s): Recurring skeleton and mas motifs, obsession with death, urban elements, written words. Interested in black and Haitian identity. Nervous, violent and energetical style

The Beginnings

Jean-Michel Basquiat was born in Brooklyn on December 22, 1960. As a child, he shows deep interest for drawing. His Puerto Rican mother and his Haitian father notice his precocious artistic capacities and encourage him to paint and draw. His father is an accountant and often brings back from work stacks of paper for his son, which the boy fills up, as well as numerous sketchbooks, with drawings. His mother loves Art and takes him regularly to the Brooklyn Museum, the Museum of Modern Art, the Metropolitan Museum of Art, all the while encouraging him to develop his own talents.

In 1967, Basquiat is sent to a private catholic school, where he becomes an avid reader, devouring texts in English, Spanish and French. With a schoolmate, he works on children books illustrations. He also likes to draw inspiration from Alfred Hitchcok's movies, and from automobiles and comics. That same year, while playing ball, Basquiat is run over by a car, and spends some time in the hospital. His mother brings him, as a get-better present, an anatomy book entitled *Gray's Anatomy*, which will be a major influence in his artist work later, fed with a number of pieces on human anatomy, and which will even inspire him the name of his band, "Gray". Years later, in an interview, Basquiat will acknowledge his mother's influence: *"I'd say my mother gave me all the primary things. The art came from*

her." 1967 is a pivotal year. His parents break up and decide that their son and two daughters are to live with their father. In 1971, Basquiat leaves his private school for a public one. Later, in 1974, when his father's promotion leads them to Mira Mar, in Puerto Rico, the boy runs off for the first time.

In 1976, the family returns to New York, where Basquiat attends the very select "City-as-School", which offers a special program for very gifted teenagers, based on practice and the 'learning by doing" method. Basquiat meets and ties a profound friendship with one of his classmates, Lower East Side Graffiti artist Al Diaz. Together, they start covering the walls downtown and the D train with poetic messages, aphorisms and strange symbols, signing their collaborative works - which Basquiat does not consider graffiti – with their fictitious character's name, SAMO (short for "same old shit").

Just a year before graduation, Basquiat sprays the principal with shaving cream during a public address, and is expelled. This time, he decides it's time to leave home, staying at various friends' places.

The "Aha!" Moment

Basquiat spends a lot of 1978 selling his T-shirts and postcards on the street to make money, checking out the wild club scene. At the Mudd Club, downtown, and later at Club 57, he meets musicians and other artists. David Byrne, Madonna and the band B-52 cross his path.

In 1978, the Village Voice publishes an article on Basquiat and his graffiti. He immediately puts an official end to SAMO's activities by painting the message "SAMO is dead" all over the walls of SOHO.

In 1980, his participation in the collective *Times Square Show* gets him real attention from the Art world itself. In 1981, an article by art critic René Ricard and published in *Artforum* entitled *The Radiant Child* launches Basquiat's career.

In 1983, in Soho, he recognizes and approaches Andy Warhol to sells him one of his postcards. Their encounter gives birth to an intense friendship and active collaboration, based on mutual seduction. Basquiat spends entire nights discussing life with his idol. They produce several pieces together. The relationship definitely represents a shift in Basquiat's career.

Into the Art World

Over the next few years, Basquiat is everywhere. His first solo exhibit is in Italy, in 1981, at the Galleria Emilio Mazzoli de Modena, and later that year, in New York, Annina Nosei gives him a show at her gallery. In 1981, he's also at PS1's *New York-New Wave* and in 1982 at Documenta 7, in Kassel (Germany), and the following year, the Fun Gallery includes his works in its collective shows, and he's part of the *Post Graffiti* exhibit at the Sidney Janis Gallery.

Though by then, Basquiat is heavily into drugs, the solo shows add up, and Basquiat makes a habit of working with more than one gallery: the Larry Gagosian Gallery in Los Angeles; the Marlborough Gallery in New York; several collaborations with the Galerie Bruno Bischofberger in Zürich; Mary Boone in New York; Galleria Mario Diacono in Rome; Thaddaeus Ropac in Salzburg; Daniel Templon in Paris; Hans Mayer in Düsseldorf…

Basquiat inspires movies, such as *Basquiat*, by Jeffrey Wright, and accepts a few cameos in *New York Beat Movie*, *Downtown 81* et *Eat to the Beat*. His too short of a career counts almost 100 exhibits.

He was 27 when he died of a heroin and cocaine overdose, on August 12, 1988.

Style

Jean-Michel Basquiat's works are filled with different recurring motifs. Many of his paintings show his strong interest in his black and Haitian identity. His style is original, edgy, violent and lively.

His career can be divided in three main periods, which overlap: during the first one, which can be reduced to 1980-end of 1982, Basquiat paints on canvas, representing mostly skeletons and masklike scrawny characters and faces, as an expression of his obsession with human mortality. He also paints elements inspired by his life on the street, such as cars, buildings, children games and graffiti.

His intermediary period, which begins at the end of 1982 and end in 1985 presents multiple-panel paintings, as well as individual paintings with visible intermediate crossbars, a dense surface with writings, collages, and representations that seem to bear little relation to one another. These works illustrate his identification with historic or contemporary black characters, and the events they were connected to.

His last period, which starts in early 1986 and extend to the time of his death in 1988, display a new genre in figurative painting, in a different style, with sources, symbols and a content that differ greatly from his other bodies of work. The influence of heroin, to which he has become dependent, is palpable. Severed members and multiple deformations of human anatomical elements represent the pain associated with his drug use.

The Beginnings

Of Carribean origin and Jewish education, Aaron Sharp Goodstone, aka SHARP, was born in 1966 in South Bronx and found his place as a teenage writer in Spanish Harlem, attending street concerts and performances, among which that of Grand Master Flash. In that context, he becomes increasingly aware of Harlem's racial tensions. At the beginning of the 80s, with DELTA, he creates the KA crew (the "Kings Arrive") who paint on New York's subway line 6.

SHARP

Date of Birth: 1966

Place of Birth: Bronx

Style: Abstract, futurist, extremely intricate lettering

Distinctive feature(s): variety of techniques (from canvas to wood)

The "Aha!" Moment

SHARP is one of the first style writers to have transitioned to the traditional art world. He's part of the original exhibitions presented by New York's art scene around Graffiti in 1983 and 1984 (at the Fun Gallery, the Kamikaze Club, East 7th street Gallery, Ground Zero Gallery). His talent gets almost instant recognition, and he's only 17 when he's selected for Art Basel's contemporary Art fair. He starts traveling around Europe for various exhibitions, and receives commissions for his work in Stuttgart (Germany), Milan (Italy), and London (UK).

Into the Art World

Though SHARP's artistic success gives him the opportunity to travel and show his work everywhere, he decides to move to France for a number of years, and is

offered exhibits at the National Museum for French Monuments in Paris, and at the "Leonardo da Vinci" National Museum for Science and Techniques in Milan. In the following years, his works are presented throughout the world, as part of group and solo shows, from Paris to Lille, Berlin, Oxford, London, Milan, Amsterdam, New York and Tokyo.

After spending 10 years in Europe, SHARP moves back to New York where he invests in the fashion industry. In 2002, he opens an art gallery in the Lower East Side. He is occasionally invited as a curator for the ANDRÉ Diligent Museum of Art and Industry in Roubaix (France). His works are part of the permanent collection of the city of New York Museum, or featured in private collections (ie. agnès b. or Count Enrico Marone Cinzano in Italy).

Style

SHARP finds strength in his multicultural background, conceiving works which are both abstract and symbolic, motivated by a number of issues, such as Native American culture, or religions. Of his Jewish education, in which figurative representation is not found, SHARP has kept a taste for symbols, and every letter of his alphabet is heavy with meaning. In addition to his Hebrew studies, he explores Greek, hieroglyphs, etc. For SHARP, spray painting on walls is comparable to hieroglyphs and represents real knowledge and actual lifestyles. SHARP is the inventor of a specific Graffiti style, known as Techno Abstract Symbolism. His lettering proliferates in ways that are elegant and Wild Style oriented. SHARP explores the tension between his letters, making them hard to decipher, creating a visual metaphor for life's energy. The rhythms he imparts to his drawings, his canvas painting or letterings cut in the wood itself, give an impression of constant movement.

Rhythm is essential in SHARP's work. He admits to music influencing him in large amounts, from Rap to classical music, from French Aznavour to Belgium Jacques Brel.

SHARP admittedly finds in Graffiti a vital form of communication. In his works, he strives to offer his viewers the feelings he encounters himself, weaving them in intricate lettering, to the point of abstraction.

Fuck it nigga, painting and mixed media on canvas, courtesy of
the artist, **Sharp**

The Beginnings

Boris Tellegen was born in 1968. He starts graffiti in 1984, tagging his alias DELTA: *"I chose my name in the 80s. I chose the name DELTA, because I thought it sounded cool and. At the time, Transformers were on television and rappers were called Captain Rock, Flash and the Ultramagnetic MCs. (…) I'd had a couple other names before that, but I wanted a new one. I saw that DELTA stood for D in the Greek alphabet. I thought it was fitting to choose a letter from the alphabet as a name for something directly linked to letters"*. In 1994, he graduates from the Faculty of Industrial Design at the Technical University Delft (with a degree in Industrial Design Engineering), but decides not to pursue a career in that sector, fear of having to sit in an office his whole life. He does give a lot of credit to his school training in regards to his work as a Graffiti artist. DELTA is considered one of the European Graffiti 3D pioneers.

DELTA

Date of Birth: 1968

Place of Birth: Amsterdam, Netherlands

Starting Point: 1984

Style: Abstract Constructivism

Distinctive feature(s): European 3D Graffiti pioneer; sculptor, painter, writer

The "Aha!" Moment

His original graffiti and 3D are pretty standard, which his (continuously updated) sketchbooks show. But his experimentations on paper steer him towards drawings that become increasingly surprising and abstract, in terms of 3D. Since then, DELTA has mastered his style and is now often referred to as THE grand master of constructivist graffiti.

Into the Art World

His first US show, in 2000, was titled *New Constructions*. Delta's fine art paintings and sculptures have recently been exhibited in Singapore, Malaysia, London, France and Italy. He has also produced work for musicians such as Linkin Park, Dj Vadim (Ninja Tune), Rima Project on Jazzanova Compost Records, Dub Records and Alex Cortez. He's developed, more recently, video games, in which he's been able to express other sides of his creativity.

Style

DELTA is proficient as a sculptor, Graffiti writer and painter. And even if writing is admittedly not his unique priority today, he still considers that lettering remains at the core of all his creations, even the most abstract. In time, DELTA has developed a style that is complex and unique. In his works, paintings and sculptures, he toys with architectural structures, multiple levels and futurist engines. His influence is major in regards to 3D lettering, and in that respect, to a great number of writers throughout the world. Today he creates amazingly intricate paintings, prints, 3D sculptures, video works and installations that bear a strong connection to his Industrial Design Engineering studies and to the Constructivists. In his own words, his pictural constructions look for a certain tension, giving the impression everything constructed might collapse at any time. His creative process varies. In works around one of his themes (*how everything rots away, eventually*), he uses his own pencil drawings which he then prints out, layering them over new drawings, adding a certain energy that is both rooted and random. In other works, DELTA explores the notion of diversion, his motifs hiding completely the initial lettering in an architectural and dense construction, which allows him to divert the eye and go beyond the lettering itself. Usually, DELTA sprays his outlines and fills them up using brushes. He's also developed a body of work around robots, honoring his years of youth. His video work also explores architectural 3D, bordering on a personal sci-fi sense, accumulating shapes, invading space in the same way graffiti organically invades the city.

DAIM

Date of Birth: 1971

Place of Birth: Lueneburg, Germany.

Starting Point: 1989

Influence(s): LOOMIT, MODE 2, Dali, Van Gogh

Style: Colorful 3D graffiti

Distinctive feature(s): 3D optic illusions that seem to emerge from the wall.

The Beginnings

Mirko Reisser, aka DAIM, was born in 1971 à Lueneburg (Germany), near Hamburg, where he moved when he was three years old. He discovers Hip Hop in 1986 in California and is particularly fond of Rap music. In 1988, he deejays a little bit before trying himself out at graffiti, in 1989, with some friends. He's 17. *"At that time we had somewhat of a "hype" [in Germany] so a lot of graffiti was going on. We had LOOMIT, CEMNOZ, BANDO, SHOE and CAN TWO and 'Subway Art' and 'Wild Style' and all of that influence through films and books".*

During the following two years, he attends school while making legal and commissioned murals on the side, and obtains his first gallery show in 1991. In 1996, he leaves for Lucerne, Switzerland, to study art, for two years. *"By the time I finished school, I was already making some money with graffiti, so I never really had to work a 'normal job', for some company or something like that. I had a lot of support from my parents, who were always behind me and I was lucky enough to stay with them until I was 25."* DAIM's influences are not so much from New York as they are European, *"because I wasn't "old school." The old-school writers in Europe, they looked to New York; they saw 'Wild Style' and read 'Subway Art' and 'Spraycan Art' and all of those books and magazines… But I was more into the stuff Hamburg offered, and stuff by LOOMIT, CAN TWO and other German writers. And into the Paris scene, with MODE 2, for example. So,*

my influences come from European graffiti. But I always drew and did sketches, and I took art classes so I was influenced by people like Dali and Van Gogh as well."

The "Aha!" Moment

His career takes an international turn in 1998, with a first U.S. show. He also fuels his new-found art world career by spending time with crews, and by organizing events around Graffiti, such as a 2000 m² mural in 2000, in Hamburg's harbor, or the *Urban discipline* exhibit. And he is part of the *Graffiti World Tour*, which takes him to Thailand, Australia, Brazil, Argentina, the United States and Mexico.

Into the Art World

DAIM loves to travel, worldwide, and has participated in about 100 exhibitions, mainly collective ones, in Germany, in Switzerland, in the United States (from San Francisco to New York via Oakland and Miami), in Spain, in France, in Belgium, in Canada, in Australia, in New Zealand, etc.

Style

DAIM is a perfectionist, and questions his work constantly: *"Graffiti also means challenge to me, because I don't want to set my own style as a limit"*. He's spent many years working to grow beyond lettering codes, increasingly steering towards 3D

to the point of bringing his letters off the walls, literally (and not)." *My main goal has always been to make my pieces as realistic as possible. The next step was to sculpt parts of the style onto the canvas. Now I'm done with the sculpting phase of my styles, and I want to complete the circle."*

DAIM's architectural approach gives him a very unique style: *"I look at a lot of architecture, and I'm sure you can see it in my letters, but that's not my goal. I don't want to build houses or anything. That's not where I'm going. I see my concrete sculptures as a model for future large-scales sculptures"* Through the years, DAIM has maintained a strong bond with lettering: *"When you do graffiti, you have to start with typography. You can make a lot strange things with your letters, but a D still has to be a D. You can look at it from a bunch of perspectives and twist it, but you still have to know how the typography has to be. There are certain rules. I concentrate on my four letters, I don't want to make fonts or anything like that yet. My letters are more self-portraits. Each letter is like a figure or a portrait."*

11/50

2009

courtesy of the artist, *DAIM*

The Beginnings

Mathias Köhler, was born in 1968 in Celle, Germany. He's 14 years old when he discovers Hip-Hop culture during a foreign student exchange and starts to tag. He puts up his first piece on a small village water tower. The graffiti is published in a local newspaper his first step towards his talent recognition. *"When I started, there was nobody else but me and a scene as we know it today, started forming in late 1984 in Munich."* That same year, young Mathias moves to Munich before choosing, in 1984, his alias LOOMIT. To be honest, Mathias chose his name in reference to the 50s movie *Niagara*, and a character named Loomis, but *"I couldn't tag a proper S at the end, so I chose the next letter of the alphabet, T."* Slowly but surely, he absorbs the Graffiti culture, as it reaches Germany. *"I just heard of Graffiti, there were comic-book artists at that time, but in November that year 'Wild Style' aired on TV, so I started with LEE, ZEPHYR and DONDI".* He introduces a first hall of fame in Munich, paints his first trains and travels to Dortmund, Amsterdam and Paris, contacting and meeting other writers.

LOOMIT

Date of Birth: 1968

Place of Birth: Celle (Germany)

Starting Point: 1983

Influence(s): LEE, ZEPHYR, DONDI

Style: Arabesques Complex

Distinctive feature(s): Intricate narratives

The "Aha!" Moment

1987 is a dark year for LOOMIT, with a heavy lawsuit, at the end of which he's condemned for his graffiti. He goes to New York for the first time, where he meets Henry Chalfant and SEEN, be-

fore taking a number of trips around the world that will inspire his evolution through an incredible number of pieces. In 1995, he begins his training as a tattoo artist with SEEN, in the Bronx. When he returns to Germany, his pieces are simply striking. His first solo show takes place in Darmstadt, in 1996. He's 23.

Into the Art World

LOOMIT's path is filled, above all, with encounters, travel and exhibitions shared with other writers such as DEER, ZEPHYR, TWIST, Phil Frost, OS GEMÊOS, etc.

His main shows are in Germany during the 80s and 90s, but he also gets a number of opportunities in Canada. As of 2000, he's invited to Italy, Switzerland, England, Brazil, etc.

Style

Considered the star of German Graffiti, LOOMIT is known for his arabesque style, to which he's added, through his various periods, human, animal or imaginary figures, always executed with surprising precision. Demons, giants or dwarves come to life among complex letterings. Each one of his murals reveals a mysterious scenario from which fantasy narratives are born. The numerous influences collected through his travels lead him to 3D, by the mid-90s: *"After my crew colleagues introduced me to computer illustrations in the early nineties, and after seeing the first DELTA and DAIM pieces, I took the step towards 3D".* His work is also widely influenced by the tattoo scene. And in his own words: *"Traveling and exercise, that's the fuel.*

JONONE

Date of Birth: 1963

Place of Birth: Harlem

Starting Point: 1980

Influence(s): LEE, A-ONE, BANDO, Jackson Pollock, Jean Dubuffet

Style: Abstract powerful writing and painting; free style

Distinctive feature(s): First writer to go abstract; dense grids combining either letters or shapes

The Beginnings

John Perello, aka JONONE, was born in Spanish Harlem, NY, in 1963. His Dominican parents are thrilled: their baby boy just loves to paint on walls. *"I was the guy you don't pay too much attention to, I used to collect comic books, that was my first passion, but as a kid I did not have passion. Writing my name was like people were not forgetting my name anymore."* Early on, he chooses his tag, adding a simple "One" to his first name. At age 13, he starts getting around, taking the subway up and down and through the city, roaming the streets, visiting abandoned buildings. While his mother thinks he's around the corner playing basketball with his friends, he's actually exploring the world. Or at least a portion of it. *"It was two different lives for me: the one in the street and the one at school where I had to put on a face on for my parents and be the good church boy. Now that I look back it was probably the best fertile ground to grow a Graffiti artist and into what I am doing today. Where I come from there was social injustice, it was the ghetto, with burnt places, vacant buildings. That was decay. You could not walk there as you do now. Civil rights were only the result of years of injustice. Malcom X died 10 blocks from my house. At the time I thought my neighbourhood was the most boring place in the world. It was necessary for me, I would have never been where I am now seen my background. It's been the best school."* He joins the 156 All Starz crew, basically a group of young kids claiming the Broadway/156th Street area. His environment is more

than insecure. JONONE dabbles in drugs, painting at night at an uncanny rhythm, competing with other writers in the New York subway, imposing his name on train cars and, already, standing out from the crowd, with his unique abstract style that, from the start, steered away from classic lettering. In 1984, his friend WEST joins the Fame City International Crew, founded in 1984 by THUD (PHIL 167), JEL (WASPY), RAZZY RAZ, AXE, SLIN 2, C.W. (CRAZY WHITE-BOY) and BRONX STYLE BOB, which JONONE also joins soon after.

The "Aha!" Moment

Painting in the street, JONONE used to hang out with ERO, who got a show at the Fun Gallery with BASQUIAT. The connection inspired him greatly, and encouraged him to work even harder. *"I felt I had to train to become an artist. And then one day, I finished a train which I'd done by myself and I thought 'Jon, you finally have what it takes. I held on to that flow, it gave me the strength to become an artist."* Sure, switching to canvas was also a consequence of MTA's repression in the 80s, but he admittedly wanted, from the start, to see his artwork live beyond the street, beyond time constraints.

Into the Art World

JONONE's path crosses that of an art dealer. Specializing in Miró, Frank Stella and Lichentstein, he encourages to continue painting and to find his own personal voice. In 1987, French Graffiti writer BANDO notices his unique style on a few New York trains and calls his mom's house to introduce himself. A couple of joints and a few beers later, the Parisian has convinced the New yorker to come to France. *"During those days, I couldn't help but wonder… How had other artists, like Kooning ou Monet, managed? They'd all been through rough patches, times of pain. So I started exploring things outside of the Graffiti scene. I checked out art exhibits, I went to the Louvre."* One thing leads to another, and he eventually decides to stay in France, setting up the 156 Crew European branch. JONONE then starts painting with BANDO, LOKISS, MODE 2, SHRINK, FUTURA 2000, O'CLOCK, POPOF, KONGO, etc. on the fences and walls of Paris.

JONONE gets his own studio in the early 90s, at the Hôpital Éphémère, and gets his first show in Berlin. Over the years, his work is exhibited in Paris, at Michel Gillet, Magda Danysz and Agnès b. and at the Swiss gallery Speerstra in the 2000s. From then on, his career soars, and shows add up, taking him from New York to Shanghai. In 2009, he's featured at the Cartier Foundation Graffiti retrospective, *Nés dans la rue*, in Paris.

Style

JONONE is by no means a classic Graffiti artist but, more than anything, a great painter. Somewhere between the American abstract expressionist Jackson Pollock and the French painter and sculptor Jean Dubuffet, he evolves in various styles that remain, despite the references, very personal.

JONONE's work is dense and luminous, with an energy that he's been drawing from his street education. In his early works, his paintings are heavy with layers, resulting in a patchwork of colors inspired by his Domingo origins, and his subway activism. *"I have a vision of a train shooting out of the tunnel. With speed, all you see are trails of colors."* Close to the action painting movement, the technique Pollock was fond of, he also borrows from the artist his famous "dripping." Over the years, his pieces work their way to the essence of painting, through various periods, among which overloaded compositions, big color spreads and the "bones" that weave themselves onto the canvas.

Color is JONONE's quintessence. He's a great colorist, exploring a rich and lively palette, with tones and contrasts that reveal subtle sets of nuances in which a harmonious composition reveals itself to be as spontaneous as it is moderate. Shaped are formed, come loose, but his flexible stroke is precise. Each painting is an abstract improvisation, the liveliness of which conveys an inner love of life. He draws a certain parallel between his painting and musical composition, and free jazz in particular: *"Jackson Pollock meets Ornette Coleman, the inventor of free jazz. My approach is the same. I compose in an unorthodox style to obtain an energy, in an abstract way. It's a more personal style, I want it to touch people. I feel in a way that what attracted me in painting was freedom. I was educated in a very strict American system where you have to have a degree, etc. When I started to do graffiti though, I found out that the system was the same, you had to do things by the code: you had to paint letters in order for it to be Graffiti. It was the same type of conservatism I was trying to escape. That's why I started free style. I was part of the first generation of artists who didn't want to fit the very strict code of Graffiti mold (with letters and bboying). Then came the other generation with more freedom."*

In this space of freedom he allows for himself, JONONE develops series of extreme variety. Among those, there's one that repeats infinitely, in an apparent writing style of its own, his tag, and another that explores ying and yang-like shapes. Sometimes his style reaches out to his family origins: *"My productivity is a meditative ritual, a spiritual journey"*. The most common denominators to all his pieces are both his colorist talents, which give a stained glass quality to his compositions, and the double-reading grid that combines a raw, energetic layer with an intense detail phase that reveals his fierce concentration.

Acrylic canvas, 2008, courtesy of the artist, *JonOne*

Previous page:
Acrylic canvas, 2008,
courtesy of the artist, *JonOne*

Left page:
Hôpital Éphémère, 1992, acrylic canvas, courtesy of the artist, **JonOne**

Right page:
Acrylic canvas, 2008, courtesy of the artist, **JonOne**

This page:
Acrylic canvas,2009, courtesy of Magda Danysz gallery,
JonOne

Next page:
Acrylic canvas,2009, 200x600cm, courtesy of Magda Danysz
gallery, *JonOne*

ASH

Date of Birth: 1968

Place of Birth: Portugal

Starting Point: 1983

Influence(s): Marcel Duchamp, Jean Dubuffet, Robert Rauschenberg

Crews: BBC

Style: Futurist; graphic

Distinctive Feature(s): Accumulation of elements; Mixed media and techniques

The Beginnings

Victor Ash, aka ASH, was born in Portugal. In 1972, his family leaves the Portuguese countryside and moves to the Parisian suburbs. His after-school free time is spent watching a lot of Japanese mangas (cartoons), or opening up his toys to unveil their mechanical secrets and to build little devices of his own. As a teenager, immersed in the electro-funk and Hip Hop scene, ASH gets introduced to the early Parisian Graffiti scene, heavily influenced by New York Graffiti itself. Understandably eager looking to stand out, he creates the BBC (Bad Boy Crew), with JAYONE and SKKI and earns his ticket into the writers competition that is raging around Europe. Between 1983 and 1986, he uses the names SAHO and ASH2. His work is photographed and published by Henry Chalfant, in Spraycan Art. He finds his inspiration in the underground parties he attends, surround by BLADE Runneresque decorum, as well as Paris tunnels and abandoned factories...

The "Aha!" Moment

In 1990, French fashion designer Agnès b. invites ASH, JONONE, JAYONE, SKKI and a few other writers to participate in her Galerie du Jour's new show entitled *Les Peintres de la ville* (City Painters). The exhibit is an important stepping stone in his career. He settles in a studio and focuses on canvas painting, extend-

ing well beyond the New York style and developing a more personal esthetic vision. He also studies the work of such recognized artists as Marcel Duchamp, Jean Dubuffet, Robert Rauschenberg, Jeff Koons et al, looking for inspiration to his own style. And in 1991, he is featured in the *Graffiti: Artistes américains et français*, 1981-1991 exhibit at the Musée National des Monuments Français in Paris and at the Schering Kunstverein and Lebendiges Museum in Berlin.

Into the Art World

Once it's launched, ASH's career takes him all over Europe. His work is shown in Berlin in 1991, both at the Galerie Gleditsch 45 and at the Gallery Exhibit, and in Paris in 1992 at the Magda Danysz Gallery. In 1995 he moves to Copenhagen, where he regularly presents his work, whether at the Taastrup Kulturcenter, the Senko Studio in Viborg, or the Galerie Mogadishni, and paints several large public space murals. He also travels frequently to Berlin for shows, and the city even commissions him a 700-square meter (7500 square-feet) mural.

Style

With his upbringing in Portugal's countryside and Paris suburbs, ASH has been confronted to different environments and contrasts, which he cultivates in his works. In his pieces, abstract backgrounds meet head-on with highly realistic everyday items that aren't necessarily connected, but always precisely executed. The shapes he likes to integrate into his paintings are the result of both organic and mechanical elements, like items from a tool-box that combine together to develop an authentic and personal visual language.

In terms of references, ASH equally uses elements from past, present and future, emphasizing formal contrasts. Science, communication, technology, architecture, graphic design, photography and design are his many sources of inspiration. ASH sees himself as a chameleon, mixing traditional canvas painting with collage and stencil techniques.

In a process similar to that of a DJ's, he mixes all his surrounding elements, and music is actually bears its strong presence in his work, if only as a soundtrack during execution itself. Lastly, while his universe is highly graphic, ASH prefers using simple colors.

Next double page:
Rayon n°2, 150x150cm,1993, courtesy of the artist, *ASH*

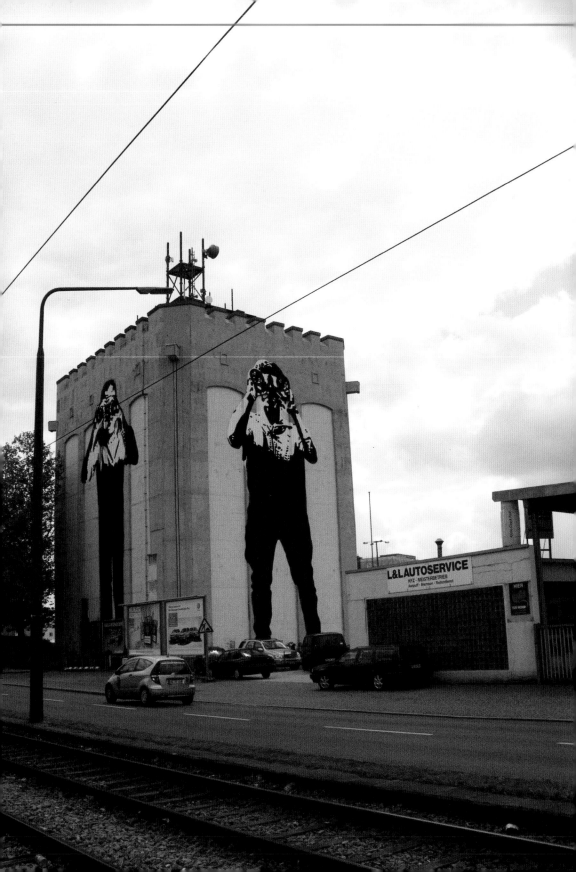

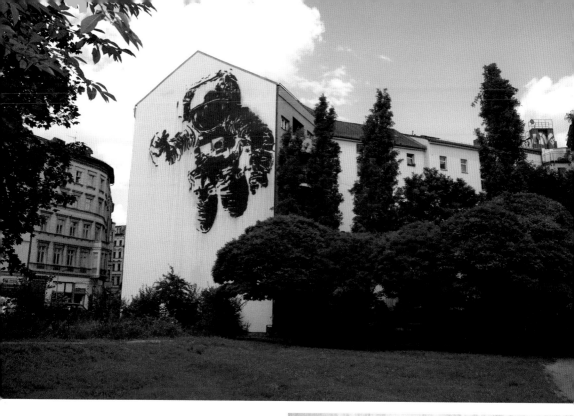

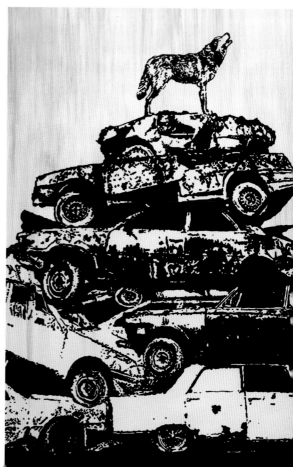

Left page:
Look at me look at you, wall in Brennan, 2009, courtesy of the artist, **ASH**

From top to bottom, right page:
Astronaut Cosmonaut, wall in Berlin, 2007, courtesy of the artist, **ASH**

Car Mountain with Wolf, acrylic on canvas, 135x200cm, courtesy of the artist, **ASH**

The Beginnings

Jay Ramier was born in 1967 in Morne L'Eau (Guadeloupe), but raised in France. His schoolteachers are quick to recognize his potential, although he admittedly never enjoyed drawing that much. By the time he's 13 and in Junior high school, though, he starts drawing constantly, finding pleasure in his first influences, alternative comics and their wealth of punk rock and funky images. He picks up on Street Art's early Parisian tremors, and is particularly fascinated by BLEK LE RAT's stencils. In 1983, he gives the street a try, and puts up his own stencils with SKKI, his technical drawing classmate.

Hip Hop swirls over Europe and television in 1984. JAY's first Graffiti can be seen in his neighborhood, near Jaurès and Stalingrad, an area that will become legendary for its importance in the debuts of European Graffiti. He also invades the Trocadéro, where all the first local breakdancers are getting together, and where he meets ASH.

With SKKI, his partner in crime, he also starts writing around the Louvre and the Palais Royal, where BANDO and BLITZ of the Alpha Force crew are already putting up their pieces. Paradoxically, for JAY, tags come later, on his way to school.

JAY

Date of Birth: 1967

Place of Birth: Guadeloupe (French West Indies)

Starting Point: 1983

Influence(s): BLEK LE RAT, LEE, Bill Blast, A-ONE, Jenny Holzer, Richard Prince, Raymond Pettibon, Kenny Scharf, John Ahearn

Style: Neo-classic influences

Distinctive feature(s): Caribbean

These training years are crucial: *"I was lucky to begin with graffiti. I don't think I could've handled being taught art in one of those fine art schools like the Beaux Arts, where usually the teachers do art while students are watching. In music, painting, dancing, there's no better way to learn than by actually practicing the art itself, and I got to do that with Graffiti."*

The "Aha!" Moment

In 1982, JAY starts, with SKKI, the "Bad Boys Crew", which will continue to occupy the European graffiti scene for decades in the making. And while JAY sees his career as one long progression over ten years or so, it is unmistakably at this moment that the premises of his unique style emerge.

JAY considers that *"there is no difference between a so-called "artistic career" and what is done "outdoors". Sure, there are differences in how you approach things, but a painting remains a painting, whether it's on wood, in a club, a church, or on a canvas that hangs in a studio or a squat."*

During the 80s, as a teenager, and beyond his graffiti, he's given a number of commissions for paintings by nightclubs, before getting his first exhibit in 1989, in Berlin.

Into the Art World

Based in both Paris and Berlin, JAY starts piling up art shows worldwide, finding legitimacy. In 1992, his work is at the Magda Danysz gallery, in Paris, where he comes back three years later for a show at the agnès b. Galerie du Jour. In 1997, he receives an invitation from the Tourcoing's Museum of Modern Art in France, before heading to New York, Tokyo, Italy, Berlin and Hamburg.

JAY and SKKI also complete a number of urban installation projects, such as the "Subjective Objective" neon tag installation neon that is up on one of Copenhagen's squares, in Denmark, in 2003.

Style

Berlin is doubtless a great influence on JAY's career. He sets up his studio there, developing his technique, being inspired by the construction of the Wall, and its Fall... In New York, he meets RAC 7, as well as MEO's mother, and their conversations on Haitian art will definitely bring structure to his work, though he doesn't feel that way: *"I don't really own a style... But my approach before starting any piece is to be very simple, smart, direct and avoid easy repetition. Something close to DADA".* But, in time, JAY's soft, dreamy, colorful designs, reminiscent of camouflage patterns filtered through graffiti style, become his trademark.

Other influences on his work are found among artists such as Jenny Holzer, Richard Prince, Raymond Pettibon, Kenny Scharf and sculptor John Ahearn, or within the Graffiti world, with artists such as DOZE GREEN, SKKI, JONONE, TKID, LEE, TOXIC, SHARP, A-ONE, all for different reasons; some inspire him in their approach to painting, and others in terms of technicality, craftsmanship, themes, or by giving him advice he's grateful for.

Critics have called him a "Black Picasso". *"Not being of those who are technically skilled, I find, in this battle against canvas and pigment, the necessary energy to give soul to my works. It's humanity in all its greatness and weaknesses, much like the Jazz motto: Blood, Sweat and Tears."* Jay qualifies his style as *"neoclassic because what I do is paint, and because I use color. Today I use shapes and elements from classic and modern painting. Before that, it was about Graffiti in the purest sense of the term. But my works are, in fact, very simple, without predicament. They are instants, moments in time taken from life itself... inspired by movies, cinema, or pictures. Painting is used to give these moments rhythm, to infuse character into the actors in my paintings."*

His works integrate broken structure shapes in which he hides his lettering and stages characters of his life. Lanky silhouettes, with a certain soft quality, are sometimes filled with smoke, like witnesses to life and its difficulties.

"Paintings are social in the way that they portray the reality of the artist and his environment and brings it into institutional spaces such as galleries and museums, where such a reality has never found a place before. You finally have to face a different view on... call it Negroes, the ghetto, Hip Hop... the lower or popular class of society... "Conscious of the fact that there are, today, very few West Indian painters, he also likes reminders of his Caribbean origins.

In addition to music, and because of his long love for music, JAY has recently been exploring the video medium. *"I like to think of myself as a painter, as I don't have the average knowledge and skills of graphic design. I enjoy outdoor graffiti or painting canvases in my studio. Lately I've been exploring the field of music, making and directing videos."*

Always questioning his own practice, JAY has started a movement, which he calls "the Re-formists" (and not Reformists), for artists who like and master drawing, but remain open in their use of techniques or technologies in order to realize their vision. *"It is the new school, in an old-fashioned way."*

Detail of a sketch, courtesy of the artist, *Jay*

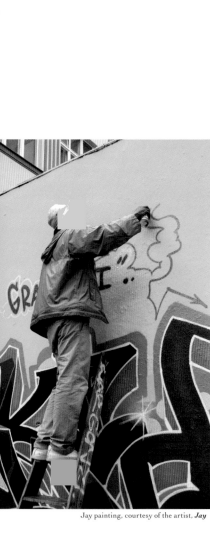

Jay painting, courtesy of the artist, *Jay*

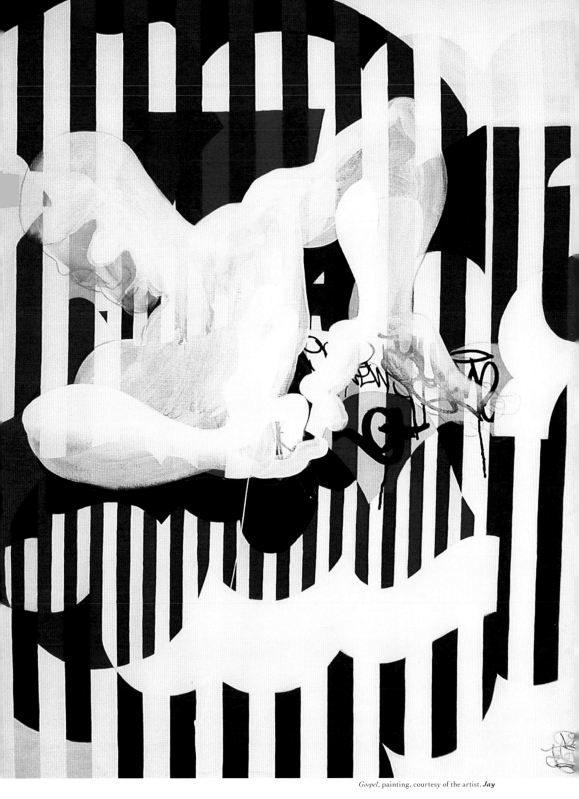

Gospel, painting, courtesy of the artist, **Jay**

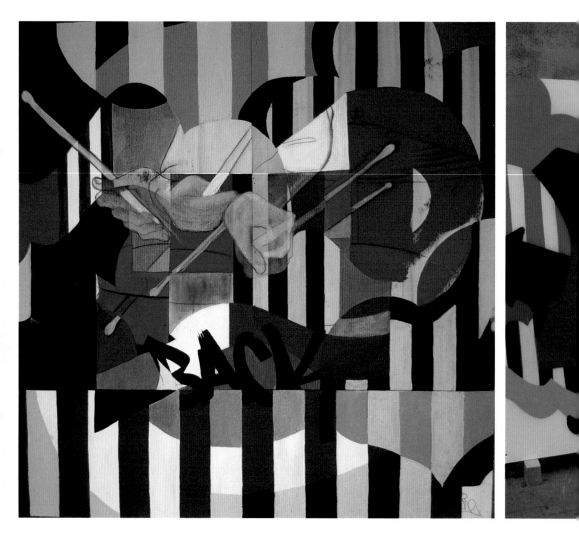

From Left to right:
Courtesy of the artist, *Jay*

Hiromi, Barcelona, courtesy of the artist, *Jay*

The Beginnings

SKKI is an artist of Polish descent, born in 1967 in Paris. He started with stencil art, and used to refer his esthetics to that of electronic music band Kraftwerk. His pen name, as he likes to call his street alias, comes from "Ski," a nickname given to him by classmates, because of his unpronounceable Polish name. He added the second K for tagging purposes and, later, © for "copyright" when he got around to incorporating his name as a label, specifying that *"the use of pen names is very frequent in literary or artistic circles... interestingly enough, most Russian revolutionaries also took pen names: Vladimir Ilitch Oulianov (Lenin), Lev Davidovitch Bronstein (Trotsky) and Skki ©!"*

SKKI

Date of Birth: 1967

Place of Birth: Paris

Starting Point: 1983

Influence(s): FUTURA, PHASE 2, Marcel Duchamp, Robert Rauschenberg, Antoni Tàpies

Style: Futurist

Distinctiv Feature(s): Mixed media conceptual graffiti, saturated backgrouds

In those days, he listens to a lot of "post-punk" music and experimental bands from the British and New York scenes. And with JAY, he gets to listen to a lot of funk. His first connection with Graffiti takes place in 1982, as he's watching the video for the Clash's then just released title *This is Radio Rlash* in which FUTURA 2000 is spraying Bronx images. What he now calls a *cultural chemical reaction* changes the way he sees things, and he starts painting in the street. In 1983, he begins to tag his name in the streets of Paris, in particular in the district of Stalingrad, with his classmate JAY, (later they'll create the mythical European Bad Boys Crew, or BBC). They quickly put up his first mural, not far, ironically from

the Parisian version of the statue of liberty. His first influences are PHASE 2 and RAMMELLZEE for their conceptualization of the urban alphabet. He's also very taken by FUTURA and his abstract murals.

The "Aha!" Moment

In 1990, his work is part of the *Painters of the City* exhibit, at agnès b.'s Galerie du Jour in Paris. And that same year, he has shows in Berlin, at the Lebendiges Museum and at the Gleditsch 45 gallery, in addition to being among the artists presented during the emblematic Musée National des Monuments Francais exhibit entitled: *Graffiti Art - French and American Artist, 1981-1991.*

In 1992, he's back in Paris for a show at Magda Danysz Gallery, another one at the John Lackmech Gallery, as well as at Espace Capon.

For SKKI, Graffiti is, admittedly, not a purpose in itself: *"I originally wanted to get recognized by a certain cultural environment, which I didn't belong to"*. He sees this phase as *"a platform of departure, a Genesis. Naturally bound art's prehistory, in the way it was done spontaneously and 'free of charge', with modest means to catch the crowd's eye quickly and massively as people roam from point A to point B in their monotonous urban space. By successfully showing my work for the first time in a gallery I had managed to finally open of the doors to the cultural world I was so eager*

to address". Despite all the contradictions and the doubts brought by his transition to the art world, he begins a career that is both connected to Street Art and to SKII's profound questionings.

Into the Art World

SKKI's career takes off at the speed of light in the 90s, from Paris to New York and Tokyo, by way of Berlin or Copenhagen. He's in a great number of group shows in galleries and in public institutions. His work is also published repetitively, in Henry Chalfant and James Prigoff's *Spray Can Art*; in *Paris-Tonkar* by T. Ben Yakhlef and Sylvain Doriat; in *Spray City, Graffiti in Berlin*; or in *Writing the Memory of the City* by Mr Mai and T.Wiczak.

He completes, in parallel, several important projects, such as *Objective/Subjective*, a 15 meter circumference mural, produced with the BBC in 2003 in Copenhagen, creating neon tags for the first time, and mixing electronic music within the visual installation.

SKKI's very involved with the alternative Berlin scene, which he feels close to. Remembering his early years there: *"The Wall was a tremendous ground for expression, almost as much New York's subway, but with more of a Euro trash spirit, kinda like free figurative. On the wall, you could write almost freely really, as opposed to the trains you had to sneak into at night. The western police could tell*

you to leave, but they couldn't arrest you if you were less than 2 meters from the East German part of the wall".

Style

Over the years, SKKI has explored different paths, questioning both painting as a practice and society itself depending on the series.

During the 80s, SKKI defines himself as a *Conceptual-graffiti artist* and mixes in his murals futuristic esthetics and increasingly present statements. In the 90s, he takes a crack at canvas, with series in which he mixes painting paint, collage and lettering, with an interest in human nature. Later, in the 2000s, he also develops an esthetics of words, with convex sentences which he adds on the outside and on the inside of his pieces. His striking messages address the public, calling out for attention: *You don't see graffiti as they are. You see them as you are.*

SKII follows the "less is more" principle, choosing his words carefully or bringing beauty to a working surface by projecting pigments on a canvas... Andrei Tarkowski's cinema, at the end of the 80s, is influential is his approach to backgrounds, which he saturates with tags before creating a new work on top of ruins. And before getting to work, SKKI always studies attentively his environment, in terms of outdoors architecture or interior space structure, eager to work in symbiosis with what will surround the piece.

In his mind, Street Art is above all "contextual" art and he often mentions that his extensive work on walls has created an everlasting bond, making him feel constrained when painting on canvas. He sees his art as a clandestine means of communication bound that connects to a subtle creative language within the urban environment. SKKI defends the idea that Street Art has the ability to express itself with a vocabulary just a diverse as what is considered traditional art, such as Expressionism, Pop, Abstract or Conceptual Art.

Top: Mural, 2007, courtesy of the artist, *Skki*

Bottom: Mural, 2008, courtesy of the artist, *Skki*

Left: Painting on canvas, 87x105cm, 1990, courtesy of the
artist, *Skki*

Right: stretched wool cover, 100x100cm, 2007, courtesy of the
artist, *Skki*

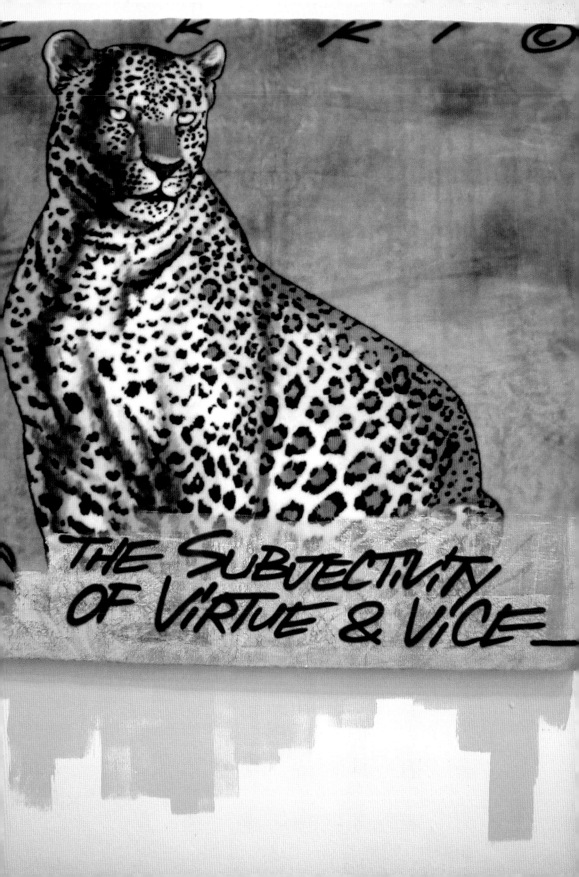

THE SUBJECTIVITY
OF VIRTUE & VICE

The Beginnings

MISS VAN

Date of Birth: 1973

Place of Birth: Toulouse, France

Starting Point: 1990

Influence(s): Mark Ryden, Junko Mizuno, free figuration, comics

Style: Figurative

Distinctive Feature(s): Sexy omnipresent female figure

Vanessa, aka MISS VAN, was born in 1973 (with her twin sister), in Toulouse, France. She's an 18-year old art student when she discovers, in 1990, the Graffiti scene which is pretty developed in her little town. Painting in the street *"came naturally. It was a way of showing that I boycotted the conventional art environment. When I started, you could say I had a somewhat rebellious heart. I also find that painting in the street, because it is forbidden, is a lot more exciting. Painting on walls, you're able to hold on to your freedom, and since it's illegal, there's no censorship."* From the start, in lieu of a classic signature or tag, she chooses a feminine silhouette, which gives her a firm ground to stand on. *"At first, my dolls were self-portraits. There's a very megalomaniac side to Graffiti, and instead of writing my name, I represented myself as one of my dolls."* In time, she takes over the streets, becoming somewhat of a mascot. *"It's a challenge I like to face, the idea my work can be erased at any time, there's something random that I find appealing. It also helps connect with people, and makes my art accessible to everyone."* She develops a quick following, inspires new talent and imitations, defining, despite herself, the bases for a feminine style in Graffiti.

The "Aha!" Moment

As soon as she starts painting in the streets, MISS VAN is instinctively recognized as a generation's icon. Her street legitimacy leads to her first art exhibit, in 1999. She's 26. Unmistakable, her art is also a groundbreaking esthetics, in the way it triggers an instinctive approach to art in the new generations. But Toulouse is a bit too small to contain her dreams, and she moves to Barcelona, Spain, in the early 2000s. There, she finds inspiration, from the people she meets to the places she visits. Her international career takes off.

Into the Art World

MISS VAN's artistic career is, in many respects, exemplary. Every show gives her the opportunity to create a new series, keeping her on her toes in the face of a unique subject that demands constant renewal. Her work is shown in numerous art galleries from Paris to San Francisco by way of Amsterdam, Antwerp, Barcelona, Berlin, London, Milan, Stockholm, New York, Los Angeles, Melbourne, etc. She's also been invited to participate in major institutional projects such as the one implemented by the Kunsthalle de Wuppertal, in Germany, and by the Baltic Art Center, UK.

Style

MISS VAN's work revolves around the feminine figure which can be alternately interpreted as an autobiographical reference to herself, or to her history as a twin. Her early dolls are born from simple graphic lines, with a childlike quality. The shapes are simple and round. Later, as the artist adds numerous details, the line becomes more refined, each one filled with hidden meanings: *"They've grown with me. I'm always sincere when I paint, I don't want to feel a gap between the dolls and, well, me. I really needed to create my own identity, maybe because I have a twin sister, and figure out how to distance myself. Later I didn't feel that need quite as much, and so my process has become somewhat more interiorized, though it also entails a dose of provocation. I've always enjoyed painting a sexy doll in a very inappropriate location. I want people to react."*

While her paintings generally give off an innocent-like quality, MISS VAN's works actually mirror a society that has grown used to conveying provocative, if not downright erotic images. Representative, in more than one way, of her own generation, she mixes doses of display and innerness, inviting everyone to reflect on contemporary questions.

MISS VAN also toys around with a sweet sense of provocation, far from the naiveté of her colors and line. *"Since my subject of work is women, I can't escape exploring sensuality, that can border on the erotic.*

I make a point of never being vulgar. I want my characters to really exist, to find their own personality. Sure, some of my dolls use their charms, in a provocative way, but it's a part of their character. I also like certain ambiguities: woman/child, angel/devil. As long as my Misses have something, I see them as achievements. I want them to be a little disturbing, unsettling, I like that they arouse fantasies. I'm looking for reactions, whichever those are, but I hope that I can derail people off their train of thoughts, help them forget their everyday life."

Her influences come from free representation, Japanese artists, graphic art, animation, pin-up from the 50s, and comics. Mark Ryden and Junko Mizuno have inspired her as well as, in another domain, the Vaugn Bodé comics, created in the 70s.

Over the years, MISS VAN's work has evolved a lot, particularly from a technical point of view. Progressively, MISS VAN is steering away from the line and working on lighter approaches. As she explores the possibilities of reducing the contrast between the shape born from the stroke and the background, she refers to soft focus, an approach found in photography, in which *"everything seems unstable and light, and things become more ambiguous and mobile. The overall effect doesn't refer to illustration, which I don't want my work to be confused with. The comparison is more difficult to draw. Slowly but surely, I've erased the line."*

In the street, MISS VAN creates simple pieces, a mixture of simplicity and logo-types, quick to execute and recognizable. Her characters, whether human or animal, convey a sense of humor in the outdoors context. They create a strong contrast, the first ones because they seem to be praying, or meditating, the second because they are rather strange and unexpected.

In the street and on canvas, MISS VAN develops a strange bestiary, filled with (sometimes) recognizable animals and imaginary idols: *"I call the idols 'soul mates'. They pray, as if they were in the sky. They work well in the street, they're easy to paint and have a very strong impact, but they're not too flashy. I don't want what I paint in the street to contrast too much with the environment, at this point."*

As art critic Caleb Neelon puts it, *"MISS VAN's formula-painting wide-eyed female characters in the street, often on their own and separate from any other graffiti in the area, and usually done in the non-standard graffiti medium of latex paint-hasn't been around forever. Ingenuity and success is often a setup for others to poach, particularly if one's innovation is a novel way of painting something with such instantly accessible and broad-ranging appeal as voluptuous women. So MISS VAN's style and formula were imitated."*

This page and next: Walls, courtesy of the artist, Miss Van

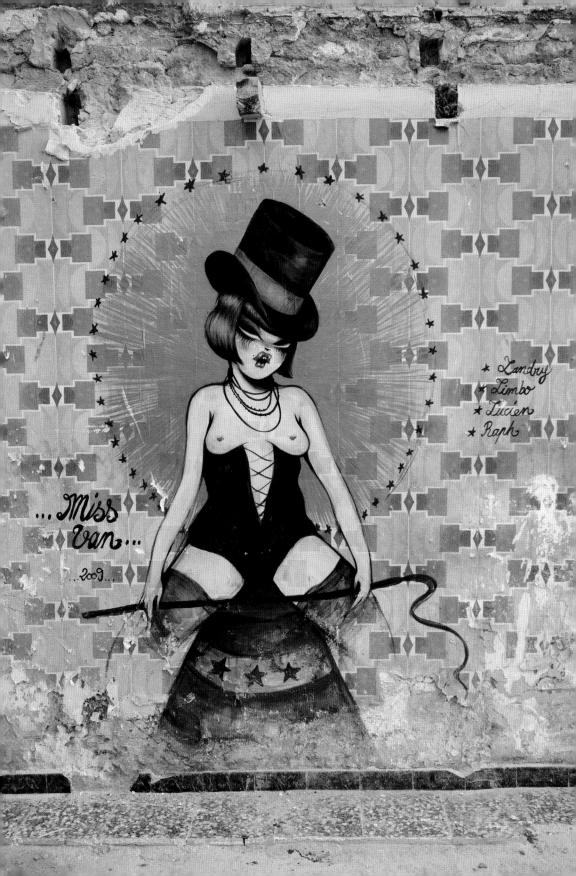

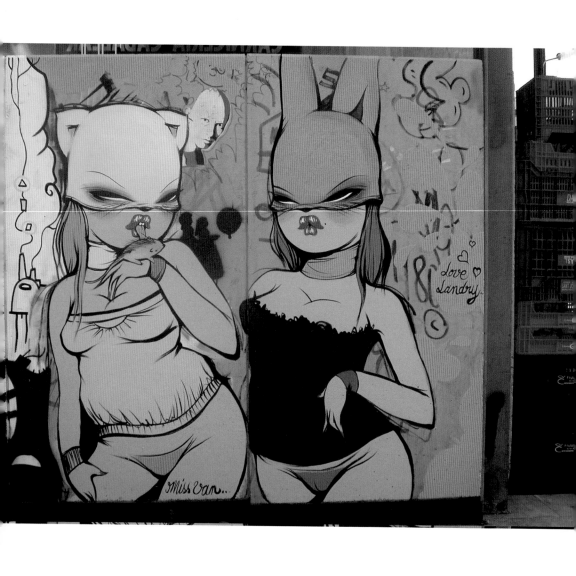

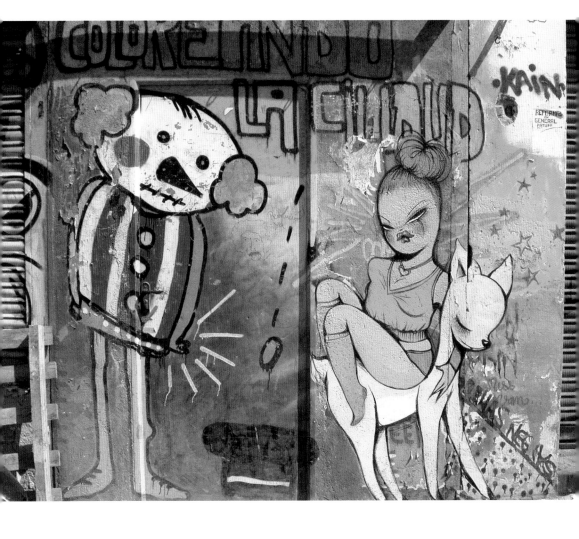

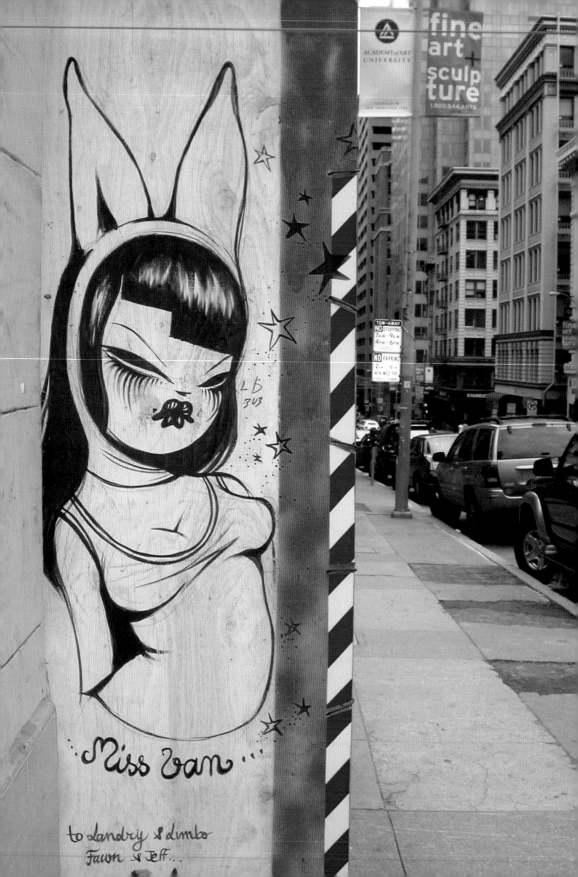

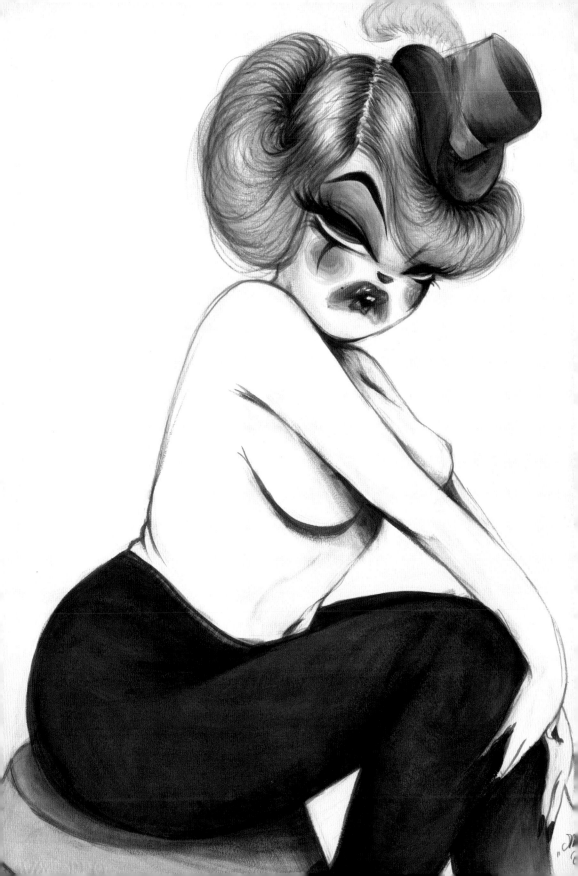

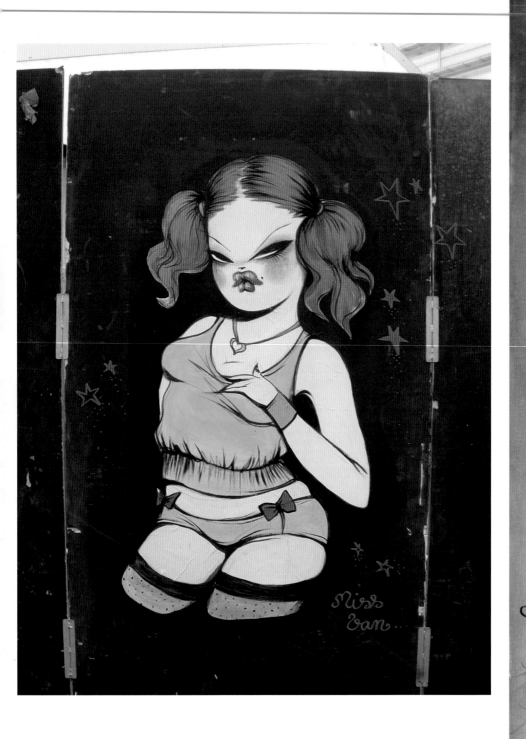

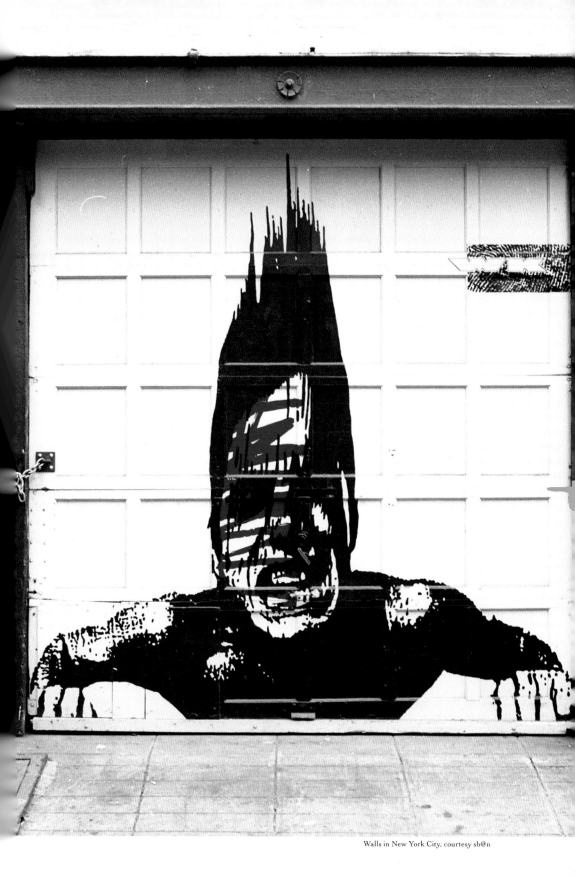

Walls in New York City, courtesy sb@n

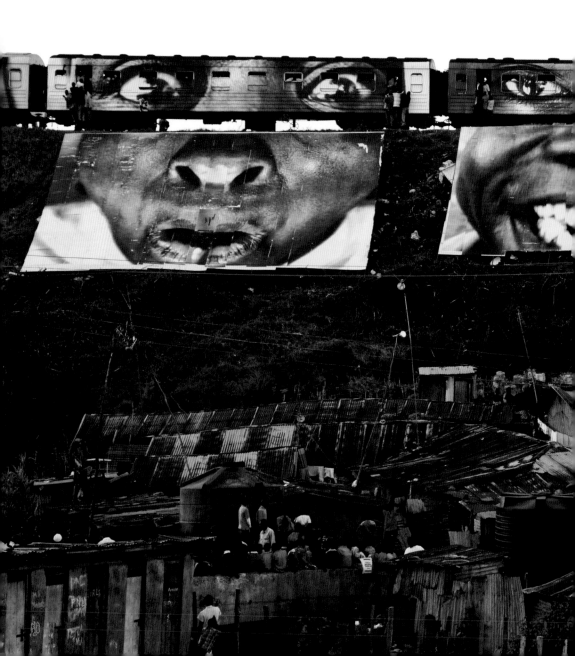

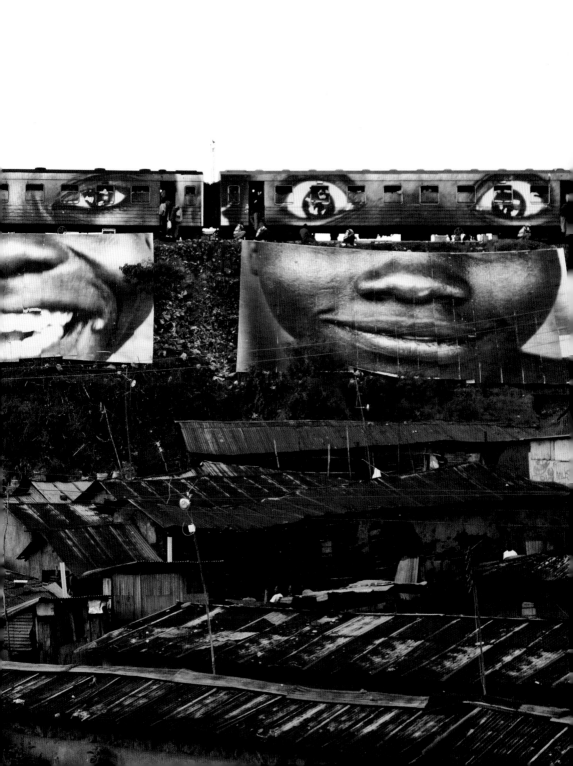

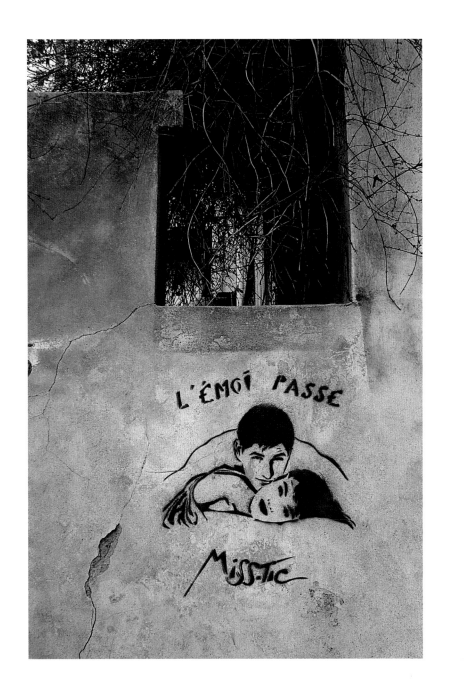

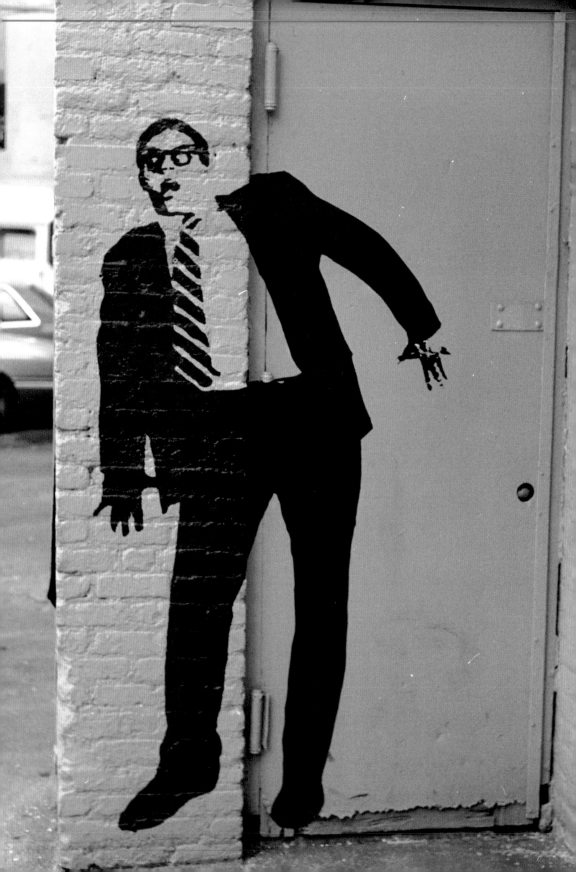

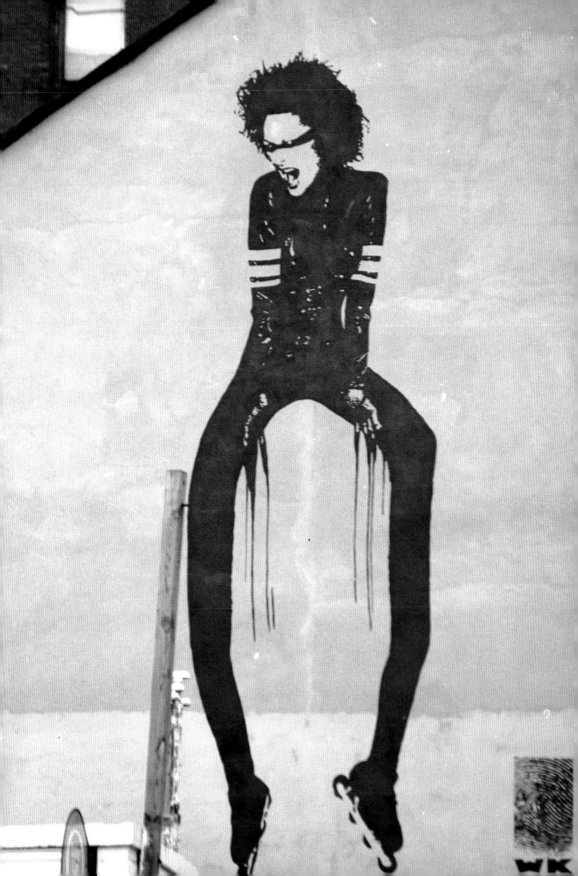

PART 3

The Renewal

For decades, the streets nurtured and hosted graffiti in its now traditional form. But around the 90s, a new creative streak makes it way. Walls find an echo on phone booths, mailboxes, street signs, in every city of the world, as support locations to new forms of expression emerging from the graffiti movement. And while traditional graffiti is still active, the Movement finds a renewed vigor and expands into different orbits thanks to a number of techniques. This unprecedented proliferation is proof of a vibrant and fertile movement.

A first, and a second generation, have come and gone. By the year 2000, the Movement unfolds dramatically onto the world. Its practice has diversified, grown, evolved. It's not referred to as Graffiti anymore, and after some semantic consideration, the term "Street Art" appears. What does it include, or rather, what does it not?

An explosive Evolution

Using the right Word.

The semantic modification is quite revealing, in terms of the evolution of the practice in itself. By the end of the 80s, writers have in some cases stopped focusing on just graffiti and its specificities. Style and technical developments within the movement are such that new paths are explored, branching well beyond graffiti's strict code. Thus is born Street Art, an art movement, graffiti being a mere chapter of this Movement, despite its importance, since street artists usually start with writing.

In essence, let's just say that writing rapidly became graffiti, which then got called, by some, spraycan art and aerosol art, as opposed to those who where using brushes. The term subway art also appeared, as opposed to those who were painting elsewhere. Soon enough, the term Street Art appeared, in an attempt to bring together all those different and mutating practices. Today, the term Street Art seems to be the most commonly accepted, as well as a strong revelator of past, present and future currents.

And of course, like any term attempting to describe an art movement, it's subject to lively discussions.

At this stage, the term Post-Graffiti has also been used by some, but it can be perceived as an awkward attempt to shed light on Graffiti's third generation creativity, even though it technically has very little to do with early 80s graffiti. Granted, it was ironically used in 1984, as the title for a Sidney Janis Gallery exhibit, but Sydney Janis was trying to bring the artistic part of the movement into the spotlights, in order to leave its "vandalism" reputation and image behind. Yet, the term remains vastly inadequate. It doesn't cover all the Movement's ramifications and fertility. And it carries the idea of a timeline, with a beginning and an end to it, as if some fatality was bound to strike. Needless to say, traditional graffiti is far from dead.

Even so, the term Street Art, can be misleading, in the sense that it does not simply include all street production, present or future. Practices born from and/or outside Graffiti offer many ramifications, which in regards to their history or roots, are legitimately part of Street Art. And while the general public and official institutions have agreed to the term, the artists themselves aren't always as consensual.

Street artists come from much wider horizons, whether those be geographical, social or cultural. We've seen how the movement has spread throughout the world since the last half of the 80s, and how it's grown beyond the unique Hip Hop culture. Graffiti artists have developed other passions, among which punk rock or skateboarding. Nevertheless, there are some common denominators to Street Art however it evolves, among which a fierce and relentless sense of artistic freedom.

New Means to one End

Street Art covers an extreme variety of techniques, allowing new approaches that go well beyond traditional graffiti and spray paint.

The emergence of these diverse techniques and ramifications, which cross one another 's paths, marks the end of New York's supremacy. In the United States alone, the West

Coast rises high with the emergence of new talents such as Barry McGee, aka TWIST, in the San Fransiso Bay Area, or Shepard Fairey, aka OBEY, in Los Angeles, with his wheatpasting posters. In Brazil, the twin brothers OS GÊMEOS have also brought murals to a total new level. In Europe, works by ZEVS, SPACE INVADER or even MICROBO also bring fresh new perspectives, conveying an even stronger and more viral character to the Movement than ever.

Ramifications and Origins

A highly repressive Context

Renewed Creativity: within the limitations of the Street Art code, those with greater inspiration grow, try to stand out and find their own voice, within the movement, as well as within their groups/crews.

Acute Competition: originality allows for recognition, and the Internet generates emulation.

Increased Activism: message is the medium.

In a context of generalized war against graffiti, of hasty recuperation by the fashion and entertainment industries, Graffiti encounters, during the second part of the 80s for NYC and in the 90s everywhere else, somewhat of a large crisis.

Only the toughest are able to resist and survive, despite the risks and penalties. The most inventive ones find ways to go around this repression, despite juggling between their need for relative illegality and the decreasing possibilities for self-expression.

At this stage, Street Art has become a worldwide practice. It has spread like a powder trail on the planet, notably thanks to movies like *Wild Style*, fanzines and, from the end of the 90s, the Internet. In the light of exchanges taking place between the Movement's various artists and activists, the fact that this art is a process appears a lot more clearly. The making of is just as interesting as the result.

All this creativity adds to the various messages in Street Art. Is medium the message, or is the message, the medium? Indeed, Street Art's rising generation is, lest we forget, the advertising generation, saturated by publicity in the very same way public spaces are. This worldwide state of affairs incites, in a more or less conscious way, a whole generation to actively defend visual freedom spaces. And this is how, through Street Art, and in the face of an over-consuming society, a form of rebellion is slowly taking place.

During the 80s, Graffiti made it possible to take over locations that the advertising industry paid fortunes for. Yet, at the turn of the 21st century, it also has become a matter of speaking against publicity's omnipresence, as well as against the dangerous turn taken towards a unique model of thought and society's stereotypes. Barry McGee uses characters of limp and disgraceful physical appearances as subjects in his works.

New protesting motivations have emerged, with greater content variety: they are political, ideological, humanist or, yet again, personal. Paradoxically, Street Art has widened its core base as well as its general audience and now includes artists from a wide spectrum of horizons, while more than ever maintaining its commitment.

Within a fueled creativity context and the increasing will to deliver a message, the birth and development of new practices and techniques is worth noting. Street Art brings back to the foreground, or sometimes even sheds a new light on a number of traditional techniques. Let's start with a few short definitions.

Murals: Large paintings executed, legally or not, on wide walls, generally outdoors. Mural frescoes come from an old tradition that is anterior to graffiti. But graffiti's spatial expansion on trains and walls gave birth, very early on, to monumental murals that are still common today.

Street Art Stencil: Lettering or design produced with a sheet of plastic, metal or cardboard that has been cut so that the ink or paint applied to the sheet will reproduce the pattern on the surface beneath. Said surface includes city walls, subway walls, as well as a number of surprising surfaces. Stencil is linked to a very ancient tradition that was born long before graffiti itself, but artists have improved it with the development of street art.

Wheatpasting (also called flyposting in the UK): The term refers to the glue used to put up street posters. Inspired by propaganda postering throughout history, mural postering appeared in Street Art as a response to the time reduction factor that made it increasingly difficult to execute regular painted murals.

Woodblocking: Woodblocking graffiti consists in paintings on small plywood (or other cheap materials), which are then hung in the street on street signs, for example.

Sticker art (also called sticker bombing, slap tagging, and sticker tagging): Street Art form in which a tag, an image or a message are applied repetitively on any surface using a sticker, generally small-sized.

Mosaic tiling: Using strong glue, a design made by setting small colored stone or tile pieces, on a surface. Probably one of the most ancient mural practices.

Street installation: Nurtured by the various techniques mentioned above, Street Art has also given birth to large-sized mixed media street installations.

Video projection/LED art: The use of video projectors or lighting devices to create an artwork on walls or other urban environments.

Murals

Essential to the beginnings of Graffiti's evolution, mural frescoes also bear their own history, which goes way beyond New York in the 70s and Graffiti writers themselves. To put it bluntly, painting started with mural painting, known as parietal art. As far as we can look back, our ancestors left paintings, murals, drawings, etchings, carvings, and pecked artwork on the interior of rockshelters and caves. Those are the first signs of communication and transmission among men. The wall is painting's original support location.

> *"Writing on walls dates back to the pre-historic cave men. Every race of human has the innate tendency to write on walls. Even our very first learning experiences as children in school, trains (…) teach us to write on walls. Can you blame us as we get older if we keep doing it?"* ABOVE, Lisbon, Portugal, 2008

The term "mural" refers to a particular wall painting technique, though, known as "fresco" in Italian. It implies that color is applied to a lime-coated surface. The term "fresco" is most often used as a metonymy in everyday language and designates mural painting in general, rather than the technique itself.

Mural painting reflects the preoccupations of every time period, whether it be as public or private, secular or religious, popular or elitist art. It plays a social, even political role. Mural painting is tightly connected to architecture, its continuation of sorts and in that respect, it uses perspective as its tool towards third dimension. Mural paintings are better at adding value and organizing landmarks than publicity, marking city

entrances, creating visual signs, identifying locations. It enables expression and so-cial connection. It is a popular art, of craftsmanship, both modest and ambitious, and throughout time it has earned the respect and complicity of a large part of the public, while remaining vastly underestimated and often ignored by cultural authorities.

Murals are fueled, depending on the context, by the need to document everyday life, by political activism or, last but not least, by inspiration and pure artistic expression.

Documenting our daily lives: The caves don't lie. And Lascaux is a perfect ex-ample of our human motivations to document our lives, as the walls unfold reveal-ing daily scenes and anecdotes that have proved priceless in our understanding of mankind. This tradition actually continues and examples can be found in Sardinia nowadays.

Religious painting: From Ancient Egypt's Valley of the Queens pyramid to ca-thedrals, religious paintings have always impressed by their sheer size and impact. Religion has fueled an unfathomable number of murals in the glory of God, hence their grandiose sizes.

Exterior decoration: Murals are often used to decorate outside architecture, many examples of which can be found in Africa. In Senegal, the Set Setal movement en-couraged children and teenagers, towards the end of the twentieth century, to paint on the walls of the capital, Dakar. Elsewhere, many cities make their blind walls available for illusion trick paintings, in an attempt to decorate, of course, but also to boost the city's moral.

Tribute and publicity: A lot of murals, beyond their ornamental character, have a commercial aspect and are either a tribute to the city in one respect or the other, or are openly advertisements.
Mexico, for example, uses murals in ways that go beyond artistic purposes, such as publicity, including for major brands that have adapted to this type of advertising, store windows and facades, etc.

Political protest: Depicting daily life events rapidly led to protesting against poli-tics and city organization. In time, painting on walls became a way to cry out, make demands or take a stand in the loudest and clearest of ways. In South America, from the early 20s on, muralist Diego Rivera's paintings mostly covered political issues and, in an attempt to create an overall "American" style, combined Mexican, Native and Eskimo art styles.

Among many other examples, let's take the Berlin Wall in Germany. Built in 1961 to separate East Berlin from West Berlin at the height of the cold war, the wall became a support to flocks of paintings. Most of which disputed the wall's presence itself. Or the revolutionary period of May 1968, in France, during which artists, students and protesters covered the walls of Paris with optical illusion art, or stencils. And in Northern Ireland, murals are extremely common, in proportions rarely reached in other countries, to the point that they've become a part of the landscape, in cities and villages. Although every community has its specificities, those murals share common issues, from loyalist activism supporting the protestant England crown to Republican protest paintings, in reaction to censorship. In Czech Republic, as in other locations, murals can also be a form of artistic rebellion against establishment or against contemporary cultural propaganda.

In all these cases, and whatever the motivation, it seems that murals have always been a potential ground for artistic expression, in addition to in their original and diverse purposes. Mexican artist and famous muralist Diego Rivera may have carried political messages, but he remained a great artist. He was invited to paint the walls of the city of Detroit, and commissioned for a massive painting within the Rockefeller Center of New York. In the French city of Toulouse for instance, mural art is also common and frescoes cover the walls of the city.

Graffiti's ramifications, which took place since the beginnings of the movement, have widely integrated the mural practice in all its variety. Even within Street Art, numerous techniques such as collage, stencil, postering and painting are mixed and matched. Famous artists still strong in murals include such as MISS VAN from France and Spain, NUNCA from Brazil or WEST from New York who is still active with his legendary Fame City crew.

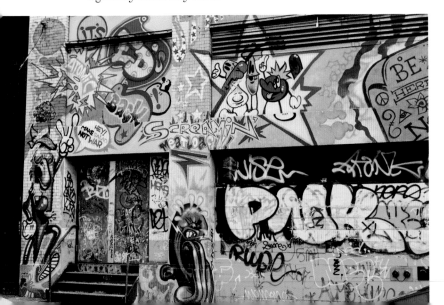

Street Art Stencil

This printing technique (or pictorial technique) makes it possible to reproduce characters or motives on various supports, several times and in a way that is as precise as its outlines. Stencil templates can be made from any material that will hold its form, ranging from plain paper, cardboard, plastic sheets, metals and wood. Color-filled using a brush or spray paint, the cut outline defines the drawing. It has been used for centuries and for a wide variety of purposes (ornamental, educational, industrial, artistic, advertising, descriptive, political or even for mere convenience). Very frequently, it is used for lettering.

Stencil art, by all means an ancient practice, has a drastic anteriority in regards to graffiti. However, with the revival (or development, should we say) of graffiti within the wider setting that is Street Art, stencil has found a new dimension. In some respect, and thanks to some of the artists who have integrated it in their practice, stencil has become, slowly but surely, a legitimate discipline within Street Art. And to distinguish regular stencil from its Street version, it often is designated as "stencil art".

A Stencil History

The origin of stencil probably stems from the technique used by our ancestors to decorate their dark and boring caves. Blowing pigments on hands spread against rocks and walls, they were able to highlight their outlines, in the same way today's children create charming daycare memorabilia. But the oldest example of known stencil takes us all the way to the Paleolithic (30,000 BC to 9,000 BC), when the first stencils were cut from leaves. The Fiji Island natives have been using bamboo leaves as stencils for as long as they remember. Some reports suggest that the Eskimos may have used dried whale skin to that purpose, but there are no traces of that practice today. The Egyptians also used stencil to decorate graves. And in Antique Greece, stencil was used to give directions, indicate murals, or as a base for the realization of large mosaics.

China and Japan (AD500 - 600) have used stencil extensively, for artistic purposes, to create Buddha images or for textile decoration, on silk in particular, with the Katazome technique for example, in the case of Japan. In the eighth century, stencil techniques travel from Asia to Turkey and spread through Europe. By the Middle Ages, they are used for manuscript illuminations, well before the invention of the printing press.

courtesy sb@ny

In the seventeenth century in France, stencil-based wallpaper appears and, later, North America's early settlers save time and money by using stencil techniques directly on the walls, Between 1760 and 1840, traveling craftsmen take their brushes, pigments and stencils with them and decorate one New England home after the other.

In the twentieth century, as early as 1905, stencil finds a new application within the coloring process of films. It also is revived during the Art Deco period in the 20s and 30s.

And at the very beginning of the 70s, stencil finds yet another trend, whether it be for interior decoration purposes, or for political and artistic means of expression as in the many cities going through political protests in 1968.

Stencil in Street Art

Stencil graffiti appeared in the 80s with BLEK LE RAT, often considered as the godfather of stencil art. Strongly influenced by New York's Graffiti scene, but looking for his own singular approach, he puts up his first stencil in 1981.

In the very early 1980s, Graffiti is taking its first steps in France. But some lucky few have been able to discover the phenomenon on the other side of the Atlantic, among whom the painter Xavier Prou. During his trip to New York, then the Mecca of the genre, he's enthused by urban artists and their productions. Back in France, and despite his very formal Beaux-Arts School training, Prou has one single obsession: to take over the streets.

Stencils in hand, he dashes through Paris, covering the walls of the city with his sharp compositions that swing halfway between poetry and activism, and uses "BLEK THE RAT" as his signature name, in reference to "Blek the Rock", a comics character, and to the underground animal he's fond of.

Great stencil artists from the 80s include BLEK LE RAT, Mix Mix, Miss.Tic. Trick, Marie Rouffet, Jérome Mesnager, EPSYLON POINT, Paul Etherno, Hervé Morlay (said VR), JEF AEROSOL, Surface Activates, Midnight Heroes, NUKLÉ-ART (Kim Prisu, Kriki, Paul Etherno, the Laughter of the Madman, the Potaches Pocheurs. In the 1990s, appear NEMO, THE TUMBLER, HAO, ZAO, the collective Splix (PIXAL PARAZITE, SPLIFF-GÂCHETTE), LASZLO, WITCH, MOSKO...

Thirty years later BANKSY, SPEEDY GRAFFITO, Jerome Mesnager, MISS.TIC, NEMO, JEF AEROSOL, BLEK LE RAT, C215, VHILS, 157, HAHA, AND LOGAN HICKS are among the most important.

Stencil is probably the perfect example among the A Street Art ramifications we've seen, which doesn not find its origins in New York. Again, its practice existed long before the birth of the Graffiti movement. In French Stencil collector Thierry Froger's own words, *"Street art is too often seen as a practice quartered in the 80s and in NY while in fact it is only a part of what took place. A lot of interesting things happened in different locations, at different times."*

Stencil is more of a tool than a medium per se, which has given its letters of nobility to something simple and effective that had always existed. It's also disarmingly easy to use, can be prepared in advance, at the artist's studio, and makes for rapid execution in the street, in addition to allowing for extensive repetition (following the tag principle) in order to be seen as much as possible.

However, there's an important distinction to keep in mind between spontaneous street stencils and those prepared in the studio. The first one is cut on the spot, and therefore of rough execution, whereas studio preparation can be compared to lace work. Stencil has found inspiration in modern cutting and overlapping techniques, hence steering its practice towards intricate and extremely developed works. Therefore, street pieces were traditionally protest oriented and politically rather, than artistically committed. Today's studio stencil artwork is often complex and utterly refined, combining several layers and 3D techniques.

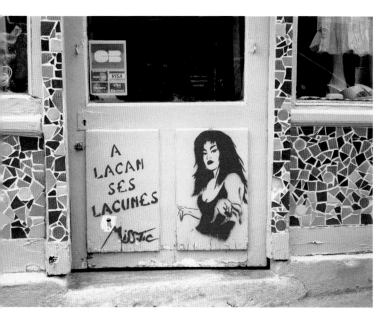

Left to right:
Courtesy of the artist *MISS.TIC*
Courtesy of the artist, *Epsylon Point*

Street Art Wheatpaste and Print

Wheatpasting (or flyposting in the UK) came as an answer to simple elementary needs. Some needed more time to prepare increasingly elaborate pieces, some simply needed to act faster to avoid the police. In any case, wheatpasting is very often seen as a fast and practical way to put up works in the street. Progressively, what had simple and practical means gave birth to a rich sub-current with various expressions.

Wheatpaste is a type of liquid adhesive which has been used throughout time in art and more particularly in such techniques as collage, papier-mâché or in the binding of old books. Political activists and legal commercial poster companies have also used it forever (as early as the nineteenth century for commercial purposes. And Henri de Toulouse-Lautrec was not only famous for his paintings: most of his contemporaries put a lot of time and effort into trying to take his posters off their walls without inflicting damage to the paper. The technique rapidly found its way into Street Art, for posters or hand-made images.

It was an answer to time constraints and, oddly enough, a way to go around the growing repression by city authorities: wheatpasting is considered a lesser offense than painting, if only because it is simpler and less expensive to clean up.
Street poster art allows for viral diffusion, a means to the propagation of the message at a sure and efficient pace, in an omnipresent urban environment. For most of the artists using street poster the underlying notion of the virus is key. The art form is a way to penetrate every part of the society, whether you want it or not.
Wheatpaste is seen as one of graffiti's close relative. Posters are usually hand-made, or printed in old-fashioned ways on fine paper to insure its adherence to walls. Often discredited due to its cheap technique, Street poster art has nevertheless grown in complexity and is now considered as an art form in itself. Like in graffiti, strategic locations and repetition are essential to spread the message, which can be a personal signature but tends to convey protest content, whether it is political, social, anti-consumerist.

The most famous actors of the genre are Shepard Fairey, with his poster campaign "Obey the Giant", D*FACE or FAILE, and in a more esthetic style, Swoon.

Street Sticker Art

How is street sticker art a part of Street Art? Well, art stickers are born from the practice of graffiti, down to its most basic principles. Sticker artists find their references and their ground of action in the city, and they're identical. They more or less cultivate a sense of anonymity and their motivation is usually recognition, or fame. Artists put up their name, their message, in the hopes that they will be seen over and over again, so that they might be, at some point, immediately recognized. In terms of their process, sticker artists confide, like all writers do, that it's all about preparation. Lastly, they share the same motto: "Don't get caught."

At a time when putting your name up on any surface of the city turns out to be, if not impossible, at the very least, difficult in the face of an increased repression, stickers proved to be, in the 90s, an reasonable alternative. Easy to prepare, to transport and to put up, stickers also leave fewer traces and are easier to clean, and therefore not as punishable by law. This marks the beginning of an interesting and true battle, in terms of creativity and locations. Stickers start appearing in the most surprising places.

Sticker art is also known as sticker bombing, slap tagging, or sticker tagging. It is nowadays used to diffuse art, an image or a message. Usually, the artists who include stickers in their practice are also involved in street postering and other forms of wall collages.

In street sticker art the proliferation of stickers is often linked to the promotion of a specific purpose or to a political message. Other cases include avant-gardist art campaigns, around the overbearing stickering of a city within particular space and time limits.

Street Art stickers, like stencils, were born from a need to answer the omnipresent repression against Graffiti. In the light of the enormous risks incurred with city tags and graffiti, the new generation of writers in the 90s quickly decided to resort to stickers as signatures, as tags.

Artists generally use basic auto-adhesive labels such as those used by students to mark their books, or the classical "My name is" stickers. UPS delivery stickers are also common in the US, symbolizing the easy and fast traveling of a name, and they generate an interesting and metaphoric recollection of the trains that used to travel between neighborhoods.

Some street sticker artists prefer creating and printing their own sticker frames and designs, reproducing them in massive quantities thanks to cheap copy top services. As easy to distribute as a business card, stickers are virus-like, passed around from hand to hand and put up without difficulty. Stickers are also called "weapons of mass production".

Several Graffiti artists have toyed with stickering, developing interesting campaigns. Among them, the most remarkable are probably Shepard Fairey, whose propaganda campaign *Obey Giant* began that way, REV's sensational sticker flood in New York City in the 1990s, as well as EVOKER, INVADER and MAGNET MAFIA, though in derivative way in regards to the latter.

This page: *Prayer Wheel*, courtesy of the artist, **FAILE**
Next page: Courtesy of the artist, **SPACE INVADER**

Mosaic Tiling

Mosaic is an artistic or decorative design made by setting small colored pieces, of stone, glass or tile usually, into a surface. The technique has been used since ancient times in art and in decoration and is now used by certain Graffiti artists.

The use of mosaic in street art is an interesting bridge between art history and Graffiti. Again, it's all about spreading a recognition sign, but instead of painting, it's made of mosaic tiles. This ramification in the movement, because of its ancient origins, stresses the viral aspects of Street Art.

Mosaic is an unexpected association to Street Art, but it respects all of the movement's principles: a signature that can be both simple and declined in more complex motives; meticulous preparation; original localisation. Mosaic requires a long preparatory process, much like a mural would, with a paint-by-number gridding system on which the piece is prepared and pre-glued in order to be put up quickly in illegal places. Just like graffiti.

There is one aspect in which mosaic differs from graffiti: it generally benefits from a long lifespan. Mosaics are fixated on city walls with super-extra-strong glues, sometimes cement. This type of intervention usually disappears with the building's destruction or facade renovation.

Among notable mosaic disciples are Colleen Frost and SUPHER, who create large graffiti mosaic murals, MEGA MAN, and SPACE INVADER who, alone, has invaded 40 cities worldwide with his video game character-inspired urban mosaics.

Mosaic, while it represents an interesting link with art history, also bears fascinating connections with pixels and the video game culture at large. SPACE INVADER's work and success examplify, in a symptomatic way, the computer raised generation, bringing together mosaic and pixels into a world city invasion life-size game set.

Woodblocking

Woodblocking graffiti is a ramification that consists in attaching to urban street signs small portions of plywood bearing a painted tag or a more elaborate graffiti. This type of intervention, born in the mid-90s in New York's context of massive repression against traditional graffiti, was quickly used worldwide. If only because these Street Art pieces are prepared in advance, they usually allow for a higher level of details.

courtesy sb@ny

Street Installations

Writers have, with time, found new grounds for creative action, inspired by their various urban space experiences. Some artists have explored 3D, using outdoor installations which can be seen as an echo to the urban environment, mixing painting, stickering, sculpture and other techniques. In most cases, and following traditions, these installations are put up illegally. However certain municipalities have commissioned temporary or definitive installatons of that kind.

There are numerous examples of installations, worldwide. Windows and doors of (generally) closed-down buildings are repeatedly the ideal frame for woodblocking, sometimes becoming a fixture within the installation itself, as seen in the SKEWVILLE binome's work. Other artists use stolen street furniture, transforming it before putting it back where it belongs. One of urban environment installation's stars, JR, likes to mix poster stickering and space restructuration at city scale.

Video Projection/LED Art

Among the unexpected ramifications stemming from Graffiti art, are video projection, laser and LED art, put up in the urban environment. Among other qualities, these installations are visible at night and much less problematic from a legal point of view.

LEDs are small shiny diodes, and relatively inexpensive. A number of artists integrate LEDs into their works, allowing for luminous pieces that are even, sometimes, interactive.

More often than not, interventions by artists using this technique have something to do with guerrilla warfare and come to interfere, in light, with on-screen commercials or shiny neon logos on high-rise buildings.

Graffiti Research Lab (also known as GRL), was founded by Evan Roth and James Powderly during their fellowships at the Eyebeam OpenLab. It's an art group dedicated to outfitting graffiti writers, artists and protesters with open source technologies for urban communication. The members of the group experiment in a lab and in the field to develop and test a range of experimental technologies. They document those efforts with video documentation and DIY instructions for each project and make it available for everybody.

The GRL gained fame by inventing the principle of LED Throwies, i.e. magnetized LEDs that can be thrown against metallic surfaces which can be found throughout the city: train cars, scaffolds, parts of facades, etc. Their work was shown for example at the Ars Electronica Prize, a digital art award of international renoun, thus demonstrating the passage of art forms stemming from graffiti into different artistic domains. Interestingly enough, it symbolizes the connection that exists between both of the youngest artistic movements in the 21st century: urban design and digital art.

Worlwide Repression

Controversy

Since the beginnings of tags in New York (in the early 1970s), the controversy, namely "art or vandalism?" has been a dividing issue, to say the least.

In the *New York Sun*, an editiorial goes as far as comparing graffiti with metastases and shakes a violent finger at the *New York Times*, which dares to simply focus on the movement's artistic value. The *New York Sun* concludes with this interesting sentence: *"The Times is supplying the ideal discourse to a generation that refuses to grow up"*.

You might have heard of the "broken windows" theory, wildly spread in the United States, originally developed by NY Mayor Giuliani, according to whom graffiti is a increased insecurity factor, leaving populations under the impression that their neighborhood is abandoned by authorities and that incivilities are unpunished.

Other points of view, not necessarily in absolute opposition, beg to be considered: with graffiti, young people keep busy in a creative (and thus positive) way, appropriating public spaces and, even, filling them with a somewhat welcome chromatic sense of joy.

We've seen how, in the late 70s, the City of New York and Metropolitan Transportation Authority, duly encouraged by Mayor Ed Koch (who stayed as head of the city from 1978 to 1989), decided to eradicate graffiti from the subway. Suddenly, access to trains has become extremely difficult, painted cars are held up in depot to get cleaned up immediately, before even being seen by the public. In April 1982, a US anti-graffiti campaign is launched by the city of New York, endorsed by New York celebrities such as boxers Héctor Camacho and Alex Ramos, actors Irene Cara and Gene Ray (from the movie Fame) or Baseball star Dave Winfield. These personalities come forward under the simple, catchy slogan: *"Make your mark in society, not on society"*. Between 1984 and 1989, one thousand employees are employed by the New York subway system to

clean their 6 245 cars and 465 stations, for an annual 52 million dollar cost. These arm-bending tools are a strong motivation for writers to give up the subway, turning their efforts and creativity towards walls and canvas. Some artists, for reasons easy to understand, even have to change their names.

The practice is not immediately labeled as illegal. But the good old times, when train depots were not under surveillance, and night expeditions didn't entail too many dangers, have come and gone. Shortly after its social debuts, graffiti, first, and then street art, become severely punishable by law.

The adrenalin rush, and the freedom found in doing something that isn't allowed, soon turn into two of the main constitutive elements within Street Art culture. A number of artists born from this movement are unable to conceive their practice without these essential factors. And to some, even, artists working within a legal framework are, quite simply, seen as phonies. Danger and prohibition are undeniable sources of inspiration, and repression, proportionally, also nurtures a high level of inventiveness, much needed for anyone who is intent on countering the laws in vigor. That, in itself, is a challenge that fuels spirits and creativity.

In 1984, the Philadelphia Anti-Graffiti Network (PAGN) was created to fight gang-related graffiti. Pretty much at the same time the Mural Arts Program was voted, as a way to encourage "real" graffiti works, more elaborated and, more importantly, legal. Mayor Rudolph Giuliani, whose first mandate begins in 1994, advocating a zero tolerance principle towards crime in general, considers non-authorized urban graffiti one of his priority targets. He's responsible for developing the famous "broken window" theory, according to which any unpunished offence, from a damaged phone box, to a tag or, well, a broken window, are the first steps towards the dereliction and impoverishment of a whole district.

In terms of legislation, street art and, more particularly, graffiti, raise the issue of personal freedom and freedom of expression, but also that of public and private space degradation. In the face of the uncontrollably growing phenomenon that is street art, which has steadily expanded since its origins, authorities have consistently done their best to limit or forbid it, without the least distinction between what might be vandalism, and actual art. In the United States, every jurisdiction confronted to a street art "issue", has the power to come up with its own set of answers in the hopes of putting an end to what is seen as the degradation of public or private spaces. Some counties

are content with simply regulating the sale of products that might typically be used by graffiti writers, but individual cities within the same zone are free to vote a variety of decrees, which go as far as paying for information given against offenders.

The regulation of graffiti-linked product sales is classic tool used in the fight against tags, in a wide number of cities around the United States. It was also proposed, but not validated, by the City of Paris, in 1992, and by Montreal's Mayor, Gérald Tremblay, in 2006. Such regulations are implemented under a variety of shapes and forms, from prohibiting vending points from public display or underage sale of of said products (usually spraycans), to proscribing altogether the sale of very thick indelible markers. Other jurisdictions go as far as to regulate the possession of supplies that could be used in making graffiti.

So, depending on U.S. cities and counties, writing, and/or buying or owning Graffiti supplies, have consequences: penalties go from the simple fine to actual jail time, community work being another option. Of course, the difficult part is catching the writers and street artists in action. Specialized units now exist, with the sole purpose of collecting evidence for months before actually arresting offenders on site. Anonymity is, more than ever, a precious quality to hold onto.

In Los Angeles, a highly sophisticated technical system named TaggerTrap is tested, with success. Triggered by the very specific sound a spraycan makes, it's alledgedly lead to a large number of arrests.

Other American companies have specialized in the collection and the archiving of information pertaining to graffiti, keeping track of all tags and other pieces signed by a given writer, enabling authorities to convict an offender based on his track record on file, rather than just the piece he or she has been arrested for.

Meanwhile, in Europe, France set the example, long before artistic graffiti took its first step. Political graffiti, and with it all potential 1968 ghosts, has severely been tracked down. But by the mid-80s, the City of Paris is fully equipped with pressure-boosted machines that effectively erase any graffiti from its walls and, following the footspteps of the RATP (the Paris Public Transportation System), doesn't hesitate to file official complaints. The SNCF, France's national train system, has recently claimed a yearly 5 million euro budget just for cleaning tags and graffiti on its trains. In 2003, it even sued specialized magazines, like GRAFF'IT, GRAFF BOMBZ and MIX GRIL, under the assumption that their photo publication policy was a clear endorsement of train graffiti. Despite their request for a 150 000 euro compensation per photo published, the claims

were refused by the French Justice Department, partly due to the wide support they indirectly benefited from. Interestingly enough, both the media and the Human Rights League voiced their concern in view of what could have set a potential precedent, not against freedom of expression per se, but against journalists' and citizens' free right to inform and be informed. In legal appeal, the court further recognized Graffiti's artistic character, refuting the incitement to degradation charge considering that the number of painted cars had steadily been decreasing.

On January 1st, 2006, the City of New York tried to pass an anti-graffiti legislation, created by Council member Peter Vallone, Jr. that virtually made it illegal for anyone under 21 to own spray paint and/or permament markers. Fashion and media mogul Marc Ecko immediately rebelled against the project going as far as suing New York's Mayor Bloomberg, in the name of all art students and other legitimate graffiti artists. However, in certain jurisdictions throughout the country, similar laws have successfully been passed.

Chicago Mayor Richard Daley has successfully set up Graffiti Blasters, an organization whose mission is to erase any graffiti within 24 hours of receiving a phone call complaint. In 1992, a new text was voted, banning the sale and possession of spray paint, and certain types of etching equipment and markers. The same text defined graffiti as an offense punishable by law, with a $500 fine per incident. That fine is higher than the penalty in application for public drunkenness, peddling, or disruption of a religious service.

The list goes on, though some cities around the world have tried to go beyond plain repression, like Venice Pit in California, providing graffiti-dedicated walls, with the admitted purpose of channeling writers' creative energy in target locations. But most writers can't risk unveiling their hard-kept secret identities, and such initiatives are often seen as ploys towards different agendas or considered an absurd and harmful form of institutionalization: in the eyes of many, graffiti is subversive, and must remain so.

Other European capitals are coming up with less creative ways to fight the phenomenon. In 2003, for example, UK's Anti-Social Behaviour Act established a new anti-graffiti legislation, calling, yet again, for a zero tolerance principle. 123 MP, including Prime Minister Tony Blair, signed the *"Graffiti is not art, it's crime"* statement. Vandal or artist-born, every type of graffiti is punished, and severe penalties have become the norm. In 2008, five taggers were condemned to prison sentences ranging from 18 to 24 months, raising yet again the issue, and debate. Should graffiti be considered an art form or a crime?

Getting Inside

"Faile gained fame on the street, and it seemed you earned your way into galleries. (...) The original idea was just to find an outlet for the work we were creating. I don't think we thought that 'if we do this, some day we may show in galleries'. At least that wasn't the goal. It was just exciting to do work on the street to get it out there and participate in a world where the art was always challenging and evolving. You'd put something up one day and the next day it was gone, or written on. Or, something new was covering just a bit of it, creating something you never expected. It was just so alive. We learned a lot from working on the street. It's probably what informed the way we work more than any other thing. We also photographed a lot and really examined the way things broke down and evolved on the street. This too was very influential in our process. It has changed now. When we started, there was no Wooster Collective or major Street Art scene. It was still small enough to count the people doing it on our hands. Now, with the Internet things have really changed. You can start out and do one great thing and find shows and a market for your work. This is great for many artists—but the culture and the motivation were different when we started." Miller of the FAILE collective

Street Art is at last considered on the inside of the Art world. Artist get invited to show inside the art institutions and are not anymore asked to stay on the outside.

Yet, many people have asked if the art was not changed by this. One has to keep in mind that a lot of Street artists start, in the early stages of their practice, working indoors, sometimes at home or, for the most fortunate among them, in a studio. The inside has never been a contradiction.

And since you ask, here are the five mandatory stages, of equivalent importance, which define any Street Art creation, according to an unchanged tradition:

 1 - preparation on paper (sketches, outlines, etc.)
 2 - preparation of equipment and supplies
 3 - careful location of adequate spot
 4 - on-site execution of said piece
 5 - immediate documentation (photo archiving)

It therefore appears clearly that, for the most part, Graffiti artists have a private and complete practice, whether they choose (or not) to further develop it on, say, canvas, for another purpose than its exhibition in the street, for your viewing consideration.

For its first Street Art exhibition in 2008, the Tate Modern in London invited artists as BLU from Bologna, Italy; the artist collective FAILE from New York, USA; JR from Paris, France; NUNCA and OS GÊMEOS, both from São Paulo, Brazil and SIXEART from Barcelona, Spain.

The following year, the prestigious Fondation Cartier in Paris, France, included artists such as SEEN, FUTURA, JONONE, Barry McGee, DELTA and many others in its *Born in the Street* show.

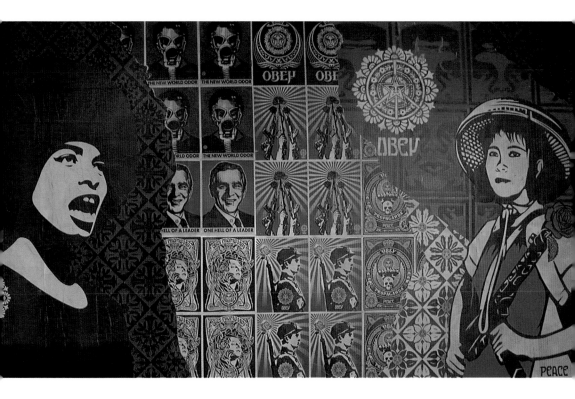

View from the wall installation at the Magda Danysz gallery in
Paris, 2005, *Shepard Fairey (OBEY)*

BLEK LE RAT

Date of Birth: 1951

Place of Birth: Paris

Starting Point: 1981

Influence(s): Pop Art, Warhol, David Hockney

Style: Stencil

Distinctive Feature(s): Accessible, black and white

The Beginnings

Xavier "BLEK LE RAT" Prou was born in Paris in 1951. After graduating high school, in 1971, he studies at the Beaux Arts and, during a summer trip, discovers graffiti in New York. He's particularly drawn to the crowns that decorate some of the signatures. Back in France, he pursues his studies and from 1976 to 1981 he focuses on architecture, a family tradition. He earns his diploma with a thesis on "adventure grounds", i.e. the communal playgrounds where children spend time to play after school, unveiling the fact that most of the kids usually paint with stolen supplies and paint. His New York memories in mind, he convinces a friend to *"paint like they paint in New York"*. In those days, ZLOTYKAMIEN is the only one to paint in the streets of Paris, and Prou starts with no conscience whatsoever of graffiti techniques. Finding spray paint is not easy, those for sale are intended for car paint professional, and his first attempts are disappointing: stone walls and bricks absorb the paint. The results are so far below his expectations that he decides to switch gear and to give stencil a try, based on yet another memory, as a child, of a Mussolini stencil in the streets of Padua.

Stencils are by no means a revolution. But BLEK sticks to using aerosols and, in those days, spray paint is a major innovation. Though BLEK clearly is the inventor of modern stencil, he admits humbly

that *"you don't ever invent anything, but you can do things your own way"*. Among his early motives, there is the small rat figure, in reference to the rat-infested streets of Paris, and the animals interfering constantly with his work, finding their way everywhere. Hence his artist name. Admittedly, *"the name did not have any deep ideological motivations, it came more from a simple observation, and in any case more unconscious that what is believed in today's many interpretations"*.

In 1982, BLEK notices Jerôme Mesnager's painted life-sized white characters all over the streets. In 1983, he also comes across BANDO's first graffiti on the shores of the Seine. A rather healthy competition emerges, inspiring urban artists to do better, to invent, to experiment new ideas. Stencil's practice remains underground enough, compared to the irruption of American graffiti across Europe.

The "Aha!" Moment

There are two important turns in BLEK LE RAT's artistic career. The first one takes place in 1991, when the police arrest him. After a yearlong lawsuit, he's sentenced to a very heavy fine. Shaken by the events and by the severe condemnation, he gives up painting in the street, and starts working on paper stencils, which he then sticks on the walls, counting on a lighter fine if he's caught. So in some strange way, police repression is what forced his technique to evolve rap-

idly; he now even admits that the episode did give him the urge to add detail to his works, and to refine his stencils.

This technique, invented out of necessity, is according to numerous observers of the movement, at the very origin of graffiti's development into poster art and sticker art.

In 1999, BLEK receives a phone call from writer Tristan Manco, who's busy working on his book, *Stencil Graffiti*, and wants to meet him. Manco tells him about the massive stencil movement that has developed in the UK, more specifically in Bristol. More importantly, he mentions that an anonymous artist, working under the name BANKSY, is becoming increasingly famous and is giving him full credits for his inspiration. This tribute gives a fresh start to BLEK LE RAT's career and, today, the world honors the pioneer he was in stencil, which is an indisputable chapter of contemporary Street Art.

Into the Art World

BLEK LE RAT's path has taken him around the world and back. His work is shown from Paris to Tokyo and from New York to Los Angeles. He's invited to do urban performances in Morocco, for example, or in Germany, where his wife was born.

Throughout the years, he's created poetic and political stencils, which have traveled with him, allowing his style and name to spread across cities. His first life-size work is up in 1983, and represents old Irish railing British soldiers, in reference to the conflicts that tore Belfast in the 70s. Throughout the years, his subjects are diverse. In 1991, he stands against the Gulf War with a soldier stencil. He starts his tribute to artists' series in which can be found a Joseph Beuys stencil, or French singer songwriter and icon Serge Gainsbourg's image, even... Tom Waits, a French president, Andy Warhol, Jesus Christ, a Venus Callipyge, BLEK finds his inspiration everywhere. His career takes off in 1999.

BLEK is invited to Naples in Italy, to Leipzig in Germany, to Barcelona in Spain. He has shows in Morocco, England, Argentina, and Taipei, China, welcomes his exhibit in 2005. His book, published in 2008, is a major success.

Style

In terms of style, BLEK LE RAT's stencils are astounding due to their unique simplicity, which allows for the image's full strength to be expressed, rather than be brought down by details. Hence an impact that always remains powerful.

BLEK's original simplicity has evolved into more complex and detailed works, as additional motives and cutting ap-

peared with the use of computer-generated assistance, that lets him blow up his creations. A large number of characters have come to populate the collection of pen portraits that still carry a message, whether it is based on political, social or artistic observation.

BLEK LE RAT has always preferred the simple black and white contrast rather than additional colors that might tamper with the stencil's impact. His black and white style might also be connected to his engraving studies. Sometimes, every now and then, details are colored for density.

His stencils have traveled through time and in the spirit of friendly competitive inspiration with Jérôme Mesnager, as mentioned, in Paris, and American stencil artist Richard Hambleton, specialized in black shadows with paint splashes.

This page and next double page:
Courtesy of the artist, **BLEK LE RAT**

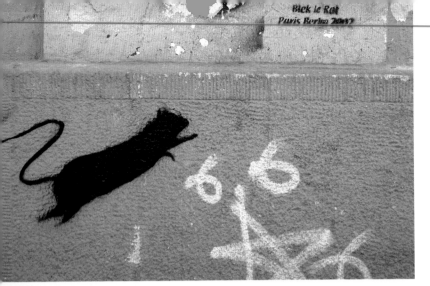

Blek le Rat
Paris Berlin 2007

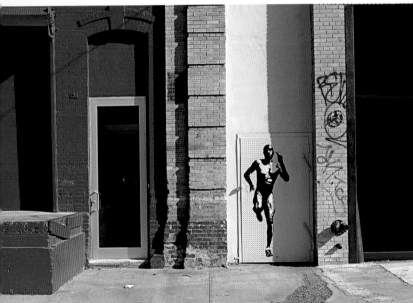

BLEK
le Rat

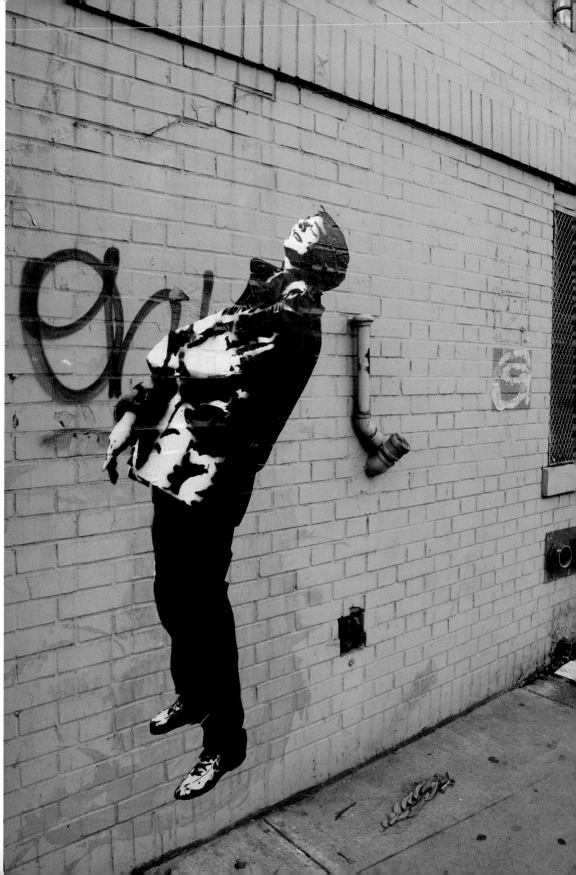

MISS.TIC

Year of Birth: 1956

Place of Birth: Orly, France

Starting Point: 1985

Influences: Theatrical.

Style: Stencil, mostly black and white

Distinctive Feature(s): Short poetic phrases combined with self-portraits

The Beginnings

MISS.TIC is a Parisian visual artist and poet born in 1956, in Orly. Her mother and part of her family die in a car accident when's she's only a child. When her father dies, six years later, she leaves Orly and its compound behind, and goes straight to Paris, her suitcase perched in the back of her tiny moped. She settles in Saint-Germain-des-Prés, takes acting classes with René Simon and joins the street theater troupe Zéro de Conduite.

In 1980, she goes to California to be with her boyfriend, and discovers Graffiti. After two years, she moves back to Paris and starts applying her artistic talents in different ways, including theatrical stage sets. She joins the VLP (Vive la Peinture) movement, struck by the work of artists like the Frères Ripoulain, who subvert street posters and, in 1985, paints her first stencils on the walls of the city.

The "Aha!" Moment

The exact meaning of her alias, MISS.TIC, remains a secret, aside from it being borrowed from a Disney character. She admittedly has a soft spot for that funny little witch, committed to stealing Uncle Scrooge's magic penny, yet constantly failing in her mission. Her poetic and humorous paintings are exactly where she wants them to be: on the walls of Paris, offered to the public, accessible by all, refusing to be locked up in museums. Her

first exhibition, at the agnès b. gallery, in 1986, puts her in the spotlight. Her quirky titles are intriguing, and based on word play and double entendre (hence usually impossible to translate - sorry!): *Maudite sorcière* ("cursed witch", also an old French expression used against a mean woman), *Femmes mur* ("wall women", also a phonetic pun for "mature women"), *Muses et Hommes* ("Muses and Men", also a phonetic pun for "museum").

Into the Art World

Recognized early on in her practice, she is by all means an urban art icon. She has shown her works in public spaces, galleries and international art fairs. Her works have been acquired by the Fond d'Art Contemporain de la Ville de Paris and the Albert Museum in London. She has worked for Kenzo, Comme des garçons, UCAR, Louis Vuitton and a French ministry; the city of Orly has commissioned her a public mural, and she recently signed the film poster for Claude Chabrol's movie, *La Fille coupée en deux*.

Maybe because of the impossible-to-translate aspect of her poetry, her career and exhibits over the course of the last twenty-something years have been, though highly successful, very French, and very Parisian.

Style

MISS.TIC transcribes her everyday life into stencils that are usually based on the "self-portrait + one line poem" combination. The poems are often a few words long, in the same writing style she has developed, and her seventies wild and dark hairdo is recognizable among all. Her stencils are generally applied in a single layer, but sometimes she uses two. Her graffiti is especially present in the 13th district of Paris, where she has her studio. *"Walls are my poems' territory,"* she says.

In recent years, MISS.TIC's texts have become more and more central in her work. *"Poetry matches well with the pochoir,"* she says, *"because, like stencil art, poetry can be condensed. A short phrase gives birth to a lot of images"*. While her stencils are meticulously prepared, her texts, born from her love for wordplay, are written impulsively. And though they have little to do with political protest, they undeniably bear certain feminist connotation, a reflection of her, if not activist, personal position. The words left on the walls resonate like excerpts from a personal diary. With an unequalled sense of dialogue and poetry, she has created a language of her own, mixing shape and words, and giving the city a new voice to share.

Next page: Courtesy of the artist, MISS.TIC

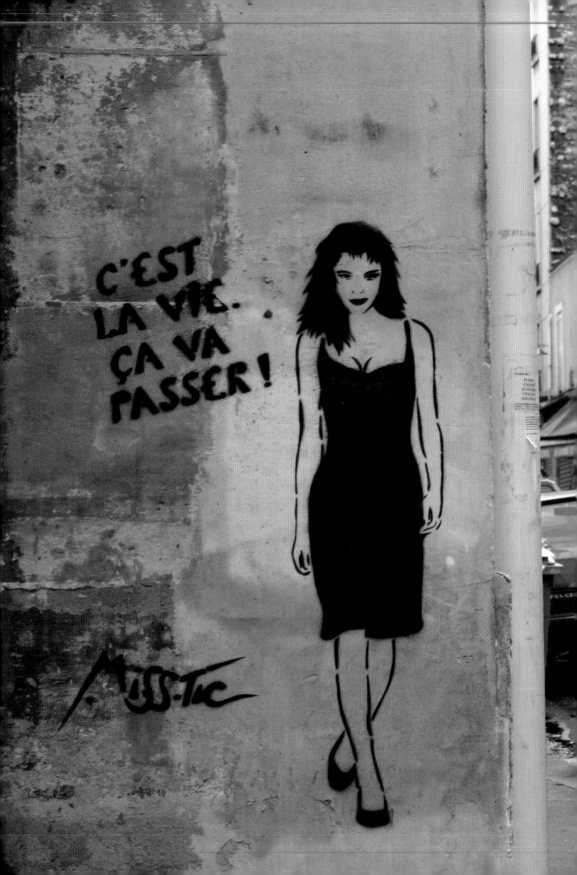

BANKSY

Date of Birth: 1974

Place of Birth: Bristol, UK

Starting Point: 1992

Influence(s): BLEK LE RAT

Crew(s): Bristol's DryBreadZ Crew

Style: Accessible, yet usually subversive stencils

Distinctive Feature(s): Anonymous artist from the Bristol underground scene, which involves collaborations between artists and musicians.

NB: Nobody knows BANKSY's true identity. Or at least, nobody that we know of. What follows is some of the information given by the artist's various official sources. Gotta love the myth, and the humor. At least, we do.

The Beginnings

BANKSY was allegedly born near Bristol, UK. He allegedly spent some time immersed in the Bristol underground scene, which is characterized by collaborations between plastician artists and musicians. BANSKY's first graffiti's, under that name, are seen in 1992. He's then part of Bristol's DryBreadZ Crew, along with KATO, an active member of Bristol's graffiti scene, TES and YOUR.

From the start, he also uses stencils as elements of his freehand pieces. By 2000, he had turned to the art of stenciling after realizing how much less time it takes to complete a piece. The legend reports that he decided to switch to stenciling while hiding from the police under a train carriage, where he noticed the stenciled serial number. With this technique, he soon became more widely noticed for his art around Bristol and London.

BANKSY's stencils feature striking and humorous images occasionally combined with slogans. The message is usually anti-war, anti-capitalist or anti-establishment. Subjects include rats, monkeys, policemen, soldiers, children, and the elderly.

The "Aha!" Moment

In late 2001, on a trip to Sydney and Melbourne, Australia, he meets up with Gen-X pastel artist, visual activist, and recluse James DeWeaver in Byron Bay,

where he stenciles a parachuting rat with a clothes' pin on its nose above a toilet at the Arts Factory Lodge. This stencil can no longer be located. He also makes stickers (the *Neighborhood Watch* subvert) and sculpture (the *Murdered Phone Box*), and is responsible for the coverart. Blur's 2003 album Think Tank.

Into the Art World

On 19 July 2002, BANKSY's first Los Angeles show debutes at 33 1/3 Gallery, a small Silverlake venue owned by Frank Sosa. In 2003, in a show called *Turf War*, which was held in a warehouse, BANKSY paintes on animals. Although the RSPCA declared the conditions perfectly suitable, an animal rights activist chained herself to the railings in protest. He later moves on to producing subverted paintings, among which Monet's *Water Lily Pond*, adapted to include urban detritus such as litter and a shopping trolley floating in its reflective waters; another notable one is Edward Hopper's *Nighthawks*.

In August 2004, BANKSY produces a quantity of spoof British 10-pound notes substituting the picture of the Queen's head with Princess Diana's head and changing the text *"Bank of England"* to *"BANSKY of England."* That same year, he walkes straight into the Louvre in Paris and hangs on a wall a picture he has painted resembling the Mona Lisa but with a yellow smiley face. *"To actually*

[have to] go through the process of having a painting selected must be quite boring. It's a lot more fun to go and put your own one up."

In 2006, BANKSY holds an exhibition called *Barely Legal*, billed as a *"three day vandalized warehouse extravaganza"* in Los Angeles. The exhibition features a live "elephant in a room", painted in a pink and gold floral wallpaper pattern. In December, journalist Max Foster coined the phrase, *the BANSKY Effect*, to illustrate how interest in other street artists was growing off the back of BANKSY's success.

2007 is an interesting year for BANKSY. In February, the owners of a house in Bristol with its side bearing one of his murals, decide to sell their home through the Red Propeller art gallery. It is listed as *a mural, to which a house is attached*. In April, Transport for London (the equivalent, for London, of public transit authorities) paints over BANKSY's iconic image of a scene from Quentin Tarantino's Pulp Fiction, with Samuel L. Jackson and John Travolta clutching bananas instead of guns. Although the image was very popular, Transport for London claimed that the "graffiti" created a general atmosphere of neglect and social decay, which in turn encourages crime. Yet, a few months later, BANKSY gains the award for Art's Greatest Living Briton. As expected, he does not turn up to collect his award, and maintains his notoriously anonymous status. In October,

most of his works offered for sale at Bonham's auction house in London sells for more than twice their reserve price.

In 2008, BANKSY hosts a London exhibition called The Cans Festival, located on Leake Street, a road tunnel formerly used by Eurostar underneath the London Waterloo station. Graffiti artists with stencils are invited to join in and paint their own artwork, as long as it dœsn't cover anyone else's. Artists included BLEK LE RAT, BROKEN CROW, C215, CARTRAIN, DOLK, DOTMASTERS, J.GLOVER, EINE, EELUS, HERO, PURE EVIL, and TOM CIVIL. His first official exhibition in New York, the *Village Pet Store And Charcoal Grill* opens October 5, 2008. The animatronic pets in the store window include a mother hen watching over her baby Chicken Mc-Nuggets as they peck at a barbecue sauce packet, and a rabbit putting makeup on in a mirror.

In addition to his artwork, BANKSY has claimed responsibility for a number of high profile and extremely subversive pieces. His art pranks are endless, and extraordinary. In time, he also has turned to complex installations. In July 2008, *The Mail on Sunday* claimed that BANKSY's real name is Robin Gunningham. His agent has refused to confirm or deny these reports.

Style

BANKSY's artworks are often satirical pieces of art on topics such as politics, culture, and ethics. His street art, which combines graffiti writing with a distinctive stenciling technique, is similar to BLEK LE RAT's.

"I use whatever it takes. Sometimes that just means drawing a moustache on a girl's face on some billboard, sometimes that means sweating for days over an intricate drawing. Efficiency is the key."

Stencils are traditionally hand drawn or printed onto sheets of acetate or card, before being cut out by hand. Because of the secretive nature of BANKSY 's work and identity, it is uncertain what techniques he uses to generate the images in his stencils, though it is assumed he uses computers for some images due to the photocopy nature of much of his work.

He mentions in his book, *Wall and Piece*, that during his early graffiti days, he was always too slow and often had to choose between either getting caught or leaving the art unfinished.

In BANKSY's own words: *"I am unable to comment on who may or may not be BANKSY, but anyone described as being 'good at drawing' doesn't sound like BANSKY to me."*

Barry McGee
(TWIST)

Date of birth: 1966

Place of birth: San Francisco

Starting Point: 1984

Influence(s): Music

Style: Painting and installations mixing wood, glass and drawing

Distinctive Feature(s): Drawing-like characters, grim faces

The Beginnings

Chinese-American artist Barry McGee, aka TWIST, was born in San Francisco, California in 1966. He's also known as Ray Fong, Twister, Twisty, Twisto. He starts painting in the streets at the age of 18, using mainly TWIST as a tag name, and after discovering Graffiti, which he embraces immediately and whole-heartedly: *"it seemed like freedom to me, it was very empowering and it is something I enjoyed doing a lot, and the people that were doing it were very interesting to me, too"*. Barry McGee is aware that his access to graffiti falls within the context of the Reagan years, which nurtured great political protests, various individual commitments and vast musical evolution. Hence the variety of his youth influences, from punk rock to hardcore, but also in the advertising jingles that he finds invasive and pervasive to our memories.

He graduates from El Camino High School, in South San Francisco, California, before attending the San Francisco Art Institute where he chooses painting and printing techniques as his majors. After a few impressive school years (in 1989, he's a recipient for the Sobel Scholarship; in 1990, he receives the Carson Paper Award Merit Scholarship before being given, the following year, the Merit Scholarship), he graduates in1991.

During the San Francisco Bay Area early 90s graffiti boom, he finds ways to develop his unmistakable style, integrating pessimistic faces confronted to the urban life experience. He swiftly gives up his alias and starts signing his murals using his real name.

His talent gains him rapid recognition and more awards. In 1992 he joins the McClymonds High School Artist Resident program, in Oakland, California. In 1993 he's the recipient of the Lila Wallace, Readers Digest International Artist Program and receives the Fleishaker Foundation Eureka Fellowship. As soon as he's done with school, in 1993, he gets a first show in San Francisco, and his work is exhibited at the Museum Laser Segall in São Paulo, Brazil. In 1994, he receives the Creative Work Fund, from the Walter and Elise Haas Fund and, in 1996, he wins the San Francisco Museum of Modern Art SECA Award.

The "Aha!" Moment

In 1998, Barry McGee paints a monumental mural for the San Francisco Museum of Modern Art, which integrates it to its permanent collection. That same year is held his first major personal exhibition at the Walker Art Center of Minneapolis. It propels him onto the artistic scene. New York collector and gallery owner Jeffrey Deitch tracks him down and offers him a show in March 1999, *Barry McGee: "the Buddy System"*. Barry McGee then adds one show to another. In

September of that same year, he's at the Rice Gallery in Houston, Texas before hitting the 2001 Venice Biennial. This last event marks his definitive entry in the Art world and, as a regrettable result, leads to the devastation and theft of his street wall pieces.

Into the Art World

Since the Venice Biennial, Barry McGee has been the subject of many exhibits. In the summer of 2001, just two weeks after the Biennial inauguration, he's part of the Parisian exhibit entitled *A Popular Art* at the Foundation Cartier for Contemporary Art, and by the end of the year his works are presented as part of *Widely Unknown* at Deitch Projects, in New York. But for Barry McGee, these times are also extremely difficult: his wife, artist and collaborator Margaret Kilgallen, dies at age 33, from breast cancer complications.

More than 70 exhibitions follow worldwide in numerous institutions, where he creates large installations integrating his drawings and his paintings, among which the Liverpool Biennial in the UK and *Drawing Now*, a major exhibition at New York's Museum of Modern Art, in 2002.

In 2004, the shows continue to add up, under his name, at Boston's Brandeis University Rose Art Museum, for example, or at Paule Anglim's in San Fran-

cisco, or as part of collective exhibits. Such institutional exhibitions give him new opportunities: he's commissioned by San Francisco City Supervisor Matt Gonzales to do a mural, in his office. It's ironically entitled *Smash the State*.

Traveling from London to Melbourne, his work integrates private and public collections, including the most prestigious ones around, like The Dakis Joannou Collection in Athens, Greece. In 2007, the Miami Margulies Collection shows, during Art Basel Miami, an installation by Barry McGee from 1998. He's also invited to the Watari Museum of Contemporary Art, in Tokyo, Japan, to MoCA Shanghai, China, to the Baltic Art Center in the UK, to the Riverside Art Museum in California. The list goes on. Yet, in the artist's own words: *"The stuff in the galleries is just arty. The art crowd is arty, and it's the same people. Sometimes I feel like if I do something indoors, my circle of people that sees things is getting smaller and smaller, where if I'm outdoors it's open to anyone to look at, or see or hate or whatnot. But doing stuff indoors - there's some good things about it, but I know the audience is very limited."*

Style

To Barry McGee, graffiti is mainly a means of communication that inspires him and enables him to reach out to the widest and most diverse audience, in an attempt to keep his work accessible to all. Environments to his murals also bear

great importance in his approach, as they help him bring out the irony in his characters. His work is developed as a demonstration of freedom in public locations that the artist perceives as being inappropriately invade by the advertising industry: *"The thing that I'm interested in now is the idea of getting rid of it, this war on getting rid of it, and this idea of silencing it or trying to get rid of something. To me, that's the more interesting thing: how in today's climate there can be huge billboards and bus stop kiosks with advertising, and then along comes like a simple tag or something that someone does on it, and that thing is immediately removed overnight."*

The work of Barry McGee mixes mural gigantism with retail drawings, at which he excels. His subjects are, above all, tainted with irony, with melancholic major figures, with dark-circled eyes, like characters lost in what we suppose to be our modern world. His colorful abstract and dripping backgrounds strengthen every one of his characters' details, glances, wrinkles and mimics. He also often paints his characters on empty liquor bottles that he collects together for installations in which his empty-eyed characters seem to drown among the accumulated glass, wood or metal materials he recycles.

Next pages : Courtesy of the artist, Barry McGee

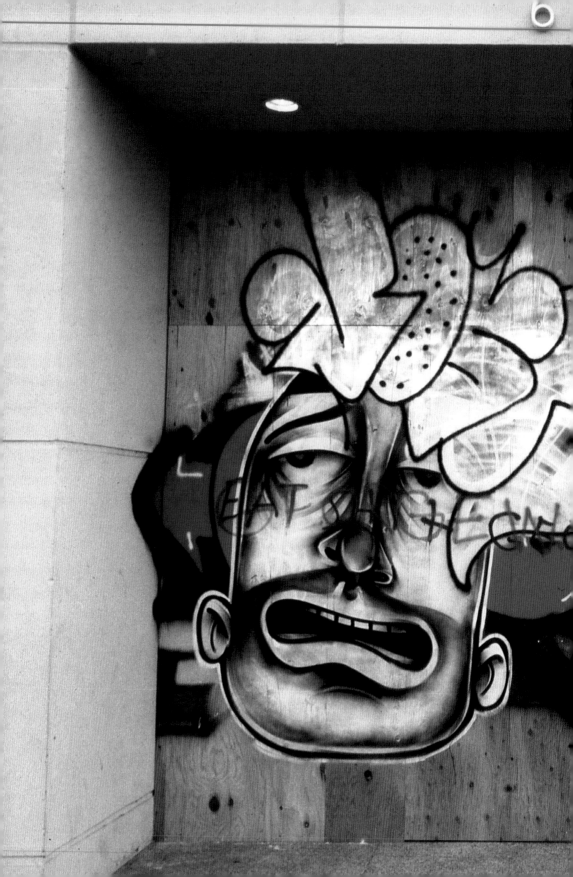

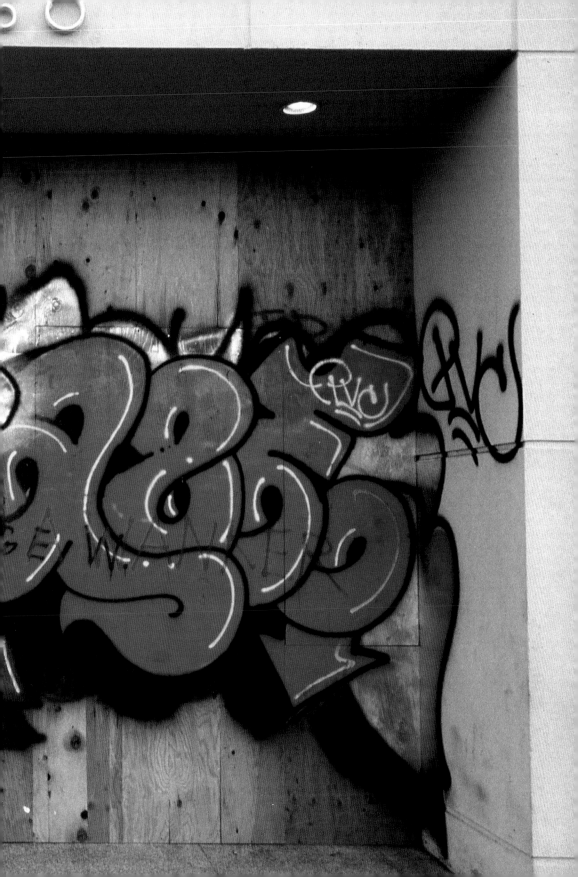

OS GÊMEOS

Date of birth: 1974

Place of birth: São Paolo, Brazil

Starting Point: 1987

Influence(s): Barry McGee,
New York Graffito style, pixação

Style: Naïve colorful paintings

Distinctive Feature(s): Monumental
mural including complex scenery
with characters

The Beginnings

OS GÊMEOS (Portuguese for The
Twins) is the street name for artists and
identical twins Otavio and Gustavo Pan-
dolfo, born in 1974, native of São Paolo in
Brazil. As the youngest in a family of four
children, they are encouraged to draw
and paint. Their elder Brother, Arnaldo,
teaches them drawing and the principles
of perspective. As early as they can re-
call, their family and close relatives have
always encouraged them.

Hip Hop culture appears in Brazil
around the mid-80s and reaches out to a
large number of teenagers, especially in
their neighborhood. Though Otavio and
Gustavo are originally attracted to break
dancing, they begin painting graffiti in
1987, around the city. Rapidly, their influ-
ence on the local scene is huge, and their
early contribution will greatly help to de-
fine a specific, unique Brazilian style.

The "Aha!" Moment

Otavio and Gustavo's approach to graffiti
is, at first, totally respectful of the New
York style. In time, their evolution leads
them to develop something a lot more per-
sonal: *"At first we were the same as the others,
painting b-boys and generally staying close to
the themes found in Hip Hop culture. As time
passed, naturally things changed. We never for-
got the roots, but we decided to go our own way."*

In 1993, OS GÊMEOS meet Barry McGee (TWIST), who's been invited to Brazil through the San Francisco Art Institute study program. The encounter is extremely significant for both Otavio and Gustavo, who spend time with the artist, sharing techniques and seeing photos of what is then made in the US, collaborating on pieces in São Paulo, before involving in a deep, meaningful friendship. From large murals, their work evolves towards in-situ installations, with smaller, site-specific street and gallery installations.

This allows them to meet other actors from the Californian graffiti and street art scene in the 90s, and marks their introduction outside the borders of Brazil.

Into the Art World

Their first group show takes place in Brazil in 1993, and it's only by the end of the 90s and early 2000s that OS GÊMEOS find their place abroad, going from San Francisco to Los Angeles by way of Cuba, and through Europe. In 2005, supported by stage director Robert Wilson, they're offered an exhibit in his WaterMill Art Center, near New York. A number of solo shows follow, for the Het Domein Sittard, Netherlands in 2007, and in 2008 at the Deitch Project Gallery, in New York, as well as in the Museu Oscar Niemeyer, Curitiba, in Brasil. That same year, they participate in the Tate Modern's Street Art exhibit, in London, and paint a monumental piece there, on the museum's facade.

Style

The twins work in total symbiosis on each of their pieces, one completing the work of the other. Because they saw so little graffiti during their debuts, they've managed to develop their own, unique and original style. *"The only things that we had were some flicks and a piece of film that showed us graffiti. So we tried to discover how these things were done. We think we ended up discovering other things as a result."*
Paradoxically, OS GÊMEOS are often considered as flags to the Brazilian style. And though they deny such a monopoly, their works often present yellow-skinned characters against brownish red backgrounds (yellow and dark red being their trademark colors). In their works, they mix traditional New York graffiti influences with elements from the pixação Brazilian graffiti movement. Their work is both filled with humor and vibrant colors, and very detailed and hard in certain of its aspects.
They've painted favelas with slogans such as: *"Welcome to the ghetto, you think you like apartheid."*

In a mixture of protest Graffiti art and folk art, the twins infuse an undeniable emotion across their works. As Jeffrey Deitch himself defines it, their art is *"(...) intellectual, the kind that an art historian can appreciate, but that kids out on the street can appreciate equally."* Their vivid paintings and their installations invite the visitors to enter the works using all their senses,

whether it is sight, hearing or touch, as an access to their world. During the shows, they recover walls from top to bottom, incorporating collages, doors, shelves and a variety of recycled items. Their yellow faces can be found in the most inappropriate locations, observing the street from every angle. Full of surprises, OS GÊMEOS' precise pieces reveal their constant attention for details. Their wooden heads, for example, impose a silent dialogue, broken only by the blowing of bubbles above the crowd.

Music also finds its place, now and then, in their installations. Using small record players and amplifiers, and a piano in a corner, they create vocal and noise-based cacophonies sounds, which, from their point of view, bear a choir-like quality.

Technically, OS GÊMEOS use cheap materials, with a preference for latex: *"Latex is paint used for walls, ceilings, floors, anything. We use it because it's cheaper, easy to find and has a good coverage, and because it has everything to do with what we want to say. (…) We decided to use different materials not only because it is more economical, but because it's more available and because it supports what we find in the streets. We always use latex for backgrounds and then outline in spray. Yellow latex and red spray paint are used just for bombing. For the big panels, we only use spray paint. We think that latex goes with our culture."*

Their style, in their own words, is like *"a tiny boat in a huge sea, with all its infinity and surprises."*

Shepard Fairey (OBEY)

Year of birth: 1970

Place of Birth: Charleston, South Carolina, USA

Starting Point: 1989

Influence(s): Skateboard and punk cultures as well as Hip Hop

Style: Giant wheatpastes, sticker art

Distinctive feature(s): André the Giant icon, political activism

The Beginnings

Frank Shepard Fairey, aka OBEY, was born in Charleston, South Carolina, where he lived until he turned 17. He confesses: *"I wasn't really exposed to graffiti, but I did get into skateboarding and punk rock."* His parents are not too happy with his school results and convince him to apply to the Rhode Island School of Design. And though his true ambition is to become a professional skateboarder, his application is accepted. *"But I'm glad I went there, because when I got there, we were pretty close to New York. Seeing graffiti and seeing that you're not the next Warhol from doing a piece across the Bronx expressway, just getting your name out there. That inspired me."* In class, he practices serigraphy. During his Providence years, he also discovers sticker culture.

During his working hours as a vendor in a skate shop, he improves his stencil technique, and sells his t-shirt creations on the side. In 1989, while he's still in school, he creates, more or less by accident, André The Giant, the icon that will accompany his artistic career. *"One night a friend was staying over and I was making a bootleg Clash shirt or something. He was bored and wanted to learn how to do that. So I flipped through the newspaper to find something for him to practice on and came across an André the Giant. I said, 'Why don't you do this?' So it just started as an inside joke."* He also produces Xerox stickers from the image, handing them out to his friends. Thus is born an invasion that rapidly becomes massive.

The "Aha!" Moment Into the Art World

In 1990, Fairey writes a manifesto to support his process, which he connects to Heidegger's phenomenology concept: *"The process of letting things manifest themselves': Phenomenology attempts to enable people to see clearly something that is right before their eyes but obscured; things that are so taken for granted that they are muted by abstract observation."* From that point on, he focuses on what he likes to call "Visual Disobedience". He also uses *The Medium is the Message*, a slogan borrowed from Marshall McLuhan.

In 1992, Fairey graduates from Rhode Island School of Design, in Fine Arts in Illustration.

His urban invasions of stunning proportions expand. He spends more and more time in San Diego and, in 1996, integrates *Obey* into his work, which turns into his signature out on the street: *"The whole idea about people having to confront their obedience instead of whining about the situation they're in and being obedient talking about".* Just then, his work is also published in the underground magazine for the first time. And because he can't make a living off his posters, he opens, with some friends, a communication agency, applying his creativity to corporate brands. His area of expertise is guerilla marketing, and he moves to Los Angeles shortly after, in 1998.

Shepard Fairey's first exhibits take place in 1999, mainly in the United States. During his travels, he implements systematic poster or sticker invasions wherever he goes, on his way to show works in a large number of underground galleries in Baltimore, Chicago, Cleveland, Detroit, Los Angeles, New York, Philadelphia, Phoenix, Raleigh, San Francisco, San Jose, but also in Tokyo, Stockholm and Birmingham. In 2004, his career takes off and he starts participating in more important projects such as the traveling exhibition *Beautiful Losers*, or for solo shows in Paris at the Magda Danysz gallery and in New York, at Jonathan Levine's. In 2006, the book *Supply and Demand: The Art of Shepard Fairey* is published. It covers about twenty years of activism. By then, Shepard Fairey is already a legend and even headlines the *New York Times'* Art section in 2007. His career becomes worldwide with his active participation during Barack Obama presidential campaign.

After his many years spent pointing out the various Administration excesses, particularly during the Bush presidency, Shepard Fairey signs the poster for Obama's HOPE campaign. Featuring the future president's portrait, the poster is what art critic Peter Schjeldahl then defines as *"the most efficacious American political illustration since 'Uncle Sam Wants You'".* More than 300,000 stickers and 500,000

posters are distributed during the campaign, with an important fundraise. The portrait, totally in line with his work, lands on the cover of *Time Magazine*, before being picked up by numerous media worldwide. In January, 2009, the HOPE portrait is acquired by the National Portrait Gallery. And that same year, the Institute of Contemporary art of Boston invites Shepard Fairey to an important retrospective exhibition.

His giant murals, in addition to his regular projects, have taken him from New York to Providence, Philadelphia, Charleston, Los Angeles, San Francisco, Long Beach and San Diego, via Paris, London and many other cities across the globe.

Style

During his first period, the iconic face of André The Giant defines Shepard Fairey's style, and is featured in all his pieces. *"I simplified the ANDRÉ face, into an icon figure, for a more serious effect, because I didn't want it to reference something as silly as wrestling. I looked at it as the Orwellian big brother face."*

Adapting the stylized icon everywhere, in large-sized posters, either placed in number one next to the other, or as one unique monumental piece. Predominantly in black and white, more rarely with a dash of red, the face is strikingly simple and its message, forceful: OBEY. After that, Fairey quickly enriches his image-

ry, creating new stickers with ANDRÉ. Then quickly his imagery evolves with a mix between ANDRÉ's face and iconic images. He does stickers such as the Hendrix Afro with ANDRÉ's face, a KISS version of ANDRÉ, Neal Armstrong's first moonwalk with ANDRÉ's face inside the helmet, etc. *"As an artist, I want to make graphics that are cool. I'm satisfying a few different things. I'm satisfying my desire to pursue the aesthetic that I enjoy as well as the concept behind the whole thing, so, you know, whatever. Sometimes all those elements can't be perfectly seamless. There's contradictions in everything. Just that I even sell clothes is a bit of a contradiction since I'm making fun of conspicuous consumption."*

With his work, Shepard Fairey is one of the pioneers of the graphics-related art, and proud of the reciprocal contributive relationship between graphics and his creativity. His body of work is both strong and increasingly complex, with different reading levels.

The simplicity of his shapes is key in the work he puts up in the street, in terms of accessibility and impact. Wheatpasting is his weapon. He puts up posters of impressive sizes in the most unexpected locations, following an important tradition in the writing world. But he takes things one step further. *"I'm not just a graffiti artist. This thing has, at least I hope, a greater degree of social relevance than most straight-up graffiti, even though I am into being a punk and an antagonist, which a lot of graffiti guys are into. I also think it's a bit more provocative than tagging. See, I never even wrote graffiti. The*

closest thing to graffiti that I do is spray paint stencils, cause you can get a lot of them around, real quick, and they're pretty permanent."

Shepard Fairey often points out publicity's omnipresence and acts like a parasite, creating interference on advertising spaces by sticking his posters over the ads: *"Why should it be ok to shove billboards and other types of advertising in public spaces where people have no choice but to look at it, just because you have money?"*

In addition to his street pieces, he puts time and effort into a more meticulous body of work prepared in his studio, using the same icons, adding more intricate details and turning them into posters which sell at cheaper prices on the web worldwide. In his originals, Shepard Fairey also mixes an amazing amount of various techniques. To wheatpasting he adds, on the same artwork, stenciling, collage, painting, etc., all in an intricate set of references.

Music is, still today, a great inspiration. The celebrity portraits he signs all share a certain inner psychology quality. Politics is another of his target subjects. Mao, Nixon and Bush are depicted in their visual environment.

Shepard Fairey has the eye of a sociologist, analyzing images and propaganda mechanisms, whether Soviet, Maoist or even American-based, and turning that familiar imagery into a universe of his own.

This page and next double page:
Courtesy of the artist, Shepard Fairey (OBEY)

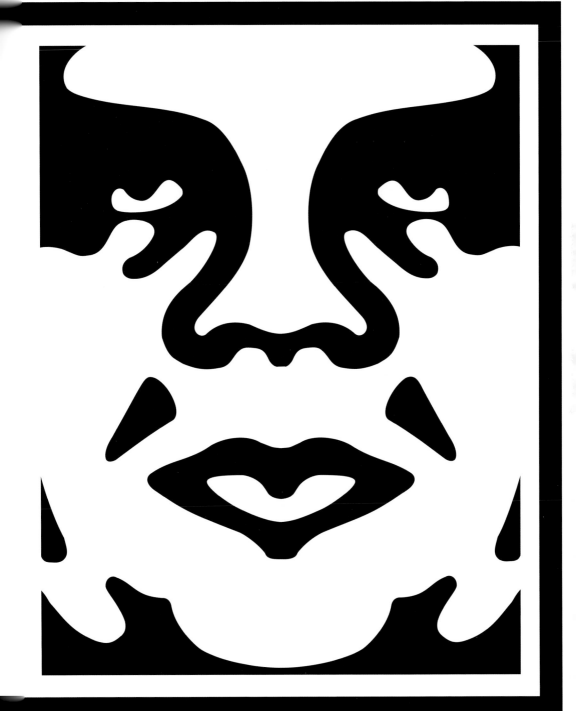

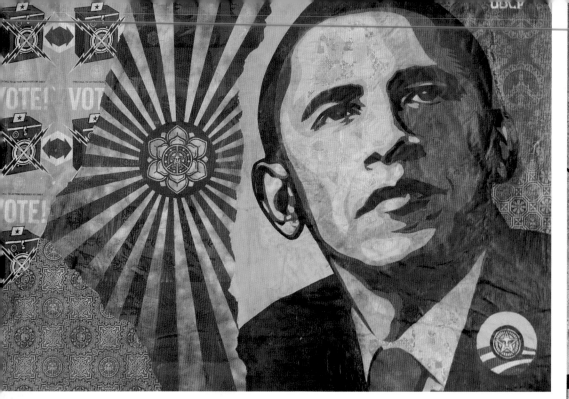

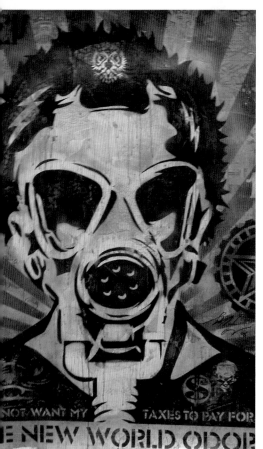

NOT WANT MY TAXES TO PAY FOR
E NEW WORLD ODOR

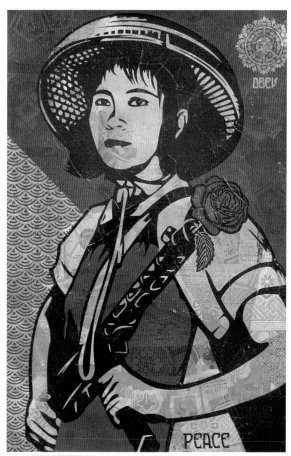

PEACE

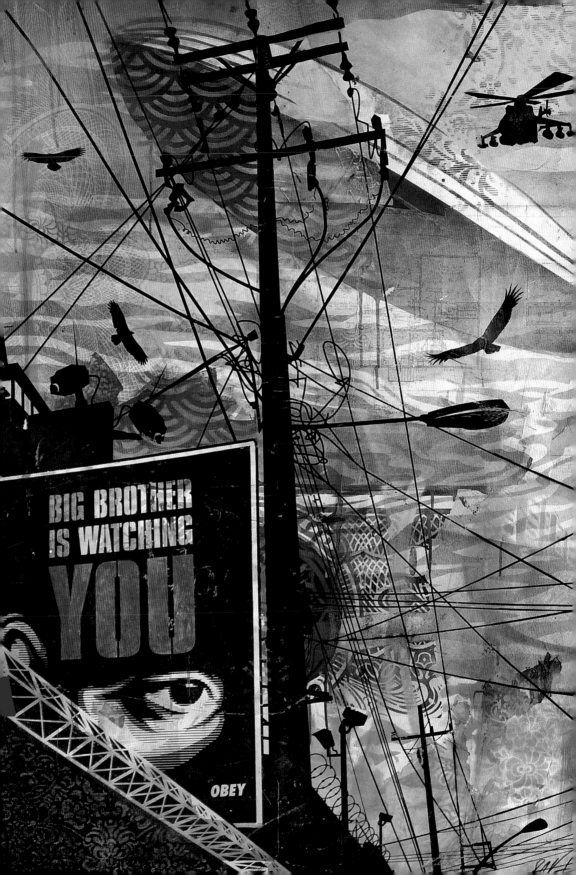

SWOON

Year of Birth: 1977

Place of Birth: Daytona Beach, Florida

Starting Point: 1999

Influence(s): Gordon Matta-Clark, Jean-Michel Basquiat

Style: Drawing, life-size wheat paste prints and paper cutouts

Distinctive feature(s): Subtle collection of human portraits and feelings

The Beginnings

Born in Florida, SWOON moves to New York in 1998 to attend Pratt University, in Brooklyn. She starts wheatpasting the streets of New York a year later. A friend of hers has a dream in which she's seen signing her graffiti, "Swoon." She adopts it as an alias and has held on to it since, to avoid prosecution for vandalism. Her work is based on the intricate relationship she has built with the urban environment as an entity. "*I needed to be in New York because it's, like, the biggest, loudest, dirtiest, most intense city we had*." And though she was convinced that, at some point, she would leave and give up her art studies, she's held on and found her personal road to success rather naturally.

The "Aha!" Moment

As of 2002, Swoon has her first group shows in Berlin or Cincinnati. And in 2005, Jeffrey Deitch himself presents her first solo show, for which she allows herself to think outside the limitations of the walls, creating a project where two-dimensional collages grow beyond anything she has done before, halfway between an installation and an entire world of her own: "*I was given a bigger space and my brain grew*".

Into the Art World

When her work is included in P.S.1 Contemporary Art Center's *Greater New York 2005*, and appears in Deitch Projects' special design district space during Art Basel Miami 2005, her career soars. In 2006, she's featured at the MOMA (and in their collections) and at the Brooklyn Museum. In addition to her many installations, she works on different projects with the different artist collectives she's part of. She has also been presented in Paris, Kiev, Moscow, Philadelphia, Los Angeles, San Francisco, etc.

Style

SWOON's work reflects the city, which is reflected in her work. She finds inspiration in traditional graffiti and in other artists who use the city as creative foundations (Gordon Matta-Clark, Jean-Michel Basquiat...). She engages the city and subway walls, hijacking and wheapasting posters in our urban environment, like street fairs. Popular and classical art forms influence her work, from German expressionism to Indonesian puppet theaters. SWOON's worlds are often populated by realistically rendered cut-out street people, often her friends and family. Riding bikes, talking on a stoop, going grocery shopping - these people traverse a cityscape of her own unique invention. Her main motivation is to translate in her art the feelings she perceives in the people she encounters every day. She "sees" what lies in people's souls, and puts it on paper, in an attempt to recreate a public environment that is able to breathe and open dialogues with passer-bys. She's also used woodblocking, wood engraving, always creating printed life-size portraits, recycling old paper and and newspapers, participating in the cycle that she sees everywhere in life: paper goes from the street to her studio to the city walls to the street...

In her preparatory work, SWOON takes a lot of photos, draws abundantly, working on photocopies, sketches and notes. A given portrait can find its bases in a large quantity of images that are often unrelated. Photography is at the heart of her process, but step 2 is about cutting up thousands of silhouettes, faces and animals, brought to paper life to create a world born from her imagination. In indoor installations, the worlds float lightly, creating spectacular and poetic volumes. In the street, her collages often appear in the most unexpected places, like invisible friends revealing themselves to the lucky ones.

Inspired by traditional graffiti and other artists who have used the city as raw material, she has been using city walls and subways as a space for creating publicly engaging work. SWOON's worlds are populated by realistically rendered and evocatively cutout street people who are often drawn from her own life. These characters explore a cityscape of the art-

ist's own invention, and include symbols of urban life such as bridges, fire escapes, water towers and street signs that create shadows and spaces through which her figures move.

In her own words: *"All I really do is cut a piece of paper, and then I roll it from the top down. And then I just roll it back out. I just have it as a very fragile, like shaking around, all cut-up piece of paper. And I use wallpaper paste, as you can see that's why this stuff comes down so easily, because wallpaper paste is meant for indoors. I kind of like that, I like it that this stuff decays. I really love brick, and I wouldn't ultimately want to destroy it. I only like to work with it temporarily. (...) I use a huge roller, and etching ink (it's oil based but I just clean it up with olive oil) and spread a sheet of paper on top then step on it a hundred times like mashing grapes or doing the twist. Depending on the paper type wetting it first can be useful for better saturation, contrary to what you would think with oil based ink. (...) I try to create something that has a kind of a life cycle. It goes up, and has this whole blossoming and decay."*

SWOON has collaborated with a number of collectives (Toyshop, Barnstormers…) on interactive performances aimed at questioning the level of the relationship engaged between people and their cities. *"I've been working on the issue for so many years that my way of going about it has evolved. The most important thing to me now is to work where people live. To address people who don't necessarily go to places dedicated to art. If they don't like the work, they get rid of it. The mere existence of such a democratic space, in which everyone is able to express themselves, legally or not, is essential to me. Showing in gallery offers a quiet space, where I can concentrate on a subject for several weeks without worrying about losing the work. That security gives me another type of freedom, which can't be found outside, in the street world."*

The Beginnings

Dean Stockton, a.k.a. D*FACE, was born in London and confronted to Graffiti at an early age. He still remembers, today, Henry Chalfant's book covers, for *Spraycan Art* and *Subway Art*. Though he admits to multiples influences, from Jim Philips to Hip Hop to punk music and cartoons, the most important one was skateboarding culture. *"I was raised in London, born and bred to hard-working parents. Mum worked in a bank, Dad worked as a panel beater and bodywork sprayer. I hated school. I had a very clever sister who was the academic one. I was never going to step to that so I decided to just sorta find my own direction. I started to get really into graffiti at a young age. My Mum stupidly bought me the book 'Spraycan Art' that pretty much changed my life. I used to draw and doodle and things like that and tried to be a graff artist as a kid, but I did not really get the full idea of it. At that time it was an American thing for the most part. I mean I would see it around, but I did not fully understand the culture of it in those days. I was too young I guess. Then as I got a little bit older I got into skateboarding and that was pretty much the center of my life. Skateboarding changed my life."* He still manages to get through school, failing all of the 'academic' subjects, because of skating and graffiti, and somehow gets into photography school, realizing soon enough that photography is not for him. Switching to a design and illustration program, he discovers something he actually enjoys: *"On my off time or between jobs I would draw little*

D*FACE

Year of Birth: 1975

Place of Birth: London

Starting Point: 1999

Influence(s): Jim Philips, Shepard Fairey

Style: Wheatpasting, hackvertising

Distinctive Feature(s): Icon-based work, cynicism and humor

characters. It really started out as something I was just doing to fulfill a creative release. Anywhere I would go I would put up these stickers and just try to cover as much of London as I could. It kind of became a subversive intermission."

He then begins working as a freelance illustrator while developing his art in the street. He begins under the pen name of D*FACE with, from the beginning, a will to awake consciousness in his fellow countrymen. Asked about his start, he answers: *"D*FACE is a secret government project started to test the public's awareness and resistance when faced with an alternative to the mundane advertising that surrounds our public domain. There is no specific goal, conclusion or end, it merely serves to test cause and reaction."*

The "Aha!" Moment

In 2004, just before the big sticker trend in London, D*FACE gets his first taste of success, somewhat by surprise, when someone recognizes him during an art opening. That's when he understands that people actually have seen his stickers everywhere, and that the subversion of his project conveys real meaning. D*FACE decides to stick to his commitment and opens the Outside Institute, a contemporary art gallery in London with a focus on street art.

Into the Art World

D*FACE has been showing his work worldwide and has participated in about 40 exhibitions since his debuts, in France, Norway, Sweden, Spain, Germany, Taiwan as well as the US, both on the East and West Coasts. He's been invited to the traveling exhibition *A British Celebration of Style*, which contributed to make him one of Street Art's icons and a representative of the British scene.

Style

D*FACE's style is rather easily recognizable: handpainted subvertisement on liberated billboard called, in his own words, *"another public service announcement"*. He cuts, hijacks and creates interference on publicity-bred or marketing-based images. Displaying his messages in cut-up letters throughout the city, he operates like a blackmailing artist, adding small motives, like his white wings.

He's also developed a language based on consumerism icons and clichés (*Marilyn Monroe* by Andy Warhol, the Che, the queen mother, etc.) hoping to stir *"some reflection into a society fascinated and fixated on success and celebrity"*. His weapon of choice is, always, clever punk rock irony. *"I wanted to encourage people to not just 'see', but to look at what surrounds them and their lives, reflecting our increasingly bizarre popular culture, re-thinking and reworking cultural*

figures and genres to comment on our ethos of conspicuous consumption. A Pandora's box of bittersweet delights - sweet and sugary on the surface, but with an unfamiliar, uncomfortable taste beneath."

In those works, a number of symbols appear. In his CliChé pieces, for example, he uses the portrait of the Che, as a perfect symbol of an accessory worn by people looking to assert some type of personal revolutionary spirit. The portrait, however, conveys a complex contradiction with the principles of the unknowing and unwilling model, turned into a mass-marketed product of consumption. D*FACE underlines modern marketing's inconsistencies and sheds light onto them, questioning fame and celebrity in the face of death.

Next double page: Courtesy of the artist, **D*FACE**

The Beginnings

FAILE is an artist collective born in 1999, originally comprised of Patrick Mc Neil (Canada), Patrick Miller (USA) et Aiko Nakagawa (Japan).

Patrick McNeil and Patrick Miller meet in high school in Arizona, USA. Both of them are pursuing an artistic career, and their collaboration starts then. However, they briefly take separate roads to go study: McNeil goes to New York while Miller chooses Minneapolis.

During one of his art shows in a New York club, McNeil meets Aiko Nakagawa, a young artist herself. Hanging out in New York's meatpacking district, they witness Street Art's emergent scene, and take an active part in it by wheatpasting the prints that Mc Neil and Miller produce in Minneapolis.

"We were always interested in the idea of an art group, similar to a band but as visual artists. Something where the work could really be made through the collaborative process, where it is a result of everyone's combined efforts. It gives us the ability to riff off each other and really be influenced by our work together. This is something Pat and I grew up with, and as that idea was really starting to come together, Aiko came into the picture and it just seemed to all make sense." - **Mc Neil**

FAILE

Date of Birth: 1999 (collective)

Place of Birth: USA, Canada and Japan

Starting Point: 1999

Influence(s): OBEY, Robert Rauschenberg, Stanley Kubrick, Andy Warhol, Cy Twombly and Roy Lichtenstein

Style: Intricate stencil, painting and wheatpaste collages

Distinctive feature(s): Complexity, multi-layered narratives

The "Aha!" Moment

In 1999, the three young students decide to collaborate together under the group name Alife (a line which they've found in an old sketch book). When they discover a Lower East Side store named A-Life, they change the name to its anagram FAILE. The group begins to develop a language based on stenciled posters combining luscious women magazine covers and comic strips.

"FAILE was about this growth process. About taking your fears and your challenges, your grief and misfortune, and creating something from that. Taking your failures and proceeding forward, becoming stronger from what you have learned...The name has a meaning that is dear to us, something that is born out of a place and time for us, and something that has a philosophical undercurrent that flows through the work we do."

Into the Art World

Following OBEY's lead, the trio sets out on wheatpasting campaigns in a large number of cities, looking to make a name for themselves and leave their imprint. Using their student loans, they travel through London, Paris, Amsterdam, Berlin, Barcelona, Copenhagen and Tokyo.

At first, FAILE find inspiration in media culture figures and in comics. Little by little, they turn the image of a dog into their emblem. Their name and that icon,

found everywhere, give them somewhat of a status in the Street Art world, which steers the collective toward a more artistic process. *"Things have changed a bit since we first started. As we have worked on the streets, our ideas have changed and it seems to become less about the public seeing it everywhere and a bit more personal."*

From London to Shanghai by way of New York, Denver, Los Angeles and San Francisco, FAILE travel all over the world for their street projects and the many exhibits they are a part of (more than 50 in their first ten years of activity). In 2003 the group switches to paint, even though they often add stencils to their collective paintings. In 2004, they choose to settle down in New York, pushing the collaboration envelope one step further.

The collective has been through a number of changes since its creation. In 2006, Aiko decided to focus on her solo career, leaving the collective to continue their work. Around that same time, FAILE completes a 108 feet long mural, (33 m), made of eighteen 6 ft (1.8 m) x 6ft canvases, for the "Tiger Translate" event held at the Shanghai Sculpture Space. The mural is largely composed of the collective's imagery and ideas juxtaposed with the ephemera collected during trips to New York City's Chinatown. In 2007, the group is invited to the key institutional exhibit "Spank the Monkey" at the Baltic Centre for Contemporary Art, in Newcastle/Gateshead, UK.

Style

Their initial experience with screen-printed posters wheatpasting in the street has led the collective FAILE to evolve towards pop painting and stencil. The iconic images used in the works of the collective are borrowed or inspired by fashion, music, comics, pulp fiction novels and even Yellow Pages ads. The multiple sources of creation bring a multi-layered complexity to their works: *"Our process of creating work involves synthesizing images to create visually visceral experiences, very similar to the way a DJ samples beats to create an audible experience"* admits McNeil.

Images are painted or stenciled, overlapping and resulting in a concept that defines the collective: a duality that is inherent to the world itself. *"There has always been an attempt to embrace the idea of duality in our work. Love/Hate, Peace/War, Violence/Beauty. This has a distinct place in the world we live and can always be felt as a constant push and pull. That kind of duality has found its way into our work by juxtaposing certain visual, language and symbols which represent these ideas"* adds Miller.

In more recent works, multiple classic core-images are combined together as a composite on large canvases to give an appearance of layering and the wear and tear of the street.

In developing their work, FAILE have managed to build intricate images. Their collage and paint patchworks of pop images create narrative threads. More recently, they have been working on various size paintings on wood and glass and have experimented with laser etching on screen prints.

Their style, enriched by time and travel, evolves at a sure and personal pace.

The Beginnings

SPACE INVADER was born in France in 1969 and has maintained total anonymity "*for safety reasons, originally, and then mostly for fun*". His first piece, a small mosaic replica of a Space Invader (a famous 70s-80s video game) character, is put up in the 1990s, in his hometown, Paris. It's the first of many to come. "*It all started when I put the first space invader in a Parisian alley. It was a sentinel, and it spent a few years alone. The invasion itself started in 1998, when I activated the Space Invader program.*" The invasion is massive, as the video-game-inspired mosaics appear around the world, unsigned, creating a buzz from London and Los Angeles to Tokyo, New York, Bangkok, etc. "*I kept the name of the game as an alias because it's a perfect definition of my work itself. I'm a space invader. It's very binary.*"

His link with Street Art is not that obvious. He discovers the Graffiti scene afterwards. His originality, however, opens some doors and he finds a warm welcome in the Movement, integrating its culture: "*I found a lot of energy and life there, as well as a family. (…) I've maintained friendships and interesting references.*"

SPACE INVADER

Year of Birth: 1968

Place of Birth: Paris

Starting Point: 1990

Influence(s): Video games

Style: Mosaic

Distinctive feature(s): Pixel esthetics

The "Aha!" Moment Into the Art World

The proliferating work of SPACE IN-VADER is a process, which was set up step by step, progressively taking over cities around the world: Aix-en-Pro-vence, Amsterdam, Antibes, Antwerp, Avignon, Bangkok, Barcelona, Bastia, Berlin, Bern, Bilbao, Bordeaux, Cannes, Clermont-Ferrand, Dhaka, Geneva, Gre-noble, Hong-Kong, Istanbul, Katmandu, Lausanne, Le Lavandou, Lille, Ljubljana, London, Los Angeles, Lyon, Manchester, Marseille, Melbourne, Mombasa, Mo-naco, Montauban, Montpelier, Nantes, New York, Newcastle, Nice, Nimes, Bets, Po, Perth, Rennes, Rotterdam, Saint-Jean-Cap-Ferrat, Tokyo, Gates, Varanasi, Vienna. SPACE INVADER is everywhere, and the buzz inflates… In 1999, fashion designer and collector Jean-Charles de Castelbajac, an early Street Art fan, gives him his first break, which leads his way into the Art market. The following year, he invades the FIAC (the International French contemporary art fair), New York's Armory Show and the Almine Rech gallery.

Thus begins a long series of exhibits, fueled by his celebrity worldwide. He's invited to Japan, Hong-Kong, Sweden, Holland, Australia, the United States, Turkey, UK, pursuing his viral process relentlessly. In 2007, he participates in the institutional exhibition dedicated to Street culture at the Baltic Art Center in England.

Style

SPACE INVADER's artistic process relies on the combination of pixel and mosaic, on the transposition of a virtual video game in real life, and on the inva-sion principle. *"I like to consider this work as a global scale project in which the notions of infinitesimal and infinitely big are in constant confrontation."* His thoughts on art and its intrusive potential are interesting in more than one way, and stand today as the most successful and complete process, in the Street Art world, on that particular issue.

Lowtech, ante-tech, SPACE INVADER as a game illustrates the emerging rela-tionship to playful paradigm, in regards to a recurring program based on a simple principle: in the same way a player faces a machine, SPACE INVADER accepts so-ciety's challenge. The game and its rules are not just part of our culture anymore, they address a deeper part of ourselves, our nature: urban, programmatic and

subjected to computer intelligence. In that context, the artwork becomes the virus and the night-performer, the hacker.

And, in accordance with the Graffiti code, SPACE INVADER documents meticulously each step of the process, in video and pictures.

The use of mosaic is rare and original in the Street Art universe, and interesting in several ways. It's a good representation of the elementary technology found in the first video games. Graphics used basic pixels, back in the days, and those pixels are easy to reproduce in mosaic: a pixel is assigned to a square. Furthermore, mosaic don't fear the damages usually caused over time. The SPACE INVADER reproductions are cemented on the walls of the city in the most unexpected and hard-to-reach places. They're all indexed, photographed and located on maps by their author. And in his use of mosaic, SPACE INVADER anchors his process in an ancient artistic tradition that has been perpetuated for thousands of years, which gives yet another echo to his work. *"Mosaic is privileged material to be cemented on outdoor urban surfaces. Mosaic is unchanging, its colors never tarnished. In the XVth century, mosaïst Domenico Ghirlandaio declared: 'The vera pittura per the eternita essere mosaico'. But in the end, of course, I chose mosaic because of its square pixel-like shape."*

No mosaic is put up randomly, and the artist selects each new location according to a number of criteria, which can be esthetic, strategic and/or abstract. Frequent passage, for example, counts,

though sometimes hidden spots are favored. Mapping is taken into account: in Montpellier, the Invaders have been placed so as to create, if you connect the dots, one big Space Invader that can only be seen as you fly over the city. *"Invading a city is a very intense experience. I immerse myself completely into my invader's role. I prepare my models in advance, and I travel with them. Once I'm onsite, I act fast, but at the same time it feels like a performance, spread over the course of several days, because it takes me at least a week. I mark the city out in squares, so that the presence of the invaders feels real. (...) I have my own map for each invasion. It's the first thing I do when I arrive in a new city: I get a map that can give shape to what will follow. Sometimes, I land a sponsor (patrons don't exist anymore), in which case I draw a map that I print several thousand copies of. They're very important because they're the synthesis of the overall process. Each one tells a story you need to break the code to. The maps are then distributed throughout the invaded city."* Each space invader is indexed *"because they're all different. The indexing is extremely detailed: number, date, location, number of points obtained, all these elements are registered in a database. And there's photos of each piece. Over the last few years, I've had a photographer help me. And aside from that process, I also use stickers, paint sometimes, use ink stamps, and invade the media. But those invasions aren't the real thing. I only index the mosaic or tile space invaders. Mosaic is the royal path to invasion."*

INVADER has also had the opportunity to adapt his urban work to gallery walls, creating "pixel-mosaics" featuring Pac-

Man and Pong, that are much more complex than his street mosaics, and also has the "alias" series, twin brothers of sorts to the street mosaics. In 2005, he launched the "RubikCubist" movement, using Rubik's Cubes to give life to a new generation of invaders and social icons. *"It's both an evolution in my work and a new direction. I use rubikcubes as raw material. I take them to conceive artistic works. Rubikcubism combines rubikcubes and cubism, it merges a game from the 1980s and an artistic movement from the XXth century. The challenge is interesting because the object wasn't intended for that purpose. (…) I've always made a point of finding rubikcubes when I travel. I figured I could use them one day. It took me four years to just get nine of thel, and I stored them in a corner of the studio, waiting for the right moment. My first piece was in 2004, I called it Rubik Space One. By playing with colors and manipulating the pieces, I managed to get a Space Invader image. And that was my first sculpture. Once I build a frame, they create a portrait and form an image, but with the cube's volume, the face has a front, and a back. Everyone is two-sided, everything has a positive and negative aspect. The shapes I create are interesting, with a double reading grid. (…) A Rubikcube is mysterious and scientific, it's a strange puzzle with a mathematical base, and it offers 43 billion possible configurations. I see it as the pixel's distant cousin. Both are machines that use number. (…) Those considerations aside, it symbolizes my generation. I had one when I was a kid, and it reminds me of the 80s, of an entire period in my life. It's my personal Proust Madeleine."*

This page and next double page:
Courtesy of the artist, **SPACE INVADER**

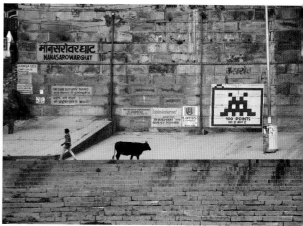

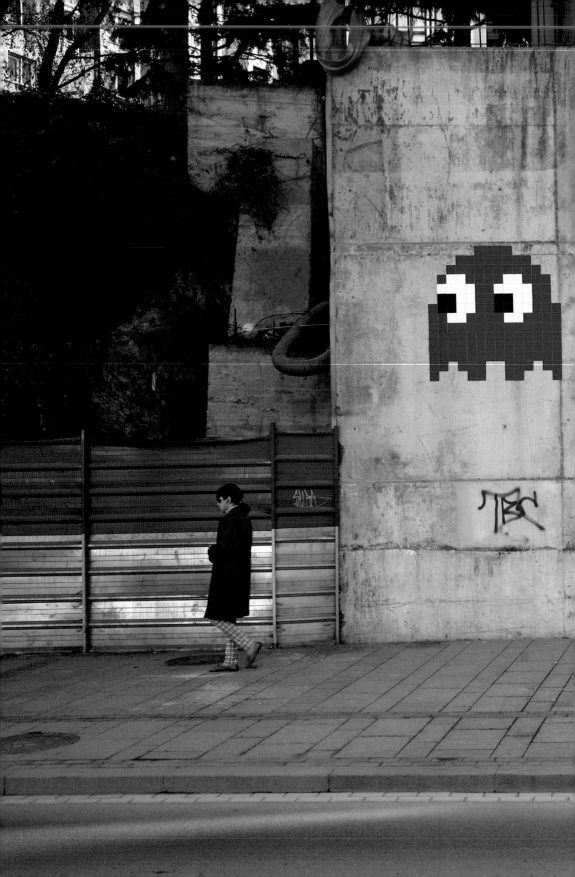

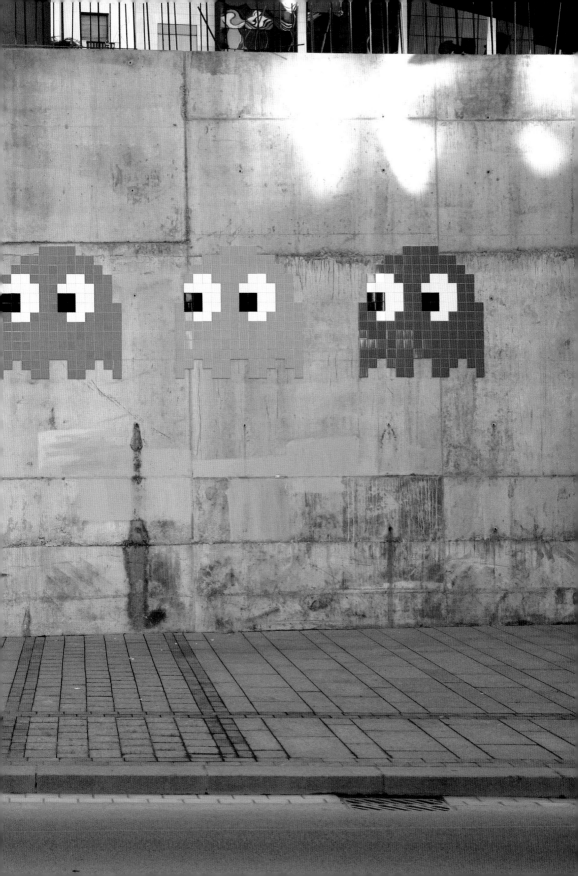

The Beginnings

ZEVS was born in 1977, in the East of France, but chose to settle in Paris. Like most Graffiti writers, he starts covering the capital's walls at a relative young age. In 1992, he's been around for a few years already, but almost gets run over by a train in the tunnels of the RER's A line. The trains in that direction are coded "ZEUS", and the teenager chooses to honor what could have killed him.

As a way of finding his own identity in the Parisian Graffiti universe, which is in full bloom, he creates his lightning strike cloud, which is easy to spray paint and becomes rapidly famous, perched at the top of the Parisian buildings. Among his close friends are INVADER and ANDRÉ.

The "Aha!" Moment

At the end of the 90s, ZEVS starts a series of pieces he calls *Urban Shadows*: using white paint, he detours the shadows projected on the sidewalk by urban furniture elements such as mailboxes, public benches, parking card vending machines. The resulting silhouettes, pastiches of the body contours left by policemen after a murder, have a rather long lifespan, create strange effects according to the time of day, and an original attempt at moving graffiti from the walls to the sidewalk. Both the public and Street Art

ZEVS

Year of Birth: 1977

Place of Birth: Saverne, France

Starting Point: 1989

Influence(s): INVADER, ANDRÉ

Style: Image and urban furniture hijacker

Distinctive Feature(s): Urban guerilla of diverse shapes and forms, subverting.

insiders are intrigued. Around that same period, the Parisian screening of ZEVS' film *Warning may provoke Damage* at the Maison Européenne de la Photographie (MEP) in Paris, is a success.

For his next series, *Visual Attacks*, 2001, he targets the huge advertising posters that cover the Paris subway station walls, "murdering" all of their protagonists with the use of red spray paint: in the middle of each model's forehead, ZEVS leaves a single, dripping red dot.

Into the Art World

Parisian galleries invite him early on. In 2002, he joins the European Street Art scene with a first solo show in Berlin. Over the course of a few years, he also participates in more than 50 group shows in Paris, Rotterdam, Prague, Düsseldorf, Berlin and Hamburg, as well as New York, and Hong Kong, He also is invited to a number of high-end art fairs.

Style

ZEVS is emblematic of the recent changes that have appeared in the Paris scene during the 90s. His actions are the consequence of transformation and evolution. In terms of urban guerilla strategy, he's an important fixture of Street Art's developments. His first graffiti, his painted shadows and his first subvertisements are more than a "I was here" reminiscence.

They're a reminder, like Shepard Fairey's campaigns, that urban signals, whether they are city owned or corporate, are never neutral.

After his *Visual Attacks*, he keeps going after the advertising world, but with a change of weapon. Goodbye spray paint, hello scalpel. On April 2, 2002, ZEVS takes hostage the image of a female model on a Berlin Lavazza poster. On the emptied out ad, ZEVS carefully leaves a message, which reads *"Visual kidnapping, pay now!"* Later, he even cuts up one of the victim's fingers (the paper model's), mailing it to the Lavazza's headquarters, asking for 500 000 euros (i.e. the average cost of the ad campaign) in exchange for the hostage. The case is closed with the simulation of an exchange, in 2004, at the Palais de Tokyo in Paris.

In 2006, the *Liquidated Logos* series subverts giant corporation logos by liquefying them. Under the visual impact of major paint drip effects, Nike, Chanel or McDonald turn to melt. In 2009 he attacks the Armani store in Hong Kong with a dripping Chanel logo, bringing him the expected trouble and attention.

Taking over the street is not a neutral choice. In-between ephemeral art and political action, ZEVS finds his own position and chooses to develop his art process on the battleground of protest and publicity strategy.

KAWS

Year of Birth: 1974

Place of Birth: Jersey City, New Jersey, USA

Starting Point: 1987

Influence(s): Garbage Pail Kids, John Pound, Barry McGee

Style: Comics esthetics

Distinctive feature(s): Perfect execution, pop and cynical double language

The Beginnings

Brian Donnelly, aka KAWS, was born in 1974 in Jersey City, New Jersey. He's still in school, around 1987, when he takes an interest in Graffiti and starts putting his name up on every neighborhood wall, even with little knowledge of the movement's culture per se, or of the way things are done in New York. In 1991, he takes the leap, writing at a higher level, covering wider areas in Jersey and Manhattan. His "thing", at the time, is to paint over advertising posters in the city. KAWS then studies at New York's School of Visual Arts, graduating in 1996, before freelancing at Disney as an animation designer. His credentials include sets for cartoons, like *101 Dalmatians*, or television series such as *Doug* or *Daria*.

The "Aha!" Moment

Between 1997 and 1999, in addition to his day job, which bears a strong and undeniable influence on his personal work (his own mascot has the body of a very famous Disney character and a skull for a head), he starts hijacking the city's bus stops' corporate ad posters in New York, thanks to a magical key, courtesy of TWIST (Barry McGee). At night, he removes the posters (Calvin Klein, DKNY, Diesel, etc.), takes them home, covers the faces with skulls and signs his work before putting them back in place, discreetly. From then on, his presence is no-

ticed by all and his fame grows. In 1998, KAWS wins the annual Pernod Liquid Art awards, and its $10,000 prize.

Into the Art World

In the early 2000s KAWS gets solo shows in Paris, Tokyo, London, Vancouver... His career quickly takes off. In 2004, he is invited to the important itinerant exhibit *Beautiful Losers* which stops in Lille, France; Milan, Italy; at the USF Contemporary Art Museum, Tampa, FL; Contemporary Museum, Baltimore, MD; Orange County Museum of Art, Newport Beach, CA; Yerba Buena Arts Center, San Francisco, CA; Contemporary Arts Center, Cincinnati, OH. His work joins the greatest collections (Lance Armstrong's or the Dakis Joannou Collection).

Pharrell Williams includes him in the show he curates in 2008. In 2010, the Aldrich Museum of Contemporary Art, Ridgefield, USA, welcomes his solo show.

Style

Executed with an almost obsessive technical precision, KAWS' works transcend cultural barriers, and find their audience in the United States, in Europe and in Asia. During his Disney experience, he's worked tirelessly, developing a visual language inspired by the corporation's icons and by the omnipresence of advertising. Consequently, his characters create "ad disruptions". As an artist, he's diverse. His toy designs greatly stand out thanks to the precision of his lines. He also uses perfect surfaced colors surfaces, which are a clear reminder of Disney's style, or at least the animation world. Like Jeff Koons and Takashi Murakami, he ironically claims ownership over popular culture icons. In addition to his recurring Disney-based character, he's also subverted the Simpsons and the Smurfs, among other examples, replacing their eyes with Xs.

His skulled Mickey is staged in two-dimensional paintings, in photos or advertisements. He's also created toys and sculptures which achieve their full dimension when produced life-size. KAWS' omnipresent character invades the advertising world and common space. It is both a signature and a message in the face of the watcher, an icon confronting its spectator. Often compared with Keith Haring, KAWS following his footsteps, playfully toying with the limits between art and artefact, between work of art and product. All the while spontaneous, joyful, as well as disturbing, cynical, if not downright morbid, his paintings and his sculptures assert themselves as some of the most fascinating examples contemporary Pop Art.

In his most recent works, KAWS has been investigating more abstract aspects, with identical results. His curves are more accentuated. His perfect surfaces bring rhythm. Contrast between colors deepens. And, sometimes, his characters seem almost hidden behind the abstract curves.

The Beginnings

Random von NotHaus, aka BUFF MONSTER, was probably born in 1979, in Hawaii. During the week, he's a good student, working hard. On the weekend, he's a Graffiti writer. He then moves to California and attends USC, to study Business Administration and Fine Art, with a clear motivation: *"I'm both an artist and a small business owner. And my idols like Warhol and Murakami have a very strong sense of business. There are lots of good quotes from Warhol, but one that I like is: Making money is art and working is art and good business is the best art. And Murakami said that the contract he signed with Louis Vuitton will be confidential for 100 years, but once its released, it will be the best piece of art he's ever made"*. After graduating college, he spends a few years in Santa Monica, before moving to Hollywood. About his pseudonym, BUFF MONSTER, he has an interesting explanation: *"That's what the ladies call me, and it just kind of stuck"*.

BUFF MONSTER

Date of Birth: 1979

Place of Birth: Hawaii

Starting Point: 1997

Influence(s): Garbage Pail Kids, John Pound, Barry McGee

Style: Japanese Manga esthetics, pink universe

Distinctive Feature(s): "Art of Super Happy Pink"

The "Aha!" Moment

In Los Angeles, BUFF MONSTER starts a massive poster campaign. But, after seven years of a very prolific career as a street artist, he gives up all street activism and dedicates himself exclusively to fine art paintings, collectible toys and select design projects.

Into the Art World

His large installations and paintings are constantly presented in numerous US galleries through mainly on the West Coast, as well as in New York, Minneapolis, the Hawaiian Islands and Denver.

Style

BUFF MONSTER is a perfect example of the prolific Californian scene. Inspired by Japanese pop culture, and shedding a different light on the polished Disney standards that have infected our society, he's a representative of Street Art's kawai (Japanese for "cute") branch, infused with Japanese culture. He qualifies his work as the "Art of Great Happy Pink" and gives heavy metal music, ice creams and Japanese culture as his main influences. For BUFF MONSTER, pink is the symbol of confidence, individuality and happiness.

"The shade of pink that I use is the most heavy metal shade that I could come up with. Metal isn't always black. (…) It's very pink… fluorescent pink, for the most part, which is very different from baby pink. It's not Hallmark cards and baby bits. It's the brightest, most killer, most obnoxious pink you can get".

Whatever pieces, whether painting on canvas, wood, or creating limited edition objects, he pays close attention to details and to the overall effect, making them as flat as possible. *"I have developed a real surface fetish, so I meticulously plan how the layers will lay down and interact. I have spent so much more time on these new pieces than I ever have before. I might spend half a day just trying to figure out how I'm going to produce one of them."*

BUFF MONSTER prepares his creations digitally, using Illustrator before printing them and placing them in his pieces and beginning a patient shape-filling painting work. Certain elements can be stenciled several times to create a mini army of sweet monsters.

"I make happy, fun, ridiculous compositions that are executed with the ut-most attention to detail". Paradoxically, part of his inspiration is found in heavy metal: Dark Fortress, Celtic Frost, Hellhammer, Iron Maiden, Fireball Ministry, Dimmu Borgir, Satyricon, Pentagram, Witchcraft are among his favorite bands. His chosen haven, Los Angeles, is another of his muses. *"L.A. inspires me,"* he says. *"It's a place in popular culture, it's the movie industry, the adult industry — and it's all about image. Porn and sex inspires me. (…) The same shapes that make up the sundaes also reference breasts, nipples, vaginas and semen. The mounds don't just ooze, they lactate and ejaculate. Again, cotton candy and strawberry ice cream are not the only reasons for using so much pink paint."*

Born from the Graffiti movement, both technically and in regards to the codes he uses, BUFF MONSTER's art remains strongly influenced by Barry McGee, Takashi Murakami and Andy Warhol.

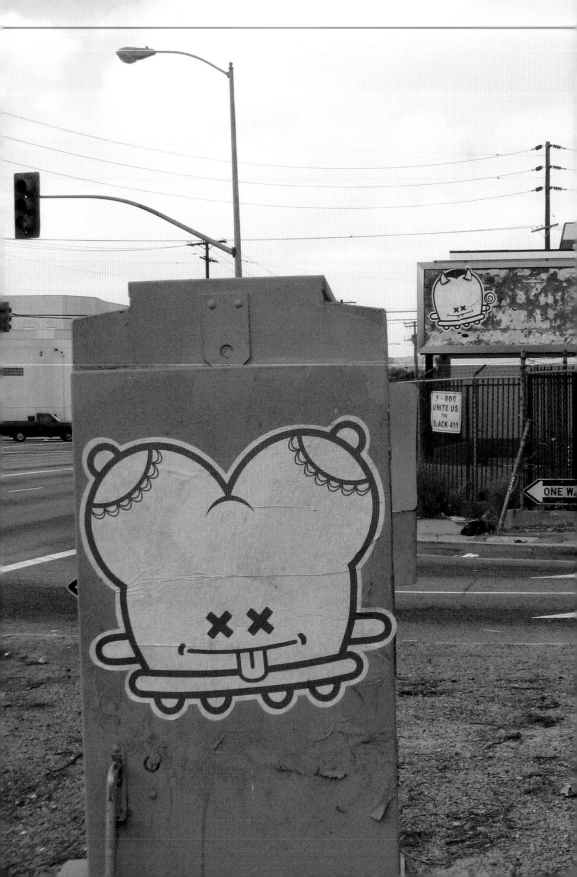

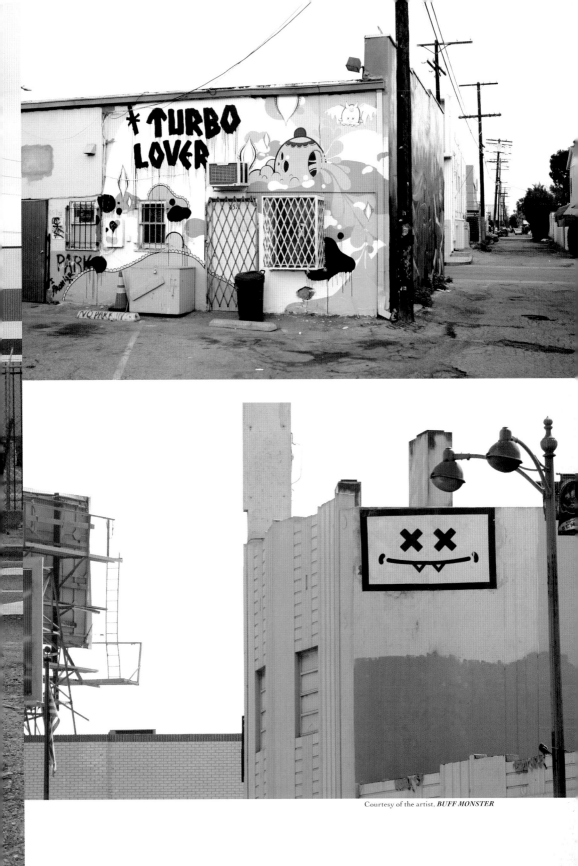

Courtesy of the artist, *BUFF MONSTER*

BLU

Date of Birth: 1981

Place of Birth: Bologna, Italy

Starting Point: 1997

Influence(s): Robert Crumb, Gordon Matta-Clark

Style: Giant mural drawings

Distinctive Feature(s): Usually figurative and monumental pieces, featuring strange characters

The Beginnings

BLU was born in 1981 in Bologna, North of Italy, considered to be the cradle for modern Italian Street Art. The often-called "red" city has inspired this young artist: as far as he can remember, he's always drawn. In 1997, he discovers the Graffiti writing world and begins to tag himself, during his Art Institute student years. During that period, he consistently tags his name in every way, shape and form he can think of, practicing every single available style that Graffiti might offer. Having explored the subject fully, he gives up lettering and calligraphy after a few years, to exclusively focus his work on what will become his unmistakably personal style.

The "Aha!" Moment

For years, BLU works on large-sized murals around the world. But in 2005, a particular piece painted in Managua, Nicaragua, grabs the street art world's attention, in terms of size (the wall is huge) and because of the strong political message it conveys against the banana republics, symbolizing how a country's natural resources and wealth can be turned against its own people. It's an extremely emotional piece, and its image travels around the world.

Into the Art World

BLU has been painting massively, and everywhere, from Italy, Spain, Germany, England, to Argentina, Costa Rica, Nicaragua, Mexico City, Guatemala and Brazil. His work, rarely seen in art shows, has been presented in Betlehem, Palestine, New York, and London, but BLU prefers sticking to the wide surfaces offered by outer walls.

In 2007, he also completed a stunning animation film, entitled "Muto", on the walls of Buenos Aires and Baden. It is said to have been viewed more than 5 million times online.

In 2008 his work is particularly noticed during the Tate Modern's Street Art exhibit, in London. In 2009, he receives the Grand Prix Lab at the Short Film Festival of Clermont-Ferrand and the Grand Prix at the International Animation Festival in Stuttgart.

Style

Death, humor, science fiction, visual impact and wildness are mixed in BLU's singular graphic style. His finds inspiration in underground and independent comic books by artists such as Robert Crumb, and admits the influence of Italian fresco tradition and of Gordon Matta-Clark's work. *"The way Matta-Clark used the building as a sculpture; it's something I try to imitate when I paint."*

BLU now only uses paint and brushes in distinct, raw and concise strokes to elaborate a parallel figurative world, with strange characters, aliens and alienated beings. He uses a very limited palette, highlights his fascination with line and form, and uses paint just for fill-in.

BLU creates giant drawings representing animal or monster-like characters of poignant allure. His scenes often feature chained-up characters, animals devouring one another, or human beings engaged in combat. His very distinctive black lines over white backgrounds are simple, outlining faces that are often reduced to their minimum features, shape, eyes, mouth and nose. A first level of details is then added, like color, bringing depth.

Only then does he add a multitude of much smaller details. Heads are often represented as sectional drawings, unveiling every thought and action hidden inside, as imagined by the artist. A procession of tanks on a wall offers glimpses into what is happening inside them. In one of the tanks, a high-ranking officer is playing a video game, aloof to the brutal reality of war. BLU is merciless when it comes to denouncing the power of the money and the servitude of men. *"Every drawing that I paint expresses a thought. So,*

it happens that my characters point at social subjects, because very often I'm thinking about our crazy society."

BLU's greater talent is his ability to perfectly integrate his work within its environment. He uses what is available. If the facades he paints have windows, they become the eyes of his character, illuminated at night, as a token of gratitude to the city's offered surfaces.

BLU does not ask for permission. He simply paints. *"To do something without asking permission... it's a way of expressing yourself"*. *"Painting in public spaces is a really interesting social experience. What I like most is not the piece itself, but people's reaction, and how the piece is being digested by the city. At the beginning, it is something new: It can be pleasant or disturbing, depending on the point of view. Then, with time, it becomes part of everyday life, and it can take on an old, familiar flavor, like those old, rusted billboards or advertising murals, forgotten in the corners of our cities."*

The Beginnings

Polish artist Mariusz Waras, aka M CITY, was born in 1978 in the city of Gdynia in North Poland. His work is recognized early in his career, mostly for its graphic qualities, and he wins several awards, among which the first prize at the "Gielda papierów wartosciowych" in 2000 (literally, the "forum for valuable papers"). He gets his first show a year later, as a student, at the Gdansk University gallery.

M CITY

Year of Birth: 1978

Place of Birth: Gdynia, Poland

Start Point: 1991

Influence(s): Architecture, poster art

Style: Stencil

Distinctive Feature(s): Texture and large size

The "Aha!" Moment

M CITY travels constantly and creates a number of works in the UK, in Poland, Germany, Brazil, Italy, or Spain. He becomes famous for his graphic designer talents and his street work after completing stunning murals in several festivals. But by 2003, his personal creativity is what brings him true recognition, and he gets two consecutive personal art shows in Gdansk.

Into the Art World

M CITY gains first access to the international scene when he's invited to participate in the *K-Spray International Stenciling Tour*, which leads him to Tokyo, Seoul, Hong Kong, to Thailand and to Taipei. Doors open instantly, landing him major exhibits over the following years in London, Budapest, Stuttgart, Ljubljana and, in 2006 and 2007, in Manchester, Rome,

Barcelona, Sao Paulo... The international exposure puts him in the spotlight, and the Street Art world truly discovers his talent and his originality.

Style

M CITY'S weapon of choice is stencil, which he uses to play with space, invading surfaces and reconstructing cities within the city, usually of very large formats, if not downright monumental. Architecture and perspectives are his main sources of inspiration.

His walls stage entire cities filled with dark silhouettes of factories, over which hover zeppelins. Trains pass by at top speed. In his own visual vocabulary, he gives birth to an iconography that seems to blast from the past, with bombs and tanks as reflections of timely symbols and traces left by history. Perspective and movement interconnect on smooth surfaces brought back to life. His stencils betray the utmost precision, and the attention he brings to shadows, heightens the impact of his work.

M CITY's esthetics favor black and white, and industrial elements, (found in the North region of Poland), are an inexhaustible source of inspiration. The cities of Gdansk, Sopot or Gdynia, his hometown, are a wealth of industrial architecture. The artist likes to *"play with architecture by assembling and dismantling new urban modules compositions."*

Courtesy of the artist, *M CITY*

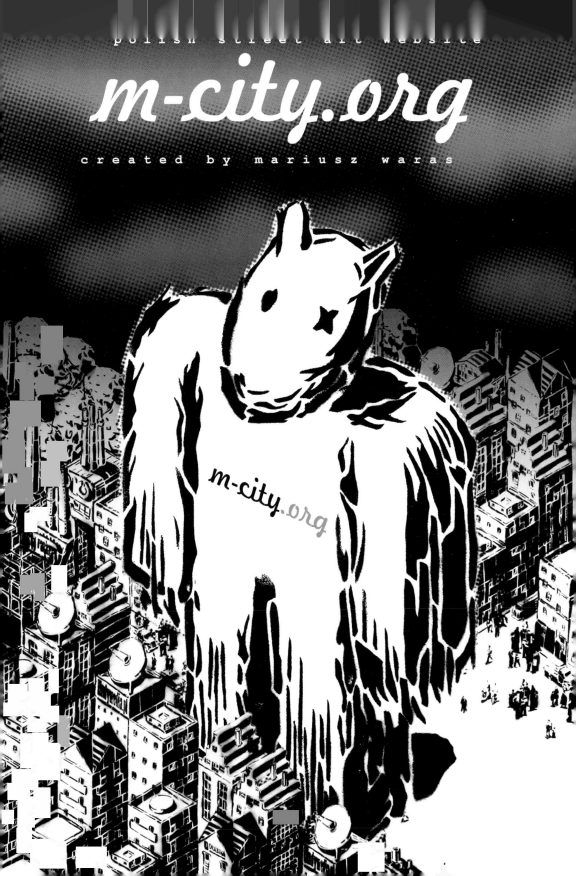

VHILS

Year of birth: 1987

Place of Birth: Portugal

Starting Point: 2000

Influence(s): BANKSY

Style: Crusted paper stencils, wall chiseling

Distinctive Feature(s): Large sizes and layers, use of unconventional techniques and materials

The Beginnings

Alexandre Farto, aka VHILS (meaning the vitals) was born in Portugal, in the area of the south-bank, across the river from Lisbon in 1987. Portugal had just joined the European Union, in the aftermath of the 1974 Revolution, which the majority of the country was then trying to forget. He begins by painting traditional graffiti in the streets of his neighborhood, at the end of the 90s, but quickly takes an interest in stencil. *"I first started writing graffiti when I was 10, but only got into it seriously when I was 13. At first it was just something to do with your friends or on your own, instead of staying at home all day. I really got into train bombing and was really involved in this scene, painting panels and so on in the main suburban Lisbon train lines, and eventually the rest of Portugal."*

Around that same time, he discovers that until the Portuguese Carnation Revolution, which put an end, in 1974, to Salazar's 30 years of dictature, there was a long tradition of political paintings on the country's street walls. *"After the revolution, the streets were taken over by murals, paintings and stencils, both political and non-political. It was quite a unique popular painting movement, more like South America than Europe."* He also realizes that his generation has completely forgotten this tradition, and that the walls have since then been totally recovered by an invasion of publicity and advertising posters. From that point, it's all about *"digging through these layers of his-*

tory. I never know what layer I'm going to find. I ripped up billboards from the streets of Lisbon. (...) There was an immediate and striking contrast between those utopian revolutionary murals and all the ads for consumer-goods that started going up everywhere. In those days no one really valued those paintings, so I grew up amid the decadent presence of these murals that still claimed a better world."

The "Aha!" Moment

"The next step was to start traveling around Europe to paint trains. Then I started exploring and experimenting with stencils and other tools and media, and thinking more and more about what I was doing, what I wanted to do, and where I wanted to go with this." In 2003, the Wooster Collective's website notices his work and does a short feature on the young 16-year old artist. And in 2006, he gets his first solo show in his hometown, at Miguel Mauricio's gallery. Under the title *Building 3 steps*, VHILS creates an indoor/outdoor exhibition, using light installations, steel boxes, spray cans, paint, bleach, and more.

"I remember reaching a point when I started thinking more and more about what I was doing. I started rationalizing things, contemplating the possibilities of reaching out to a wider audience, to be able to communicate with more and more people; people who could, if you wanted to become less specific, understand what you where saying, what you were putting out on the streets. Nowadays I'm focusing on trying to push the boundaries of communication with people."

Into the Art World

VHILS started early, and is already considered today to be Portugal's Street Art representative. He's among the most recent discoveries in the Art world, after being particularly noticed during the UK Fame festival, when one of his wall works is seen next to a BANKSY piece. Not surprisingly, Lazaride, BANSKY's gallerist, offers him his first solo show in London, opening for VHILS, in 2009, the doors to international success.

Style

Alexandre Farto is faithful to his roots. "All of this has obviously resulted from my work back in the days, with pure, raw graffiti, which I still love to do." His ascension, though, owes a lot to his personal and prolific style. He has a clear predilection for portraits, and concentrates, like JR, on tightly-framed faces. Inspired by Lisbon's tradition, he creates substance within the wall, using a complex combination of wheatpasting, photography, and stencil. "My work is more and more about finding in situ materials and turning vandalism into a form of art — about destruction as an act of creation."

His subjects are the people he meets on the street: "The idea is why shouldn't everyone be an icon? It's not about the people, it's about the confrontation, the juxtaposition between our consumption culture — all the needs advertisers create — and our individuality."

He mostly uses recycled materials, often found onsite, and explores the layers of publicity posters that are already up. He then ads, puts up, scratches, rips off, revealing the form, using ink and bleach to eat into the surfaces, exposing the layers beneath. If needed, lately, he's been known to grab a jackhammer. Out of the substance, he produces works that are strong and heavily filled with emotion.

"I am interested in exploring and exposing the ephemeral nature of things, the contrast that comes from opposing old layers with new ones, glamour and decay. This is pretty much what I witnessed when growing up in a country where the old and traditional was devoured by the rapid urbanization process that took over its landscapes."

VHILS works are complex and poetic, and act as visual metaphors, *"to reflect upon our own layers. Its aim is not to come up with solutions but to conduct research, to confront systems, materials, processes, elements, to create friction and confront the individual with the process, with the system: an active critical process that stems from the same environment upon which it aims to reflect."*

Courtesy of the artist, VHILS

The Beginnings

Francisco Silva aka NUNCA (meaning "never" in Portuguese) was born and raised in São Paulo, Brazil, where he still lives and works. He's only twelve when he begins to paint graffiti and Brazilian pixação (Brazilian graffiti form) in the streets. His creations have always been figurative, but have progressively incorporated native figures and cannibal references.

NUNCA

Year of Birth: 1983

Place of Birth: São Paulo, Brazil

Start point: 1995

Influence(s): Pixação, OS GÊMEOS, Dubuffet

Style: Figurative and native Indian geometrical combination

Distinctive feature(s): A mix of tradition and modernity, with wooden and metal serigraphy aspects.

The "Aha!" Moment

In 2004, NUNCA is part of a first exhibit, locally, before getting a solo show. 2007 is the turning point for the young artist who receives an invitation to the Museum of Modern Art of São Paulo, before going to Scotland for *The Graffiti Project*, a monumental work, with his fellow countrymen OS GÊMEOS and NINA, at the Castle of Kelburn. That same year, he is featured at the Musée des Arts Modestes in Sète (France) and participates in his first European group at the Magda Danysz Gallery.

Into the Art World

His next steps in the Art world have taken him to London's Tate Modern, in Spring 2008, signing a monumental mural outside the prestigious institution during its major Street Art exhibition.

In a very short period of time, traveling around Europe, NUNCA has gained fame and prestige. He is already considered a Brazilian Street Art star, with publications galore.

Style

Whether on canvas or on walls, NUNCA's art strongly evokes ancient native Brazilian traditions. By placing his iconography in a contemporary frame environment, on the side of freeways or under bridges, ha has opened a dialogue between Brazilian ancestors and contemporary Brazil, between the old and the new. His work also raises the question of globalization's influence on the native culture, that of Brazilian people's deep nature and that of the fight to survive in today's modern metropolis.

The combination of figurative and geometrical painting with pixação's written expression results in a body of work that shapes together tradition and modernity. The technique used to create shadows and to define the figures is the same one used by the conquerors at the time of Brazil's colonization when telling their adventures of the new world: wood and metal engravings. The only difference is that, here, NUNCA uses brushes and spray paint to reach the desired engraving effects rather than dry points. In the same way, his use of deep red ochre is a clear reminiscence of the urucum, a red pigment used by certain Brazilian tribes to paint their faces and bodies during an-

cient rituals. NUNCA's style, while unmistakably Brazilian given his origins, deals with issues that are international by nature

"I believe because of the mixing breeds, Brazil is culturally rich, but we don't value that cultural richness, we don't respect ourselves, we don't try to improve our self-esteem. The images I use of Indians are a way to depict that this rich culture lives within each Brazilian, but the foreign exploitation in the country, diminishes Brazil's self-esteem. An Indian in the city either chooses to maintain its roots or to use NAIQUE (Nike)'s sneakers. The Knowledge of Indigenous people with its unique way to see the world is rooted in the Brazilian culture, as well as its natural resources in the Amazon forest. I always try to politicize my work, with subjects that can be about cannibals, the ravishing exportation of Brazilian fruit, of Indigenous culture, the forgery of labels, but the focus of my interventions questions how the traditional culture mixes, maintains or loses itself to globalization."

His work also brings into question globalization and its influence on native indigenous cultures. The Brazilian native figure painted on the Tate Modern façade in 2008, with its paint roller and cup of tea, shows the unexpected relation between a major artistic institution and a street artist, represented as a cannibal and can't resist honoring, along the way, the infamous cup of tea, yet another British institution.

NUNCA works in his studio, on canvas, as well as on the street. Pursuing his street art is fundamental in his eyes, and the source of his inspiration, as he himself underlines: *"When I go out to paint in the street, my goal is to paint people who live there. I paint for them. My paintings are a reflection of Brazilian interbreeding. Who is not "half-blooded" in Brazil today? As far as I'm concerned, I am incapable of saying whether I am a black, white or Indian."*

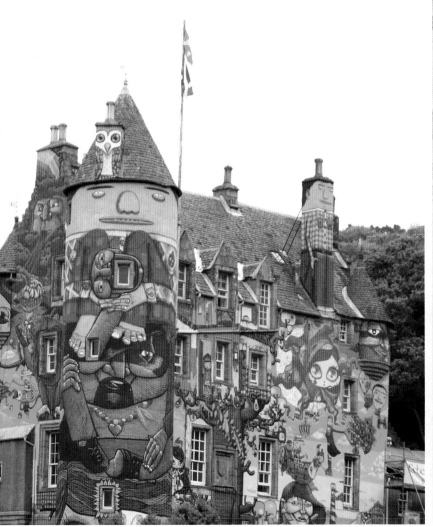

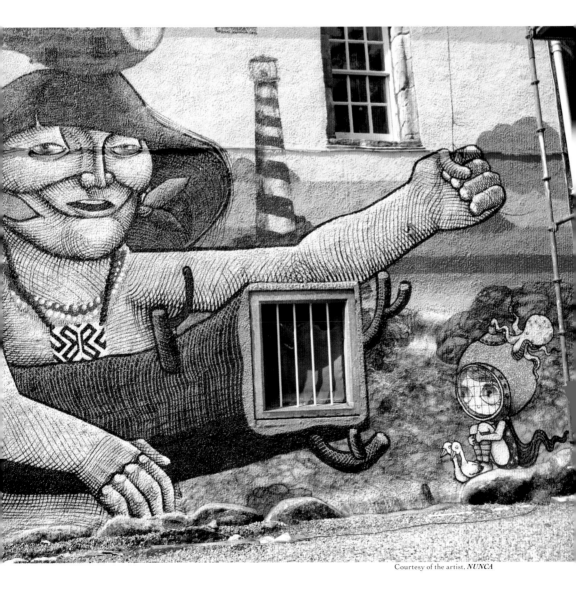

JR

Year of Birth: 1983

Place of Birth: Paris suburbs

Starting Point: 1999

Influences(s): OBEY

Style: Giant black and white wheatpasted portraits

Distinctive feature(s): Gigantism, emotion, activism

The Beginnings

JR was born in a Parisian suburb in 1983, and maintains his anonymity. He begins graffiti as a teenager, but shows strong dispositions for art, both in class and out on the street, where he stands out. Rumor has it that photography happened by accident, after finding a camera in the subway. *"I got to street art through graff (i.e. graffiti) and somewhat by default. Graff in it-self wasn't enough. And I wasn't that great at it. What I liked was the 'I was here' side of things. (…) And here I am, dragged by friends, in the tunnels. They were in it to paint, I wanted to keep a trace, document the moment, the action. I slipped my first film in the case. I felt nerv-ous, I had 12 shots, I wanted every single one of them to be amazing. That was my thing, from the start: to show places and crazy situations I could connect to. Of that first shoot in the tun-nels, out of 12 photos, I put 6 up in the street. And things took off"*. His initial artwork is the subject of his first book, released in 2005: *Carnets de Rue* (Street Notebooks), a travel journal dedicated to Urban Art.

The "Aha!" Moment

"At first, I didn't have any strategy. I started by putting myself up in the RER's (Rapid Tran-sit Rail System in the Paris greater area that reaches out to the suburbs) and the city cafes' small advertising boards. And then the first street art wave hit us. I felt totally connected to that emerging scene. So I watched what the oth-er guys were up to, the wheatpastes, the stencils,

etc. I looked into the wheatpasting and sticker-ing techniques, cheap large-sized prints... And then to stand out and turn it into a real artistic process, I framed my photos using a fat cap to draw a line directly on the wall. I liked the prov-ocation of a tagger's picture being wheatpasted on the wall, and then retagged!"

After a first unofficial exhibit he puts up on the walls of the Cité des Bosquets in Montfermeil, France, (a "Cité" is the equivalent of a US urban "Project") in 2004, JR decides to set up his 28mm-lense right in the heart of the neighbor-hood. With the cooperation of actor Ladj Ly, also director of the Kourtrajmé col-lective, who lives in the Cité, he does a se-ries of bareheaded, full-framed portraits of the Cité's youth and, later, wheatpastes throughout the Cité a number of huge portraits featuring its inhabitants. Ironi-cally enough, JR's career takes a sudden turn during the October, 2005 suburb ri-ots, which take place in the suburbs of... Clichy-Montfermeil. The riot images on the television news, as reported by all the media who have invaded the Cités, show JR's photos as giant backdrops to the events. The project was about capturing the interesting and striking faces of the inhabitants, and supporting their capac-ity to take ownership of their living en-vironment. But the images' impact and force is what the media capture and react upon.

From then on, he continues to turn his snapshots into posters, and the streets into universal, galleries under the open sky. From Los Angeles to Berlin, he holds on to his independence, showing his work illegally out on the street, which he con-siders a gallery of his own. His projects always convey a strong social and cul-tural impact.

His faithful friend and partner in activ-ism, Emile Abinal, writing about the book that follows, explains: *"With a cer-tain insolence, JR provokes passer-bys and questions social and media representation in a generation which people can only observe at the frontier of Paris or on the News. His book, '28 Millimeters', regroups 28 portraits selected among the series' most meaningful shots. It also presents pictures taken on the spot, reflect-ing the moments shared with the Cité's young people, and several actions completed in the street during the year 2005."*

Into the Art World

In more ways than one, JR's path is un-expected. As of 2003, he travels and his work is seen worldwide. By 2008, the prestigious Tate Modern invites him to put up a monumental piece on its façade. But during those five years leading to London, his projects remain sharply fo-cused on projects inspired, prepared and completed on site, from Brazil to Kenya or Sierra Leone, for example. FACE-2FACE is the title of his 2005 initiative in the Middle East, and was probably the first one to bring him international atten-tion and respect. His original trip is an attempt to understand why the Palestin-

ians and the Israelis couldn't simply live together. Once there, drawing conclusions from the many similarities existing between the two people, he decides to take portraits of Palestinians and Israelis who hold the same jobs, each in their own country, and to place those large-sized portraits facing one another, in unavoidable locations, on the Israeli and Palestinian sides. In 2008, his WOMEN project is developed in the same way, with the admitted objective to underline women's central role in Kenya, in Sudan, in Sierra Leone, in Liberia and to embrace their dignity and beauty by wheatpasting the gigantic portraits on trains, walls and hills around their countries. In Brazil, recently, he has been developing an immense project in the Rio de Janeiro favelas.

Style

Though he now is introduced as a photographer, and invited as such in photo festivals everywhere, among which the famous Rencontres of Arles, in France, in 2009, JR remains deeply connected to the Street, its culture and energy. He considers that covering trains or walls with a photo is part of his work because he needs *"to follow the image from the beginning to the end, in order to give it meaning once it is replaced"*. As in the Graffiti world, location is key, though his work stands out because of its monumental format: his eyes are the size of a train car and his smiles cover hills... JR is an artist and

an activist, engaged in his work on a political level: *"Art has the responsibility to raise questions, not to bring answers"*.

His 28mm portraits place him inches away from his models' faces, in an attempt to capture their deepest features and their most personal feelings, in a very intimate way, looking for the variable intensities of a glance, an expression, a smile or a glare. The way he accesses his models' eyes has an Avedon quality. He spends time bringing out extreme expressiveness through faces because, paradoxically: *"the photo itself is not important, putting the work up in the right location, is. I spend more time wheatpasting than I do taking pictures"*. This is the essential distinction that confirms JR as a street artist, in addition to Shepard Fairey's admitted influence on his work.

His giant photos bring Street Art a new perspective as they find their resting places on Jerusalem's wall, at the bottom of an abandoned pool, on the 2000m² surface of a city's roofs... Street Art can be monumental, especially when it can only be seen, in some specific cases, from the sky. JR's subject is human, questioning where the actions around his photos actually belong, where they should be taken, where they should be placed. Yet in his photos it is also striking to see, above the pictorial quality, the intensity of the looks the artist captures. Blowing them up also brings a special emotion as giant expres-

sive eyes looks at the passer-by from the top of a hill or from a bridge, leaving one in awe.

In his recent project in the Favela de Providencia, he covered all the houses on the hill with portraits that connected in one large one seen from afar. And on site, he collected 250 000 photos taken on the spot and put back-to-back in 24 images per second format, creating an unequalled film-documentary. JR is an OVNI in the Movement, and in constant mutation. From Street Art, photography, writing and films to social activism (he has opened a cultural center in Providencia), JR's art needs to been seen as an ensemble, where everything comes together, hopefully for the greater good.

This page and next pages: Courtesy of the artist, *JR*

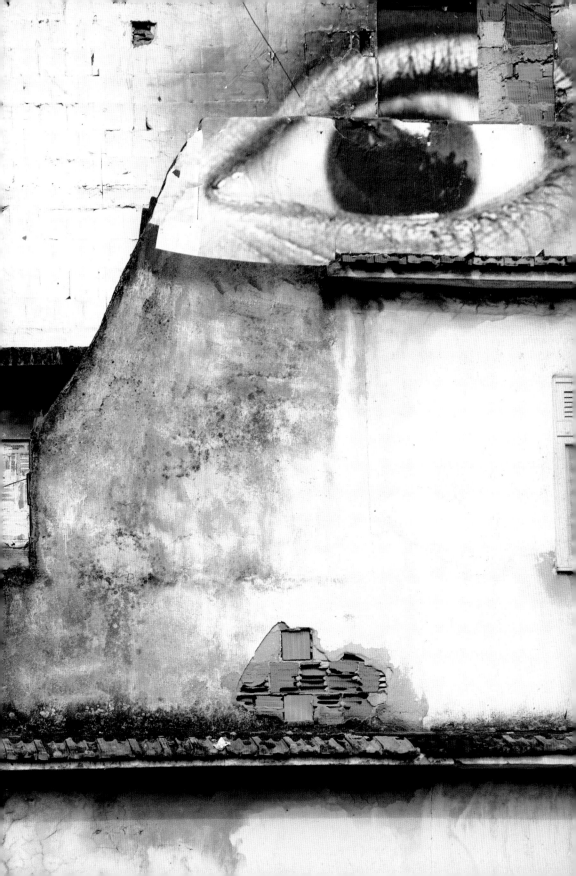

GLOSSAIRE

A number of extensive and rather complete Graffiti glossaries exist online, and you should refer to them, should you wish (as you should) to explore the wealth and diversity of the Street Art vernacular. In the meanwhile, here is a short selection of terms and expressions, based on commonly found words that you might consider useful, or that bear a significantly different meaning in the Graffiti world.

3D: Lettering style. Created by FLINT 707 and PISTOL, this particular technique gives two-dimensional painted letters the appearance of 3D depth. It can be combined with other styles for added complexity, for example with Wild Style.

Activism: Behavior or practice based on direct and militant actions in connection with one's personal beliefs, principles, goals. In Graffiti, it designates people's strong commitment to the movement and to its development.

Alias: Assumed name, word or term, used instead of another. In Graffiti, it is chosen for its facility to be memorized in the "fame game", its rapidity of execution on the city trains and walls, as well as a way to guarantee a writer's hidden identity.

All City: The status of a writer, a crew, famous throughout a city. A writer starts by being "up", the most prolific and talented ones become "all city".

Back to back: Throw-ups or pieces painted one after the other on one wall or surface.

Background: In Graffiti, the background is a crucial way to homogenize a surface, in order to give a piece its depth and visibility. It is an essential phase in the execution of a mural.

Battle: In Graffiti, a battle is a contest among writers or crews, to determinate those with the best style. A battle can last anywhere from a few hours to a full day.

Getting up Battle: A contest among writers or crews over a period of time that can last anywhere from a few days to a month, to determinate who can execute the largest number of tags across a city. Participants must provide compensation to the winners based on previously agreed terms, usually in the form of money or supplies, like paint.

Bite: Highly criticized practice in which one writer copies another writer's style. Plagiarism.

Black Book: See Piece Book.

To Blend: Technical term. Applying the paint so two colors transition smoothly from one another.
"What made me realize that what I was doing was special was when one day, while I was in a tunnel, I saw kids tagging and there they were, talking about color blends and palettes. I was like "check this out! They're talking like artists." **JONONE**

Blockbuster: Lettering Style based on large-sized square-shaped elements, which usually come in two-color combinations. BLADE and COMET claim its invention. Easy to execute, this style is used to do large pieces quickly, and often times to cover up other writers' pieces.

To Bomb: To paint pieces, using spray-cans, in many locations. The term implies proliferation.

Bubble Letters: Lettering Style. These round-shaped, bubble-like letters were created by Phase 2 in the early days of Graffiti. They're often used as throw-up letters to save time.

To Buff: Verb. In the Graffiti world, to buff means to erase, eradicate. To buff is to remove painted graffiti with chemicals and other instruments, or to paint over it with a flat color. The verb appeared when New York's MTA started cleaning its trains, starting a war against graffiti, and is also used when a piece is "buffed" from a wall by city personnel.

Burner: Noun, slang. Is said of an excellent piece, one that "burns", with highly visible and striking colors that give depth and impact to the work. Originally used to define the best Wildstyle window-down pieces. Also used to qualify the winner of a style competition.

"The 'burner' considered mostly to be done right below the window of the rolling page and/or car uses colors very fruitfully and multiple arrow styles, inertia bits or blocks for extensions of arrow barbs or tips. Its classification can be built in jewelry. Whereas 'Wild Style' cannot. For 'Wild Style' does not have the back side of itself. The 'burner' does. Its 3-D outline is correct for it to be built."

RAMMELLZEE

Caps: Interchangeable spray-can nozzles. Each writer owns a variety of caps in order to adapt his cans to his needs. Each cap brings a different quality to the stroke, ranging in thickness, density and style, from skinny caps to fat caps, often called softballs because of the wide and soft-looking spray they produce.

Cloud: Technical term. Style decoration born in the early days of Graffiti. A painted cloud helped a tag stand out from the other tags.

Computer Style: Technical term. Lettering style belonging to the Wild Style category, creating a pixel effect.

Crazy: Adverb, slang. A synonym for "really".

Crew: Group of writers. Often reduced to two or three letters. A writer can have belonged to different crews. Specialized website list thousands of crews. Most notably: FC (Fame City), OTB (Out to Bomb), CIA (Crime In Action, Crazy Inside Artists), TNT (The Nations Top, The Nasty Team), TPA (The Public Animals), PIC (Partners in Crime), TFF (The Fabulous Five), TMT (The Magnificent Team), UA (United Artists).

CTA: Chicago Transit Authority.

Culture Jamming: Appropriation of existing mass media (e.g. billboards, ads and posters) to subvert the original meaning/message. Motivated by the idea that advertising is a form of propaganda.

Cutting lines: Technical term. Technique based on very thin lines.

Def: Adjective, slang. Term born in the early days of Hip Hop culture. Built upon phonetic for Death, it means "really good".

Dope: Adjective, slang. In Hip Hop culture, stands for "cool".

"When I first got into graffiti, I always used this word. Sometimes I cringe at its utterance now." -
BUFF MONSTER

Down: To be in good terms with, to have a bond. "He's down with us"

Drip: A drip running down a letter can be one of two things. Done unintentionally, it betrays the work of a beginner or poor writer. Executed on purpose and with control, it becomes a styling effect.

Fade: Style effect. To blend one color into another adjacent one; to lighten progressively the intensity of a color.

Fame: Level of recognition a writer earns with his tag.

Fanzine: Type of magazine done by fans of a given topic. In the movement, fanzines, mong before the birth of the Internet, played a key-role in the propagation of Graffiti images, and in the knowledge and culture around the movement, and were instrumental in a writer's status. Phase 2 launched the first Graffiti fanzine: "International Graffiti Times".

Fat: Adjective, slang. Used instead of "thick", as well as for "good". Also spelled "phat".

Fill: Noun. Colored surface inside a letter in a piece

Fresh: An early hip-hop term synonym for "cool". Stands for a "really good" graffiti.

To Get Up: To execute a large quantity of tags.

Giraffiti: Noun. Also known as "heaven spot" or "heavens". A giraffiti is a piece executed above usual heights or in a difficult place to reach. It increases an artist's fame.
"None of us never said that we were going to do "graffittis". On the inside, we would say that we were going tagging." **RAMMELLZEE**
"Back then I don't think anyone ever thought much about the future of the movement and where it was going. Surely I didn't. It was a passing fancy, a fad, a sign of the times. Social unrest and war were at the forefront of our culture. There were gangs and there were causes, there was indecision and there was pressure. There was a feeling of helplessness and there were messages to be delivered. Modern day Graffiti was that movement." **FUTURA 2000**

"Art should be representative of the times we live in. When I look at Impressionist or Surrealist painters, I feel those were movements of their times. When I see what was done on the iron horse, I feel that the CRASH, the Kels, the Skemes, the Dez, the Daze and the Part, there was more to it than the name or the letter. What made the composition and the construction of their images was the artist himself and what surrounded him." **JONONE**

Graffiti: See page 16.

Guerilla art: One of the Graffiti movement's given names, in connection with the important dedication to the movement that being a writer requires.
"I think graffiti artists were the great innovators of guerilla art, art as warfare and mass advertising. A graffiti writer's objective is to brand himself and advertise as much as possible in as many places as possible" **MARE 139**

Hacktivism: An expression merging the words "hacking" et "activism"; a policy of hacking or creating technology to achieve a political or social goal.

To Heaven Hard: To reach high areas such as freeway signs and the roofs or upper floors of buildings.

Hip Hop: Cultural, artistic and protest-based movement, born in the Bronx, New York, during the early 70s. See page 46.

To Hit: To tag up any surface with paint or ink.

"As in, when I'm driving around and I ask my buddy, " You wanna hit that spot?" **BUFF MONSTER**

Hit up: Noun or verb. When something is covered with tags. To tag.

Homemade: A type of homemade marker made out of various containers filled with ink. Homemades have been made out of many things, including deodorant containers. Shoe polish kits are also sometimes used s for tagging, especially those that consist of a bottle with a brush/sponge device attached, etc.

Insides: Originally referred to tags made on the insides of subway trains.

IRT: The Interborough Rapid Transit Company was the private operator of the original underground New York City Subway line that opened in 1904, as well as earlier elevated railways and additional rapid transit lines in New York City. The IRT was purchased by the City, in June 1940. The former IRT lines (the numbered lines in the current subway system) are now the A Division or IRT Division of the Subway. It is a train line in New York that had many burners because its cars were all flats.

To Kill: To hit or bomb excessively. To get up intensively.

King: Noun. The best with the most. Some people refer to different writers as kings of different areas. King of throw-ups, king of style, king of a certain line, etc. Before being a king, you start as a toy, and might move up to being a knight.

Landmark: A highly considered location where graffiti is not erased immediately.

Married Couple: An older subway term from New York, designating two cars permanently attached and identified by their consecutive numbers.

Mob: Whole crew doing graffiti on a wall at the same time.

MTA: Metropolitan Transit Authority is responsible for public transportation in the state of New York carrying over 11 million passengers on an average weekday systemwide, and over 800,000 vehicles on its nine toll bridges and tunnels per weekday.

Mural: Large-scale painting on a whole wall; usually a large production involving one or two pieces and usually some form of characters.

Old-school: Adjective. A reference to the early days of writing, and more generally to the Hip Hop culture from the mid 70s to mid 80s. Old-school writers are given respect for being there when it all started, and specific writers are remembered for creating specific styles.
"The new get their education from the old and they become the influence of tomorrow. The cycle is completed when the student becomes a teacher, a position of education and responsibility." **FUTURA 2000**
"I remember standing on the 4 on 183rd St. and seeing DELTA 2 and SHARP pieces roll by. Or being in Brooklyn on the A and counting IZ THE WIZ throwies buzz by. I remember seeing RICH, MIN and JULY and feel the force throw-ups can deliver. I remember looking at QUICK throw-ups and running from one end of the platform to another just to try to read what he had written inside

them. Yeah I guess our generation was an elite group of writers. People are always talking about the old school and whenever there is an interview they always show the same trains. There was a lot going around and in different forms like throw-ups, tags, silvers etc. It was not just about painting pretty pictures to have pretty photos." **JONONE**

Outline: Drawing done in a piece book in preparation for a definitive piece. Also called a "sketch". Can also refer to the outline put on the wall and then filled, or the final outline done around the piece to finish it.

Panel piece: A painting located below the windows and between the doors of a subway car.

Piece: Important graffiti painting, short for masterpiece with at least three colors to be considered as such.

Piece book: Sketchbook that every writer carries around at all times. Also called "black book" or "writer's bible". Writers prepare and practice their sketches in detail, in order to be ready, day of, to execute the actual piece as fast as possible.

Pixação: Distinctive form of graffiti born in São Paolo, Brazil, based on triangular long vertical letters.

Props: Means "respect", comes from "proper respect". This hip-hop/rap term has made its way into common usage.

Repression: City authorities have Graffiti, is used for actions made to slow down and eradicate tagging and graffiti in public spaces. Repression can go from fines to jail time. Most of the writers have been the victims of intense repression and have experienced jail time.
"There will be faster techniques and smarter youngsters to deal with this." **LOOMIT**

Ridgy: Subway car with corrugated, stainless steel sides, unsuitable for graffiti. Writers did mainly two-color throw-ups and some top-to-bottom throw-ups (one color and silver because silver was hard to buff) on these types of cars. Ridgies ran in Brooklyn.

Silkscreen: Noun. Printing technique that uses a screen of silk or other fine mesh to support an ink-blocking stencil. The attached stencil forms open areas of mesh that transfer ink as a sharp-edged image onto a substrate. Paint is moved across the screen stencil, forcing or pumping ink past the threads of the woven mesh in the open areas. Also called "screen printing" or "serigraphy".

"An old technology, but I love it. Except for some of the very large posters I've done, all the thousands of posters that I've put up over the years were silkscreened by hand. It can be a lot of work, but it's the fastest and best way I've come up with to reproduce an image for mass consumption." **BUFF MONSTER**

Spraycan Art: Noun. See page 15.

Stencil: Noun. Stencil technique in visual art is also referred to as "pochoir". See page 289.
"Every time I think I've painted something slightly original, I find out that BLEK LE RAT has done it as well, only twenty years earlier" ***BANSKY***

Style: Specific lettering technique, comparable to a font, often developed and/or perfected by specific writers, i.e. Bubble Letters, Wild Style, Broadway Style.
"There are many pioneers who have (through the very fact that they were there) established the standard by which excellence will be determined. My choice for style guru would be PHASE 2. Of all the writers of this generation, he was truly an artist whose developments in lettering and spray painting techniques would provide many of his peers with "food for thought" for two more decades." ***FUTURA 2000***

Subvertising: Spoofs or parodies of corporate and political advertisements to make a statement. This can take the form of a new image or an alteration to the existing image. A subvertisement can also be a part of social hacking or culture jamming.

Subway: Noun. Undergound public transportation system.
"I was always at home in the subway system. Obviously so were a lot of others. It makes perfect sense that the subway system would literally become the "vehicle." It just happened, it invited it. Suddenly graffiti wasn't limited to tenement halls, schoolyard walls, and bathroom stalls. Graffiti had found the speed at which it needed to be seen. To keep in step with the fast pace of communication and information sharing. What had started out as playing in subway tunnels had progressed into midnight forays deep in the interiors of the system." ***FUTURA 2000***

Supplies: Brushes, bombs, caps, buckets, markers, everything a writer needs to create a piece.
"As mundane and insignificant as they may seem, the right ones are so very important. When I'm in far away places like Hong Kong and Milan, I'm surprised how easy it is to find great supplies at Mom n' Pop hardware stores." ***BUFF MONSTER***

Tag: Nickname or alias for a writer in the street. All Graffiti writers have one. It is used as a brand of sorts, and used as a form of identity, like a signature. It is the most basic graffiti form, a writer's signature with marker or spray paint. It is the writer's logo, his/her stylized personal signature. If a tag is long it is sometimes abbreviated to the first two letters or the first and last letter of the tag. Also may be ended with the suffixes "one", "ski", "rock", "em" and "er". Also can be turned into a logo.

"Take as examples SPACE INVADER, ZEUS or ANDRÉ, who use to be taggers. It's obvious that they tried, in creating logotypes, to escape the tag logic found on every street corner of the city (Paris), and in many shapes and forms. There is such an accumulation of tags that, in order to gain some sort of fame, they decided to go about it differently. They also offer another type of emotion and a vision that goes beyond a simple tag." **JONONE**

Tag Banging: Graffiti term. Using violence to defend a tag.

Tagger: Graffiti term. Usually used to differentiate the people who only do tags, from writers who do pieces and have more elaborate and creative goals.

Throw-up: Rapidly executed pieces. Also called a throwie.

"Over time, this term has been applied to many different types of graffiti. Subway art says it is "a name painted quickly with one layer of spray paint and an outline", although some consider a throw-up to be Bubble Letters of any sort, not necessarily filled. Throw-ups can be from one or two letters to a whole word or a whole roll call of names. Often times throw-ups incorporate an exclamation mark after the word or letter. Throw-ups are generally only one or two colors, no more. Throw-ups are either quickly done Bubble Letters or very simple pieces using only two colors. With regards to traditional graffiti, I think the throw-up is most important thing. Coming up with a great little 2-letter throw-up is far more difficult and fun to look at than any piece. New York made 'em famous, but throw-ups in San Francisco in the mid-nineties are some of my favorites." **BUFF MONSTER**

Top-to-bottom: Graffiti noun. Piece that extends from the top to the bottom of a subway car, completely covering it. Can also refer to a wall or building that has been pieced from top-to-bottom. The first top-to-bottom car is said to have been completed, in 1975, by HONDO.

Toy: Graffiti noun or verb. Is said of a new, inexperienced, incompetent writer, or of an older writer who still does poor work. An old saying originally gives "TOYS" as an acronym for "trouble on your system". Also designates the act of "toying" someone else's graffiti is to disrespect it by means of going over it. "Toys" is often added above or directly on a "toy" work. An acronym meaning "Tag Over Your Shit".

Train: Refers to a subway train.

"A train is known to be a gigantic rolling page in the biggest gallery system on the planet... the book of truth." **RAMMELLZEE**

"The first influential train I saw was a LEE Quinones whole train called Soul Train, it had dancing characters that were taller than me, it pulled up on me as I waited for the train on 149st Grand Concourse which was also the infamous Writers Corner or Writers Bench train station where writers would meet to look at the passing trains and exchange black books for signatures and drawings. From that point on I knew I wanted to do it so I secretively began my writing career in my public school walls and bathroom and the rest is history." **MARE 139**

Wack: Noun; Street Art slang. Below the level one might expect. Anything that looks weak. Badly formed letters, incompetent fills, dumb tags, etc.

Wheatpasting: (also called flyposting in the UK): Street Art technique. See page 289.

"Having taken a few notes for the Obey, the idea was to wheatpaste the shit out of cities and get up as much as possible to get the name out and to make our mark, so to speak. One other reason was the pure enjoyment of what was going on in the streets and wanting to be part of that." **MCNEIL** from **FAILE**

Whole car: Graffiti piece covering a whole car. See also "top-to-bottom". FUTURA 2000 was considered one of the whole car masters, as were CAINE 1 in 1976 and THE FABULOUS FIVE soon after.

Wildstyle: Lettering style. An intricate lettering based on interlocking letters. It's a complex style with a lot of arrows and connections. Wildstyle is considered one of the hardest styles to master and often completely undecipherable to non-writers.

"The second method in the hierarchy of competition is known as "Wildstyle" which of course by title, is anything that can be done in calligraphy. That starts with a style known as "blockbuster" which has no arrows on it and moves further in competitive style with arrows, an emotional symbol of direction." **RAMMELLZEE**

Window down: A piece done below the windows of a subway car.

Writer: Practitioner of the art of Graffiti. "Writing" is often used to make a difference with plain tagging. Integrates a more creative meaning to the practice.

Yard: Train yards where writers would gather to do their pieces.

Zine: Short for fanzines.

INDEX

ANDRÉ: 219, 329, 354

Andy Warhol: 095, 139, 216, 306, 338, 342, 361

A-ONE: 158, 186, 187, 250

ASH: 242, 243, 247, 248

AXE: 201, 231

BABY FACE 86: 040, 083

BAMA: 042

BANDO: 167, 224, 230, 231, 248, 305

BANKSY: 305, 314, 315, 316, 371

Barnstormers: 336

Barry McGee: 007, 284, 285, 303, 317, 318, 319, 324, 325, 358, 360, 361

BBC: 242, 256, 257

Bill Blast: 248

BLADE: 043, 044, 047, 067, 074, 075, 095, 112, 113, 156, 157, 159, 168, 210, 387

BLADEONE: 043

BLEK LE RAT: 248, 304, 305, 306, 316

BLITZ: 248

BLU: 303, 364, 365, 366

BOM5: 211

BOXER: 167

BOZA: 036

BRONX STYLE BOB: 231

BUFF MONSTER: 165, 360, 361, 363, 389, 390, 393, 394

BUG 170: 038

CAINE 1: 044, 105, 395

CAP: 211

C.A.T. 87: 042

CAT 2233: 040

CAY 161: 083

CHAIN 3: 112, 113

CHAKA: 164

CHINO 174: 044

CLIFF 159: 043, 044, 080

COCO 144: 042, 083

Colleen Frost: 295

COMET: 156, 210, 387

COOL CLIFF 120: 038

COPE 2: 113, 210, 211

CORNBREAD: 028, 035, 036

CRASH: 056, 067, 104, 105, 106, 111, 112, 113, 114, 120, 134, 139, 156, 157, 158, 159, 160, 164, 168, 196, 390

CRAZY WHITEBOY: 201, 231

CURVE: 036

C.W.: 201, 231

DAIM: 224, 225, 229

David Ellis: 007

DAZE: 057, 104, 105, 112, 113, 114, 115, 133, 134, 136, 156, 157, 159, 164, 186, 192

DEER: 229

DELTA: 186, 193, 218, 222, 223, 229, 303, 391

DERO: 211

DEZ: 113, 200

D*FACE: 292, 337, 338, 339

Diego Rivera: 287, 288

DIME 139: 044

DINO NOD: 038

DISCO 107.5: 104, 139, 158

DONDI: 084, 089, 095, 113, 118, 119, 120, 121, 128, 129, 156, 158, 168, 192, 196, 228

DOZE GREEN: 007, 136, 137, 250

DR. PEPPER: 210

DUST: 156

EASY: 211

ESPO: 036

EVA 62: 041

EVOKER: 294

FAB 5 FREDDY: 085, 120, 158, 159

FAFI: 187

FAILE: 292, 294, 302, 303, 342, 343, 344, 395

FLAME 1: 044

FLINT 707: 037, 041, 042, 055, 386

FLITE: 200, 211

FREEDOM: 186

FRIENDLY FREDDIE: 037, 038

FUTURA: 037, 047, 054, 055, 056, 057, 061, 062, 064, 067, 084, 104, 113, 119, 120, 139, 157, 158, 159, 164, 167, 168, 187, 193, 231, 256, 257, 303, 389, 391, 393, 395, 397

GHOST: 211

HAZE: 004

Henry Chalfant: 008, 015, 016, 075, 094, 139, 186, 193, 196, 197, 201, 228, 242, 257, 337

HEX: 164

HONDO1: 042

HOPE: 328, 329

HURST: 118

IN (KILL 3): 043

IVORY: 211

JA: 211

JAY: 248, 249, 250, 256

Jean-Michel Basquiat: 067, 068, 081, 089, 095, 129, 157, 158, 160, 187, 213, 215, 217, 334, 335

JEC STAR: 042, 083

JEL: 201, 231

JOE 136: 038, 083

John Fekner: 157, 187

JONONE: 047, 056, 187, 201, 230, 231, 232, 242, 250, 303, 387, 390, 392, 394

JOZ: 211

JR: 023, 297, 303, 371, 378, 379, 380, 381

JSON: 211

JULIO 204: 028, 036, 037

JUNIOR 161: 083

KAD: 036

KAWS: 358, 359

Keith Haring: 067, 081, 095, 129, 133, 139, 156, 157, 160, 166, 212, 214, 359

KEL 139: 104, 119, 156

Kenny Scharf: 129, 133, 213, 248, 250

KEO: 200

KILLER56: 210

KINDU: 044

KONGO: 231

KOOL 131: 156

KOOL EARL: 035

KOOR: 186

LADY PINK: 047, 104, 105, 113, 114, 134, 138, 139, 140, 158, 160, 168

LAZAR: 038

LEE: 037, 038, 044, 045, 074, 080, 081, 082, 083, 095, 104, 112, 113, 133, 136, 139, 156, 157, 158, 192, 196, 210, 228, 250, 395

LOKISS: 231

LOOMIT: 224, 228, 229, 392

MAD: 156

MAGNET MAFIA: 294

MARE 139: 196, 197, 390, 395

MARK 198: 210
Martha Cooper: 015, 075, 119, 139, 201
M CITY: 367, 368
MEDISCO92: 210
MEGA MAN: 295
MICKEY: 118
MICO: 042
MISS.TIC: 019, 047, 290, 310, 311
MISS VAN: 047, 262, 263, 264, 288
MITCH 77: 104, 113, 139
MODE 2: 007, 056, 167, 187, 192, 193, 195, 224, 231
NAC 143: 104, 139
NASTY: 167
NOC 167: 075, 105, 112, 113, 114, 118, 132, 133, 134, 135, 139, 156, 192, 196, 197, 212
NOVA: 042, 084
NUNCA: 288, 374, 375, 376
OBEY: 023, 024, 165, 284, 327, 329, 343
O'CLOCK: 231
OS GÊMEOS: 007, 114, 187, 284, 303, 324, 325, 326, 374
PADRE: 156
PHASE 2: 014, 015, 028, 037, 038, 041, 042, 043, 055, 080, 083, 084, 085, 112, 120, 156, 159, 256, 257, 393
PHIL 167: 201, 231
Phil Frost: 229
PISTOL: 041, 042, 386
PJAY: 210, 211
P-NUT2: 210
POPEYE: 210
POVE: 211
PSYKOZE: 022
QUICK: 391
Quinones: 068, 080, 082, 395
RAKAN: 036

RAMMELLZEE: 084, 088, 089, 090, 113, 120, 136, 158, 168, 186, 257, 388, 389, 395
RAZZY RAZ: 201, 231
RELAX: 164
REV: 294
REVOLT: 156, 158, 200
RICAN 619: 083
ROGER: 044
SCOOTER: 038
SEEN: 024, 029, 047, 066, 067, 075, 094, 095, 096, 156, 163, 164, 168, 201, 210, 211, 228, 229, 303
SHARP: 056, 158, 187, 218, 219, 250, 391
Shepard Fairey: 006, 007, 023, 024, 165, 284, 292, 294, 327, 328, 329, 330, 337, 355, 380
SHRINK: 231
SJK 171: 042
SKEME: 113, 200
SKKI: 047, 242, 248, 249, 250, 256, 257, 258
SLAVE: 088, 118
SLICK: 164
SLIN 2: 201, 231
SNAKE 1: 042, 084
SOON: 163
SPACE INVADER: 165, 348, 349, 350, 394
STAN 153: 105, 139
STAY HIGH 149: 028, 037, 038, 039, 042, 043, 055, 121
STITCH 1: 042
SUPERKOOL 223: 040
SWOON: 334, 335
TAGE: 044
TAKI 183: 028, 037, 047
TAN: 083
TELER: 163

THUD: 201, 231

TKID: 250

TOPCAT 126: 037

TOXIC: 186, 250

TRACY 168: 037, 038, 043, 044, 105, 112, 114, 134

TRAP: 211

TRASH: 186

TURUK: 083

TWIST: 358

VHILS: 370, 371, 372

WAP: 042

WASPY: 201, 231

WEST: 047, 200, 201, 202, 288

White: 080, 081, 113, 118, 120, 121, 126, 136, 158, 168

WICKED GARY: 038

YEM: 164

ZEPHYR: 056, 075, 105, 113, 119, 128, 129, 139, 156, 158, 168, 200, 228, 229

ZEUS: 354, 394

ZEVS: 354, 355

ZODIAC: 163

Published by **DRAGO**

ISBN 978-88-88493-52-7
Printed in Italy (E.U.)

DRAGO head office
Via Marie Adelaide 12 - 00196 Rome - Italy
Tel: +39 06 45439018 / +39 06 45439132
Fax: +39 06 45439159
www.dragolab.com
For distribution enquiries: books@dragolab.it

In addition to the distributors below,
"From Style Writing to Art: a Street Art anthology"
may be purchased from the publisher's website www.dragolab.com

DRAGO WORLDWIDE DISTRIBUTION

North America
SCB DISTRIBUTORS
15608 South New Century Drive
Gardena, Ca 90248
Tel: + 1 310 5329400 Fax: + 1 310 5327001
For sales: gabriel@scbdistributors.com
www.scbdistributors.com

UK, Ireland, Scandinavia, France, Belgium,
Turkey, Southern Europe, Southeast Europe,
Eastern Europe
ROUNDHOUSE GROUP
Lorna House,Lorna Road, Hove, BN3 3EL
Tel: +44 (0)1273900540
Fax: +44 (0)1273774204
For sales: sales@roundhousegroup.co.uk
www.roundhousegroup.co.uk

France
CRITIQUES LIVRES DISTRIBUTION SAS
B. P. 93 24, rue Malmaison
93172 Bagnolet Cedex France
Tel: +33 (01)43603910
Fax: +33 (01)48973706
For sales: critiques.livres@wanadoo.fr

Italy
LIBRIMPORT SAS
Via Adda, 16/B 20090 Opera (MI), Italy
Tel: +39 0257605590 Fax: +39 0257606002
For sales: librimport@libero.it

Germany, Austria, Switzerland
and The Netherlands
VISUAL BOOKS SALES AGENCY
Laubacher Str. 16 - D-14197 Berlin
Tel: +49 3069819007 Fax: +49 3069819005
For sales: service@visualbooks-sales.com